Acts of
Transgression

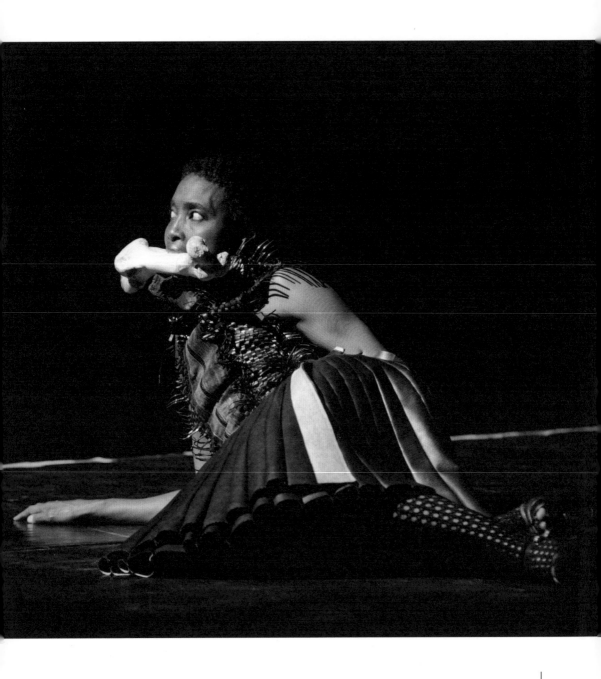

Nelisiwe Xaba, *Sakhozi says 'Non' to the Venus*, 2012.
Courtesy Institute for Creative Arts.
Photograph by Ashley Walters.

Acts of
Transgression

Contemporary Live Art in South Africa

EDITED BY JAY PATHER AND CATHERINE BOULLE

WITS UNIVERSITY PRESS

Published in South Africa by:
Wits University Press
1 Jan Smuts Avenue
Johannesburg 2001

www.witspress.co.za

First published 2019

http://dx.doi.org.10.18772/22019022798

978-1-77614-279-8 (Paperback)
978-1-77614-280-4 (Web PDF)
978-1-77614-281-1 (EPUB)
978-1-77614-282-8 (Mobi)

The publication of this volume was made possible by funding from
the Institute for Creative Arts, University of Cape Town.

Project manager: Robyn Sassen
Copyeditor: Alex Dodd
Proofreader: Alison Lockhart
Indexer: Sanet le Roux
Cover design: Hybrid Creative
Book design and layout: Hybrid Creative
Typesetter: MPS
Typeset in 11 point Crimson

CONTENTS

PART THREE: RETHINKING THE ARCHIVE, REINTERPRETING GESTURE

PART FOUR: SUPPRESSED HISTORIES AND SPECULATIVE FUTURES

Acknowledgements

Acts of Transgression is dedicated to those whose lives may be represented by or reflected in performance, but whose existence is not a performance, and who are living manifestos of courage and dignity in the face of transgressions against the human spirit.

To each one of the contributors – thank you for your dedication to this project, for challenging and shaping our understanding of live art in South Africa. To the artists whose works are discussed in this book – thank you for initiating this research through your practice. We are also indebted to the artists, photographers, galleries and publications named in the captions for permission to reproduce images.

We would like to thank the University of Cape Town (UCT), the Andrew W. Mellon Foundation and the Donald Gordon Foundation for their financial support, and the Deans of UCT's Humanities Faculty, as well as the Board, for their institutional support of the Gordon Institute for Performing and Creative Arts (GIPCA) and the Institute for Creative Arts (ICA) over the years.

The hard work and commitment of many project managers, technicians, artists and academics have been instrumental to the development of the Institute since its inception, and especially to the realisation of the Institute's Live Art Festival. In particular, we would like to thank: Adrienne van Eeden-Wharton, Samantha Saevitzon, James Macdonald and Bongani Kona.

I (Catherine Boulle) wish to make particular mention of Sheenagh Brighton-Goedhals, Margot Beard, Deborah Seddon, Kirsten Shepherd-Barr, and most especially, Sally Boulle – brilliant women, brilliant teachers whose mentorship and wisdom have propelled me. My deepest gratitude is to Ben Stanwix who accompanied me on this long editorial journey with great patience and love.

I (Jay Pather) want to extend my deepest gratitude to my various colleagues and teachers from my early days at the University of Durban-Westville (now the University of KwaZulu-Natal) and New York University for planting seeds of curiosity and care that have endured. I want to acknowledge Jelili Atiku, RoseLee Goldberg, Guillermo Gómez-Peña and Lois Keidan who, from diverse regions of the world, have inspired me. I also want to express appreciation to my partner, Andre Links, for his love and support.

Introduction

JAY PATHER AND CATHERINE BOULLE

THE TIMES

On 2 September 2014, audiences entering the Cape Town City Hall on the seventh evening of the Gordon Institute for Performing and Creative Arts (GIPCA) Live Art Festival were hit with the pungent smell of cow dung – the sensory setting of Chuma Sopotela's *Inkukhu Ibeke Iqanda* ('The chicken has laid its eggs').[1] Sopotela's series of slow and careful ritualised acts included writing 'Nkandla' on the wall in dung, in reference to then President Jacob Zuma's private residence, revealed earlier that year to have been lavishly renovated with the use of public funds. In the course of the performance, Sopotela removed the South African flag from her vagina. Tebogo Munyai's *Doors of Gold* unfolded in an adjoining room, where the artist's naked body was foregrounded as a trope for acute vulnerability in his evocation of the Marikana massacre, but also of the erasure of black men who have died in South Africa's mines without record or ceremony. In yet another room, *Limelight on Rites*, by dancer and choreographer Sello Pesa, featured two performers dancing to loud music with and alongside a coffin, while others pitched funeral plans to audience members, similarly highlighting the black body as an expendable commodity for barter and trade – even in death.

These deliberate, sometimes opaque, sometimes stark gestures, and the many that preceded and followed in the Festival programme, seemed to search for a different language – a corporeal vocabulary of seepage and excess – to articulate the distension of the time. Performing states of despair and protest, attack and response, against an overwhelming onslaught on the black body by continued economic and psychic oppression, they cited the failure of systems of communication; a breakdown of language and logic.

Only six months later, Chumani Maxwele flung excrement at the statue of Cecil John Rhodes on the University of Cape Town's Upper Campus in an act of calculated political significance that was also a searing physical manifestation of emotional overflow.[2] Dressed in black tights and a bright pink hard hat with a placard that read 'EXHIBIT WHITE ARROGANCE @ UCT,' Maxwele's striking intervention, as deliberate and crafted as a performance, cut through layers of obfuscation around institutional racism to give voice to an irrepressible anger and impatience at the slow pace of change in a supposedly postcolonial country.

This action, and the subsequent Rhodes Must Fall (RMF) movement to which it gave rise, tapped into expanses of feeling, which, once released, could not be contained. Emotion spilled out beyond the confines of 'rational' response, rupturing attempts, of the kind that have become synonymous with South Africa's transitional reconciliation period, to neutralise expressions of pain or to silence outpourings of anger. Advancing a politics of radical action, the movement was a backlash against the rationalist imperative to 'put into words,' a collective assertion that talking has proven ineffectual and that compromise has operated as a cover for 'a regime of forgetting.'[3]

In South Africa, live art is born of extremity. Its syncretic form has evolved in response to rapidly changing social climates, colonial imposition, cultural fragmentation and political upheaval; its affective tenor of excess and irrationality embodies the unpredictability of crisis. It proffers a new language that resists the narratives of certainty and linearity through which a neocolonial agenda has been perpetuated (even if sometimes inadvertently) in this country, reflecting – without seeking to resolve – the inscrutability and urgency of states of socio-political flux.

TROUBLING TERMS

In the west, too, performance art has its roots in times of extremity. It flourished in early twentieth-century Europe alongside the rise of fascism, culminating in movements such as Dadaism and Futurism.[4] Unable to give expression to the depth of their emotive responses to fascism through conventional forms of art-making, artists explored disruption, nonsense language, the non sequitur, the illogical and the fragment, seeking an anti-form that defied the previously sacrosanct logics of artistic convention.

In the 1970s, the term 'performance art' came to represent a departure from the 'traditional materials of canvas, brush or chisel,' a fundamental rejection of the art object, and a renunciation of art's patriarchal lineage via a radical turn to the physical body.[5] Artists used their bodies as canvas, taking their work into public spaces and forums and across the disciplinary borders of visual and conceptual art in search of anarchic forms that would engage more viscerally with the political ferment of the time – anti-war activism, the rise of feminism, the Civil Rights Movement. Bringing viewers into contact with the immediacy of the artist's raced, classed, gendered and sexed body – unfiltered by facades of character – was also a direct means of troubling the rigidity of gender categories and sexual identities, and in this way performance art became imbricated with feminist and queer politics.

In the twenty-first century, increasingly driven by technology, performance art has encompassed works that do not solely rely on a living, breathing, performing body. In recognition of this added layer of interdisciplinarity, and of the fact that the (un)finished artwork may be as much about process as product, performance art became more frequently referred to as 'live art' in the early 2000s – a term that has been taken up in the interdisciplinary context of the Institute for Creative Arts (ICA), where this collection was initiated.

While the sensitivity of twentieth-century Euro-American performance art to its socio-political context is an important touchpoint in this study, it is also a counterpoint – for this collection situates experimental performance within a precolonial and decolonial African genealogy of ritual, ruptures and experimentality, refuting the notion that South African live art is a western import. It derives from a mode of performativity and political radicalism that is integral to African tradition and protest culture. Site specificity, ritualised performance and notions of embodiment have been central to South African cultural practices of healing, shamanism, mourning, initiation and celebration for centuries – certainly long before colonial contact.

Like the origins of live art, the terms 'classical African performance' and 'African tradition' – including their use here – ought to be approached critically, for they suggest a homogenous 'Africanness' when, in reality, the ancient performative practices of southern Africa (let alone the continent) are numerous, specific and unique, encompassing the traditions of the Nguni and Khoi-San peoples. Exploring the complexities of each of these lineages is not the work of this book, but of critical

importance to this research is an understanding that the characteristics and iconography of contemporary South African live art long predate the emergence of 'live art' as a label, tracing back, through the complex entanglements and encounters of colonialism and apartheid, to ancient traditions and performative modes. Both 'live art' and 'performance art' are used in this book to refer to experimental and often radically transgressive performative works, and 'classical African performance' to refer to indigenous practices, but with cognisance of the inadequacy of any one term to hold a multiplicity of forms and to convey the intricacies of South Africa's performance heritage.

LINEAGE

The role and involvement of the audience has been a significant dimension of African performance from classical tradition through to contemporary live art. Immersion, improvisation and participation can be traced back to the San trance dance recorded in rock art paintings dating back thousands of years.[6] The fluidity of what we now identify as distinct and separate disciplines was similarly characteristic of early communal performance, where music, dance and visual art were incorporated into social and spiritual rituals. The embeddedness of performance in daily life on the continent has also been widely observed through the period of colonisation and into independence.[7] In *The Wretched of the Earth*, Frantz Fanon writes:

> In the colonial world, the emotional sensitivity of the native is kept on the surface of his skin like an open sore which flinches from the caustic agent; and the psyche shrinks back, obliterates itself and finds outlet in muscular demonstrations which have caused certain very wise men to say that the native is a hysterical type ... we see the native's emotional sensibility exhausting itself in dances which are more or less ecstatic. This is why any study of the colonial world should take into consideration the phenomena of the dance ...[8]

Under colonial rule, the often-violent imposition of European culture impelled classical African dance and ritual to develop along new lines of improvisation and hybridisation. But these adaptions took shape with a degree of self-reflexivity indicative of Homi K. Bhabha's notion of 'colonial mimicry': in the slippages

that occur in the colonised's 'not quite' imitation of the coloniser, there is an 'ambivalence' which gives rise to the possibility of agency and subversion.[9]

The musical and dance form *isicathimiya* is a good example of an extremely fluid form that developed out of this complex interplay between culture and artistic innovation under constraint. It derives from the intricate rhythmic structures of extensive and extended dance forms prevalent in the 1920s and 1930s, such as the traditional Zulu war dance *indlamu*. Unable to perform these spatially free forms in confined migrant hostel spaces, workers recreated the dance, transforming the characteristically loud and emphatic stamp of classical Zulu dance to a soft withdrawn leg. The quietness and subtlety of this 'dance of the cat' – from the isiZulu word *ukucathama* meaning 'to tiptoe' or 'walk stealthily' – was also as a result of rehearsing at night when other workers were asleep.[10] And so the *isicathimiya* was born, and later made internationally popular by the choral group Ladysmith Black Mambazo.

This deconstruction is starker, still, in the Nazareth Baptist Church's amalgamation of Christianity, Zulu tradition and Scottish dance attire. At the Church's annual festivals, young men dance as Scotsmen (*isikoshi*), dressed in 'tartan like-skirts and pith helmets,' in a tradition that dates back to the early 1900s.[11] Isaiah Shembe founded the Church near Durban in 1910, purportedly because of 'the mission churches' rejection of converts wearing African traditional attire.'[12] Magnus Echtler notes that Shembe's choice of Scottish dance uniform was likely inspired by 'the Highland regiments of the British Empire,' although its place in a dance of worship remains open to much speculation.[13] Likewise, scholarly interpretations of the dance span 'the range from resistance through symbolic inversion to the enculturation of Christianity, or even the transformation of a military tradition into religiously motivated nonviolence.'[14] Occupying an ambiguous point between subversion and appropriation, the *isikoshi* dance is perhaps Bhabha's mimicry writ large.

South Africa has a long history of protest marches and rallies abundant with performances of all kinds, whether in the form of communal expression through chants, singing, the intricately synchronised *toyi-toyi*, or individuals in breakaway performances that make use of costume or naked flesh, visual images or spontaneous poetry.[15] Peter Horn writes in *Theatre and Change in South Africa* that, in the 1980s,

> various cultural forms (music, dance, poetry, drama) appeared both within the context of political and trade union meetings and in the form of 'cultural' events with

a clear political connotation. Elements of this culture were taken from 'traditional' culture and its transformation in an African ghetto (traditional Xhosa songs and dances) but also from 'foreign traditional' cultures, such as the marimba players.[16]

Importantly, tradition is not merely excavated in contemporary live art, but subverted, reimagined and distorted in complex and ambiguous ways, and with a great degree of self-consciousness. Pesa's *Limelight on Rites* (alluded to above) and Samson Mudzunga's burial performances in Limpopo in the 1990s probe the conflict between urban and rural rituals around death, and the displacement of the black body in the commodification of funeral ceremonies. In *Uncles and Angels*, Nelisiwe Xaba and Mocke J. van Veuren reference the Zulu Reed Dance to probe the exploitation of the female body that is embedded in patriarchal tradition and phallocentric conceptions of nationhood. Athi-Patra Ruga's early work *Ilulwane* recreates the Xhosa initiation ritual while interrogating the models of masculinity and sexuality that it reinforces.

All of these western-derived practices and indigenous forms of embodiment, hybridity, immersion and protest serve as points of lineage and determinants of character, scope and purpose in the evolution of contemporary live art in South Africa.

STREAMS OF INFLUENCE

In the section 'Theatre and Performance' of the Encyclopaedia of South African Theatre, Film, Media and Performance (ESAT), Temple Hauptfleisch identifies two influences in the development of theatre:

> The coming of European colonization in 1652 brought many new performance forms and introduced the notion of theatre (as a formal and distinctly separate social system) to the sub-continent. In consequence two performance systems developed: on the one hand there are the indigenous forms which were initially largely found within tribal context [sic], particularly in non-urban areas, but later developed a variety of more urbanized forms and styles ... On the other hand, the European-style theatre that the Dutch, French, German and particularly British colonials introduced between 1790 to 1880 provided the basis for the formal theatre system in South Africa today.[17]

The reductiveness of Hauptfleisch's categorisation belies the reality that traditional modes of performance evolved, not in tandem with European forms, but in spite of, and in reaction to, the exertion (and sometimes brute force) of colonial power. Nevertheless, Hauptfleisch's dual categorisation is useful in that it offers a broad-strokes understanding of two central strands of influence in the development of live art in South Africa: experimental twentieth-century Euro-American performance art and its intersection with classical African performance and protest culture. The former is observable in some of the early productions of the Cape Town-based Glass Theatre, and in the work of artists like Chris Pretorius, Peet Pienaar and John Nankin – artists who, influenced by performance art developments in Europe and America, staged their own localised rebellions against the political status quo, the realism of plot-driven theatre and the conventions of visual art.

The latter is observable in the practices of Boyzie Cekwana, Robyn Orlin, Nelisiwe Xaba, Tracey Rose and Mamela Nyamza, through to Albert Khoza, Chuma Sopotela and Sethembile Msezane – all of whom evoke elements of traditional African ritual, but in conversation with (and always engaging in a deconstruction of) western modes of theatre-making, dance and performance art that have informed their education and practice.

In order to engage with the richness of contemporary live art in a postcolonial, postapartheid South Africa, as this book calls on readers to do, its history and multiplicity of influences must be understood as traversing the full range and multiple intersections, contradictions and hybridisations of these indigenous art forms and western-derived performative practices. The works of the artists discussed in *Acts of Transgression* exemplify these wide-ranging influences.

THE CONTEXT

The idea for a collection of essays exploring contemporary live art in South Africa was conceived, and the book itself developed and edited, at the ICA – an interdisciplinary arts institute, formerly known as GIPCA, based in the University of Cape Town's Humanities Faculty.[18] The nature of the work that the ICA supports and engages in – from public lectures and symposiums to fellowships and festivals – is experimental, innovative and collaborative, moving across and between disciplinary boundaries. This is the context in which *Acts of Transgression*

arose in late 2016; it is also the environment in which the book took shape throughout 2017 and 2018, and which has invariably shaped the book.

References to the ICA are made throughout *Acts of Transgression*, in particular to the ICA Live Art Festival, which has provided opportunities for contributors to this book to experience, first-hand, a number of significant live art works. First held in 2012, and thereafter in 2014, 2017 and 2018, the Festival has featured pioneering artists whose practices have emerged from an array of disciplines – established artists, such as Warona Seane, Tossie van Tonder, John Nankin and Nelisiwe Xaba, as well as younger and (at the time) lesser-known artists, such as Richard September, Spirit Mba and Themba Mbuli. Contributors have, of course, gone beyond the pool of artists featured at the Festival.

The answer to 'why this collection?' is, in part, that no text about South African live art exists. Performances have existed as fleeting moments in time, sometimes captured on film, but with scarce written critique of the themes that artists are mining, or analysis of the critical thinking that goes into curating experimental works. Furthermore, the study of the interdisciplinary nature of live art presents an opportunity to disrupt disciplinary silos in art education – an interrogation more pressing now than ever, particularly in response to calls to decolonise the institution. In the early period of South Africa's democracy, troubling academic parochialism was largely a matter of introducing new content to art curricula inherited from colonial models. As South Africa begins to face questions that were avoided in the early 1990s, not least questions of material equity and land, art-makers are searching for ways in which the nuances and paradoxes inherent in these issues may be expressed and given form. The field prompts us to question 'pure' art forms, such as theatre and dance, as well as the object-centred visual art form and archaic musical traditions that linked, for example, melody with music. Artists are questioning these narrow categories and opening up new spaces for experimentation and new ways of looking. By inviting a closer relationship with events unfolding outside of the sterile civilities of a white cube gallery or the safety of the proscenium stage, they provide experiences that trouble and sometimes shock a certain presumed logic.

But the value of live art is not only as witness to, or engagement with, conflict. Its multidisciplinary approach characterises an artistic consciousness that is restlessly in search of a way to arrive at something that remains elusive. Its feeling

is urgent, risky, edgy, provocative. It is colourful not just in image but in content – artists' untrammelled, idiosyncratic points of view eschew the trappings that might render a performance fit for easy or feel-good consumption. In many instances the results are unpredictable. Indeed, the hallmark of much live art is the integrity of a performance that may have taken months to prepare, but that is open to anything in the event of its happening.

Live artists also defy the logic of commerce. Commercial art enterprises (galleries, fairs, auction houses) have supported and sustained many artists. But they have also sucked away at some of the core impulses of why we make art. By stepping outside of commercial spaces and unsettling the economies and socio-political relations they govern, live artists put themselves at great risk – aesthetically and politically, but particularly financially. The fact that a performance cannot easily be bought, bubble wrapped and hung bears testimony to this.

The twin impulses to find an (anti-)form that resists the commercialisation of art, and that mirrors and responds to the irrationality and turbulence of its setting make live art a compelling, even necessary, mode for the expression of contemporary complexities. In these times of extremity, to place the responsibility for acts of terror against vulnerable people on individuals *only* – often political leaders like Donald Trump – is something of an illusion. Because millions of ordinary people put them in power. Racism and fascism, sexism and homophobia – the -isms and phobias by which pernicious regimes become known – are what ordinary people do to other ordinary people. And yet, an awareness of how we think, and why, begins to dislodge something deep in the consciousness. By interfering with accepted logics, live art in South Africa forces us to scrutinise our own constructions and to be vigilant.

THE TITLE

The post-rainbowism moment in South Africa could perhaps be traced along two key lines: a growing cynicism in nation-building and the protection afforded by state; and the beginnings of a dislodging of established systems based on systemic prejudice. The former was made most visible in the aftermath of the Marikana massacre and the exposés of Nkandla and state capture, and the latter by the eruption of the Rhodes Must Fall movement. But the fall of Rhodes, in its weight

of bronze and symbolism, has only concretised – and given us a more pointed language to describe – a reality that South African artists were already articulating: once-stable systems and institutions, master narratives, unquestioned forms of memorialisation and government development plans no longer account for who and where we are. As Sarah Nuttall suggests in her chapter, we have exhausted our faith in facts (a faith perhaps always precarious) to speak to and for us; it is emotions and psychic energies that enable us 'to trace the meanings of a time.' More particularly, this collection contends that it is the emotions and energies forcefully articulated in the works of contemporary South African live artists that hold an account of our unfolding now.

The 'transgressions' of this book's title – like the art form to which it refers – offers numerous interpretations. At its most immediate level, it references the provocativeness of live art – a rejection of disciplinary boundaries and conventional rules of art-making. The artworks explored in this collection take the form of live and filmed performances, protest action, interventions and installations that draw on the disciplines of visual art, dance, African traditional healing and ritual, photography, film and fashion, amongst many others. The title is also a reference to the transgression of boundaries between the aesthetic and the political, performativity and everyday acts, as well as the inclusions and exclusions of archive.

The insights offered and arguments forwarded in this collection also trouble, subvert and explode the essentialising discourses and categories of race, class, gender, sexual orientation, nationhood and nationalism. In doing so, forms that hold these subversions are made porous, and transgressions emerge here too. Lieketso Dee Mohoto-wa Thaluki, Nondumiso Lwazi Msimanga and Mwenya B. Kabwe, in particular, infuse their analyses with deeply personal accounts of the impressions that particular works have had on them. Introspection thus takes shape as a specific methodology – a counter to the clinical distance of academic discourse and an extension of the idea that emotions and emotiveness, perhaps more so than ever before, serve as an instructive gauging point of these complex and uncertain times.

THE BOOK

The artists examined here, although in excess of 25 and certainly a cross section of contemporary artists in South Africa, by no means form an exhaustive list. Nor is the collection an exhaustive exposition of where live art is at in the country. This is owing to the vision for the book – a rigorous conceptual engagement with, rather than a chronological overview of, live art in South Africa. The collection is principally concerned with conceptual underpinnings – specifically, understanding live art against shifting notions of crisis. This is the vital thread that binds these chapters: artistic agency within a time of political urgency.

The four parts of the book are intended to direct the reader towards a number of key themes. Part One helps us to take the measure of live art in South Africa against a backdrop of contemporary complexities – the ways in which artists draw from and respond to this milieu, laying bare its incongruities and iniquities. Nomusa Makhubu's chapter is an excavation of space and place – the still-contested, deeply segregated nature of Cape Town's public spaces (exposed through the performative interventions of artists like Khanyisile Mbongwa, Buhlebezwe Siwani and Chuma Sopotela) and the profound sense of unbelonging experienced by the city's black citizenry. Uncontainable emotion, in Makhubu's study, is that of anger and frustration at a persisting geographical and psychological placelessness.

In Catherine Boulle's analysis, the anarchism of live art is viewed through the lens of pioneering performance artist Steven Cohen, whose dissonant works offer profoundly political interpretations in this time of turbulence. Boulle probes whether Cohen's disruptive interventions might move beyond rupturing oppressive ideologies of the past and gesture towards a future in which violent systems of subjugation have loosened their hold.

As noted above, Sarah Nuttall brings 'affective structures' to bear on her study of live art – and offers these as an 'integral and visceral dimension of the grammar of the political.' Her concern with how we might curate performative practices of disruption and ambivalence, such as those of Dean Hutton and Mohau Modisakeng,[19] reverberates into Jay Pather's probing of key conceptual issues associated with curating and 'taking care of' the immediacy and spontaneity of live art in contemporary South Africa. A way forward, Pather suggests, is to conceptualise the role of the curator as the creator of open and enabling platforms

where disparate issues are served with fluid, porous structures, divested of an imposed curatorial order or sensibility.

The chapters comprising Part Two proceed from an interest in the black female body as a site of trauma and contested histories, but also of resistance and the emergence of new forms of expression. Same Mdluli's study of the visual and linguistic codes by which the black female body becomes 'knowable' and consumable is a provocative exploration of performativity beyond the stage, and even beyond live art as we know it. In their unscriptedness and non-structure, these public interventions and acts of disruption and protest start to reframe our understanding of the 'live-ness' of live art.

Lieketso Dee Mohoto-wa Thaluki approaches the work of Chuma Sopotela from her position as a black woman grappling with the complex live art practice of a fellow black woman artist, and with a particular interest in the visceral corporeality of Sopotela's work. This emerges, Mohoto-wa Thaluki reveals, from Sopotela's methods of 'situatedness' – the manner in which she excavates and then embodies her contemporary social context. Cognisant of the ineffability of Sopotela's work, Mohoto-wa Thaluki's speculative exploration defies the knowability that comes through definitive interpretations.

Nondumiso Lwazi Msimanga, like Mdluli, is interested in the relationship between protest and performance art, but particularly in its linguistic and embodied manifestations. Activist art, Msimanga contends, performs trauma doubly to articulate a new language as an emergency and an emergence. Msimanga's mining of the language (and non-language) of trauma is taken up in Gabrielle Goliath's exploration of the ways in which traumatised black bodies – routinely subjected to forms of physical, ontological and structural violence – might resist the homogenising erasure that such violation threatens. Goliath explores Tracey Rose and Donna Kukama's ritualistic performances and applications of invocation which render the absent visible and the silenced heard; a profound realisation of agency that works against systemic and bodily violation.

In Part Three, Katlego Disemelo, Bettina Malcomess and Alan Parker think through the nature of the performative and the shifting composition of archive. Disemelo argues that online self-styling and image-making practices that expose the absurdity of heteronormative gender and sexual identity categories are carefully curated performative acts. Moreover, these performances by FAKA,

Umlilo and Albert 'Ibokwe' Khoza signal the emergence of a radical queer archive that reconfigures traditional conceptions of archive in our increasingly digitised and visual culture. Parker is similarly engaged in an interrogation of archive – in particular, the embodied archive – as a means of communing with (and contesting) inherited knowledge and behaviours. He considers performances by Gavin Krastin, Sello Pesa and Igshaan Adams that reimagine and subvert rituals concerned with the dead in order to rethink knowledge of the past, and ourselves, in the present.

Through the works of FAKA, Dean Hutton and Athi-Patra Ruga, Malcomess offers a response to the reductive discourse of the queer body as a site of lack. This is a response premised on an exploration of the 'emptying out' of gesture, as Malcomess terms it, in order to reveal the language of queer performance as an articulation, not of multiply inscribed oppressions, but of the conditions and limitations of the queer body's becoming or coming into visibility.

The final part of this collection looks backwards in order to, or perhaps in the hope of, moving forward: how do we remember our past and conceptualise our present in a manner that might bring into being a revitalised future? The destabilising of historical narratives is of critical interest to both Khwezi Gule and Andrew J. Hennlich. Via the works of Sikhumbuzo Makandula, Buhlebezwe Siwani and Sethembile Msezane, amongst others, Gule problematises the commemorative and memorial culture of post-1994 South Africa, and asks how we might instantiate a counter-narrative of memory and belonging. Hennlich reads Athi-Patra Ruga's immense body of work *The Future White Women of Azania* against the revolutionary and redemptive possibilities of Walter Benjamin's model of history, and perceives Ruga as principally engaged in uniting and reconfiguring South Africa's past and present 'in an urgency to reframe the now.'

In Mwenya B. Kabwe's hands, this interest in the imprint of historical narratives on our present subjectivities becomes forward looking. Kabwe explores Afrofuturism as a deconstruction of westernised, colonial systems of knowing, probing the ways in which Africa might imagine itself in, and into, the future as a strategy to know differently; 'to radically disturb' the politics of knowledge. What possibilities might we bring into being, Kabwe asks, if 'we start from the premise that we know; that we are full of knowing?'

For Massa Lemu, one answer to how we might shift reductive historical discourses – particularly essentialist art-historical discourses that have homogenised and

anonymised notions of an African collectivist past – lies in the artistic practices of collectives Gugulective and iQhiya. Their performance interventions, Lemu argues, are demonstrative of a generative, subject-centred, decolonial praxis that works against racial and gendered subjugation and gestures towards 'the possibility of free and autonomous black subjectivities who determine their own identity and social reality.'

·

We return once more to the idea that recurs throughout this collection, and indeed in the political economy of postapartheid South Africa – an overflow of emotion that is in excess of language. Transgression, the arguments collected here would seem to suggest, is the inevitable by-product of this overflow. Feelings of rage, frustration, placelessness, violation and exclusion that can no longer be held or contained in our country spill out onto the streets, assault our consciences, confront our bodies, challenge our notions of community and public, destabilise our knowledge of past and present, our visions of the future, and what it means to know at all.

An innate, perhaps inescapable, human response to such instability is the compulsion to find meaning, identify causes, predict outcomes, and seize upon certainties. But in the performative acts of transgression that we call 'live art' there are no such certitudes; no promise of closure or resolution. Live art, experimental art-making in front of our eyes, tries on and tries out new ways of seeing and being in the world, feeling its way forwards (sideways, backwards) into unknown spaces, stepping outside the boundaries of what is known and comfortable as it stakes out new territories and vocabularies of expression. Artists trouble our worldviews and test our ability to function without familiar coordinates, chipping away at false certainties. The effects are often disorienting, but vital, it would seem, if we intend to do more than dream of a fair, critical and robust society from the safe remove of intractable ideological standpoints. So it is that this study of contemporary live art in South Africa – the first of its kind – is both timeous and imperative.

1. Passages in this introduction first appeared in the *Daily Maverick*. See Jay Pather, 'Op-Ed: Live Art 2017 Reflects the Crises that are Besetting the World,' *Daily Maverick*, 16 February 2017, https://www.dailymaverick.co.za/article/2017-02-16-op-ed-live-art-2017-reflects-the-crises-that-are-besetting-the-world/#.Wu-D1tNubMI.

2. For a discussion of 'the response to the extremities of a failed democracy' expressed as 'spillage, interruption, and overflow,' see also Jay Pather, 'Negotiating the Postcolonial Black Body as a Site of Paradox,' *Theater Journal* 47, no. 1 (2017): 143–152, doi: 10.1215/01610775-3710477.

3. Brandon Hamber and Richard Wilson, 'Symbolic Closure through Memory, Reparation and Revenge in Post-Conflict Societies,' *Journal of Human Rights* 1, no. 1 (2002): 36, accessed 15 January 2018, doi: 10.1080/14754830110111553.

4. RoseLee Goldberg, *Performance Art: From Futurism to the Present*, 3rd ed. (London: Thames and Hudson, 2011).

5. Goldberg, *Performance Art*, 152.

6. Temple Hauptfleisch, 'South African Theatre: Some Major Trends of Past Developments,' in *Words and Worlds. African Writing, Literature, and Society: A Commemorative Publication in Honour of Eckhard Breitinger*, eds. Susan Arndt and Katrin Berndt (Trenton: Africa World Press, 2007), 58. See also: J.D. Lewis-Williams and D.G. Pearce, *San Spirituality: Roots, Expression, and Social Consequences* (Cape Town: Double Storey, 2004), 81–108.

7. See for instance: Victor Turner, *From Ritual to Theatre: The Human Seriousness of Play* (New York: PAJ Publications, 1982); Peter Larlham, *Black Theater, Dance, and Ritual in South Africa* (Ann Arbor: University of Michigan Press, 1985); David B. Coplan, *In Township Tonight!: Three Centuries of South African Black City Music and Theatre*, 2nd ed. (Johannesburg: Jacana, 2007); Barbara Thompson, 'Rituals of Healing,' University of Iowa Stanley Museum of Art, accessed 5 January 2018, https://africa.uima.uiowa.edu/chapters/arts-of-healing/rituals-of-healing/.

8. Frantz Fanon, *The Wretched of the Earth*, trans. Constance Farrington (New York: Grove Weidenfeld, 1963), 55–56.

9. Homi K. Bhabha, 'Of Mimicry and Man: The Ambivalence of Colonial Discourse,' *October* 28 (1984): 125–133, accessed 1 June 2017, doi: 10.2307/778467.

10. These descriptions of *indlamu* and *isicathimiya* were first given in Jay Pather's verbal response at the discussion entitled 'Opera in a Post-Eurocentric Globalized World' hosted by the University of Cape Town's Archive & Public Culture Research Initiative on 16 October 2014.

11. Magnus Echtler, 'Scottish Warriors in KwaZulu-Natal: Cultural Hermeneutics of the Scottish Dance (*Isikoshi*) in the Nazareth Baptist Church, South Africa,' in *Africa in Scotland, Scotland in Africa: Historical Legacies and Contemporary Hybridities*, eds. Afe Adogame and Andrew Lawrence (Leiden: Brill, 2014), 326.

12. Echtler, 'Scottish Warriors in KwaZulu-Natal,' 327.

13. Echtler, 'Scottish Warriors in KwaZulu-Natal,' 332.

14. Echtler, 'Scottish Warriors in KwaZulu-Natal,' 326.

15. *Toyi-toyi* is a South African dance, often performed at protests, thought to have been introduced into South Africa by African National Congress exiles returning from military training in Zimbabwe. Oxford English Dictionary, 'toyi-toyi,' Oxford Living Dictionaries, accessed 10 January 2018, https://en.oxforddictionaries.com/definition/toyi-toyi.

16. Peter Horn, 'What is a Tribal Dress? The *"Imbongi"* (Praise Singer) and the "People's Poet." Reactivation of a Tradition in the Liberation Struggle,' *Theatre and Change in South Africa*, eds. Geoffrey V. Davis and Anne Fuchs (Amsterdam: Harwood, 1996), 117.

17. Temple Hauptfleisch, 'Theatre and Performance,' Encyclopaedia of South African Theatre, Film, Media and Performance (ESAT), accessed 5 January 2018, http://esat.sun.ac.za/index.php/South_African_Theatre/Overview.

18. GIPCA was established in 2008 with a fixed-period grant from the Donald Gordon Foundation. Thereafter, the Institute continued its work as a result of a grant from the Andrew W. Mellon Foundation, and under a new name – the Institute for Creative Arts. The name change came into effect at the launch of the ICA on 5 April 2016.

19. Dean Hutton is a genderqueer artist who uses the non-binary pronouns 'they,' 'them' and 'theirs.' This is reflected in the discussions of Hutton's work throughout the book.

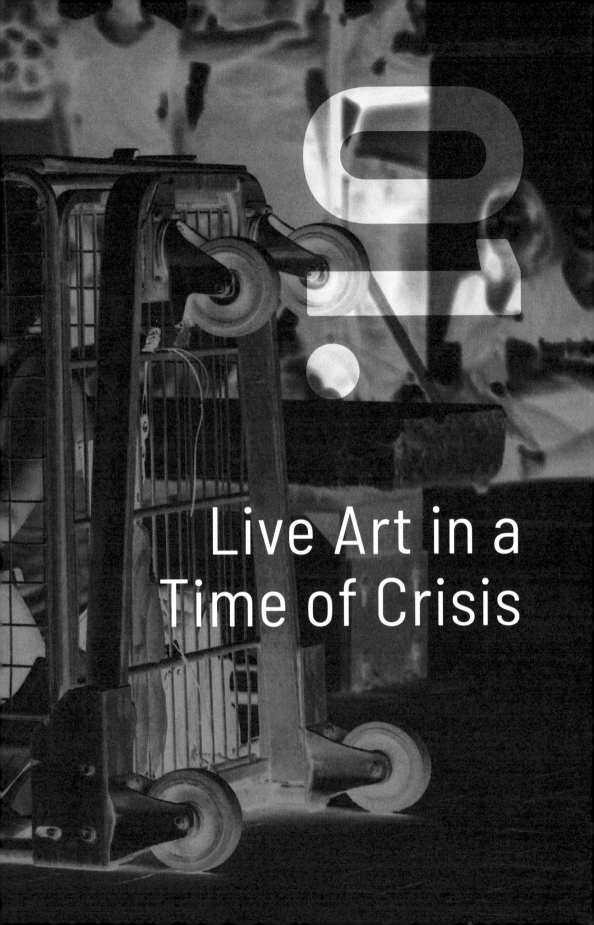

Live Art in a
Time of Crisis

Artistic Citizenship, Anatopism and the Elusive Public: Live Art in the City of Cape Town

NOMUSA MAKHUBU

But then because you have to do all this, when you get to the final step, something strange has happened to you and you speak the way a drunk walks. And, because you are speaking like falling, it's as if you are an idiot, when the truth is that it's the language and the whole process that's messed up. And then the problem with those who speak only English is this: they don't know how to listen; they are busy looking at your falling instead of paying attention to what you are saying.

NoViolet Bulawayo, *We Need New Names*[1]

On an early summer's evening in 2017, passersby stop to see why a crowd has gathered in Long Street, Cape Town, and discover two black women taking off and putting on their clothes. These 'ghels' speak isiXhosa, teasing the audience. Using township lingo, they direct their statements to onlookers familiar with what is being said, but also to those who seem oblivious to their taunting assertions. Seeing these ghels may be titillating and amusing for some, but to others, these women are indecent, discomforting and even vulgar. Their expressions, articulations and gestures may seem to belong to black townships and therefore appear 'out of place' in the central business district (CBD). The transgressive linguistic strategy of this work points to the fact that most white and coloured people in Cape Town (and South Africa) do not speak isiXhosa and so cannot *listen* to what is being said.[2] The performance points to continuing racial segregationism in South Africa and, more significantly, to a profound sense of not belonging.

This work by Buhlebezwe Siwani and Chuma Sopotela, titled *Those Ghels*, formed part of the 2017 Institute for Creative Arts (ICA) Live Art Festival, held in Cape Town, which also featured Khanyisile Mbongwa's *kuDanger!*, Sethembile Msezane's *Excerpts from the Past* and Dean Hutton's *#fuckwhitepeople*. These works, as I show in this chapter, explore intertwined themes of spatial segregation, language and displacement. By so doing, they demonstrate the critical impulse in contemporary live art in South Africa to question volatile identities through spatial politics, and to locate them within the incoherence and incongruence of postcolonial urban spaces. I argue that this form of creative protest constitutes a radical intellectual creative language, which deciphers the psychological and emotional burden of historical prejudice, reinforced through racial and class division. The sense of being out of place – 'anatopism' – articulated in these works is not only crucial in questioning the race-gender-class matrix within conditions of postapartheid citizenship, but is also critical to uncloaking violent processes of unhoming that continue today.

My argument locates these works within a psychogeography of anatopism, pointing directly to dispossession and a deep sense of alienation. The term 'psychogeography' is often associated with the Situationist International, a Marxist organisation that sought radical change by constructing 'emotionally provocative situations' and 'collective ambiences' in public, and by countering the alienation caused by capitalist processes.[3] Guy Debord characterises psychogeography as 'the study of the precise laws and specific effects of the geographical environment, whether consciously organized or not, on the emotions and behavior of individuals.'[4] It arises in response to social relations emerging from the design of modern cities, which heightens social difference. Debord and other Situationists created various interventions and encounters precisely to probe the spatial politics of modern cities. I use the term here to draw from its radical stance towards class politics and how such politics manifests in urban planning and organisation. I apply it cautiously, however, to the intricacies of the postapartheid South African context where the sense of not belonging emerges from the *longue durée* of colonial settlement, land dispossession, forced removals and racialised economic segregation.

Using the lexicon of the township, *Those Ghels*, *Excerpts from the Past* and *kuDanger!* offer sharp criticism of persistent segregationism. Performed in the CBD, these interventions probe, implicitly and explicitly, the conditions of apartheid in

postapartheid South Africa, a context in which race determines various forms of alienation. Many black, isiXhosa-speaking people are forced to learn English to access work, while most white and coloured South Africans would not recognise an insult in isiXhosa. These interventions engage not only with anatopism in post-apartheid South Africa, but also with a growing feeling of resentment in response to unchanging racial attitudes. The key themes of language and place intimate a sense of anger at the refusal of white South Africans to share living spaces (affluent suburbs remain predominantly white, while townships remain completely black), or to reciprocate by means of learning an African language. In the city of Cape Town – regarded by many as the country's 'hub of racism' – live art interventions unmask raw, unreconciled sentiments about apartheid and postapartheid injustices.[5]

Live art encompasses a variety of interdisciplinary, open-ended interventions in which situations and encounters are created. Lois Keidan describes it as a 'cultural strategy'; 'art that is immediate and real, and art that wants to test the limits of the possible and permissible.'[6] Live art often grapples with a combination of socio-political concerns and emerges from the 'developing crossover of "art", "performance art" and "theatre" practices,' which gives 'rise to increasingly explicit concerns for the "integration", "intersection" or "hybridisation" of arts practices in time-based "live" work.'[7] A performative practice of 'disrupting borders, breaking rules, defying traditions, resisting definitions, asking awkward questions and activating audiences, Live Art breaks the rules about who is making art, how they are making it and who they are making it for.'[8] Through its direct concern with space-time politics, it exemplifies anatopism. Keidan goes on to note that 'live art is synonymous with practices and approaches that cannot be accommodated or placed, whether formally, spatially, culturally or critically: practices and approaches that could be understood as being *placeless* simply because they do not necessarily fit or often belong in the received contexts and frameworks art is understood to occupy.'[9] In its evocation of placelessness, live art always operates within the politics of place and belonging.

In this way, I see live art as a question of citizenship or as a mode of understanding belonging and governance, and thus discuss the concept of anatopism through that of artistic citizenship. Defined as an idea that encapsulates the 'belief that artistry involves civic-social-humanistic-emancipatory responsibilities, obligations to engage in art making that advances social "goods,"' artistic citizenship refers to

artists who perform 'social responsibilities' or regard their practice as a form of social service.[10] The concept of art that 'performs a civic function' is sometimes seen as oxymoronic, since 'the artist epitomizes unsullied individualism, an inner-directed free spirit who answers to the muse, not to the state,' whereas citizenship 'entails group membership with common privileges and obligations conferred from without and regulated by a national government.'[11]

Artistic citizenship points not only to what artists do as citizens, but also to how they speak to national and city publics. If citizenship is understood to have 'symbolic importance as a signifier of an inclusive or exclusive understanding of membership and national belonging,' then it also paradoxically intimates the very opposite of belonging.[12] Elsewhere, I question the viability of the nation-state, a violent form of governance in postcolonial Africa.[13] Emerging from a brutal and dehumanising colonial process, the 'nation' as a form of governance continues to signify dispossession, and has not shown tolerance for transgender and transrace leadership. Indeed, it seems to perpetuate racism, sexism, homo-prejudice and economic inequality. Using Michael Watts's characterisation of Nigeria's political economy as 'nationalist "unimagining"' rather than an 'imagined community,' I argue that new artistic strategies reflect 'an un-imagining of the national scale [where] the formulation of citizenship becomes dislocated from the national scale.'[14] This has been a difficult argument to make because it raises a question for which I have no answer: what would the alternative be to current nation-states as forms of governance?

I propose a shift away from the conventional definition of artistic citizenship as art serving to fulfil social responsibilities. Rather, I use it here as a way to describe how live art in urban spaces operates in contexts of social fragmentation, creating situations that draw attention to the habitus of social segregation and continued processes of displacement and dehumanisation. In South Africa, race and racialisation remain symptomatic of social breakdown and the continued obscene consumption of the violated, un-homed, un-citizened body. In the interventions that I focus on, live art as social practice is not only a way of performing new norms of citizenship, but it also pries open the transgressive practices of citizenship that constitute different forms of publicness. The public appearances, public performances and public engagements of live art reveal the raced and gendered body as it announces, renounces, uncovers and challenges Eurocentric market-driven definitions of belonging to place.

As a term, anatopism was used by the 'French doctor Paul Courbon in 1937 ... to describe some psychological problems encountered by a Russian living in France, whose uprooting and foreignness prevented him from adjusting to his new environment.'[15] In this chapter, I use the concept with reference not to persons, but to the psychosis of the post-1994 city. Anatopism manifests, I argue, in the systemic economic strategies that cement racial and economic segregation. Live art interventions in Cape Town are seldom about public gatherings or establishing public common ground, but operate in factious, unsettled and incongruent arenas of still-segregated urban South Africa. They explode the post-1994 utopian rhetoric of uniformed public space in order to reveal its destructive aspects.

In the analysis of the selected live art interventions, anatopism therefore defines two seemingly contradictory processes. Firstly, it can be seen to define the character of postapartheid cities, which are made up of incongruent architecture modelled after European cities. Neoclassical architecture, for example, reinforces the spatial politics of racial and class division through which the poor are systematically displaced. Secondly, anatopism arises as a political strategy that artists use to challenge this incongruence by, for example, creating situations in which the township is juxtaposed with the city centre. This artistic strategy counteracts the perception of the township as existing at the margins of the city, where all that is associated with it is regarded as out of place in the urban sphere. As a strategy, anatopism reveals the central place of the township in cities (as Mbongwa's work illustrates) through the exploitative labour system, which causes township residents to be constantly present in the city but never to belong.

Using the first definition, Cape Town's social processes can be characterised as anatopic. Praised as the 'European city in Africa' or, as Valerie Geselev asserts, as 'a European boil on the bottom of the black continent,' Cape Town is incongruous for most black South Africans who live in or visit it.[16] Spellbound in hyperaesthetic spectacular wealth and scenic fantasy, the city suppresses its nefarious character and its schizoid blunted emotions toward catastrophes of cage-like social segregation.[17] Extending this idea, my analysis takes into consideration that live art as artistic citizenship can be seen to redefine notions of the body, senses of belonging and shifting political communities.

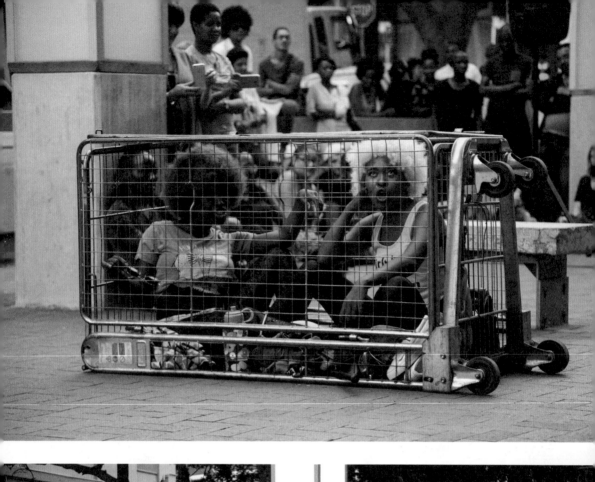
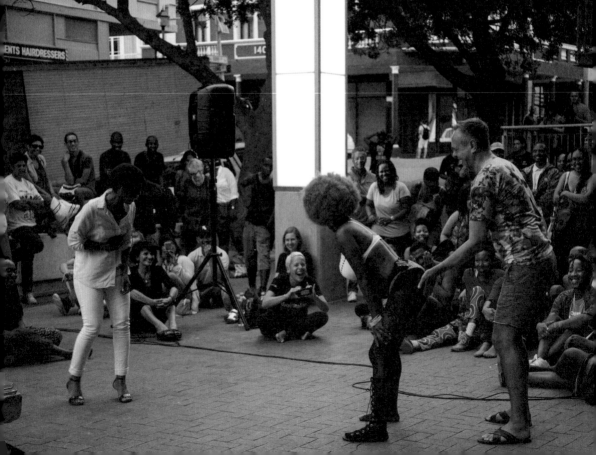

'I KNOW WHY THE CAGED BIRD SINGS': PERFORMING PLACE IN CAPE TOWN

Returning to *Those Ghels*, I focus here on its themes of place and placelessness.[18] In the 2017 Live Art Festival performance, Siwani and Sopotela sat in a cage-like storage trolley watching television cartoons, wearing bright onesie jumpsuits and mocking each other. They then took off their jumpsuits, switching clothes as though getting ready for a night out, while enticing the crowd with seductive dance moves and assertive hollering. The images on the television screens switched from cartoons to sexually explicit music videos. Throughout the performance, the ghels talk to each other and their audience in isiXhosa and township slang, mixing, shifting register, reclaiming and mastering urban language in its crudeness and versatility.

It becomes apparent that the cage-like structure represents the tiny rooms of a township house in which the ghels watch television and change clothes. However, the mobile cage in *Those Ghels* is not limited to a particular place. It symbolises different spatial scales: mind-space, home-space, township, urban and global. In the first instance, the mind-space is represented as the changing consciousness of both performers. In the initial stages of the performance, the performers do not speak but babble like children. While they do so, their eyes are fixed on the television screens. If one considers this in relation to the home-space and township, the performance can be seen to divulge the consequences of the brutal, prison-like design of townships.

Black townships, sometimes referred to as 'refugee camps' or the 'dumping ground of apartheid,' were an apartheid-era apparatus constructed to separate black people living in urban areas from whites.[19] Forced removals to townships under the enforcement of the 1950 Group Areas Act radically changed cities across South Africa. As Fiona Ross observes of the impact of the Act on Cape Town: 'the city that prior to the Second World War had been the most integrated in the country quickly became the most segregated.'[20] Townships like Khayelitsha, in Cape Town, were established as recently as 1985. Townships, or *lokasies*, have remained cage-like spaces of inferiorisation in which residents live in small, box-

Figure 1.1. and 1.2. Buhlebezwe Siwani and Chuma Sopotela, *Those Ghels*, 2017.
Courtesy Institute for Creative Arts.
Photograph by Ashley Walters.

like houses with barely any spaces for imagination, creative thinking or mental emancipation (such as libraries, parks, playgrounds, and so on). Unlike white areas, which have been coded as inhabited by rational individuals who own property and assemble occasionally as a public to watch the orchestra, attend ratepayers' meetings and so on, townships are seen as a self-producing and self-perpetuating problem, plagued by crime and irrational violence. People who live in townships are often euphemistically referred to as 'the community' and viewed as being in constant need of charitable patronage, whereas white areas, viewed as housing individual, responsible citizens, have 'public spaces.' Since no whites live in townships or become fully involved over time in their daily dynamics, the township is like a cage through which black life is turned into a site of spectacle; a space in which black bodies are scrutinised, judged and held captive.

The metaphor of the cage, resonant with the televisual box, demonstrates the anatopic character of pre- and post-1994 South African cities. In *Those Ghels*, the urban and global spatial scales are interrelated. The ghels watch American Disney cartoons and later music videos from different parts of the world, mimicking dress codes as images of commodity become identity. The cage itself, a trolley that usually carries objects, is reminiscent of the way in which Manuel Castells characterises urban spatiality as 'the highly structured concomitant of capitalist relations and forces of production.'[21] In its mimicry of world cities, or of what David McDonald calls the 'world city syndrome,' Cape Town is anachronistic.[22] Trapped in the desire for Cape Town to look like an old European city, 'politicians, policymakers in Cape Town, as well as business leaders and the media have become fixated with the idea of being a "world city."'[23] In this sense, it is out of place in the context of peri-urban and rural South Africa. McDonald argues that the theoretical paradigm of a world city 'fails to assess and address the key features of urban capitalist crisis that shape Cape Town and neoliberal policies and institutions that have emerged as a result of it.'[24] In Siwani and Sopotela's performance, the cage and the television mirror each other, both generating the desire for an alternative world.

Those Ghels illustrates the racially charged social geography of prejudice and revulsion that still haunts Cape Town. Since the ghels also act in a way that is at odds with the behaviour of well-behaved, aspiring-to-be-white girls, their performance engages with the perception that they are uneducated, intoxicated by the opium of the televisual image, and that they will grow up in their township

only to trawl the streets of the CBD looking for wealthy men, tourists, sex and money. However, towards the end of the performance, they comfort and cover each other. This spatial incongruity, the cage, the township home located in the heart of the city, is precisely what makes *Those Ghels* a significant tool for opening up a seemingly impossible conversation about South Africa's complex political issues. The performance reveals these issues as entrenched in the country's ostensibly irreversible spatial complexes, or rather the refusal to change them radically.

LOCATING LABOUR IN THE POSTAPARTHEID CITY

Responding to the irreconcilably discordant nature of South Africa and its fractured publics, curator Khanyisile Mbongwa examines the disparities between inner-city and township public spaces. Known as one of the co-founders of the arts collective Gugulective, which rejected the hegemony of wealthy, commercial public and private galleries on which artists had come to depend, Mbongwa's work poses important questions about the way in which townships are perceived, and the necessity of rethinking racialised spatial politics. For instance, Gugulective insisted on performing interventions in black townships, which are avoided by conventional middle-class audiences. Looking at the persisting systemic violence experienced by township residents, Mbongwa's work characterises post-1994 inner-city public spaces as exploitative. In her creative practice, Mbongwa engages with the psychogeography of townships in relation to the CBD – in particular, the city's simultaneous exclusion of township residents and dependence on their labour.

In the 2017 Live Art Festival iteration that I observed, Mbongwa's performance *kuDanger!* was located in an underground storeroom in the colonial architecture of the Ritchie Building at the University of Cape Town's Hiddingh Campus, evoking the subterranean, subconscious repression of, and dependence on, township life in the make-up of the inner city. The four performers, including Mbongwa, portray the overlooked, seemingly absent yet glaringly present inner-city labourers residing in black townships. In the minimally lit space, three performers pack and unpack beer bottle crates, throwing them to each other while another performer represents the melancholy of displacement. Intoxicated, he stands above the three individuals who perform the tiresome labour of constructing and deconstructing walls made of crates.

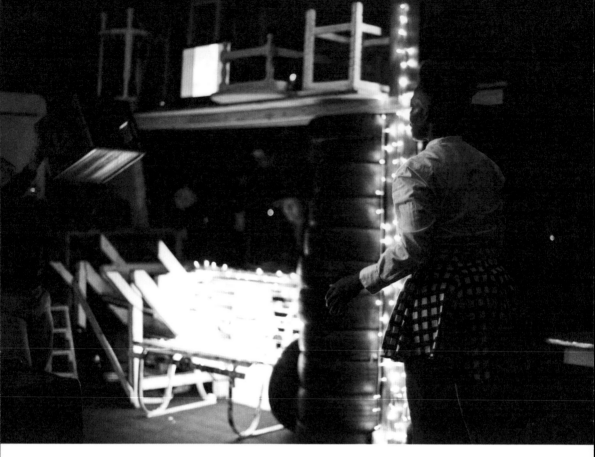

Figure 1.3. Khanyisile Mbongwa, *kuDanger!*, 2017.
Courtesy Institute for Creative Arts.
Photograph by Ashley Walters.

Drawing on the anatopic spatial metaphor of the shebeen or beerhall in the bowels of a building marked by its colonial architecture, Mbongwa enacts the rapacious sucking of life by an iniquitous system. Each audience member is offered alcohol to drink, and is then led into a very narrow passage from where they can view the performance. Throughout, the viewer is immersed in a cacophony of songs, and the voice of Pastor Xola Skosana is emitted from television screens.[25]

Again, the televisual box, the cage, the underground cave-like space and box-like beer crates evoke the psycho-social effects of living in apartheid-era black

townships. Citing Steve Biko's powerful statement that 'township life alone makes it a miracle for anyone to live up to adulthood,' Skosana characterises townships as death camps rather than residential areas.[26] He argues that the black body 'attracts violence' in a system that keeps it caged.[27] While *kuDanger!* illustrates this crisis, where the response to exploitation and psychological and geographical imprisonment is often alcoholism and self-hatred, Mbongwa's work leans towards a constructive and reformist approach. Mbongwa's concept of *irhanga* (passageway or alleyway) as an emancipatory space in the township identifies the township as a mechanism for apartheid's brutal policies, which should be seen as temporary – a transit between home and work – and not necessarily as home-space. For Mbongwa, the intention is not just to perform things that are seen to belong to a township in the context of the CBD, but also to highlight the extent to which Cape Town's economy thrives off the displacement and impoverishment of its black citizens. Mbongwa demonstrates that the wealth of the CBD is dependent on the preservation of black townships by showing that townships were constructed to keep cheap labour close to the inner city. In *kuDanger!* one becomes acutely aware of place and, more importantly, one's unsettled position in it.

Black people are forced to work, traverse, navigate and suffer highly securitised white spaces and the master's gaze which reduces blacks to inferiors, criminals or units of cheap labour, without which white South Africa would collapse. In the CBD and other white spaces, one is 'black'; in townships, one is just another person. The different publics of racially defined areas (white suburbs, black townships and languages) constitute themselves and operate differently from one another although they are structurally related. Wealthy elites engage in militant particularism and exclusion in the form of gated estates and via the defence of speculative property values. The languages are different, the class and race composition is different and the forms of public spaces (in parks, malls, street life, for instance) are very different.

LAND-LANGUAGE-LOSS
Difference is accentuated, albeit with the intention to dematerialise it, in Anthea Moys and Roberto Pombo's *Rechoir*.[28] This performance begins with a conversation between two men, one speaking Afrikaans and the other isiXhosa, highlighting the lack of common ground between residents of different townships (coloured and

black) which are often in close proximity, separated by a road or railway line. Since neither man understands the other's language, the impossible conversation ends up tangled in misunderstandings and misinterpretations. *Rechoir* is performed by a local choir, varied in age and race, which was established with the intention of bringing together people from different historical group areas in Cape Town, and providing a space where the young could learn from the old. In the discord of voices, the choir does not sing conventionally, but makes use of various props, like balloons, to evoke a form of singing. The artists, Moys and Pombo, who are initially in the position of conductors, at one point switch roles with the choir. Although the performance uses humour to address issues produced by persistent spatial segregation, it highlights both the conditions of separation and the persistent conditions of anatopism.

Another work that confronts this incoherence of land, loss and language is Sethembile Msezane's *Excerpts from the Past*. In this performance, Msezane sits on a bed of soil. Porcelain cups and saucers are laid out in front of her, which she picks up and drinks from, her pinky in the air, as though at a bourgeois tea party. These gestures and articulations, associated with colonial British settlers, are also portrayed as things that are out of place. Msezane wears a beaded *isiheshe* (a beaded veil traditionally worn by amaZulu women when they marry) which covers her face, and a delicate lace cape over a corset. The artificial hair that she wears as a skirt mimics a colonial lady's dress. In the context of the austere colonial architecture of the Ritchie Building courtyard, the bed of soil on which she sits is not only symbolic of the incongruence that characterises contemporary spatial configurations but, specifically, of the disorienting psychosomatic experiences of historical injustice that the surrounding edifices evoke. Voices emitted from an old wooden-box radio filter through in a ghostly fashion: at one moment we hear a British accent and, in the next, voices from parliamentary proceedings where members speak isiZulu. Interspersed among the audio clips is Miriam Makeba's 1966 performance in Stockholm, in which she is heard explaining the meaning of the Xhosa song *Igqirha Lendlela Nguqongqothwane*, also known as 'the click song.'

During the performance, we hear the filmic rendition of a prophetic conversation between Shaka Zulu and a British lieutenant, referred to as Febana kaJoji (King George's go-between), about the separate governance and settlement of the Zulu and the English, in which Shaka asserts: 'Our people are different yet you ask that we come together.'[29] The conversation unfolds:

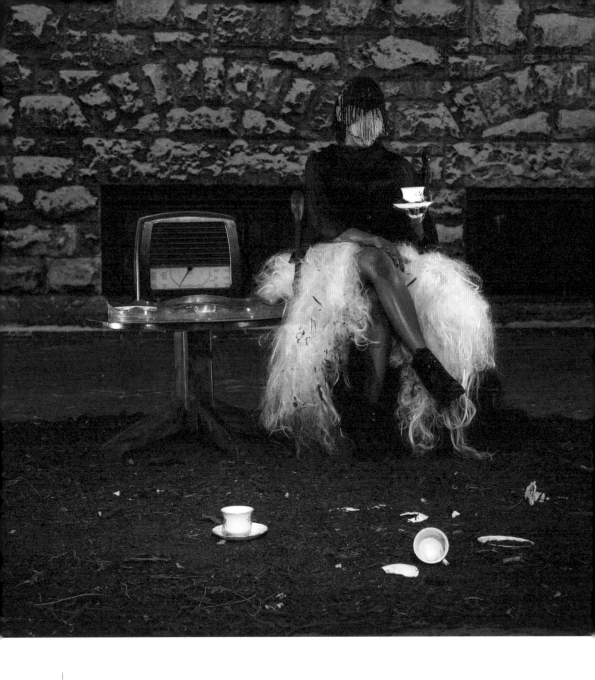

Figure 1.4. Sethembile Msezane, *Excerpts from the Past*, 2017.
Courtesy Institute for Creative Arts.
Photograph by Ashley Walters.

SHAKA: This nation you speak of ... who would govern it?

LIEUTENANT: There would be representatives sent out from our king, who, together with you, would deliberate, make laws, see to the needs of the people.

SHAKA: Your people would know the needs of my people?

LIEUTENANT: We would learn, learn each other's needs.

SHAKA: How would we live in this nation?

LIEUTENANT: As neighbours, village near village.

SHAKA: And how would these villages be placed, Zulu-English-Zulu-English-Zulu?

LIEUTENANT: The land is vast Baba, there's plenty of room for all, without crowding.

SHAKA: Without crowding, Febana, you mean Zulu-English?

LIEUTENANT: Until our needs become clear.

SHAKA: I see. But what would happen, Febana, if after many generations the children of your children were still unable to learn the needs of my people? If their stars remained different, would they then leave to go back to the lands where you came from? Or would they have learned to love this land so deeply that no other land would be home? What would happen, Febana, if this land without crowding became crowded? Which of those unborn children would then be called African, yours or mine?[30]

As the conversation continues, Msezane picks up the soil, pours it into the delicate porcelain teacups and smashes each one on the ground. The soil, a metaphor for land and memory, slips through her fingers. The issue of land emerges in the conversation between Shaka Zulu and the lieutenant, who defines it as 'vast' and proposes that, as such, it can be divided up to segregate different races or socio-linguistic groups. Drawing from Homi K. Bhabha, André Lepecki posits that the 'colonialist condition as the condition of modernity' means that 'the colonialist project ... introduces a spatial blindness (of perceiving all space as an "empty space").'[31] The speculative gaze of colonial conquest of land, people and resources is often characterised by 'a failure of the historical imagination, its inability to imagine a peopled landscape, thereby perpetuating the fiction of an uninhabited subcontinent.'[32] This failure masks the destructiveness of colonialism. When

Msezane smashes the soil-filled porcelain cups, she directs anger at the usurping of land that was seen as vast, while its people were forced, through policy, into small rural homelands and overcrowded urban townships.

Bringing the past and present into proximity, Msezane explores the transience of national collective memory, and poses questions about citizenship. The audio footage from the parliamentary proceedings at the State of the Nation Address (SONA) on 9 February 2017, the night before the Live Art Festival iteration of Msezane's performance, underlines the notion of belonging and citizenship in the context of colonialism's historical theft of land. The question of land ownership has been central to the success of opposition party the Economic Freedom Fighters (EFF). Addressing the economic imbalances bolstered by unequal land ownership – the legacy of colonialism, and by extension, apartheid – the EFF has faced resistance, its representatives often violently removed from parliament for their confrontational statements and actions. The audio recording played in Msezane's performance is an example of this. In the sound clip, EFF members of parliament are heard addressing the Speaker of the National Assembly, shouting 'we shlalo, shlalo,' and asking in isiZulu, 'why do you ignore me?' During the SONA, the EFF questions the legitimacy of President Jacob Zuma, calling him a criminal (for the various cases of rape and corruption mounted against him). Pandemonium ensues and EFF members are beaten and thrown out by parliamentary security. The violence of the events in parliament, fresh in the memory of the audience, is juxtaposed with the memory of colonial violence. Watching *Excerpts from the Past*, focusing not only on what is performed but also on the audience, illuminates the sense of apprehension towards politics in South Africa. The televised spectacle of violence at the nucleus of the nation-state alters the social imaginary. In chronicling crimes of governance – colonial, apartheid and contemporary – there is a gradual process of unimagining the legitimacy and viability of the postcolonial modern nation-state and interrogating citizenship.

Considering Mahmood Mamdani's arguments about the bifurcation of power in colonial Africa, which entailed the construction of distinct concepts of 'citizen' and 'subject,' imperial citizenship for natives signifies 'not belonging.'[33] Regarded as uncivilised, natives were afforded limited rights. Mamdani writes: 'Citizenship would be a privilege of the civilized; the uncivilized would be subject to an all-round tutelage. They may have a modicum of civil rights, but not political rights,

for a propertied franchise separated the civilized from the uncivilized ... For the vast majority of natives, that is, for those uncivilized who were excluded from the rights of citizenship, direct rule signified an unmediated – centralized – despotism.'[34] In this way, the separation between citizen and subject was a deeply dehumanising process, and its legacy has created particularly fragmentary experiences of contemporary citizenship.

As Faranak Miraftab shows, the current Central City Improvement District in Cape Town, a public-private partnership founded in 2000, resembles the ways in which colonial and apartheid-era structures operated through displacement, segregation and the establishment of urban citizenship based on wealth.[35] She points out that 'contemporary urban struggles by residents for citizenship and urban services improvement are not divorced from past struggles that have shaped these physical and social landscapes.'[36] From the 1800s onwards, moneyed businessmen acquired voting rights based on the value of the property they owned; as Miraftab illustrates, 'political citizenship was contingent on wealth and property ownership.'[37] She also shows that, over the years, Cape Town's city centre became 'the site of fierce historical struggles for urban citizenship and inclusion.'[38] The black population, women and the working class did not have political citizenship rights.

Msezane seems to suggest that contemporary South African politics is characterised by this sense of not belonging because of its past. Land, as portrayed in *Excerpts from the Past*, is volatile. As the performance ends, Msezane walks around the piece of land where pieces of colonial furniture have been placed, carrying a wooden walking stick. Her performance is an uncompromising expression of anger about displacement and placelessness in postapartheid South Africa.

VULGAR PUBLICS: WRITING RACE IN POST-1994 SPATIAL POLITICS

In an interview with Charl Blignaut, writer Teju Cole, who was visiting Cape Town in 2013, asserted: 'I realised how political it was to simply be alive as a black person who speaks ... I realised that certain of my critics will only be happy when I'm dead and I stop speaking.'[39] This profound sense of anatopism, of feeling invisible or hypervisible, for black citizenry, globally, remains unshakeable. This sentiment is often expressed by young artists, like those discussed above, for whom

both speaking and *speaking in their own languages* is a form of resistance. This also reveals the severity of the current political and cultural climate in which those who are denied meaningful citizenship are, by extension, denied the right to live full, purposeful lives, to appear and to be heard. Since live art is often about appearing in public, the aspects that are immediately visible or noticeable are an artist's race and gender. Black bodies in performance are coded differently to white bodies – as are, in South African racial categories, coloured bodies. In Cape Town, race signifies spaces where certain bodies belong and where they do not. Race circumscribes the movement of certain bodies in certain spaces. Race in Cape Town is both spectacular and furtive, marking territories that render things utterly out of place.

The non-appearance of Dean Hutton in their public intervention *#fuckwhitepeople* at the 2017 Live Art Festival – a particularly poignant and significant strategy – showed how fragile the politics of live art can be. In being literally out of place during their intervention, Hutton drew attention to the dangers faced by artists who cross the invisible lines of race and territory. Hutton's intervention, in which they wear a self-designed suit imprinted with the words 'fuck white people' in bold type (in the style of American conceptual artist Barbara Kruger) has provoked heated and violent responses. Having appeared in public wearing the suit, they have been confronted, threatened, labelled a racist and criticised for appropriating the struggles faced by black people while living in a white skin. After their *Fuck White People* installation, included in *The Art of Disruptions* exhibition at the Iziko South African National Gallery, was defaced by representatives of the Cape Party – a separatist party seeking the political independence of the Western Cape province – and in the light of escalating threats, Hutton chose not to appear physically for their intervention at the Festival. In response to these events, Hutton attests that 'the work democratises the creative process, helping people to develop a language to articulate their conditions.'[40] Using written language, Hutton also points out the spatial complexes in Cape Town:

White people in general tend not to feel racialised, or feel answerable for our actions in terms of a racialised identity. We exist in spaces where we very rarely 'feel white'. We exist at a level of default because every space is open to us, to use and exploit at will. We tap out too easily, as 'not all white people' when confronted for both interpersonal racism and our programming into white

supremacy. We are individuals first, with little to no collective responsibility for actively dismantling the systems that keep us white. Being white is a construct which we have too heavily invested in emotionally and spiritually.[41]

In Hutton's work, whiteness is an imagined public, a construct arising from a particular history of violence that excludes even non-conforming white people. Archiving the insults and vulgar language from members of the white community who see this art intervention as attention-seeking racism against whites, Hutton draws attention to the psychosomatic character of anatopism in segregated publics.

The directness of the words 'fuck white people' resonates with the growing anti-white sentiment in South Africa. Whites are seen to be, though sympathetic, unwilling to sacrifice and change the conditions of apartheid racism in which they have flourished. As Hutton seeks to demonstrate, whites in South Africa are not made to feel out of place, uncomfortable, unwanted and uncitizened in the same way that black people have been and continue to be.

The responses to Hutton's work that characterise it as vulgar have often been violent. This, it can be argued, is what lies at the crux of the psychogeography of anatopism in the city of Cape Town: the latent violence that constantly threatens to break the surface. Hutton's work and the work of the artists I have discussed above draw attention not only to encounters with the systemic violence of the city, but, more importantly, to the raw sentiment to which these encounters give rise. The processes through which people are made to feel out of place in the postcolonial city are inevitably violent.

CONCLUSION

Given the weight of history and the continued reinforcement of social difference through neoliberal policies, the possibility of untrammelled, deracialised, rational discussion about a non-racial future might not be possible, since a sense of shared public space seems elusive. The radical intellectual interventions by artists such as Siwani and Sopotela, Mbongwa, Msezane and Hutton are just some examples of the ways in which live art is used to protest against racial inequality and the deepening sense of anatopism – of being un-homed and made to feel out of place. This anatopism is not just about spatial dynamics but about how these dynamics

are entrenched in internalised unreconciled feelings of pain, rage, anger, distrust and disquiet. Focusing on the emotive aspects of the experience of embodied citizenship or denied citizenship reveals that artistic citizenship in postcolonial cities interrogates the unquantifiable and uneasy lived experiences of the limits of citizenship. In Cape Town, persistent social segregation sustains the reproduction of many different publics, and rampant property capitalism reinforces privatised publics. The sense of home in postcolonial cities is therefore constantly shifting. These emotive aspects reproduce vulgar and precarious publics. I have re-asserted here the notion of the nation-state as ineffective in contemporary African contexts – a question that is continually raised by artists. These interventions, and other similar ones across the continent, demonstrate that it is necessary to rethink alternative forms of governance. The sentiments indicating the urgency for radical change can no longer be ignored.

1. NoViolet Bulawayo, *We Need New Names* (London: Chatto and Windus, 2013), 193–194.
2. According to statistics, in the Western Cape, Afrikaans is spoken by 48 per cent of the population, isiXhosa by 24 per cent and English by 20 per cent. 'Western Cape,' Wazimap, accessed 25 August 2017, https://wazimap.co.za/profiles/province-WC-western-cape/. Formal racial categories in South Africa are generally: white, African/black, coloured, Indian and the category 'other.' I use these terms cautiously as people do not always subscribe to them, especially the term 'coloured.'
3. Guy Debord, 'Report on the Construction of Situations and on the International Situationist Tendency's Conditions of Organization and Action (June 1957),' in Ken Knabb, trans., *The Situationist International Anthology,* ed. Ken Knabb (Berkeley: Bureau of Public Secrets, 1981), 17–25.
4. Guy Debord, 'Introduction à une Critique de la Geographie Urbaine,' *Les Levre Nues* 6 (1955): 11–15.
5. Hlabangani Mtshali, 'Cape Town – The Hub of Racism? 5 Recent Incidents,' *The Citizen,* 5 December 2014, accessed 25 August 2017, https://citizen.co.za/news/south-africa/286312/racism-cape-5-recent-incidents/.
6. Lois Keidan, 'This Must be the Place: Thoughts on Place, Placelessness and Live Art since the 1980s,' in *Performance and Place,* eds. Leslie Hill and Helen Paris (London: Palgrave, 2006), 10.

7. Nick Kaye, 'British Live Art,' in *Performance: Critical Concepts in Literary and Cultural Studies*, ed. Philip Auslander (Abingdon: Routledge, 2003), 218.

8. Live Art Development Agency (LADA) quoted in Deirdre Heddon, 'Introduction: Writing Histories and Practices of Live Art,' in *Histories and Practices of Live Art*, ed. Deirdre Heddon and Jennie Klein (London: Palgrave, 2012), 1.

9. Keidan, 'This Must be the Place,' 10 (emphasis mine).

10. David J. Elliott, Marissa Silverman and Wayne Bowman, 'Artistic Citizenship: Introduction, Aims, and Overview,' in *Artistic Citizenship: Artistry, Social Responsibility, and Ethical Praxis*, eds. David J. Elliott, Marissa Silverman and Wayne Bowman (New York: Oxford University Press, 2016), 7.

11. Randy Martin, 'Artistic Citizenship: Introduction,' in *Artistic Citizenship: A Public Voice for the Arts*, eds. Mary Schmidt Campbell and Randy Martin (New York: Routledge, 2006), 1.

12. Ruth Lister, *Citizenship: Feminist Perspectives* (New York: New York University Press, 1997), 50.

13. Nomusa Makhubu, 'Screening the Fantastic: Citizenship and Postcolonial Theoconomies in African Video-film and Photography,' *African Identities* 15, no. 2 (2017): 208–227, doi: 10.1080/14725843.2016.1247686.

14. Makhubu, 'Screening the Fantastic,' 209.

15. Dominique Bluher, 'Necessity is the Mother of Invention, or Morder's Amateur Toolkit,' in *Amateur Filmmaking: The Home Movie, the Archive, the Web*, eds. Laura Rascaroli, Gwenda Young and Barry Monahan (New York: Bloomsbury, 2014), 216–217.

16. Valerie Geselev, 'Cape Town Reimagined as an African City,' *New African*, 569 (2017): 76–78.

17. Drawing from Ranjit Hoskote, Jay Pather shows how live art illuminates the 'schizoid' nature of cities. As Hoskote notes, 'most of the world's cities today are schizoid'; they 'aspire to the comfort and sophistication of an international economy and culture,' while 'they conspire to maintain the oppressive local structures that keep the shantytown enslaved, the hinterland brutalized, the inner-city ghetto isolated,' in turn sharpening 'economic asymmetries that already exist and produc[ing] new cultural discontinuities' as well as 'generat[ing] social conflicts and political uncertainties.' Ranjit Hoskote quoted in Jay Pather, 'Shifting Spaces, Tilting Time,' *Rogue Urbanism: Emergent African Cities*, eds. Edgar Pieterse and Abdoumaliq Simone (Johannesburg: Jacana, 2013), 435.

18. Maya Angelou's autobiography *I Know Why the Caged Bird Sings* recounts her upbringing in racist Stamps, homelessness, being renamed 'Mary' by a racist employer, and being raped by her mother's boyfriend. Narratives of the brutality of racist America are revealed as profound questions of, and struggles for, citizenship for a black woman growing up in a state that limits how that sense of citizenship can be performed.

19. Waghid Yusef, *Citizenship, Education and Violence: On Disrupted Potentialities and Becoming* (Rotterdam: Sense Publishers, 2013), 88.

20. Fiona C. Ross, *Raw Life, New Hope: Decency, Housing and Everyday Life in a Post-Apartheid Community* (Cape Town: University of Cape Town Press, 2010), 2.

21. Manuel Castells quoted in Neil Smith, 'Spaces of Vulnerability: The Space of Flows and Politics of Scale,' *Critique of Anthropology* 16, no. 1 (1996): 63–77, accessed 18 March 2017, doi: 10.1177/0308275X9601600107.

22. David A. McDonald, *World City Syndrome: Neoliberalism and Inequality in Cape Town* (New York, London: Routledge, 2008).

23. McDonald, *World City Syndrome*, 1.

24. McDonald, *World City Syndrome*, 1.

25. Xola Skosana is a well-known pastor in Cape Town, and founder of the Way of Life Church.

26. 'Pastor Xola Skosana on Black Pain,' YouTube video, 3:19, posted by *Real Talk*, 5 March 2016, accessed 18 March 2017, https://www.youtube.com/watch?v=9r8HPdAA8nM.

27. 'Pastor Xola Skosana on Black Pain.'

28. The hyphenation in the subheading indicates the interrelatedness of the three words, land, language and loss, in the context of postapartheid South Africa. The sense that land has been lost historically, as Msezane's work shows, is entwined with a sense that this displacement eroded the sophisticated use of local languages.

29. 'Shaka Zulu Deleted Scene in the American Copies of the Movie,' YouTube video, 3:21, 29 December 2015, accessed 18 March 2017, https://www.youtube.com/watch?v=cdP9qBJhYU0.

30. 'Shaka Zulu Deleted Scene.'

31. André Lepecki, *Exhausting Dance: Performance and the Politics of Movement* (New York: Routledge, 2006), 14.

32. Benita Parry, 'Review of *White Writing* by JM Coetzee,' *Research in African Literatures* 22, no. 4 (1991): 198, accessed 28 January 2017, www.jstor.org/stable/3820373.

33. Mahmood Mamdani, *Citizen and Subject: Contemporary Africa and the Legacy of Late Colonialism* (New Jersey: Princeton University Press, 1996), 17.

34. Mamdani, *Citizen and Subject*, 17.

35. Faranak Miraftab, 'Colonial Present: Legacies of the Past in Contemporary Urban Practices in Cape Town, South Africa,' *Journal of Planning History* 11, no. 4 (2012): 283–307, accessed 17 March 2017, doi: 10.1177/1538513212447924.

36. Miraftab, 'Colonial Present,' 285.

37. Miraftab, 'Colonial Present,' 288.

38. Miraftab, 'Colonial Present,' 284.

39. Charl Blignaut, 'Teju Cole: Even Breathing is a Political Act,' *City Press*, 19 September 2013, accessed 28 January 2017, http://www.news24.com/Archives/City-Press/Teju-Cole-Even-breathing-is-a-political-act-20150430.

40. Dean Hutton, 'This Is What Dean Hutton, Creator of "F**ckWhitePeople" Art, Has To Say About Its Vandalism,' *Huffington Post South Africa*, 20 January 2017, accessed 25 August 2017, http://www.huffingtonpost.co.za/2017/01/18/this-is-what-dean-hutton-creator-of-f-ckwhitepeople-has-to_a_21657586/.

41. Hutton, 'This Is What Dean Hutton, Creator of "F**ckWhitePeople" Art, Has To Say About Its Vandalism.'

CHAPTER 2

Upsurge

SARAH NUTTALL

Struggles to give an event or an epoch a name and to assign it a meaning have always been constitutive of key political and social transformations. To name is to shape and reshape an imaginary, to frame what is at stake at a given moment, or to open, reopen or foreclose a set of possibilities. A name can be given to a set of events that have not yet happened. Such a prefigurative name calls into being, conjures up, that which does not yet exist; that which only exists in an incipient state; or that which, it is hoped, is still to come. An earlier name can also be recovered or resurrected, reanimated and given to events in the present whose structures, qualities or causes have no direct relationship with the past. Such a name is usually borrowed from an existing archive where it found its canonical place, and where its meaning is more or less sealed off. Although the historical period to which it refers is considered, at least putatively, closed, the power and energies of such a name are harnessed in the present and drawn upon to meet entirely other goals, with different protagonists, at risk at times of anachronism. Such a name operates both as a memorial and as an index of a future deferred, still to be realised. It calls for a temporal rupture, the recapture and repurposing of past possibilities in the present. We could refer to such a name as analogical.

The question of when an epoch begins and when can it be deemed closed is always open to a multiplicity of responses. So it is with South Africa, and its highly complex concatenation of what is past; when and how to characterise the present, how to read and understand times of crisis, upsurge and turbulence. For a long time during and after 'the event,' naming what has happened, its momentousness, might still be an object of contention. If to name is to interpret and therefore to

assign a meaning, such a task is by definition unfinished since no account of an event or its meaning can be said to have captured everything. Every meaning is haunted by another meaning. This makes deciphering an interminable task, always subject to revision. These questions carry a particular vitality and urgency when writing of the upsurge of decolonisation debates of the last three years. What the event is and what shape it will take carries, simultaneously, a political and philosophical opacity and luminescence.

The velocity and unexpectedness of the social is such that naming it often comes afterwards, after the fact. Rarely does it precede the event. Even when a name announces the event, the latter seldom unfolds exactly as announced, and so there is always a gap between the event and its name. What we most often have before us are partial and fragmentary accounts. Every archive, whether of the past or the present, takes a set of standpoints in order to compose itself – and leaves things aside. Projects of reconciliation and revolution, which dispense with particular aspects of events, narratives or people's lives, produce remainders as they sanitise the hard facts and affective dimensions of history. What has been left aside is not disempowered: it is always the seed of undisciplined energies, energies gained from their very position of having been left aside. These energies, recaptured by new social actors, are reinvested in acts of disruption, of upsurge. This could offer us our first frame for thinking about attempts at erecting an emerging archive on the ruins of an older one. Attempts, that is, at ushering in a new time.

HISTORIES OF FEELING, EPISTEMOLOGIES OF EMOTION

A second frame, or arc of questions, opens here. It is not only incompleteness, that which is left aside, that presents itself in times of epochal change or moments of historical ignition and turning: the freeing of energies that have been contained is also a period of intense feeling and emotion. How do we archive histories of feelings and emotion? Archives are often still understood as constituted by things that can be documented. That is, as constituted by things, objects, artefacts or traces of human actions that can be collected, assembled and classified. Such traces are usually thought to be tangible, visible or material. Even when they appear intangible, such as a voice that can be sensed but not actually heard, a material artefact usually frames them. How do we document a history of emotions? What would histories of democracy and nation-building (and their antitheses) look like if they were drawn in

relation to 'archive[s] of feelings'[1] and phenomenologies of emotion?[2] How might we 'read for emotion,' Anna Parkinson asks, in volatile political landscapes.[3] We might examine, as Parkinson does in another context, 'vital "scenes"' of emotion,[4] enabling us to analyse the limits and consequences of a putatively democratic subjectivity or sociality, the role it assigns to emotions and the sometimes-traumatic dimensions of what it patently disallows. We can consider affect and emotions as forces that occupy and address the subject, for example, the postapartheid subject, in a variety of ways. Reading for the multivalence of emotion, and for the dynamics of emotional reflexivity, enables us, Parkinson argues, to work with archives of feelings rather than with 'memory' as such.[5]

This is important in times of upsurge, as in the Rhodes Must Fall and Fees Must Fall movements in South Africa, and the concatenation of emotions that the work of discarding, destruction, reassembling and creation involves. The vital scenes that such work produces cannot be reduced to traumatic events alone. These are composed also from acts of defiance when existing norms are sometimes brutally confronted and disassembled, in which feelings are potent and capable of powering immense reservoirs of untapped energies, some of which are turned into social and political forces, producing a poetics and politics of turbulence.

As intense psychic energies are at work in periods of upsurge and turbulence, we can see emotion as an expression of what Parkinson calls 'the legible social.'[6] The quality of an era's affective structures, long after the traumatic event, and in relation to the compromises of democratic sociality, can help us to trace the meanings of a time. Complex and self-conscious languages of affective gestures can be made to speak: emotional turbulence, political upsurge and the labour of thought burst and spill as the clock turns to a different era, especially starkly. Emotions, for Parkinson, are not only 'expressive outward manifestations of a subject's interiority [but] an integral "hinge" or interface' between the artist and the production of the social at large.[7] At the very least, this suggests and requires a different modality of archiving: an archive of feelings will be as much about remembrance and the restaging of material traces as it will and must be about the curation of ambivalence and turbulence. This is so because intense psychic energies are at work in periods of upsurge and turbulence. Tracing the meaning of a time through communities of affect enables the emergence of unconventional figures of the political. Put differently, emotions are an integral – and visceral – dimension of the grammar of the political itself.

Why would we want to write a history of emotions and of the changing tides of sentiment in the process of documenting change? Krista Tippett writes in a different context but in a manner that speaks to South Africa now: 'We have outlived our faith in facts to tell the whole story or even to tell us the truth about the world and ourselves.'[8] On the one hand, in what is increasingly being characterised as a post-truth world, we need facts more than ever. On the other hand, facts, as well as objects like memorials and statues, seem increasingly less able to speak to the temporalities of turbulence that this book seeks to name and understand. It is emotions and psychic energies that offer us important truths about where we are, and by extension, it would seem that an archive of these feelings must enable a more accurate account of a historical time. What kind of curation is required to attend to this kind of Real? More specifically, could we, and on what terms, think of curation as an act of care and healing? Of taking care and, in its radical sense? What form might acts of care take in performative practices of disruption, separation and tearing apart?

A POLITICS OF ACCELERATION

2012: the year of Marikana and the beginning of the end of a certain vision of the after-apartheid. The shooting of black miners resisting corporate power and their own political and economic disempowerment under a form of rule that did not deliver to them either social justice or racial reparation. The time at which, for many, perhaps paradoxically, notions of anti-blackness emerge with new conceptual and political force: the miners of Marikana would not, having been killed, been subjected to the power of the necropolitical, according to this newly visible force of critique, had they not been black. 'Race resurges as an instigator of turbulence twenty-two years after democracy,' Jay Pather writes.[9] Certainly race re-emerges both as repetition – the disregard of black working life as life without immunity, notwithstanding its usefulness as a source of exploitation – and as disavowal of the strong hope and sustained practice under the historical sign of the non-racial, according to which race could no longer be taken as a criterion by which life is measured. Anti-blackness as a conceptual point of breakthrough becomes an important lens, especially after 2012, through which artists and performers, writers and poets, begin to articulate new kinds of aesthetic form, or debates about form as such. These latter attempts at forcing epochal change

through a powerful dialectics of reversal often take the form of a negative dialectics of acceleration.

The politics of acceleration is the speeding up of a system or a form, exacerbating its velocities, amplifying its contradictions, to try to implode it from within. This mode of escalation, as it has been deployed by young twenty-first-century South African university students, has drawn tactically on what Matthias Pauwels has suggestively called 'critical philistinism': the deliberate and explicit rejection of more mediated and so-called more complex or sublimated approaches to art.[10] These more 'apparently prudent and productive acts of cultural decolonization' – satire, parody and revisionism, rereading, reappropriation – all 'risk affirming the order they set out to critique.'[11] I am reminded of what Ernesto Laclau and Chantal Mouffe once referred to in another context as 'wild antagonism'[12] – here, wild antagonism to the slow constitutionalism and painstaking reconciliation of the immediate postapartheid years, as well as to progressive accounts of resublimation – that is, the diversion of potent energies into more 'acceptable' aesthetic forms – which want to teach us to think and see better.

At the University of Cape Town (UCT) in 2016, student protesters tore down works of art from their long-established positions on the walls of the University, and burned them. Amongst the paintings burned were works of black resistance art, what we might read as 'collateral damage' in a furious attempt to undo what these earlier resistance works could not: the apartheid-style postapartheid order, the new old status quo.[13] This rising wave of fire was raw, confrontational and engaged in the politics of acceleration, breaking back on the shoreline of the present in the midst of growing inequality and the failures of the left to counter the forces of a consolidating neoliberalism. It has risen on a tide of anger, including towards art itself, and it has sought to ignite what Theodor Adorno would have called a potent politics of negation, fuelled by a critique not only of capitalism and class relations, but of legacies of colonialism and racism.[14] It is the *shock of the new old*, where what was taken by some to be the past is not past but *coeval* with the present.

An accelerationist politics maximises the possibilities of destruction, repurposing the current order's infrastructures against itself. Recent articulations of accelerationism have tried to jam capitalist logics by, for example, abducting their abstract systems and logics and turning them towards social justice-inspired ends. In the case of student protesters in South Africa in 2015 and 2016, disrupting classes and exams, vandalising university property, forcibly removing the statue

of Cecil John Rhodes at UCT and burning paintings in frustration at a culture too slow to change were intensely emotive and politicised forms of frustration and anger, rage and disappointment; forms of protest that accelerated calls for what I have elsewhere called 'a redistributed university.'[15]

In 2012, South African photographer Mikhael Subotzky exhibited a series of photographs, the frames of which he smashed with a hammer. The exhibition, *Retinal Shift*, included high resolution images of the artist's left and right retinas, self-portraits of the eye, made with the help of an optometrist. 'I was fascinated by this encounter,' Subotzky reflected in an interview: 'at the moment that my retinas, my essential organs of seeing, were photographed, I was blinded by the apparatus that made the images. So it is a self-portrait of myself the photographer, at a moment that I could not see.'[16]

Subotzky moves from a figuration of what he could not see – implicitly, what he could not see as a white South African – to a shattering of his elegant allegorical study. He then moves on to a complete withdrawal from the practice of photography as such, conscious of 'how fraught its history is.'[17] After smashing *Retinal Shift*, he said in a 2017 interview: 'I have come out completely from the world of making photographs. I have lost faith in photography or at least I have lost interest in practising it myself.'[18] Subotzky chooses an act of what Pauwels calls 'nonart'[19]; here, it is what we could perhaps call an art of the empty wall. Is an art of the empty wall – which participates in a politics of velocity and acceleration, a negative dialectics – at least in this moment of historical time, an act of radical acknowledgement, or radical defeat? Is it both at the same time?

RELATIONALITY AND NON-RELATIONALITY

In Mohau Modisakeng's performed self-portrait, a four-minute video entitled *Inzilo,* thickened ash forms a kind of second skin, a crumbling layer that Modisakeng slowly flicks and peels from his hands and feet. From the opening moment of the work, until almost half way into it, his arms are spread wide, preceding an act of self-propulsion as he rises from his chair. The velocity of the propulsion is productive, perhaps, of a subjectivity that is a becoming open to its own future. The nakedness of the artist's torso is suggestive of the price, vulnerability and exposure of this process, igniting an emergent subjectivity for a changed era.

Modisakeng wears a billowing skirt and it is into this skirt – or at least it appears to be so – that the second skin, shed from his limbs, is deposited and eventually

discarded. Ghostly black dust rises and falls in clouds as Modisakeng, in a series of slow, seated ritualistic movements, suddenly stands and lifts up his skirt, casting off its contents. *Inzilo*, an isiZulu word for 'mourning' or 'fasting', is described as a work in which the artist's body:

occupies centre stage ... [and] enacts a mourning ritual by sitting, standing, and rotating slightly, all the while throwing a burnt ashy substance into the air ... [Modisakeng] performs an elaborate rite of passage in which [he] seems to draw the material for his transition from within his own body. In the absolute purity and focus of the moment, Modisakeng is turned inwards but gesturing outwards, undergoing a mysterious transformation that is at once a private ceremony and a public declaration.[20]

The fine coal dust hanging in the air surrounding the body gives visual form in an extraordinarily suggestive way to the artist's psychic residues and archives of feeling, released from their internment in interiority, let out and allowed to breathe, in the world outside; a visualisation of the labours of thought and feeling. 'My work has always presented a channel for me to engage my mind and my spirit in something reflective and introspective,' Modisakeng has said.[21] But introspection is also a social and collective process for him, recalling the idea explored above that the life of emotions is not only an expressive outward manifestation of a subject's interiority but part of the grammar of the political.

The black skirt that billows, and the peeling off of outer layers, offers us room to think outside of the straightjackets of hypermasculinity and the encasing of bodies in gender identities with their accompanying tightnesses, limitations and violence. Reimagining gender identity, releasing it from obsolete meanings, has been a profound part of forcing a new future by South Africa's rising generation. The presence of the chair in which Modisakeng is seated for all but the final scene of the performance is a marker not only of movement – from a position of rest to an ambiguous but powerful form of activity – but also, perhaps, a marker of an outward and expansive upsurge of emotion, both private and political.

Shannon Walsh and Jon Soske, noting that the artist is alone in this image, as he is in most of his works, suggest that the image captures a representation of 'a relation of non-relation – the desire and the impossibility at once.'[22] In their introduction to *Ties that Bind: Race and the Politics of Friendship in South*

Africa, on the cover of which is a photograph of Modisakeng standing as the ash-like air around him rises, Walsh and Soske argue that thinking about white supremacy and anti-blackness requires that we 'confront a relationality that exceeds the language of relation.'[23] This is because 'the constitutive violence of settler civil society works to render full, ethical reciprocity between white and black ... impossible in advance.'[24] The poetics of non-relation comes back to the problematic of reasserting, while also letting go of, race. The multivalencies of Modisakeng's work and practice exceed the framings that the book can perhaps offer. The title of the book itself suggests the binds and bondages of entangled lives, dramatising the desire, and impossibility, of cutting ties; a politics of refusal

Figure 2.1. Mohau Modisakeng, *Inzilo*, 2013.
Courtesy the artist, Ron Mandos and WHATIFTHEWORLD.

that stands open to the unthought as a personal process of black reinvention and consciousness drawn to a conversation with the self; an opening of an empty space free of interlocutors, interpreters or anyone else who wants to do the work of *seeing better* than the self itself.

In a related work, *Ukukhumula* ('Unclothing'), 13 performers re-enact the gestures of *Inzilo*. The ash in *Ukukhumula* is refigured as a white powder or chalk, and the idea of a shedding of the self (or a part of the self) is extended and multiplied. *Ukukhumula* refers to 'the final stage of the cleansing ceremony performed as the symbolic closing of an extended period of mourning in some African traditional practices.'[25] As described in the 2014 Live Art Festival programme: 'The peeling

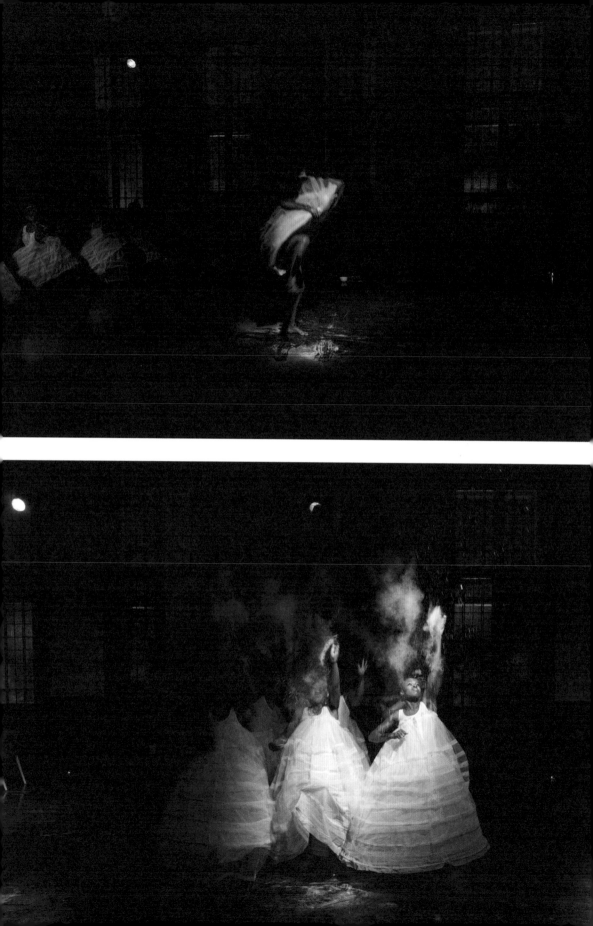

off of "dead skin" or moulting in particular becomes an emotive element in the performance ... Removing the seemingly charred layer of "skin" reveals the new delicate skin of each of the performers, evoking both a literal and metaphoric shedding.'[26]

STANDING IN FOR THE REAL

Dean Hutton's work *Fuck White People* has, amongst other iterations, taken the form of an installation and a public performance intervention. In making the work, Hutton also foregrounds their genderqueer identity, describing it as 'not particularly male or female ... I identify across different intersections ... It's a constant state of war with patriarchy and the way in which we are all made to pay these massive debts to capitalism, and the way in which we're asked to violate others.'[27]

As an installation, *Fuck White People* formed part of the 2016 Iziko South African National Gallery (ISANG) exhibition titled *The Art of Disruptions* and featured a large poster, a chair and the jacket from Hutton's three-piece bodysuit, all covered in the words 'Fuck', 'White' and 'People.' They intended it, says Hutton, as 'a catalyst to start everyday conversations around white supremacy, racism and privilege.'[28]

Hutton explains: 'This is my artwork. But these are not my words. [In 2016] I photographed a student, Zama Mthunzi, wearing a T-shirt with the words "F**k White People" smeared in black pain(t). He was threatened with expulsion and a case at the Human Rights Commission. None of the complainants said anything about the front of the T-shirt which read "Being Black is Shit."'[29]

In an interview with Gabriella Pinto, subtitled 'on using love to disrupt, starting with the self,' Hutton makes a series of statements that I draw together below as a word installation.

> You cannot go roughly into the world anymore. People are going to call you out... I also have deep discomfort with call out culture. But fuck it, it makes

Figure 2.2. and 2.3. Mohau Modisakeng, *Ukukhumula*, 2014.
Courtesy Institute for Creative Arts.
Photograph by Ashley Walters.

people work harder to be better human beings ... that is what the world that is coming demands of you. We've seen the limits of what legal rights give you ... You have to remain thinking ... and it's exhausting, but it's really exhausting being violated all the time too ... I'm asking for a translation of one thing into another pain ... It's asking you to translate the possible feeling of what it feels like and to not cause that ... Because we're rushed in the way we have to live and survive capitalism ... human kindness ... take[s] time and ask[s] more of us as individuals ... You just think about all the little communities that you belong to and about making those spaces a little safer for some people ... I still feel like I am a work in progress. There [are] these holes of not understanding in all of us ... Because of the way that hyperlinked reality works, the way that you just discover and stumble and have access to such wide, weird things ... This useless information is all in my head but the way in which it eventually functioned was to teach me better ways of being human ... It's about unlocking words to explain my feelings about things.[30]

In this word installation, echoing while also elaborating on Hutton's own word installation – the black and white text 'Fuck White People' all over their own bodysuit – we can follow a clear and forceful line of thinking that is also an archive of feeling. Hutton's first invocation is of 'a world that is coming.' They focus on the need to 'work harder,' especially white people, to respond to one's time and place, to rethink thinking – work that involves an act of translation from the 'possible feeling of what it feels like' [to experience racism, sexism] into 'another pain,' and the refusal to inflict such pain. The work and thought of translation requires a taking back of time, *contra* capitalism's attempt to extract more and more of the self as exchange value, the possibility of profit(ing). What is the aim of taking time to work through, to think? It is to make spaces – 'the little communities you belong to' – safer for other people, those who have been excluded and hurt by racism, sexism and other forms of violence to the self. Finally, the notion of working on the self, to produce a self for the world that is coming, is to understand and construct the self as a work in progress, to self-installate, as Hutton does in *Fuck White People*. To be a work in progress is to know that there are 'holes of not-understanding' in our understanding of the world. It is a compelling grammar of the political, of political whiteness; a deeply thought and felt self-in(ter)vention. 'How do you live as a conscious being in a world that constantly asks you to take, to profit and to be unthinking and distracted?' Hutton

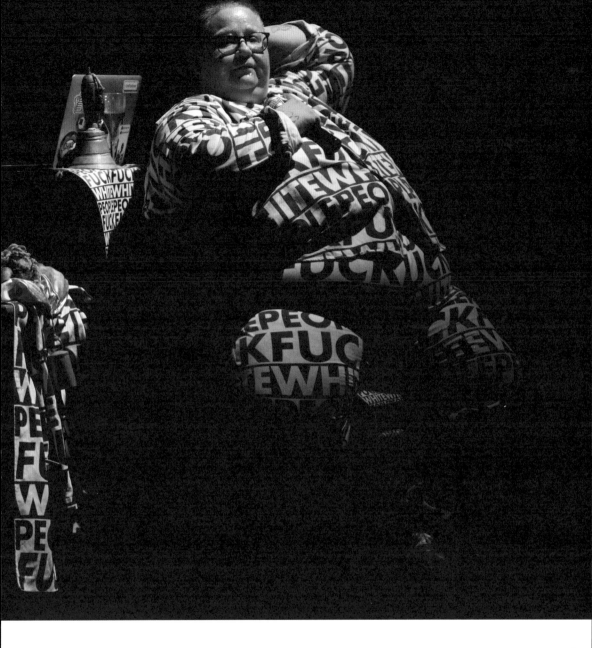

Figure 2.4. Dean Hutton, *Plan B, A Gathering of Strangers (or) This Is Not Working*, 2018.
Courtesy Institute for Creative Arts.
Photograph by Xolani Tulumani.

asks. 'Even just in the basic way we speak to people who occupy the same spaces as us. It's really hard work.'[31] Hutton offers a process of what Rosi Braidotti has called 'thinking about thinking' in a highly visceral way.[32]

Using the mediums of video, photography, performance and social media, they find a way to name and call out both underground and expressed structures of anger, anxiety, shame and turbulence. This includes resentful white subjects, envious of the actual victims of a time and place, attempting their own chance at victimhood and absolution from history's assessment of who they have been. The idea of self-installation is a powerful articulation of the politics Hutton espouses. They make every instant (the) work itself: every time they put on the suit, breathe, move, walk or enter social space, they interrupt it. Hutton says about the suit: 'There is a rumour that I wear it all the time. And I wish I could actually because it needs to be said in every part of every day.'[33]

They place themselves as both subject and object at the same time, covered in a suit, not confined to the gallery space and a logic of self and other, but walking around in the city, in space, out in the world at large. Many white people who encounter the walking, sitting, talking installation are outraged – outraged by the interruption Hutton inserts into the world; the supposed shared space which is not in fact shared. Recently, Hutton has had to rethink the wearing of the suit in public because of threats of violence. This only makes their statement that 'even though I am saying "fuck white people," my practice is fundamentally about love' even more radical.[34]

In 2017, *Fuck White People* was found by the Equality Court in Cape Town to be an expression of art as opposed to hate speech. This, after men wearing Cape Party T-shirts defaced the installation in the ISANG exhibition with a large sticker reading 'Love Thy Neighbour,'[35] and lodged a complaint with the South African Human Rights Commission that the work amounted to hate speech.[36] In the view of Chief Magistrate DM Thulare, 'if there was one thing the work had achieved it was "to draw South Africans to a moment of self-reflection."'[37] In his view, the words 'fuck white people,' properly contextualised and understood, conveyed the message: '"Reject, confront and dismantle structures, systems, knowledge, skills and attitudes of power that keep white people racist."'[38] He 'found that the words "white" and "people" were not directed at all whites but rather to a system of oppression inherent in "white domination."'[39]

The judgment is laudable and the legal explanation obviously correct. What is notable, and of interest to my argument, however, is that the legal explanation drains the installation of its radical affective charges. People publicly expressed their hatred of the work, felt frightened by it and ridiculed it, most often invoking Hutton's weight, race and sexuality – in that order. While the judgment invokes 'structures [and] systems,' what makes the work striking and troubling to people is its radical affect. 'The court was asked to strip it of affect and pronounce on its proper denotative meaning, even though the work is clearly intervening at the level of deep affect and emotion. Its affective charge is way in excess of its juridical meaning, even though the juridical interpretation is clearly not incorrect,' writes Daniel Roux.[40] The affect in this work is, in fact, excessive to every available frame (to the extent that Hutton was forced to provide the frames for interpretation of the work in order to avoid legal sanction). So the judgment 'does not redeem the artwork; rather we have a logic of affect and naming that speaks to the limitations of legal or factual understanding,' that evokes an inchoate future category that is technically supported in law but one that is not yet available as a legitimate form of socially legible feeling, an affective foundation to a recognisable form of politics and naming.[41]

Hutton's radical attempt at intervening in the air we breathe – listening closely also to black South African students' repeated phrase 'I can't breathe,' politically, ideologically, historically – seeks to vaporise the very basis of the category of whiteness as it likes to think of itself, taking the world at large as its exhibition space. In this sense, Hutton attempts to stand in for the very place of the *Real*.[42]

CONCLUSION

Periods of upsurge attempt to harness the power to name in the production of political time. Breaking and unmaking, they nevertheless remain entangled in the aftermaths of what came before. They address the radical incompleteness of the archive of the present, forcing open its aporias, and letting live and breathe its neglected and marginalised undersides. The harnessing of self-propulsion to the rise of an expressive turn in South African culture and politics is a process of coming alive from numbness. An ethics of propulsion fired through the final years of Jacob Zuma's theatrical and disturbing reign, powered by generational dissonance and disruption of the order that had settled into the postapartheid

status quo. Much of its propulsive energies were driven by a young intellectual class, from inside of universities themselves.

In Sethembile Msezane's striking *Chapungu – The Day Rhodes Fell*, a performance piece referred to by several authors in this collection, the heavy weight of the Rhodes statue is lifted from its plinth while Msezane rises as a living sculpture in the form of a prosthetically enhanced Zimbabwean bird. In Msezane's invocation of what Anthony Reed has called the performative 'black fantastic,'[43] live art takes the form of 'wearable sculptures' in a vivid synecdoche for an era's zero time.[44] Calls to and from the ancestral, from the dead as that 'originary scene of radical equality,'[45] can come from many places, as political time is remade, and the incompleteness of the archive is drawn towards a fuller history of what has transpired.

The work of inscribing 'disavowed subjectivities' into a radically incomplete archive,[46] often by listening to and writing histories of feeling and emotion, parses the fault lines that propel a new and renewed confrontation between the love and hatred of art; entanglement and the politics of refusal; non-racialism and anti-blackness; the shock of the new and the repurposing of the old. Tracing these fault lines reveals the terms on which artists evoke interior and exterior worlds, private and public histories of feeling, their transparencies and opacities, and the shifting registers of each in contemporary performance art.

What, then, is an archive of care? Is it, as some have argued, a form of curatorial practice in which practices linked to traditional understandings of curating as 'caring for objects' are 'reconstituted in relation to (re)acknowledged subjectivities'?[47] Perhaps an archive of care relates in some iterations to Anthony Bogues's observation that: 'while political action and practice are always vital, the formations of new ways of life emerge from the ground of humans acting, working, through politics, *to get somewhere else*.'[48] Is an ethical practice of curatorial care, particularly during times of turbulence – as Pather suggests in this collection – constituted by a form of curatorial disappearance, a disavowal of the curator who directs, translates, convenes and interprets, enabling, now, the work alone to speak?

What, too, of other kinds of conceptual care, a form of listening for, and to, moments when the terms of critique we rely on in the present reach their own limits and propel, in turn, their own practices of marginalisation? When, for instance, as Paul Gilroy has put it, anti-blackness critique dissolves some of 'the sticky engagements with particular histories and local ecologies of belonging,' or deploys too generic a raced identity in a world in which 'racism assembles racial

actors in over-determined circumstances'?[49] How will we know how best, and with care, to both critique and listen for histories now hidden by new articulations of time and politics, hauntings perhaps, by archives in their turn marginalised in the struggle for the overthrow of racial orders and the building of worlds to come? Epistemologies of critique, practice and care to which selves, and history, may turn again, for purposes as yet unthought.

Editors' note: We want to acknowledge news reports that implicated artist Mohau Modisakeng in an act of verbal abuse of his partner, Nomonde Mdebuka. We also want to acknowledge the public statements by both Mdebuka and Modisakeng refuting these reports and asking that this be considered a personal matter. In consultation with writer Sarah Nuttall and Wits University Press, we have proceeded with the essay in its original form.

1. Ann Cvetkovich, *An Archive of Feeling: Trauma, Sexuality, and Lesbian Public Cultures* (Durham: Duke University Press, 2003).
2. See Anna M. Parkinson, *An Emotional State: The Politics of Emotion in Postwar West German Culture* (Ann Arbor: University of Michigan Press, 2015). She writes how 'strong and often extremely negative emotions were an integral component of postwar phenomenology.' Parkinson, *An Emotional State*, 1.
3. Parkinson, *An Emotional State*, 1.
4. Parkinson, *An Emotional State*, 2.
5. Parkinson, *An Emotional State*, 4.
6. Parkinson, *An Emotional State*, 5.
7. Parkinson, *An Emotional State*, 11.
8. Krista Tippett, *Becoming Wise: An Inquiry into the Mystery and Art of Living* (New York: Penguin, 2016), 9.
9. Jay Pather, 'Negotiating the Postcolonial Black Body as a Site of Paradox,' *Theater Journal* 47, no. 1 (2017): 158, accessed 10 November 2017, doi: 10.1215/01610775-3710477.
10. Matthias Pauwels, 'In Defense of Decolonial Philistinism: Jameson, Adorno and the Redemption of the Hatred of Art,' *Cultural Politics* 13, no. 3 (2017): 333.
11. Pauwels, 'In Defense of Decolonial Philistinism,' 335.
12. Ernesto Laclau and Chantal Mouffe, *Hegemony and Socialist Strategy: Towards a Radical Democratic Politics* (London: Verso, 1985), 171.
13. Pauwels, 'In Defense of Decolonial Philistinism,' 329.

14. Theodor W. Adorno, *Negative Dialectics*, trans. E.B. Ashton (London: Routledge, 2004).

15. Sarah Nuttall, 'The Redistributed University,' lecture presented at the European Graduate School, Malta on 15 October 2017.

16. 'Retinal Shift – Self-Portraits,' Mikhael Subotzky Archive, accessed 1 September 2017, http://www.subotzkystudio.com/works/retinal-shift-works/.

17. Mikhael Subotzky quoted in Joost Bosland, 'A Hermeneutics of Empathy: The Artist Interview in South Africa,' Master's diss., WiSER, Wits University, 2018, Appendix, 17–21.

18. Subotzky quoted in Bosland, 'A Hermeneutics of Empathy.'

19. Pauwels, 'In Defense of Decolonial Philistinism,' 337.

20. 'Statement on *Inzilo* for the South Africa Pavilion, Venice Biennale, 2015,' Mohau Modisakeng Studio, accessed 25 October 2017, http://www.mohaumodisakengstudio.com/inzilo/ixxwsk0w8csflze62a0oca1lxx4ikn.

21. Anne Taylor, 'Mohau Modisakeng, Standard Bank Young Artist Award Winner for Visual Art,' National Arts Festival, 28 October 2015, accessed 25 October 2017, https://www.nationalartsfestival.co.za/news/modisakeng-sbya16-art/.

22. Shannon Walsh and Jon Soske, *Ties that Bind: Race and the Politics of Friendship in South Africa*, eds. Shannon Walsh and Jon Soske (Johannesburg: Wits University Press, 2016), 308.

23. Walsh and Soske, 'Thinking About Race and Friendship in South Africa,' in *Ties that Bind*, 18.

24. Walsh and Soske, 'Thinking About Race and Friendship in South Africa,' in *Ties that Bind*, 18.

25. GIPCA, *Live Art Festival 2014 Programme* (Cape Town: GIPCA Live Art Festival. August–September 2014), 44.

26. GIPCA, *Live Art Festival 2014 Programme*, 44.

27. Gabriella Pinto, 'Creative Womxn: Dean Hutton on Using Love to Disrupt, Starting with the Self,' Between10and5, 18 August 2016, accessed 3 November 2017, http://10and5.com/2016/08/18/creative-womxn-dean-hutton-on-using-love-to-disrupt-starting-with-the-self/.

28. Dean Hutton, 'This is What Dean Hutton, Creator of "F**ckWhitePeople" Art, Has to Say About its Vandalism,' *Huffington Post South Africa*, 18 January 2017, accessed 3 November 2017, www.huffingtonpost.co.za/2017/01/18/this-is-what-dean-hutton-creator-of-f-ckwhitepeople-has-to_a_21657586/.

29. Hutton, 'This is What Dean Hutton, Creator of "F**ckWhitePeople" Art, Has to Say About its Vandalism,'

30. Pinto, 'Creative Womxn.'

31. Pinto, 'Creative Womxn.'

32. Rosi Braidotti, 'Posthuman, All Too Human,' Tanner Lectures on Human Values, presented at Yale University, 1–2 March 2017.

33. Pinto, 'Creative Womxn.'

34. Pinto, 'Creative Womxn.'

35. The Cape Party is a political party that aims to bring about the secession of the Western Cape from South Africa.

36. Petru Saal, '"F-k White People" Exhibition is Art, Not Hate Speech – Court,' *Times Live*, 5 July 2017, accessed 3 November 2017, https://www.timeslive.co.za/news/south-africa/2017-07-05-warning-explicit-language-f-k-white-people-exhibition-is-art-not-hate-speech-court/.

37. Saal, '"F-k White People" Exhibition is Art.'

38. Saal, '"F-k White People" Exhibition is Art.'

39. Saal, '"F-k White People" Exhibition is Art.'

40. Daniel Roux, e-mail message to author, 24 November 2017.

41. Roux, e-mail message to author.

42. I am grateful to Penny Siopis for her discussion with me on this point.

43. Anthony Reed, 'African Space Programs: Spaces and Times of the Black Fantastic,' *Souls* 16, no. 3–4 (2014): 351–371, accessed 2 April 2018, doi: 10.1080/10999949.2014.968951.

44. Bankole Oluwafemi, 'Standing for Art and Truth: A Chat with Sethembile Msezane,' TED Blog, 18 September 2017, accessed 10 April 2018, https://blog.ted.com/standing-for-art-and-truth-a-chat-with-sethembile-msezane/.

45. Achille Mbembe in conversation with Sarah Nuttall, 'A Questionnaire on Monuments,' *October* 165 (2018): 111.

46. Leora Farber and Renée Mussai, 'Curatorial Care, Humanising Practices: Past Presences as Present Encounters,' *Curatorial Care, Humanising Practices Programme* (Johannesburg: University of Johannesburg, 11–13 April 2018).

47. Farber and Mussai, 'Curatorial Care.'

48. Anthony Bogues, 'And What about the Human? Freedom, Human Emancipation, and the Radical Imagination,' *boundary 2* 39, no. 3 (2012): 41 (emphasis mine), accessed 10 April 2017, doi:10.1215/01903659-1730608.

49. Simon van Schalkwyk, '"Imagination is Everything": Paul Gilroy Chats to the JRB about Race, Land and South Africa's Role in Overthrowing the Racial Order,' *Johannesburg Review of Books*, 4 April 2018, accessed 10 April 2018, https://johannesburgreviewofbooks.com/2018/04/04.

'Madam, I Can See Your Penis': Disruption and Dissonance in the Work of Steven Cohen

CATHERINE BOULLE

> *I feel really strange because I'm trapped into [an] old, white, male, patriarchal role that really doesn't fit me well. It's difficult to explain ... that I'm not that thing that I am.*
>
> Steven Cohen, interview with the author, 6 March 2017

Demographically and physically one thing; experientially, another. I would like to begin with a story and a saying that move from this point of incongruity. In a wide-ranging 2017 interview with Steven Cohen, the seminal South African performance artist related an anecdote from one of his earliest interventions, *Dog*. Uninvited, Cohen first publicly performed the piece in 1998 at the Goldfield's Kennel Club Obedience Show in Johannesburg's East Rand, Cohen inserted himself into the dog show lineup as a performing mongrel dressed in his iconic tutu, bare-bummed, a dildo up his anus and a bag covering his penis. Midway through his show-dog routine of flick flacks, jumps and somersaults, the ball bag flew off. Cohen recalled:

Afterwards, this nice lady came running up with my ball bag, and said: 'Meneer, you forgot this.' She's actually in the video, finally getting exasperated, getting up from her table in the background ... Here's this Tannie who's like, everything you did is wrong, but this is your thing [I must return it]. I love that about people and society and that [sense of] always in two directions, always ... And that's the value of performance, that pull hard in many directions at the same time.[1]

In 2017, the Pan-African collective Chimurenga devised the Spring curriculum for the RAW Academy in Dakar around the implications of the colloquial South African saying, 'Angazi, but I'm sure' – its English translation: 'I don't know, but I'm sure.' The curriculum outline explains: 'It is a deliberately self-contradictory phrase that is usually spoken in prelude to a reply – often, when one is asked for directions or facts. "Angazi, but I'm sure if you turn left you will get there." ... The respondent is uncertain – of what they "know." Or, perhaps, they are certain, but they do not know how to speak it. Or, they know, but do not know what they know.'[2] The many simultaneous directions in which Cohen pulls his viewers reflect the paradox at the heart of this South Africanism. 'I don't know, but I'm sure,' might speak for the experience of watching a Cohen performance that one both does and does not 'get.' More precisely, I use this intuition of paradox and self-contradiction as a means to approach the significance of disruption in Cohen's work – the rules and spaces he has defied, the categories and stereotypes he has exploded, from the late 1990s until today.

In 2018, South Africans are poised somewhere between 'rainbowism' and a future characterised, to borrow from Lwandile Fikeni, by an 'aesthetics of rage.'[3] The vestiges of the Nelson Mandela-era rhetoric of forgiveness and reconciliation butt against an anger long suppressed – silenced, Fikeni argues, by the project of rainbowism itself – that is now demanding an outlet. The country's shifting political terrain and public discourse have also been increasingly marked by disillusionment with the government's failed promise of material redress for black South Africans. In the *New South African Review 5: Beyond Marikana*, Prishani Naidoo suggests that the roots of the 'deepening disappointment with, and critique of, existing political forms and practices that pass for democracy in South Africa today' lie in the state-sanctioned killing of 34 miners at Marikana in 2012,[4] and can be traced through the rise of opposition party the Economic Freedom Fighters (EFF), the fracturing of the Tripartite Alliance, and increasing service delivery protests.[5] At the time of writing this chapter, Cyril Ramaphosa's ascent to the African National Congress (ANC) presidency seems to represent, at once, further inroads along the government's neoliberal trajectory, and a firm stance against a culture of greed and profiteering that has eroded the ruling party from within.

Cohen's work – always imbricated with its socio-political setting – is both situated within this state of suspended uncertainty and long precedes it. When the '*Simunye*: We are One' narrative of a united and reconciled South Africa was in its

beginnings,[6] his performances emerged as a deeply disruptive force, unsettling the new narrative of nationalism, and rupturing the chauvinism against which it was pitted – the racist, patriarchal, heteronormative social hegemony established by colonialism, cemented under apartheid, and largely taken for granted in white South Africa.

Achille Mbembe's writing is helpful here: 'When I first arrived I knew almost nothing about South Africa ... One vague philosophical idea nevertheless animated me: the question of *interruption*. I was deeply intrigued by the event by which a society formerly at war with itself had consciously chosen to escape the deadly logic of repetition and decided to start anew ...'[7] My study probes the ways in which Cohen breaks from the repressive ideologies of the past, but also considers whether he might be seen to be staging acts of disruption in the forward-looking manner Mbembe gestures towards. In other words, impeding, however momentarily, the 'deadly logic' of repeated cycles of violent othering from persisting in the present, and reverberating into the future.

I turn to Chimurenga once more: '"Angazi, but I'm sure" is a break between our linguistic selves and a world, between knowledge and our ability to speak or map it.'[8] Cohen thrusts his viewers into spaces of knowing and ineffability, cognitive confusion and corporeal resonance. His works interrupt the reproducibility of the -isms of the past and present because they posit a glimpse of a future in which violent systems of othering have lost their coherence and loosened their hold. This is a future of which we know almost nothing but are perhaps sure, or of which we know but cannot yet speak. I am not that thing that I am. A country that is and is not its past. A pull back, a pull forward. Always in two directions.

THE UGLY GIRL WALKS

In 1998, Cohen performed, amongst numerous other works: *Patriotic Drag* at the ultra-right-wing Afrikaner Weerstandsbeweging (AWB) rally at Fort Klapperkop, Pretoria; he took a rendition of his work *Faggot* to a bridal fashion show in Killarney Mall, wearing little more than a white corset, silken gloves, thigh-high pantyhose and a red G-string, with a sparkling dildo in his bottom; his *Ugly Girl* persona, echoing that of *Faggot* but with blood splattered across his chest, attended the glamorously outfitted horse race, the Durban July; and *Dog* flick-flacked its way across Sandton Square at lunch hour in the heart of the wealthy Johannesburg business district.

The eruption of Cohen's public interventions shook many of the previously unchallenged bedrocks of whiteness: masculinity and militarism, notions of beauty, dominance, memorialisation, belonging and the simple pleasure of enjoying one's lunch (life) guilt-free. At each setting, Cohen was forcibly removed, or almost. In Sandton Square, a black security guard – protector of white privilege in walled suburbs and gated communities as in upmarket restaurants – chased after him unsuccessfully. I would like to pay particular attention to *Ugly Girl at the Rugby* as illustrative of these early works, and for its guerilla attack against the (ostensibly) unalterable monolith of racial and gendered normativity, which recurs throughout Cohen's oeuvre in new and shifting ways.

In this iteration of *Ugly Girl*, Cohen walks towards the Loftus Versfeld rugby stadium in Pretoria in 1998, a high point for rugby fervour following South Africa's win at the 1995 Rugby World Cup – a victory celebrated and later romanticised as signalling the birth of the new, racially harmonious nation. Dressed in a composite of his *Faggot*, *Ugly Girl* and *Princess Menorah* personae – garish make-up, an orange wig and red platform heels accentuating his leopard print stockings – Cohen walks to buy a ticket to the South Africa versus Wales game. As he does so, groups of men having *braais* (barbecues) and drinking in the parking area outside confront, grope and laugh at him, beers in hand, and peer beneath Cohen's makeshift tutu to verify his genitals.

A manifestly queer body in the stronghold of conservative white patriarchy, Cohen is an embodiment of out-of-placeness or, indeed, place*less*ness at a time in South Africa when there was no commonly used language to describe queer experience, and few public spaces in which to be openly gay. Cohen shatters the mythology of rugby's unifying power and, more broadly, the urge of masculinity to self-present as a coherent subject – one who sits squarely within recognisable frames of identification, who belongs where he is (and only goes where he belongs), whose appearance and identity, in other words, cohere.[9]

The rugby stadium is significant in South Africa as the site where these pretensions to a cohesive white heteronormativity converge. Jonathan Jansen noted in 2009: 'When one enters the almost all-white, almost all-Afrikaans rugby stadium called Loftus Versfeld in Pretoria, it becomes immediately clear that this game is much more than rugby ... for this is the sport in which power, nationalism, and masculinity are projected and entrenched in Afrikanerdom.'[10] When Cohen's onlookers jeer at him, they are engaging with a puncturing of the 'completely closed

coherent world' – reified in the symbol of Loftus – in which white Afrikaners, and indeed almost all white citizens, lived during apartheid.[11] Asserting their machismo against the abject figure in their midst, Cohen's onlookers simultaneously reinforce the binarised (white and black, self and other) apartheid-era conception of identity from which they have benefited, while participating in a performance that renders sexual and racial identity contingent, relational and iterative. These men demonstrate, as vociferously as the artist himself, that identity takes its bearings not from within, but from without – from the other against which it can be measured. Here, then, an act of othering becomes its own source of disruption, upending the ostensibly stable models of identification upon which it professes to lie.

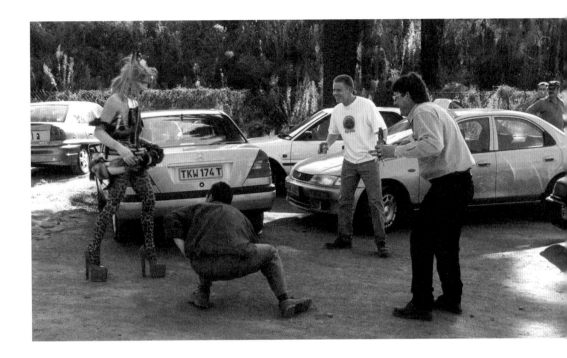

Figure 3.3. Steven Cohen, *Ugly Girl at the Rugby*, 1998.
Copyright: Steven Cohen.
Courtesy Stevenson, Cape Town and Johannesburg.
Photograph by John Hodgkiss.

I would like to go further still. Cohen's onlookers might be seen to be stepping out of their worldview, if only for a moment and certainly unwittingly, through the 'fissures and holes in perception' that Cohen breaks open via his own incoherence.[12] A white, vulnerable, grotesquely effeminate man, able-bodied yet unstable in his self-inflicted heels – the fissures that Cohen creates are pinpricks perhaps. But they nevertheless let in the light and air from a kind of alternative universe, near impossible to conceive in 1990s South Africa, in which whiteness is disentangled from authority, masculinity from power, and patriotism from physical prowess.

MOVEMENT AS POLITICAL ACT

Cohen's decentring of the white male subject, a provocation at the heart of his practice, finds a curious manifestation in the numerous performances in which he impedes his own movement, most commonly with excessively high heels. Shaun de Waal and Robyn Sassen suggest a link between the artist's heels and the deformed foot thought to be one of the 'immutable signs of identity' that Jewish bodies were seen to carry in anti-Semitic cultures in the twentieth century.[13] I read a deeper and more contemporary significance into these hindrances – the precarious shoes but also, more tellingly, the works in which Cohen reduces his movement to crawling or limping – along the lines explored by theorist André Lepecki in his seminal work *Exhausting Dance: Performance and the Politics of Movement.* Examining European and American experimental dance in the 1990s and early 2000s, Lepecki argues that the deployment of stillness or interrupted motion in dance holds profound political and ontological importance because it runs contra to modernity's (and capitalism's) relentless movement forward, the tyrannical drive onwards in the name of progress. Lepecki establishes his thesis as follows:

> From the Renaissance on, as dance pursues its own autonomy as an art form, it does so in tandem with the consolidation of that major project of the West known as modernity. Dance and modernity intertwine in a kinetic mode of being-in-the-world ... Dance accesses modernity by its increased ontological alignment with movement as the spectacle of modernity's being.[14]

> The 'still-act' is a concept ... to describe moments when a subject interrupts historical flow and *practices* historical interrogation ... The still *acts* because it interrogates economies of time, because it reveals the possibility of one's agency within controlling regimes of capital, subjectivity, labor, and mobility.[15]

Reading Cohen's performances against Lepecki's argument illuminates an important facet of the artist's work: the obstruction of movement as political act, as socio-political interrogation. As Cohen crawls, limps or walks his way unsteadily across a particular setting, he intimates the navigation of a political landscape and a probing of the concept of nation-building, with all its attendant discrepancies between rhetoric and reality.

Limping into the African Renaissance was first performed in Swaziland at 11 pm on 31 December 1999, anticipating the arrival of the new millennium. The work takes its name from the concept, made famous in Thabo Mbeki's 1998 speech as then deputy president of South Africa, of a vision for Africa's rebirth, to be brought about by Africans' agency to determine a different future.[16] 'How can we be but confident that we are capable of effecting Africa's rebirth?' Mbeki asked. 'How can we be but confident that through our efforts, Africa will regain her place among the continents of our universe?'[17] Against Mbeki's rhetoricising, this image of Cohen comes into view: face muzzled in a sadomasochistic head mask with a black dildo over his mouth, his own penis bound but exposed as his lacey dress flaps around, limping and staggering, sometimes on all fours, attempting at other moments to dance and pose, all the while trying to balance with one foot inserted into the thigh of a flimsy prosthetic leg.

The artist's slow and clumsy procession, a literal frustration of the ability to move forward, becomes a subversion of the desire for progress. The word 'renaissance,' which connotes renewal via a move backwards, a revival of something that was (or, as Cohen puts it, 'a kind of new old'[18]) jostles against his artistic intention, which has persistently been to interrupt what once was – the racist, sexist, homophobic subjugation that defined apartheid South Africa. In the artist's counterintuitive motion, he muddles through what it means to be in a country that seeks to march into the future by pulling away from its devastating recent past, while yearning for a lost and distant time. In response to Mbeki's abstraction, Cohen asks: but, a rebirth of what?

The artificial limb, designed to assist amputees in regaining movement, is inverted in *Limping* into its own form of disability. The artist explains that the work considers 'the absurd handicap of whiteness and the extra leg, the third leg, privilege, that handicaps.'[19] That Cohen critiques both whiteness and the African Renaissance project within a single work is the conceptual paradox that underlies his physical backward-forwardness. I perceive Cohen's statement and movement as a mocking reflection on the idea, fabricated by white South Africans fearful of change in the new dispensation, that the introduction of policies like Black Economic Empowerment was incapacitating white people, engendering a kind of reverse racism. But the work also seems to offer a less ironic grappling with the place and position of whiteness, positing the inability to circumvent the blindness of white privilege as a very real impediment to belonging in post-1994 South Africa.

In his 1999 work *Voting*, Cohen's nearly impossible heels become truly so – 1.2-metre-long gemsbok horns are attached to pointe shoes – and he crawls on his hands and knees, sometimes dragging (in full drag) his torso forward by the pull of his arms, to queue at his designated Johannesburg polling station. He waits in line for hours, propped up on his knees and elbows or lying on his stomach for long stretches between inching forward slowly. His fellow voters tower over him. 'When you go inside, you're going to take this off?' one woman asks Cohen, gesturing at his outfit.[20] He shakes his head. 'You just go like this?' she asks again, believing, perhaps, that he might strip away the drag queen trimmings and vote as his 'real' self. Other interactions captured on video revolve crucially around this question of identity. One man points at Cohen and asks, 'What is this? Is this a person or...?' his voice trails off.[21]

Voting is an iteration of *Crawling*, which Cohen performed in the late 1990s at an exhibition opening, a Gay Pride march, a theme park, a film festival, an art museum and even during a flight from Cape Town to Johannesburg. Thirty years earlier, genre-defying American artist William Pope.L began performing his public works, known collectively as 'crawls,' in which he crawls or, more accurately, pins his body to the ground and squirms and writhes along the streets and sidewalks of New York.[22] Lepecki understands Pope.L's "'giving up of verticality,'" as the artist has described the work, as a 'choreopolitical statement.'[23] Citing Henri Lefebvre, Lepecki contends:

> Pope.L's crawls propose a kinetic critique of verticality, of verticality's association with phallic erectility and its intimate association with the 'brutality of political power, of the means of constraint: police, army, bureaucracy.' Because they so clearly embrace horizontality, Pope.L's crawls reveal how the vertical 'bestows a special status to the perpendicular, proclaiming phallocracy as the orientation of space.'[24]

Sliding along his own horizontal plane, Cohen enacts a similar critique of the historically phallic nature of power in South Africa, and the state apparatus used to wield it. The piece suggests, too, the residual influence of bodily hierarchies. Reactions captured in the 20-minute video distillation of the seven-hour performance are primarily laughter and incredulity, but Cohen has explained

that his crawling works are the most gruelling to perform because 'people take advantage like you cannot believe. That's the work I've most been hurt in, by people kicking, or pouring, or putting burning cigarettes on me.'[25] In this view, *Voting* and *Crawling* would seem to reveal the enduring alacrity in South Africa to *abjectify* – to treat as inhuman anything or anyone that presents as different, smaller, lower. His impeded movement destabilises the idea of progress in the knowledge of how low the threshold for debasement continues to be. A seismic shift in race and power relations was the dream during the transition period in South Africa, but the reality is much closer to what Cohen, in his slow crawl and awkward limp, seems to suggest: the erosion of the 'pervasive force' of racism and phallocracy,[26] in all its overt and insidious guises, is best measured in infinitesimal gains.

BUT FOR WHOM?

Disruption, of course, never disrupts evenly. As Cohen noted in our discussion: 'This contradiction and this duality and everything – it's not the same for everybody. The one [viewer's] beauty is the other one's *kak*.'[27] To this I add my own acknowledgement, as author, of the extent to which my whiteness, heterosexuality and lived experience of privilege inform what I perceive as Cohen's disruptiveness, and the meaning and value with which I invest it. Nowhere is this matter of perspective more troubled than in *Maid in South Africa*, Cohen's 2005 work featuring the artist's long-term collaborator and domestic worker, Nomsa Dhlamini. The performance begins with Dhlamini, 87, dressed in traditional Swazi clothing which she strips off to reveal a maid's uniform, and beneath that a lacey chemise, until finally she is in white suspender tights, naked from the midriff up, except for a pair of purple plastic nipple covers. In her underwear and high heels, Dhlamini irons, sweeps, washes and dusts the Cohen family home, but the most difficult moment to watch is when she leans over the dirty toilet and starts to scrub, her naked breasts swaying as she moves.

Twelve years later, in an interactive presentation reflecting on his career, Cohen described *Maid in South Africa* as 'the least-liked work I've ever made, and it's the work I like least.'[28] Despite its failure, he maintains that the work still has something important to say about apartheid's invisibilising power: 'That image of Nomsa's old tits swinging over the toilet while she cleans white people's shit

... is the correct indictment of apartheid.'[29] But correct for whom? And by whose rationale? Having perceived an audience's response to *Maid in South Africa*, it does not seem an oversimplification to suggest that the difficulty of this statement, and indeed the work as a whole, falls along racial lines. For white South Africans, the majority of whom bought into, and all of whom have benefited from, a system of cheap black labour, a bald confrontation with the degrading work they inflict in their own homes is uncomfortable. The irony, of course, is that Dhlamini must be sexed up in order for the image to jar – so ingrained is the relation between white madam and black maid, so unyielding the image of the latter's invisibility. The work further troubles at the level of language – specifically, the bodily language of camp. In Cohen's hands (and body), camp is a defiant act of gendered incoherence; inscribed on Dhlamini's heterosexual body, in a position of subservience, it feels ill-fitting at best, repressive at worst.

For black viewers, the work hits at an altogether different frequency: it is not disruptive but violently repetitive. It is Mbembe's 'deadly logic' in action, staging for repeat consumption the image of the poor black woman – doubly demeaned by her scanty outfit – with limited agency, dependent on and dictated to by her white masters. It is 'the rigor mortis of the stereotype,' to take Homi K. Bhabha's metaphor, stiffening into the South African social imaginary.[30]

The age-old idea of art holding up a mirror for society to consider its own reflection seems almost naïve by comparison. For, in *Maid in South Africa*, the very act of looking is rendered problematic – who does it, who invites it, who allows it. Moreover, despite the discomfort alluded to above (or perhaps *because* of it), white viewers have tended not to recognise their own image in the mirror's reflection. In our discussion, Cohen explained that the predominant reaction on the part of white audiences has been to point fingers rather than look inwards: 'People didn't see that apartheid is terrible in *Maid in South Africa*. They see that I'm terrible. They see that art is terrible. They see that I'm abusive. But they don't even [think to themselves] that "I'm a white person" ... So, I don't know if I made the work right. Or I don't know if there's a way to make that work right.'[31]

To the work's miry mixture, then, we might add a failure of intention – an affront to black viewers that inadvertently exculpates whites. Or something else: a display, not via the work itself, but in the responses it has prompted, of the politics of white complicity. As Marie Breen Smyth writes, when the dominant

discourse shifted in South Africa, 'to be associated with the old regime was shameful, not something that one admitted easily or freely. And this shame was a private shame, one that led people to reinvent themselves, and to alter their public pronouncements.'[32]

A BLOODY IMMERSION

Nine months before the opening of his November 2017 exhibition, *put your heart under your feet ... and walk!* – made in remembrance of Cohen's life partner, Elu, who passed away tragically in 2016 – Cohen explained: 'I [have] trapped myself into having to make a performance about Elu ... I can't do it. I can't do it. So I have to fail. Because I can't not do it.'[33] This stream-of-consciousness tussle between fear and compulsion is a good place from which to begin working through Cohen's most recent performances – given a particularly close reading here in order to delve into their intricacies and draw out their manifold political references.

The companion pieces *blood* and *fat*, two of the three video works in *put your heart under your feet*, are performed in a South African abattoir amid the daily routine of slaughter. The unambiguously titled *blood* begins with Cohen – barefooted, whitened skin, blackened lips, in his characteristic tutu and intricate make-up – releasing a cry that seems part horror, part resignation as he climbs into a trough of blood above which a freshly slaughtered cow is suspended, throat slit and dripping. Here he performs a visceral ritual of private mourning in the most literal sense, for behind him cattle carcasses are being eviscerated, their hearts and lungs gutted and hung on hooks. Cohen feels the partially congealed gore with his feet and hands before kneeling and then lying down in it.

In the background, which comes into focus only in glimpses, workers look on occasionally, but generally pay the artist little attention. Cohen moves his head beneath the dripping carcass and the rounded droplets of blood fall onto his arm, and then his face, eyelids, lips. This is a sprinkling rich with twisted religious symbolism: a purgatorial drip-torture; a purification, through baptism, in a bloodied font, consecrated beneath a sacrificial cow; a messianic act of self-sacrifice declaring, 'this is my body, this is my blood.' In a further Christ-like echo, the blood has an aliveness to it, appearing to change in colour from wine to scarlet and in consistency from thick sinew to a shimmering liquid.

Figure 3.4. Steven Cohen, *put your heart under your feet ... and walk! (blood)*, 2017.
Copyright: Steven Cohen.
Courtesy Stevenson, Cape Town and Johannesburg.

Cohen's slow movements are set against the uninterrupted sounds of the slaughterhouse, which jostle with his emotional state – sawing, cutting, scraping and grinding that we hear, but the action of which we never see. Even audio-visually, then, there is a kind of dismemberment taking place, a severing of the senses. Alongside the performance, a cow is trapped in a narrow metal pen, knocked out and then exsanguinated, while the artist cups his hands in the trough and spreads blood across his throat. Blood rushes from the cow so quickly that it gathers into a fluffy foam; it dies slowly. In the final moments of the performance, Cohen kneels in the blood, his hands trembling against his chest, eyes closed, and

at the sound of another cow collapsing, he yells out, louder and more mournfully than before, and turns his head away from the workers who open the pen.

In the adjoining chamber, where carcasses are stripped of their hides, eviscerated, severed and sliced, intestines spilling onto the floor, *fat* unfolds. Cohen wears the same make-up and tutu, but here his fetish boots are more precarious than usual – heel-less high heels that mimic a hoof. He weaves tentatively between innards, tools and segments of fatty tissue draped over hooks, stopping at one point to hang from a chain and perform a kind of fleeting, absurd ballet. He strokes one of the hanging carcasses, and rests his head against it lightly, again visibly moved by this gauntlet of death. Workers pull, cut and grind around him; a man sharpens a knife as Cohen walks past. The act of defamiliarisation that Cohen performs here – rendering strange this procedural killing against what we might presume to be the workers' inurement to slaughter – owes its affective power in part to the macabre beauty of the scene. In its intricate folds and creases, the yellowed pieces of fat reflect the ruffles of Cohen's tutu; the pink rims of Cohen's eyes match the hanging flesh he caresses. The performance draws us into a palette of soft creams and pinks.

The messiness we would rather turn away from or expunge has always been Cohen's preferred theatre. Here, it takes the form of a grotesque space that conjures intimate loss but also, I am contending, socio-political disorientation. It is useful at this point to compare *blood* and *fat* with Cohen's earlier, and perhaps best-known work, *Chandelier*. Much has been written about this durational performance intervention in which Cohen – body painted white, wearing an enormous chandelier fashioned into a tutu – enters an informal settlement in Newtown, Johannesburg at the very moment that the settlement is torn down by government authorities to make way for the construction of the Nelson Mandela Bridge. The film captures only a small segment of the work's almost five-hour duration, during which Cohen moves through the settlement and engages with residents, iridescent against the dirt, and later the dusk, while shacks are rapidly and violently dismantled around him.

Yet the work's central point of unease, I believe, is not often delved into. Cohen inserts himself in full drag regalia into a space of poverty and devastation and, bar a few threatening advances, is allowed to continue for hours because his privileged status as a white man safeguards him. Through its uncomfortable voyeurism and

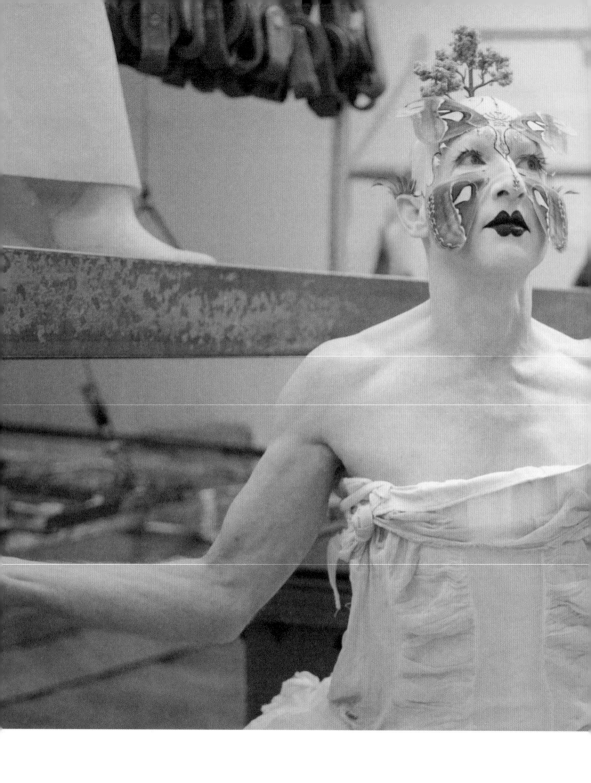

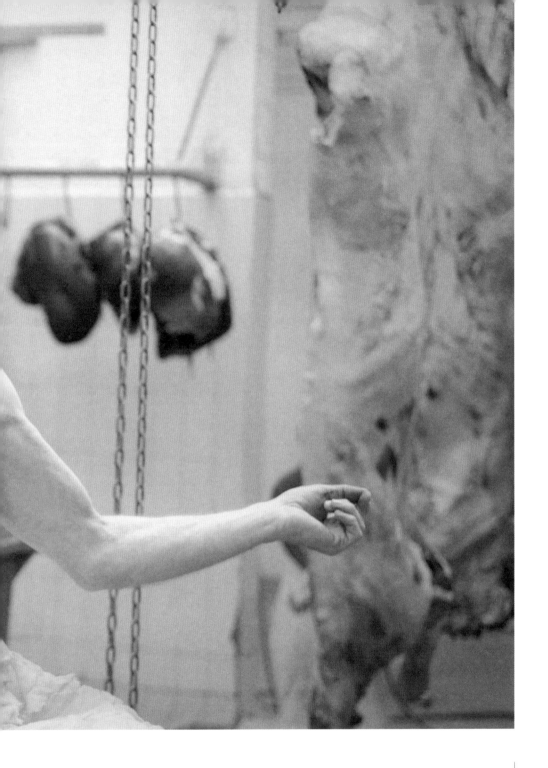

Figure 3.5. Steven Cohen, *put your heart under your feet ... and walk! (fat)*, 2017.
Copyright: Steven Cohen.
Courtesy Stevenson, Cape Town and Johannesburg.

questionable politics, the work spotlights, in contrast to Cohen's immunity, the inescapable vulnerability of the people who surround him. This vulnerability is both immediate, in that the inhabitants are about to lose what little they have in the way of homes, but also functions at a much broader and more disturbing level: Cohen's spectators are poor and black in a country that continues to subjugate both. And while Cohen can move with relative ease, despite clunky heels, out of this space of squalor, his onlookers are perpetually entrapped in a cycle of poverty and state-sanctioned violence and neglect. In this reading, *Chandelier* is a profound and disturbing commentary on the persisting power of white privilege.

At first glance, *blood* and *fat* would seem to occupy a similarly contentious space. A confrontation with death that is deeply moving for the white artist but part of the black labourers' daily routine has implications beyond the abattoir and the killing of animals. It is subtended by the still-true reality that black bodies are forced to withstand and grow accustomed to forms of violence and degradation unfamiliar to whites. Cohen consciously seeks out a triggering space for a work of artistic catharsis; for black South Africans, traumatic triggers are pervasive, they rise unbidden. Moreover, the mixture of confusion and obliviousness with which the workers regard this strange made-up figure, submerged in blood and stroking chunks of meat, opens up a distance – akin to that in *Chandelier* – between us, the viewers of the video performance, and them, the immediate onlookers. We, on the carefully curated and edited end of the performance, have the benefit of perceiving it as a work of art.

Only on rewatching *fat* does it become clear that one of the workers uses his phone to film or photograph Cohen. I make this observation with some caution, for it is a brief moment, four seconds perhaps, that is easily missed on first viewing and, as such, likely falls outside of the artist's intention. Nevertheless, because the relation between intention and effect is so consistently thrown up for question in Cohen's practice, I feel some licence to read into this sideways glance of the camera a puncturing of the assumption – accompanying the workers' desensitisation to slaughter – that they might be equally oblivious to spectacle. I suggest that this moment further complicates the question of positionality raised in *Chandelier*, for the worker who films and presumably rewatches Cohen's performance sets up a crossover between immediate and secondary audience; abattoir worker and gallery-goer. This is not a shared space

of the 'Simunye' kind, but one that draws attention to the viewers' complicity. Like the rugby fans in *Ugly Girl* whose jeering unwittingly renders them co-collaborators in a demonstration of identity's contingence, the aesthetic allure of *fat* pulls viewers, unknowingly perhaps, into a kind of visual complicity. To read the work's colours and textures as beautiful, even fleetingly so, is to separate pretty palette from dying cow. It is to participate, in other words, in the same unconscious disassociation from cruelty that facilitates the work of the slaughterer. Repulsed but magnetised, shocked and seduced, this thorny crossover shows up the viewer's own act of self-contradiction.

From the mid-1990s to the early 2000s, when Cohen's early works were intervening in incongruous settings, confronting ethics and aesthetics alike, the roots of apartheid ideology remained deeply embedded in numerous strata of South African society. But it is also true that the country was enjoying 'its longest period of uninterrupted economic growth since the mid-1960s.'[34] National rhetoric was buoyant with hopefulness, propped up by aspirations towards unity and reconciliation. In 2018, no such stability or assumed racial amity exists. Cohen's film *blood* distorts the dream of the rainbow nation into many shades of one colour – a bloody red – that is a more apt metaphor for the violence of our history and the volatility of our present than a rainbow could ever be. Navigating his way around fat and flesh in barely manageable heels, and lying in an abundance of death, Cohen suggests that the territory of the times is precarious indeed.

But there is also this: if rainbowism is taken to represent a suppression of black pain – via a willed-into-being state of racial harmony, and a forced forgetfulness of the atrocities of the past that persist in the present – then *blood* and *fat* might be seen to work against this project of silencing by grappling with the 'social violence left unattended by the TRC [Truth and Reconciliation Commission].'[35] Cohen converts the ethereal transcendence hoped for in the 1990s into a tangible and bloody immersion in private grief and collective rage. He sits in the mess in which he is implicated and allows it to flow. If the work's religious symbolism of baptism, purgatory and self-sacrifice – blood spilled for the sake of new life – heralds a rebirth, the African Renaissance refigured once more, then perhaps it is via a visceral accountability. In *Seeing Differently: A History and Theory of Identification and the Visual Arts*, Amelia Jones takes Jacques Derrida's famous line, "'il n'y a pas de hors-texte'" to mean 'that there is no "beyond" that does not hold vestiges of

what it seeks to supersede.'[36] And yet, Jones goes on, 'the key political urgency of *Seeing Differently* is that we must try, and try, and continue to try' to think outside of the limited conceptions of identity that threaten to define us.[37] Cohen's latest work rings out with the same struggle – the difficulty of reimagining what, where and who we are, and the critical necessity of engaging in the messy work of trying.

WHERE TO FROM HERE

In keeping with the contradictions I have explored throughout this chapter, I would like to end at the beginning. In our 2017 interview, Cohen recalled a moment, dressed in his characteristic drag, when an old homeless man sleeping on the pavement looked up at him and said: '"Madam, I can see your penis."' Cohen went on: 'That's such an important statement for me. It's so political. It's so much everything that the work's about. Like, why's madam got a penis? Why is madam a madam? Why is it all evident? It's so South African.'[38]

And another beginning: Jones prefaces *Seeing Differently* with her personal journey of grappling with categories – social, racial, academic, class – in which, throughout her life, she has felt she only partially belongs. Though she no longer possesses the certainty of self or position that she did in her early career, she observes that this circumspection offers its own usefulness: 'I have no idea who I am. Perhaps this is the best place to begin to rethink identification and the visual.'[39] A category-defying madam with a penis, a perpetual outsider who is, in some senses, a privileged white South African male like any other – this is the position from which Cohen, not unlike Jones, performs a reimagining of identification and the visual.

Yet it has also been my contention that this work of rethinking and resisting reductive binaries is oriented towards a future. Cohen has spent a lifetime provoking, via acts of performative disruption and dissonance, experiences of internal incoherence. In his public theatre, white men holding fast to a hegemonic worldview undermine their own subjectivity; a woman repulsed by his work runs after him with his ball bag; a performance that opens one mind is a violent trigger for another; complicity reflects and refracts in uncomfortably schismatic directions; and notions of progress are rendered almost unmeasurable.

But only almost. For, as South Africans, humans, cognitive beings, we have the capacity to occupy multiple and multiply conflicting viewpoints within a single performance, even a single moment. There is, then, space and possibility for movement. This is the future, I believe, that Cohen posits. One in which 'the deadly logic of repetition' no longer reproduces itself in perpetuity because a shift in positionality, ever present, holds the potential for a shift in consciousness. From a place of unknowing, we might know again, and differently. We might say: 'Angazi.' And in the very next breath: 'But I am sure.'

1. Steven Cohen, in interview with the author, 6 March 2017.

2. Chimurenga, '"Angazi, but I'm Sure,"' in *RAW Academy Session 2* (Dakar: RAW Material Company – Center for Art, Knowledge and Society, 2017), 9, accessed 1 December 2017, http://www.rawmaterialcompany.org/dyn_img/cms/eb10a 7dcbe1577508745bc25a7441770.pdf.

3. Lwandile Fikeni, 'Protest, Art and the Aesthetics of Rage: Social Solidarity and the Shaping of a Post-Rainbow South Africa', paper presented at the 15th annual Ruth First Memorial Lecture, Johannesburg, South Africa, 17 August 2016, accessed 15 February 2017, http://witsvuvuzela.com/wp-content/uploads/2016/08/Final-1-Lwandile-2016.pdf.

4. Prishani Naidoo, 'Introduction: Political Reconfigurations in the Wake of Marikana', in *New South African Review 5: Beyond Marikana*, ed. Gilbert M. Khadiagala et al. (Johannesburg: Wits University Press, 2016), 1.

5. Naidoo, 'Introduction,' 1–3. The Tripartite Alliance refers to the political alliance between the African National Congress (ANC), the South African Communist Party (SACP) and the Congress of South African Trade Unions (COSATU).

6. *Simunye* is an isiZulu word meaning 'we are one.' In the mid-1990s, it was the slogan for South African Broadcasting Corporation (SABC) 1, a public service television channel.

7. Achille Mbembe, 'Why am I Here?' in *At Risk: Writing On and Over the Edge of South Africa*, eds. Liz McGregor and Sarah Nuttall (Johannesburg: Jonathan Ball, 2007), 160.

8. Chimurenga, '"Angazi, but I'm Sure,"' 9.

9. I am indebted here to Amelia Jones's reflections on the contingency of the outward markers of her identity (gender, sexuality, race). She writes: 'Sometimes the relationality of my sense of identification is almost too much, and I yearn for a belief in my own

(even momentary or potential) coherence. I come from a place of deep understanding of *the urge to cohere oneself* – being an outsider or feeling the incursion of "difference" is a scary thing.' Amelia Jones, *Seeing Differently: A History and Theory of Identification and the Visual Arts* (New York: Routledge, 2012), xxv–xxvi (emphasis mine).

10. Jonathan Jansen, *Knowledge in the Blood: Confronting Race and the Apartheid Past* (Stanford: Stanford University Press, 2009), 73–74.

11. Antjie Krog, *Begging to be Black* (Cape Town: Random House Struik, 2009), 126.

12. Adrian Heathfield, 'Alive,' in *Live: Art and Performance*, ed. Adrian Heathfield (London: Routledge, 2004), 9.

13. Shaun de Waal and Robyn Sassen, *TAXI-008: Steven Cohen* (Johannesburg: David Krut, 2003), 17.

14. André Lepecki, *Exhausting Dance: Performance and the Politics of Movement* (New York: Routledge, 2006), 7.

15. Lepecki, *Exhausting Dance*, 15.

16. Thabo Mbeki, 'The African Renaissance, South Africa and the World,' speech presented at the United Nations University, Japan, 9 April 1998, accessed 15 November 2017, http://archive.unu.edu/unupress/mbeki.html.

17. Mbeki, 'The African Renaissance.'

18. Cohen, interview.

19. Cohen, interview.

20. Steven Cohen, *Voting*, Vimeo video, 9:41, June 1999, accessed 15 January 2018, https://vimeo.com/250117492.

21. Cohen, *Voting*.

22. Adrienne Edwards, 'William Pope.L: The Will to Exhaust,' *SPIKE Quarterly* 45 (2015): 118, accessed 15 December 2017, http://walkerart.s3.amazonaws.com/magazine/Spike45_Pope%20L.pdf.

23. Lepecki, *Exhausting Dance*, 93.

24. Lepecki, *Exhausting Dance*, 93.

25. Cohen, interview

26. Lepecki, *Exhausting Dance*, 92.

27. Cohen, interview. *'Kak'* is an Afrikaans slang word meaning 'shit' or 'rubbish.'

28. Steven Cohen, Sphincterography, the Politics of an Arsehole, lecture-performance presented at the ICA Live Art Festival, Cape Town, 24 February 2017.

29. Cohen, Sphincterography.

30. Homi K. Bhabha, "'Black Male': The Whitney Museum of American Art," *Artforum International* 33, no. 6 (1995): 110.

31. Cohen, interview.

32. Marie Breen Smyth, *Truth Recovery and Justice after Conflict: Managing Violent Pasts* (New York: Routledge, 2007), 42.

33. Cohen, interview.

34. Roger Southall, 'Introduction: South Africa 2010: From Short-term Success to Long-term Decline?' in *New South African Review 1: 2010: Development or Decline?*, eds. John Daniel et al. (Johannesburg: Wits University Press, 2010), 1.

35. Fikeni, 'Protest, Art and the Aesthetics of Rage.'

36. Jones, *Seeing Differently*, 13.

37. Jones, *Seeing Differently*, 13.

38. Cohen, interview.

39. Jones, *Seeing Differently*, xxvi.

The Impossibility of Curating Live Art

JAY PATHER

The performance by Mamela Nyamza, which marked her status as the 2011 Standard Bank Young Artist for Dance at the National Arts Festival, was curated in a venue featuring a rectangular stage framed by black curtains, black dance mats, raised seating, and lights and sound that were controlled from the back of the massive auditorium.[1] An ideal setting for viewing dance. Or not. Because, at that juncture, Nyamza was not performing dance in the conventional sense, or as the typical stage set-up accommodated. The work – intense and impeccably crafted – was gestural and minimal in its physicality. Entitled *Amafongkong* (an isiXhosa slang word for fake merchandise imported from China), the performance occupied that provocative space between radical dance work and live art collaboration (with the Adugna Dance Company, a company of mixed-ability performers from Ethiopia). Through acerbic satire, *Amafongkong* evoked a continent under constant siege by a voracious global economy, critiquing the persistence of poverty, unemployment and economic crisis in the guise of development through global investment. Devoid of the kind of narcissistic technical virtuosity that characterises much conventional dance, this razor-sharp work required a critical, contemplative audience. The audience needed to sit considerably closer than is generally required for dance performances and made possible by the auditorium space.

As a result of this blind spot in communication and assumptions made in the curation of the work, chaos ensued in the lead-up to its premiere. In a matter of hours, the audience seating, technical control and stage management all had to be moved and recalibrated. The audience was now to be placed on stage and the very large raised seating area was covered in black plastic, resembling a morgue,

and not without due significance: the work did put an end to expectations of an award-winning dancer and choreographer. When some audience members walked out – a predictable response to a work that disrupted several notions of dance – they could no longer slip away quietly. In this new intimate configuration, they had to cross the stage to reach the exits and then walk 'backstage' where cast members with chopsticks in their hair were eating Chinese takeaways – Nyamza's comment on new imperialisms in Africa.

In that moment, with all its attendant chaos, a radically different approach to performance (and a new challenge for curation) hovered in the stuffy, restless space. Discomfort seemed to help rather than hinder the birth of this complex work. The inclination towards curation as control – insisting that the work take place in the format originally intended – could have ruined the work and closed possibilities for a more ambitious curatorial vision by rendering it clinical, representational and reductive. As it was, the audience bumped along just as the ideas did. It was a gruelling experience for all involved in the production, but it was emblematic of a development in the curation of live art. As boundaries and disciplines become blurred in performance curation in South Africa, its vision, challenges and blind spots imply a project much more expansive than 'to take care of,' as curation has been narrowly defined.[2]

In this chapter, I consider key conceptual issues associated with curation and specifically live art curation in contemporary South Africa. As curator of the Institute for Creative Arts (ICA) Live Art Festival (held thus far in 2012, 2014, 2017 and 2018) and other interdisciplinary events, I use these experiences to explore curation as mediation and as a site for the emergence of ideas that challenge dominant culture, the dangers of transferring the curation of objects to the curation of liveness, the lure and limits of curation within thematic frameworks, and the curation of live art in spaces of crisis. Finally, I probe possibilities for a new vocabulary for taking care of live art that better reflects and keeps pace with this ever-shifting art form in a society in necessary transition.

CURATION AS MEDIATION

The curator of performance has, until very recently, been understood as an individual, often the producer of a festival, who works within the limitations of

budget, duration and venues to develop a programme of work. Curation, borrowed from the visual arts, implies something much more than this 'programming' role, though sometimes the terms are conflated without attention to the necessary content that curation implies. In South Africa, programming disparate works traditionally involved the use of 'standards' for performance, inherited from colonial frameworks, which determined the intentions for the selection, production and dissemination of works. So, it was possible for a programmer to work uncritically within Eurocentric paradigms and to offer these paradigms as universal. This kind of programming has dominated performance.

By contrast, the act of curation gives spaces for the rationale behind a selection of works to surface, at times deliberately intertwining an overarching narrative that emerges across the curated works with lectures, panel discussions and post-production conversations between audience and artist. This broader discourse is crucial in South Africa as we embark on the vast processes of decolonisation, and where inherited assumptions around what constitutes a 'good standard' have become highly contested. The demystification of programming and the mediation of ideas, inherent in best practices of curation, are powerful tools in this process. Of course, the inherent danger of this, taken up later in this chapter, is that the curator becomes another arbiter of hermetically sealed ideas.

CURATION AND EMERGENCE

The curation of live art in South Africa occurs most routinely within visual art exhibitions. Several contemporary artists, such as Nicholas Hlobo and Dineo Bopape, consider performance integral to their practice. Curators often include performances in the course of these artists' exhibitions, and they serve as both a continuum for, and an extension of, the artists' practice.

The curation solely of performances by a selection of artists is rare, but it has emerged in South Africa with increasing regularity, possessing its own particular dynamic and challenges. In 2007, I curated a series of works by visual artist Ruth Sacks, performance artist Dinkies Sithole, choreographer Dada Masilo and theatre-makers Leila Anderson and Chuma Sopotela in one programme. Titled *Fresh II*, the curatorial intention was to expand the scope of performance by inviting artists from different disciplines to experiment with hybrid forms and take risks in their practice. The

facilitation of a collection of challenging works that blurred disciplinary boundaries, one after another on a single evening, provided a lens through which audiences could experience and contemplate various possibilities for interdisciplinarity, and the emergence of new thoughts and forms to contain these.

In response to art critic David Hickey's declaration that "'the meaning of the show emerges from the show itself. The curator is a more or less inspired art herder,'"[3] Paul O'Neill and Mick Wilson write:

> This figuring of authentic culture as emergent and self-organised – rather than commissioned, prescribed or authored from elsewhere – is precisely one of the most important themes within the curatorial discourse of the last two decades ... One such theme is precisely the trope of emergence and the dialogical negotiation of artworks into public existence through the organic, open-ended co-production and conversation of artists, curators, artist-curators and other players ... The argument we propose is that curatorial discourse has acted as an engine of emergence for a set of contemporary practices, ones that do not simply rehearse the marketing of inconsequential novelty.[4]

O'Neill and Wilson also rightly point out that the notion of 'emergence' does not come from the arts and is also certainly not new. They cite Raymond Williams's construction of "'dominant, residual and emergent" cultural moments' in *Marxism and Literature*, reading 'residual' as comprising 'those cultural elements that derive from a grand tradition and are employed in legitimating contemporary social relations,' while 'emergent cultural innovation comprises new practices that produce new meanings, values and kinds of relationships.'[5]

I (with Catherine Boulle) have noted in the introduction to this book what can rather reductively be understood as the two streams in the development of live art in South Africa: one that was imposed and remained dominant (the importation of ideas and forms from the west); another that categorises live art as integral to this country in its indigenous and marginalised classical African traditions, which also produced new hybrid forms in the colonial encounter over several centuries. As democracy in South Africa has taken root, the notion of the curator as more than a 'herder' – rather an initiator of the emergence of ideas that explicitly challenge dominant colonial discourse – has had a transformative

effect on the practice of curation. This informed a series of workshops and performances for the Jomba! Festival in Durban, under the title *Republic* in 2002 and then *Paradise* in 2004. In both iterations, early-career to mature artists, predominantly black artists, were taken through a series of workshops in a range of disciplines, and produced works in shop windows, alleyways and rooftops in Durban. Similarly, a series of workshops, run in different parts of the country ahead of the Spier Contemporary exhibition in 2007 and 2010, generated work by (amongst many others) Chuma Sopotela, Kemang Wa Lehulere, Mwenya Kabwe, Anthea Moys and Maurice Mbikayi.

In these instances, the curation of sets of performances was linked to initiatives for the emergence of new work. Collaborations across disciplinary boundaries proved particularly generative, evident in the award-winning work, *U nyamo alunampumlo* ('The foot has no nose'), by writer Kabwe, visual artist Wa Lehulere and performance artist Sopotela. In meeting colonialism's highly sophisticated, deeply ingrained and pervasive influence over the arts, what became paramount was curation as a site, not only for the emergence of new ideas, but also for the unravelling of forms and the letting loose of possibilities for new directions.

It became equally important to challenge ideas around the place and commercial value of emerging and time-based art, and resist dominant discourses prevalent in art criticism, art institutions and art education, and apparent in the kind of publics who attended art events in South Africa. In 2012, prompted by an event that I convened two years earlier called *pre-post-per-form*, which included a combination of conference presentations and performances, the idea arose for a festival dedicated entirely to live art, hosted by the Gordon Institute for Performing and Creative Arts (as the ICA was then known). In the early 2000s, live art began to develop from protest marches and move into gallery spaces. This momentum was complemented by writers and theorists of performance, such as Bongani Madondo, Adrienne Sichel and Ashraf Jamal, who began writing about experimental performances more frequently. The idea of curating live art in South Africa as a site for mediation and emergence became more focused and complex.

CURATING LIVENESS (FROM TEMPERATURE TO SMELL)

As has been acknowledged by several writers in the last few years, the concept of curation is not always accurately borrowed from the visual arts where the injunction 'to take care of' sits neatly inside the conceptual ordering of encounters with static objects in a gallery. Taking care of live art may share some of these concerns, as evident in the discussions above, but the curation of performativities asks for further sets of ideas to meet the demands of art-making that is not complete, inanimate, nor static. To take care of a performance is to take care of art-making that unfolds in front of one's eyes.

In the 2017 ICA Live Art Festival, Jelili Atiku performed *Come Let me Clutch Thee*, a performance work that explored the persistence of oil spillage on the African continent, especially in the Niger Delta region, and 'its unprecedented impacts on ecosystem stability, biodiversity and food security.'[6] The work began with a procession that featured Atiku in a white wedding gown and a fellow performer in a white suit and a hard hat, suggesting an oil-rig manager and his bride. The bride's train was affixed to a trail of approximately 50 plastic cans of raw petroleum. Heading for the Iziko South African National Gallery, the pair made for an entertaining spectacle walking up Government Avenue in the colonial Company's Garden. The midsummer heat was oppressive, and the hot tar slowly began to melt the plastic containers. As the procession moved into the Gallery, the Festival project manager and I became aware of a terrible sight under the flowing train of Atiku's gown: many of the bottles had melted and the viscous black fluid was seeping through. A powerful metaphor for the work aside, disaster loomed as the couple strode across the Gallery's pristine floors that the production team had worked so hard to protect. Any interruption of the work at this point (to save the floors) was impossible.

Beyond the practical difficulties that this example provides, it illustrates the less-understood invitation that curating presence extends – an encounter with the unpredictable. Performance is presence. Whether we refer to the presence of (more obviously) a performer, the more hidden technical elements of producing a living work, the management of audience encounters in the space, or the weather, the presence of living and changeable elements defines the form. To invite this unpredictability at its most elemental, especially when the territory is untrammelled, is to invite a walk through fire, illuminating and scalding at the same time. And it is this walk that asks for different sets of philosophical, political and social ideas around the curation of performance.

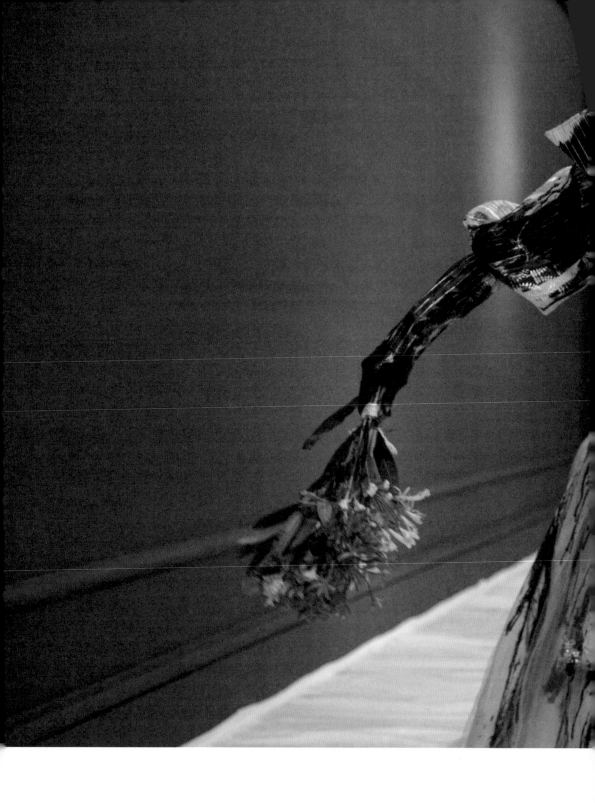

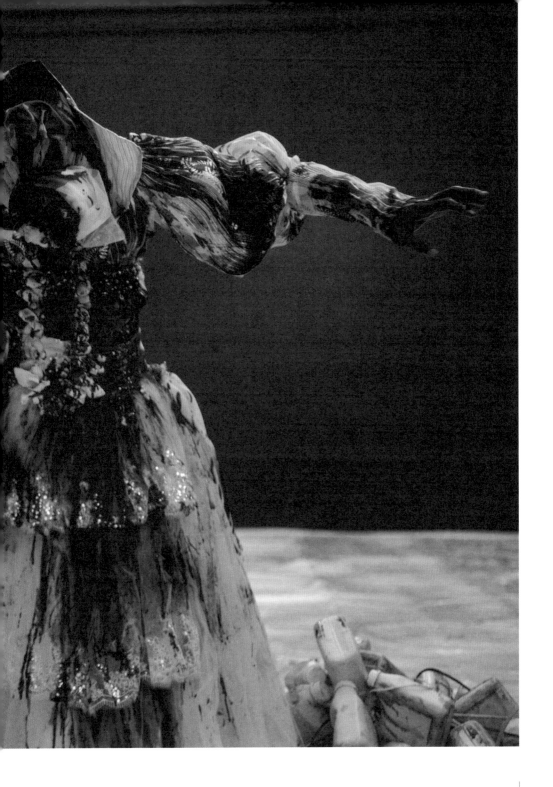

Figure 4.1. Jelili Atiku, *Come Let me Clutch Thee*, 2017.
Courtesy Institute for Creative Arts.
Photograph by Ashley Walters.

In 2014, I curated a series of four works around the theme *The Body and Mortality* in several rooms in the Cape Town City Hall. Chuma Sopotela's *Inkukhu Ibeke Iqanda* ('The chicken has laid its eggs'), an intense, brooding work, was made all the more intense by the unplanned and overwhelming smell of the fresh cow dung on which Sopotela performed. Several audience members, unable to move on to the rest of the programme, dashed for the doors to get air. No neat curation of performances around a theme, rhythmically timed to provide light and shade, could envisage the specific intensity of that smell.

Not to discount issues of curatorial ordering and the planning that may realise this, the examples of both Atiku and Sopotela's works ask us to look more closely at the dangers of blindly co-opting strategies from the curation of objects. They also point to the need to search for other grammars to describe what the curation of live art may ultimately suggest, achieve and fail to achieve. Shared and transparent sets of ethics and aesthetics between curator and artist also become critical in a context where presenting a work according to a meticulous curatorial plan is sometimes a welcome *impossibility*.

THE QUESTION OF THEME

Bertie Ferdman offers a succinct account of the development of the use of central concepts in art exhibitions:

> With the rise of group exhibitions and biennials in the late eighties, the independent curator became like an art star, whose role began 'to be understood as a constellation of creative activities, akin to artistic praxis.' This transformation of what O'Neill calls the *curator-as-auteur*, exemplifed by Swiss curator Harald Szeemann's concept of 'the modern-day *Großausstellung* ("great exhibition") in which artworks are tied to a central concept and are assembled into new and often surprising interrelationships,' was a signifcant shift in the development of curatorial models that continues to this day.[7]

The question of a theme for a programme of live art follows this development. It can also offer a way in to innovative practice, an axis to orientate oneself and navigate some extraordinarily dense and obscure work. However, while a theme

may indeed be the mainstay of mainstream curation, often signalled by the title and *raison d'être* of an exhibition, its role is much more contested in live art where the imposition of central or overarching concepts can have the effect of diminishing works that rely on risk, immediacy and the live moment. Live art emerges from the fringes of disciplines such as the visual and performing arts, social sciences and electronic media, and inhabits a suspended territory of no (wo)man's land. Untrammelled and unconfigured, each individual work in a larger programme is likely to unfold according to its own laws, topography, dynamics and logics, although there may well be resonances across works.

For the 2014 Live Art Festival, although works were not accepted according to a pre-announced theme, as works were juxtaposed and grouped with others, six themes emerged organically: *Republic (or Nation, Authority, Nationalisms)*, *Body and Mortality*, *The Periphery as Threshold*, *Framed (and Framing)*, *The Abject Object* and *Femininities*. This plural version of *Femininities* signalled a wide, discursive scope of approaches and provocations. Two contrasting performances under this theme that worked with tradition and modernity were *The Ancestral Omega* by Weaam Williams and *Caught* by Nomcebisi Moyikwa. Through the use of the Medora, a traditional headdress rich with meanings inherited over centuries, Williams's work explored the feminine narrative of the Cape Malay people 'brought to South African soil by Dutch colonials.'[8] Moyikwa's dancers performed a fresh, contemporary dance language under a suspended light bulb, in high heels and short skirts. Bodies fell and recovered, 'shedding the old silhouettes and vigorously reaching for and revealing new forms.'[9]

Caught was followed by *Walk: South Africa* by Sara Matchett and Genna Gardini, a work created in response to Indian performance artist Maya Krishna Rao's *The Walk*, which was itself a response to the violent attack on Jyoti Pandey who was repeatedly raped in Delhi in 2012. *Walk: South Africa* was a parallel response to the gang rape and murder of Anene Booysen in 2013. The actions of outrage by citizens in India, in the form of marches and protests, were felt on a much larger scale than in South Africa, and the performance of *Walk: South Africa* in the Cape Town City Hall grimly evoked how inured the South African public has become to the systemic violence against women that has pervaded this country. Finally, *Can't I just decide to fly?* by Nigerian-American artist Wura-Natasha Ogunji, a public endurance performance in which a group of masked women hauled water

kegs through the streets of Cape Town, explored 'the relationship between physical labour, beauty and social change.'[10]

The *Femininities* theme had merit in that each work under its rubric extended a conversation begun by another. And yet, I am increasingly wary of borrowing from the language of the curation of objects in which diverse works are meant to 'talk to each other.' While the intention behind the juxtaposition of objects inside a gallery is to enrich the overall experience, the enduring and central premise of live art is to break away from a convention that promotes predictability, repetition and easy, reductive associations. This break from the well-rehearsed regimes of experiencing art renders the work unstable and rudderless – a matrix on which live art thrives. The degree of unpredictability and the ability of the artist to deliver moments of unique encounter are often the barometer, somewhat problematically, of the success of a work of live art. Pitfalls aside, and while the idea of a completely unique action is absurd in our oversaturated contemporary times, that moment in the relationship between artist, space and audience is full of potential for unexpected sensations and meanings to emerge. Within this scenario, the idea of creating a series of thematic frames to hold the work, as curation implies, becomes increasingly leaden and inappropriate.

The relationship between levels of unpredictability, fluidity and transformation is particularly resonant in societies in crisis. The persistent lack of economic transformation amidst other critical areas of redress around issues of race, class and gender in South Africa has, at the time of writing this chapter, spurred new levels of violent mistrust of singular perspectives and promises. This turbulence makes particular demands of artists. It is no wonder that much South African theatre and dance, in their conventional modes, struggles to remain relevant. Live artists take on the challenge to respond to the crises of our time in multivalent, collaborative, consultative forms that invite instability into their work. In resisting commodification, many artists show an uncompromising and direct relationship with the contexts that have generated their work.

In the lead-up to the 2017 Live Art Festival, we decided to abandon the overt articulation of themes altogether. Academic presentations by Panashe Chigumadzi and Nomusa Makhubu, as well as panel discussions, were intertwined with performances in the Festival programme. Punctuated by these pivotal spaces for discourse, sometimes with the artists themselves, the performances took on a

range of meanings and connections with each other. It was a space for self-reflexive discussion too. Gavin Krastin's work *Pig Headed* prompted a heated discussion on race and the representation of a black government by a white artist. Mamela Nyamza initiated a discussion around the institution as a fortress (citing the hosts of the discussion, the University of Cape Town, as an example) that appropriates artists' discourse without engaging with the artists themselves. Viewing the performances with questions such as these in the air was extremely valuable. The immediacy of live art found its place through a plethora of images, performative experiences, audience immersion and many blistering conversations.

The calls on the curator to navigate this complex space and take care of the work and its audiences are challenging and even sometimes unattainable. This essential lawlessness and volatility in the creation of new forms resonates deeply with the project of decolonisation in that there is an awareness that the performances are at times being viewed and curated using inherited models that are not just ideologically bereft, but that do not fit the work. The curation of anarchy or crisis is a contradiction in terms, riddled with notions of commodification, appropriation and gentrification. In global contexts, such curation flirts with re-enactments of regimens of touring and exhibiting black bodies derived from a not-so-distant past. Taking care of bodies becomes imbricated with a sickly liberalism. The inequitable representation of race and gender in directorships of art institutions only exacerbates these tensions.

Perhaps the term 'curation,' or the act of curation itself, has run its course. The need for care in spaces of vulnerability and fragility, hallmarks of liveness in the wake of attempts at invisibilising disruptive presence, is plain to see. However, in such spaces, the curation of live art prompts, at the least, the writing of new grammars.

CURATION AND CRISIS

The art world has often displayed curious responses to crisis. Regarding crisis both as an attack on commercial interests and art markets, and as an attractive selling point, the machinery of galleries and museums then proceeds to invite, package, label and sell it. Artists sometimes find their representations of crisis in large-scale exhibitions that swallow the work; this is part of the machinery of

acquiring, displaying and selling what is of the moment. Even smaller galleries and organisations that adopt a more conceptual, philosophical approach may not have strategies for curation that are malleable and responsive to complex contexts of live performance, borrowed as they are from the curation of objects inside of a stable white cube.

The following example, which I have cited before, bears retelling.[11] The Tokolos Stencils collective, a loose collective of activists and artists based in Cape Town, appeared in a group show entitled *Plakkers* ('stickers' or 'squatters' in Afrikaans) at the Brundyn+ gallery.[12] For the show, they installed a portable toilet, taken from an informal settlement, and left the lid open before departing the venue. In front of the installation was a single line: 'There are none as invisible as those who wish merely to be seen.' The gallery had the portaloo immediately removed because of the offending smell and, in response, the collective spray-painted slogans on the front of the gallery such as 'Bourgeois Gallery' and 'Dehumanisation Zone.' The inability of the curatorial enterprise to hold this kind of disruption exposes a tension between curation and crisis.

In 2016, an exhibition of photographs related to the Rhodes Must Fall movement, curated by Wandile Kasibe for the Centre for African Studies Gallery, was disrupted and shut down at its opening by students from the Trans Collective, a group that prioritises the concerns and representation of transgender, gender non-conforming and intersex students at the University of Cape Town. The Collective protested against the lack of representation of transgender students in the exhibition and in the movement. The disruption of an exhibition, the subject of which was disruption itself, and the emergence of an uncontainable, uncuratable matrix of crisis, surfaces as a new point of departure to consider. Disruption emerges as a particular performative form and, increasingly, as an extension of the kind of language that is missing from sanctified curatorial spaces. Ignoring this, political proclivities aside, would be futile.

STARTING POINTS TOWARDS A NEW GRAMMAR

Edward Said's words provided a point of departure for the 2014 Live Art Festival's theme of *Republic:* 'There is nothing mysterious or natural about authority. It is formed, irradiated, disseminated; it is instrumental, it is persuasive; it has status, it

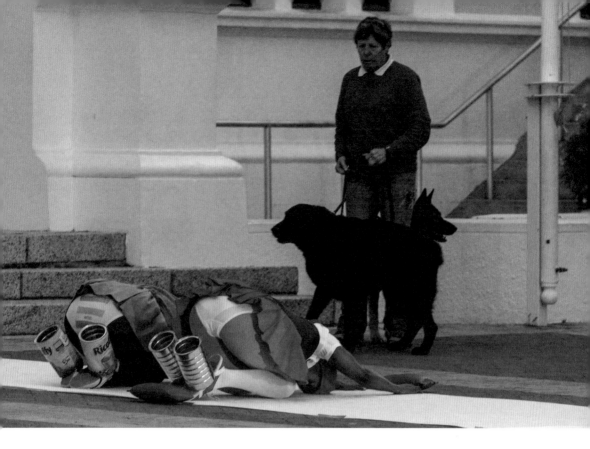

Figure 4.2. Mamela Nyamza, *19 Born 76 Rebels*, 2014.
Courtesy Institute for Creative Arts.
Photograph by Ashley Walters.

establishes canons of taste and value; it is virtually indistinguishable from certain ideas it dignifies as true, and from traditions, perceptions and judgments it forms, transmits and reproduces.'[13]

Included in this theme was Eduardo Cachucho's work *Flatland*, which emerged from research into an experiment carried out by academic, journalist and apartheid-era prime minister of South Africa Hendrik Verwoerd in the 1930s, entitled *A Method for the Experimental Production of Emotions*. Mamela Nyamza's *19 Born 76 Rebels* reminded viewers of the agency invested in simple gestures of

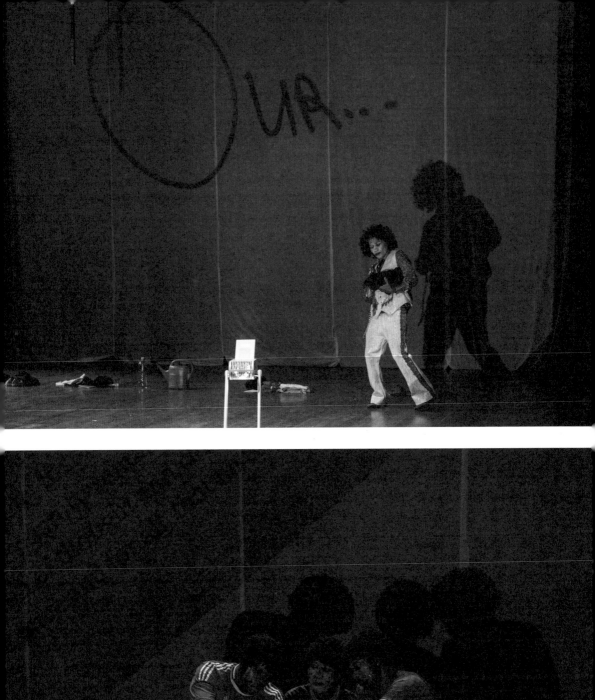
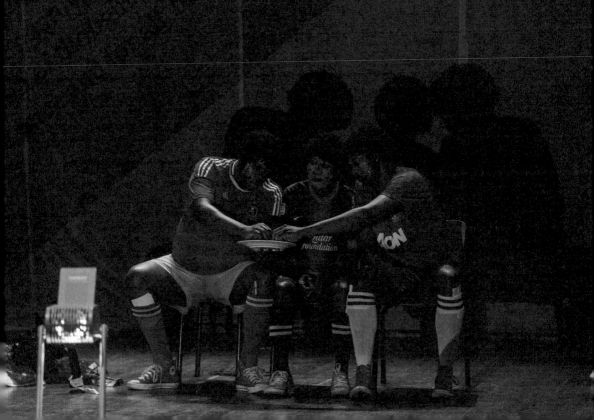

authority. Replete with live dogs that interrupted the slow-moving and elegant work, *19 Born 76 Rebels* ventured into now (in 2018) familiar spaces of disruption.

Boyzie Cekwana's *In case of fire, run for the elevator* collapsed form and reduced its performers to purveyors of inane acts of cheap entertainment. Cekwana described the work as 'a story of food and its intricate, uneven and invisible poetics ... a tawdry essay on the disquiet of an angry stomach grumbling at the deafening din of culinary correctness.'[14]

Cekwana's work was indicative of the despondency and impotence out of which movements such as Rhodes Must Fall would later erupt. While *Republic* may thus be generously described as pre-emptive of the Fallist movements, the curation of the Festival three years later would require a markedly different approach. As noted above, the imposition of themes for Live Art 2017 appeared impossible. Forms of engagement with both artist and audience existed in a significantly more contested space than had been the case in 2012 and 2014. A clear demonstration of this was the work presented at the 2017 Festival by iQhiya, a collective of black women artists, whose members decided not to perform at all, and instead engaged in an interactive conversation about representation, institutions and collectives.

The momentum of these shifts is expansive, the overflow unpredictable. Live artists seem to be asking to be left alone, or at the least not to be curated in conventional frames and according to the old strictures. The best way 'to take care of' may then be to let loose the inclination for control and frames of reference, and instead expand the platform that brings a work of live art into being, creating an open-ended programme as well as a fluid conceptual space. As suggested at the outset, there is also a necessity to find mechanisms to diversify the language and vision of curation. In lieu of, but hopefully moving towards, such a vision, I offer five elements (terminologies, spatialities, rhythm, opacity and audience) as starting points in the creation of new grammars for curation.

Figure 4.3. and 4.4. Boyzie Cekwana, *In case of fire, run for the elevator,* 2014.
Courtesy Institute for Creative Arts.
Photograph by Ashley Walters.

TERMINOLOGIES

In the 2017 Live Art Festival, Albert Khoza worked with African rituals of cleansing as he confronted modernity, crisis and excesses of pain and dislocation. In its use of form, his work *Take in Take out (to live is to be sick to die is to live)* reminded viewers that what we call 'live art' has existed on the African continent for centuries. Moreover, the encounter with modernity, as expressed through the use of text in English and video projections, provided several instances for self-reflexivity. Khoza moved seamlessly from the ritualistic burning of *impepho* (incense used in ancestral ceremonies and rituals) to answering a red telephone, through which he communicated with his ancestors. Sporadic snatches of this interplay between ancient ritualistic practices and the modern appear with great detail and nuance in contemporary performance, prompting the question: how does the curation of live art on this continent, and specifically in South Africa, transcend the boundaries and expectations established by the terminology of contemporary western practice? Although ancient ritualistic practice is prevalent in the work of many contemporary African artists, Khoza's 2017 work signalled an urgent need for the interrogation of ill-fitting terminology imposed on works that have meaning beyond their temporal and conceptual contexts.

SPATIALITIES

In the 2014 Live Art Festival, a collection of works curated under the theme *Periphery as Threshold* worked with space as a curatorial tool and with the notion of the outsider as part of South Africa's developing democracy. Cameroonian performance artist Christian Etongo explored illegal immigration in his work *Quartier Sud* which was curated outdoors. Gavin Krastin's *Rough Musick*, which positioned the ashen queer artist of European descent as primitive and ethnically other, started in a small, closed space and ended in the Company's Garden. Brian Lobel and Season Butler's *Cabaret Crawl*, 'a progressive night of drinking, levity, dancing and art' in the queer clubs and bars of Cape Town, was a raucous and ironic search for performativity outside of mainstream theatrical spaces.[15] These works explored how, when layers of dominant culture are peeled away, shifted and repositioned, so are others revealed and reinscribed. The periphery and the centre may not be far from one another, replacing each other in turbulent exchanges.

Athi-Patra Ruga's iteration of *The Future White Woman of Azania* at the 2012 Festival took place in a storefront bathed in neon light. Dean Hutton's work at Live Art 2017, which was meant to be performed in a public square, had to be hastily reprogrammed due to violent death threats levelled against Hutton for their work *#fuckwhitepeople*. The solution we devised was for Hutton to perform remotely to a live camera that fed the projection of the work onto a colonial statue at the assigned outdoor public square. Discourse on whiteness and privilege, transmitted across disparate physical spaces, was a particular triumph for a malleable form that will not bow to challenging, even violent, contexts.

Live art works bend space, whether disowning the white cube, confounding the proscenium arch or spilling out onto a street or into cyberspace. The curation of space involves extending the question of whether the space serves as a malleable enough canvas for the questions the artist poses. This provides immense possibilities for encounters with a range of publics.

RHYTHM

At the 2017 Spielart Festival in Munich, I chaired a panel of artists in the series *Crossing Oceans* that considered the notion of universality. The fallacy of notions of universal rhythm in live art was a dominant theme. Rhythm, technically the intervals between an accent or a non-accent, essentially derived from the patterns of a heartbeat, determines flow and disruption, engagement and disengagement in the experience of a performance. In an insular world, it may be easy to isolate a regular rhythm; the grand narrative perpetuated by colonial forms is premised on the idea that there is only one rhythm or flow. Rhythm is as crucial to curation as it is to performance – listening to the heartbeat within and between works. Unpredictability, a hallmark of post-structuralism, can quickly become normalised and contained inside of an insular community as society adapts. Likewise, the experimental can become mainstream, perpetuating the myth of a universal rhythm, even in experimental work. The opportunity to experience a range of contexts engenders a probing of the unpredictable rhythms that derive from varied worldviews. Questions central to curation that the *Crossing Oceans* panel grappled with included: How can rhythm, imbibed through a pervasive colonial heritage, be shaken off in postcolonial contexts? In the process of embracing the decolonial project, how speculative, patient and courageous must we be in considering new rhythms in curation?

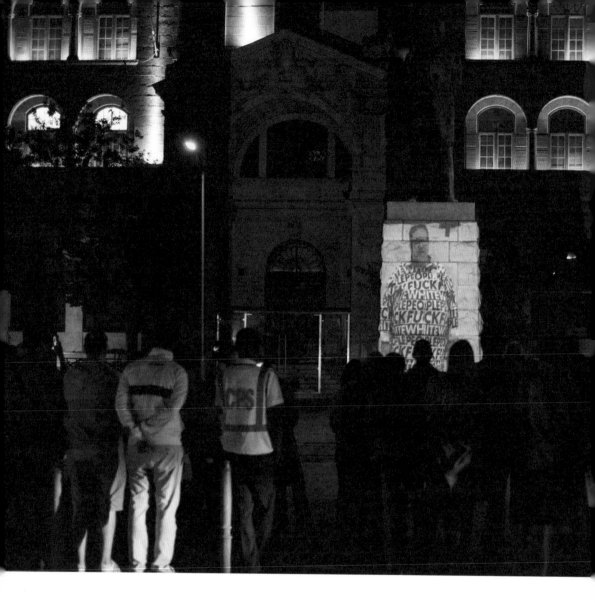

OPACITY

Universality in cultural, artistic and linguistic formations was a mechanism for allowing the economic machinations and pillaging of the colonial project to work under the guise of standards of civilised cultural formation. This took the form not just of language but of every aspect of human endeavour – from law to culture to desire and sexuality, from matters of etiquette, vocal tone and beauty to how one conceived of space and the subjectivities of time, as colonial calendars and topography were all refracted through a colonial lens.

Figure 4.5. Dean Hutton, *#fuckwhitepeople*, 2017.
Courtesy Institute for Creative Arts.
Photograph by Ashley Walters.

The notion of universality in a post-structural, postcolonial world has been variously challenged over decades, and an acknowledgement of opacity, which asks for the specificity of context, helps us to invite the challenges that live art often presents. But there is, at the same time, increased technology that shrinks spaces via travel, the accelerated movement of humans and rapid development of hybrid communities all over the world – and so again the idea of universality resurges. This tension between local contexts and the appropriation and co-option of these in global contexts provides rich possibility for encountering new worldviews.

Curation enables a bespoke relationship between artist and audience. In South Africa, the possibility for stubborn opacity to inspire active forms of watching exists as a prompt for new ways of looking and stretching what that bespoke relationship may include and exclude.

AUDIENCE

The four Live Art Festivals hosted by the ICA have each included panel discussions, talks and audience engagement. This has helped cross the performer/ viewer divide and has encouraged a more collaborative pursuit of the sometimes-elusive semiotics of live art. Artists have also offered audiences a wide range of engagements – from the ritualistic prayer in Hasan and Husain Essop's *Gadat*, to the live streaming of Foofwa d'Imobilité's *Dancewalk* from Central Cape Town to Gugulethu, to the performative discussion of iQhiya's *Performing Visibility*.

In exploring new grammars for curation in the contexts sketched above, it would seem that the responsibility for navigating meaning and unpredictability needs to be shared by both curator and audience. To share this responsibility is to position the audience in a different power dynamic with the artist, the work, the curator and the institution in which the work is hosted. As active purveyors of meaning and experience, the audience helps to generate the freedom for new ideas and sensations to take root. There is, then, the possibility for a grammar to emerge that can articulate this exchange in new forms of curation, and in the curator's relationship with the audience.

CONCLUSION: DEATH OF THE CURATOR

The five elements identified above are posited as starting points for considering contemporary moments of crisis and curation, and for embracing curation as more than the execution of preordained plans and designs. These elements are also posited in an effort to acknowledge, in times of turbulence, an invitation to the unknown, characterised by the paradoxical task of curating anarchy.

In considering the development of live art in the contexts I have outlined – in other words, from the development of singular works in art exhibitions to collections of work and entire festivals – the role of curation has become increasingly prominent. Yet, in embracing disruption and crisis, it would seem that

curation should, in fact, be *less* visible because it is the works themselves and the relationships with audiences that should take precedence. More than just moving works out of galleries and theatres and into public spaces to increase access to work and disrupt conceptual strictures, the visibility and autonomy of the artwork *as an artwork* needs greater interrogation in spaces of crisis. This emerges more and more as artists engage with transgressive actions, intent on blurring artistic boundaries in an effort to communicate with a wider range of people than attends the average gallery.

Although there will always be a space for the vision and guidance of a curator in creating platforms for live art, ego-driven curation, which threatens to stifle and contain, must dissolve. It follows, I believe, that the curation of live art requires another vocabulary – one that breaks away from the commercial strategies and interests of (some) object-centred work – in order to understand its own imperatives and goals. In the interim, conceptualising curation as the creation, simply, of a platform has been helpful in my own practice; a platform that facilitates work without forcing connections and interpretations.

Finally, I would like to extend the idea of the increasing invisibility of the curator in the name of taking care of live art. In starker terms – for the curator to die in the process as a way to conceive of curation in times of crisis. To cease to live (and interfere) in the creation of presence, to disappear completely, may be the most productive strategy; a curatorial approach that refines and redefines the edges of involvement and disengagement, seeking out the delicate balance between these two positions in order to give life to new works that are probing and provocative while remaining speculative and unknowable.

1. 'Mamela Nyamza is 2018's Featured Artist,' National Arts Festival News, 8 January 2018, accessed 10 January 2018, https://www.nationalartsfestival.co.za/news/mamela-nyamza-2018-featured-artist/.
2. The etymology of 'curation' is the Latin *curare*, meaning 'to take care.'
3. David Hickey quoted in Paul O'Neill and Mick Wilson, 'Curatorial Discourse and the Contested Trope of Emergence,' *ICA Bulletin*, 4 December 2008, accessed 10 January 2018, https://www.ica.art/bulletin/emergence.

4. O'Neill and Wilson, 'Curatorial Discourse and the Contested Trope of Emergence.'

5. O'Neill and Wilson, 'Curatorial Discourse and the Contested Trope of Emergence.'

6. ICA, *Live Art Festival 2017 Programme* (Cape Town: ICA Live Art Festival, February 2017), 28.

7. Bertie Ferdman, 'From Content to Context: The Emergence of the Performance Curator,' *Theater Journal* 44, no. 2 (2014): 8, accessed 15 January 2018, doi: 10.1215/01610775-2409482.

8. GIPCA, *Live Art Festival 2014 Programme* (Cape Town: GIPCA Live Art Festival, August–September 2014), 11.

9. GIPCA, *Live Art Festival 2014 Programme*, 19.

10. GIPCA, *Live Art Festival 2014 Programme*, 17.

11. See Jay Pather, 'Negotiating the Postcolonial Black Body as a Site of Paradox,' *Theater Journal* 47, no. 1 (2017): 156–157, doi: 10.1215/01610775-3710477.

12. *Tokoloshe* is an isiZulu word that translates as 'a mischievous and lascivious water sprite that causes trouble.'

13. Edward W. Said, *Orientalism* (London: Routledge, 1978), 27.

14. GIPCA, *Live Art Festival 2014 Programme*, 26.

15. GIPCA, *Live Art Festival 2014 Programme*, 13.

Loss, Language and Embodiment

Corporeal HerStories: Navigating Meaning in Chuma Sopotela's *Inkukhu Ibeke Iqanda* through the Artist's Words

LIEKETSO DEE MOHOTO-WA THALUKI

South Africa has a vibrant and thought-provoking performance art scene. In this smorgasbord, the work of Chuma Sopotela has struck me as the most interesting. Sopotela is a young black South African woman artist who has been working in the industry in Cape Town for over 15 years and has also travelled internationally. Whether it is that her work stems from a fixation with the physical body or that her physical body reflects and comments on bodies *like mine*, which I refer to as 'black woman bodies,' I am not certain. Sopotela, an artist trained principally as a performer who then segued into performance art, has an ability to use multiple modalities and media in interesting ways. As a black woman, her body both unintentionally and in more pointedly performative ways insists on deconstructing, destabilising and deliberately bringing into question spectators' ideas of what black woman bodies do and signify.

I have had several interviews with Sopotela, telephonically, via e-mail, and in person, primarily between 2014 and 2016, in which we discussed her work and the work of other artists. In our 2015 e-mail correspondence, Sopotela indicated that: 'What interests me is the gaze that history has given us. Historical books are not written by us, the black female bodies, but by many white bodies ... This gaze was then transferred from generation to generation ... Our own gaze as Africans shifted from that of Historical Black Africans to that of the slave traders/oppressor.'[1]

This expression of her interest in how history positions narratives about bodies, particularly black female bodies, resonates strongly with me, as do the corporeal aspects of her works. This chapter is an excavation of *Inkukhu Ibeke Iqanda* ('The chicken has laid its eggs'), a work Sopotela first performed in Zurich in 2013, and in South Africa in 2014. In conversation with Sopotela and other theorists, I tease out the potentialities and implications of embodiment, social situatedness and what I see as her articulation of a black feminist performance language. I use these categories in an attempt to position Sopotela's layered and complex practice in the live art field in a context-specific way. I seek to concentrate on 'the social and contextual nature of knowledge ... [making] the embedding situation prominent in the process of cognition' which can be understood to be an expression of 'situated knowledge.'[2] I propose that Sopotela's foregrounding of her lived experience as a black woman in contemporary South Africa, the context and situatedness of her work, is what positions her practice so lucidly and with such boldness within the live art space. In conversation with Sopotela, I seek to probe the artist's use of multimedia, personal experiences, and political and historical references.

INROADS

Sopotela's work is of unique significance to me as a performance-maker and writer in that I have often felt in my spectatorship of her performances that I am the person about whom she is choosing to speak. All at once, her work serves to implicate me as a black woman while simultaneously explicating my positionality as spectator. *Inkukhu Ibeke Iqanda* is a particularly complex work, which the artist describes as an exploration of:

> abortion actually ... I remember sitting in a taxi and this taxi driver and this old woman are talking about young girls in the township ... and how they ... look like chickens and they look like they have tyres around their waist. And I was listening to young girls and how they say that ... their partners would prefer them not to be like *umleqwa*, which is a chicken that runs around, but they prefer them to be like [a] Nandos chicken which is that chicken that is wide open and is beaten by that hammer, so they must have that body – they must be wide open. So I started Googling the association of chicken and the

black female body and I actually quite frankly looked at the chicken and ... the black female body because that's what I was looking at in the township [where] black women [predominantly live]. But I was mainly looking at the female body ... Now if you take a chicken and you hold it on its wings, obviously the intestines fall towards the bottom, and ... the bottom of their stomach becomes a bit more round.[3]

In the making of her work, Sopotela enters into what I refer to as 'situated' research. In the case of *Inkukhu*, she collected a number of objects – chickens made in mediums such as rubber and wood, or composed of images – that served as stimuli for the images with which she began working. It was from her observation of these images and how they related to the stories she wanted to tell that she began to create the work. In other words, Sopotela began from her view of the world of the work and its relationship to her reality. This is an expression of situated knowledge and is also a clear way to use her social-political-economic-psychological-geographical standpoint to build theoretical work. In this case, the observation of the chicken became a way to think about a woman's body. The initiating factors of the work stem from this understanding of knowledge as situated in context, and this situatedness reflects the perspective from which she views the subject matter. As such, her methodology seems to subscribe to the notion that 'experiences, social practices, social values and the ways in which perception and knowledge production are socially organized [can be] seen as mediating and facilitating the transition and transformation of situatedness into knowledge.'[4] In her methods of contextual observation and in deriving the work's impulse from her own situatedness, Sopotela begins an excavation of her social context and its meanings and implications. She begins from an understanding of the subject matter as a reflection of her own social situatedness and of the situatedness of the 'young girls in the township' who initiate her research.

While situatedness in and of itself is not necessarily a unique aspect of theatre- or performance-making as a preoccupation, it is the fact that Sopotela is a black woman maker that I find most interesting. It is not often that I have watched a work that shows specific and uncurated 'black womanhood,' presented in all its complexities and contradictions, in ways that ring true for me as a black woman spectator. It is this aspect of Sopotela's work that I find, most strikingly,

a moving and useful expression of the contemporary phrase 'black girl magic' – it opens up a space for her to speak outside of the many intersections which oppress her, while simultaneously not ignoring the crushing burden of their constant presence. It is the precise situated knowledges of being a black woman in a world and industry designed to reject this – what bell hooks calls 'imperialist white supremacist capitalist patriarchy'[5] – that make Sopotela's work both confounding and exciting.

Sopotela makes active use of her 'angle of repose' in order to position her work in the world in which the inquiry is initiated.[6] My use of 'angle of repose' is derived from Laurel Richardson's fitting insistence that the value of a point of view in a postmodernist world lies in its specificity – what she calls 'crystallization,' referring to the phenomenon of viewing multiple facets of a single situation or phenomenon in detail.[7] As such, I suggest that Sopotela's positioning of her work within specified situatedness allows for a healthy suspicion of supposedly universal truth claims, which, Richardson notes, can work to mask or serve 'particular interests in local, cultural, and political struggles.'[8]

This situatedness is what Donna Haraway refers to as feminist objectivity.[9] Sopotela falls within the frameworks of feminist discursive traditions that contend, as Haraway puts it, that: 'Feminist objectivity is about limited location and situated knowledge, not about transcendence and splitting of subject and object. In this way we might become answerable for what we learn how to see.'[10] Feminist discursive traditions thus create a framework for contextually valid and reliable research. My view of the work as engaged in this kind of situatedness is what gives rise to the feeling that Sopotela implicates me as a black woman spectator in the stories that she tells through her body. In the instance of *Inkukhu*, this had the effect of breaking open the seal of my own situatedness in my body so that even as I – in the moment of the performance – relate to Sopotela and her struggles, I am opened up to an excavation of my positionalities, my subjectivities and ways of seeing how history and the immediate moment of performance are related.

When Sopotela takes her situated perceptions into the realm of the imagination and begins to make work, this is the point at which she uses her own imaginative skills and tools in order to comment on social issues and how they affect her. Herein lies the powerful aspect of the performance-making process, which allows her to make commentary and to use other imagery. Through these interventions

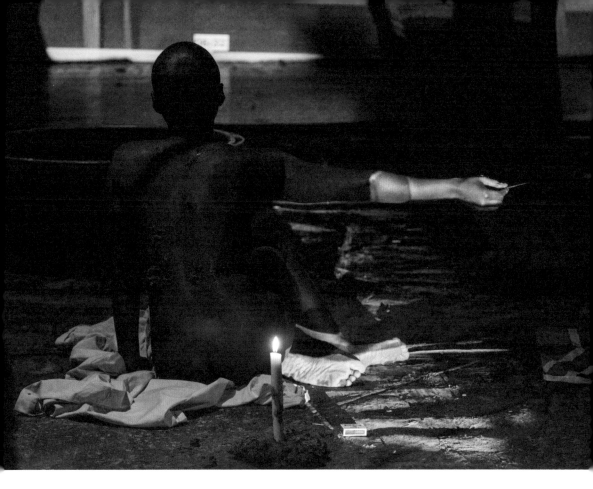

Figure 5.1. Chuma Sopotela, *Inkukhu Ibeke Iqanda*, 2014.
Courtesy Institute for Creative Arts.
Photograph by Ashley Walters.

she can make her work a situated social commentary rather than alleging the objective observation of facts that has been the hegemonic positionality of heteronormative, white supremacist, cisgendered, patriarchal 'angles of repose.'

It is precisely the muscularity of this offering, the shifting between self and society, and the intricacy of her performance language that I find both intriguing and beyond definition. *Inkukhu* is ineffable to me both experientially and in my attempts to analyse it. There is something of the strange-yet-familiar, or the familiar-made-strange, in her use of strong, visually bold red in the room, the bareness of the dance style and box-like theatre in the Victoria Girls' High School



in Grahamstown where I saw the work. On walking in, one is struck by the smell of *impepho* (incense used in ancestral ceremonies and rituals) and cow dung. A candle is lit in a cowpat on the stage. And a massive wig of braids formed into a kind of chandelier hovers above Sopotela, as if to swallow her and, at other times, as if to protect her.

CONVERGENCE WITH HISTORY

Sopotela refers to history both as a construct of social identity (as in individual personal histories) and also as a broader framework for holding our notion of time and place (as in history over centuries or the histories of a country). More specifically, she is interested in history inasmuch as it contains stories about, for, or in relation to black women and black woman subjectivities. The gaze of this history, the impression it gives of being a 'view from everywhere,' has consistently shifted away from the story of the historical black person to that of the slave trader/oppressor. She makes reference to the notion of black woman bodies and the subjectivities they evoke by virtue of being present: 'When we look at the black body whether it's in the street or it's in the performance art space or it's in the theatre, we unpack or we analyse it through the gaze of the coloniser who ... took the body and put it in the glass chamber and ... it was scrutinised and degraded ...'[11]

Sopotela seems to consider this function of the historical framing of black bodies and black woman bodies as continuing to act upon the work of black woman theatre- and performance-makers in fundamental ways. The invisibility of the gaze is really a function of the overarching feeling of its being both from everywhere and nowhere. This suggests that only some bodies can tell certain stories in believable ways. For instance, this is the reason one finds many stories of black women as caretakers (nannies, mammies), black women as 'natural' victims of abuse (rape, domestic violence, racism and so on.) and black women as inherently promiscuous or vulgar. This 'assignment of meaning to the appearance'[12] of black woman bodies is what Oyèrónkẹ́ Oyěwùmí refers to when she laments that 'the body is given a logic of its own. It is believed that just by looking at it one can tell a person's beliefs and social position or lack thereof.'[13] Sopotela seeks to undermine this construct of racial knowability by telling the kinds of stories that her own body is not necessarily assigned by colonial logic to tell.

Sopotela also sees the assigning of fixed meaning to the bodies of black makers and performers as a way in which the ability to claim authorship over one's body and its artistic skills and inclinations is undermined. She refers to the situatedness of her body through 'a colonial lens' and critiques the very thing that draws me to her work: that I inflict a complicity and involvement upon myself because my body is *like* her body, and that I come to her work with assumptions about the proximity of our experiences. My subscribing to the idea that her assigned meanings approximate my assigned meanings, by virtue of our being in bodies that suggest similar positionalities in relation to history, in relation to society and in relation to the community of spectatorship of live art in South Africa, is precisely the problem of the gaze with which she is occupied. She laments such self-identification with the work as being part of the same kind of oppressive constructs and reductive ideology by which black woman bodies continue to be scrutinised and degraded:

I'm the author. So I do have the right to do as I please with my writing ... but in my observation... I am received as ... a black woman who is being influenced by the work too, unconsciously. So there's a belief or there's a thinking that I am unconsciously being used by ... [colonial history] ... to do what they did to us.[14]

In *Kafka's Ape*, Phala Ookeditse Phala writes: 'My skin is not necessarily my truth but my biological makeup. We cannot always escape our external realties. We are sealed in our bodies.'[15] It is this contentious lament 'my skin is not necessarily my truth' that makes it important for me to understand how Sopotela views her own work and that underlies why her subjectivity within the work is of great interest to me. Her artistic approach presents an exciting way of working which situates the knowledge that initiates her works not only within herself but also within a counter-history; a view of history from the eyes and perceptions of those whom history traditionally regards as objects of historical movement rather than subjective agents in history-making. I am making a claim for Sopotela as an artist, particularly as a sociological artist, by using her own words and my personal encounters with her work to describe and analyse her artistic practice.

Sopotela positions her situatedness (and her angle of repose) as both the framework that she is trying to deconstruct and also the tool by which she excavates her subjects of study. This is a fundamentally useful paradox as it positions her

body on those stages not only as a signifier but also as a disruption of the idea that her body and its meanings can be signified by visual cues. She disrupts assigned meanings by positioning her body differently from what one might expect while also imbuing the space with the undeniable stamp of her presence.

It is through her own eyes that I want to interpret this work in order to see more clearly what she sees. To do so, I make use of Sopotela's reflections on her work to excavate, with the artist, the possibilities of black woman methodologies in societies and spaces that would have us silently 'sealed in our bodies' and entombed by the overbearing tropes of black woman as victim, object, invisible other.[16] However, she also seeks to free her works of the inclination to pin her body down to the confining categories of 'black' and 'woman.' Nonetheless, this attempt brings assigned meanings (the hegemonic 'logic' of her body) to the theatre commune, giving the spectator collective an opportunity to resist, communally, the stagnating hegemony of the black woman body even as it is the most visually present signifier.

It is through this fierce contestation that Sopotela brings facets and clarities to the connections between situatedness and imagination. The notion of 'situated imagination' is contested by theorists in the field; Marcel Stoetzler and Nira Yuval-Davis look to clarify the concept by suggesting that 'imagination needs to be understood as situated as much as knowledge does.'[17] My impression is that Sopotela seeks to situate and locate her imagination through strategies by which she destabilises the monolithic assigned meanings that threaten to contain her work in the public imagination. In *Inkukhu* these strategies involve: the deliberate attempt to trigger personal memories in the spectator; the use of her body, as representative of meanings assigned to the black woman body, to destabilise these meanings; and the unconventional use of visuals that both confirm and compromise the assigned meanings.

Sopotela uses everyday objects and sensory triggers in her works. I am forced by the smell of *impepho* and her use of the cowpat to make personal connections that are less about the artist herself and more about myself as a spectator. This is also the case with her use of hair extensions in *Inkukhu* – the braided extensions are presented as an installation in the space around which Sopotela performs tasks, such as lighting a candle which is upright in cow dung, moisturising her skin with cow dung, as well as removing the flag of the Republic of South Africa from her vagina.

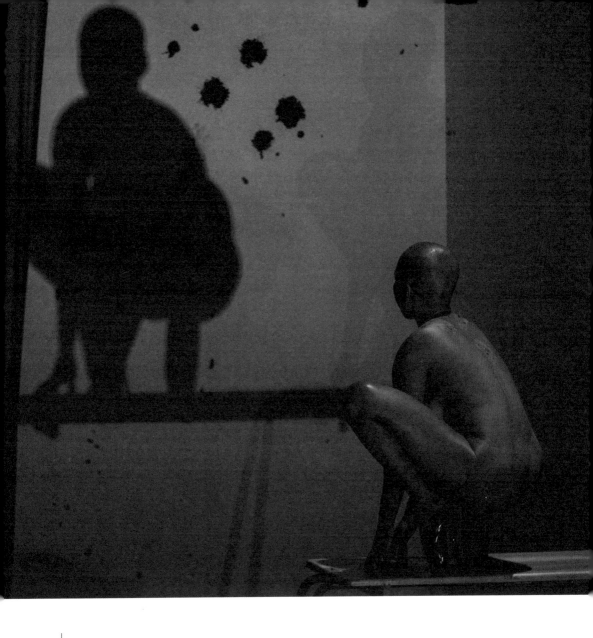

Figure 5.2. Chuma Sopotela, *Inkukhu Ibeke Iqanda*, 2014.
Courtesy Institute for Creative Arts.
Photograph by Ashley Walters.

The hair extensions bring to mind popular urban black womanhood because of the prevalence of the style in which they are braided. Sopotela makes this point clearer in the projection of images, which include a woman with braided hair who forms the backdrop to her performance. In the iteration of the performance that I watched, the hair was a very large installation hung from the ceiling under which and into which she occasionally moved. She used the hair extensions as a marker of space in the work, a kind of chandelier, but also as a marker of an urban black woman subjectivity that travels between the domestic worker, the birther of the nation and herself. At one point she squats, naked, with her back to the audience and seems to confront the hair piece. There is, what seems to me, a confrontation during which the chandelier begins to rise up into the rafters and Sopotela dusts herself off and prepares to wash her body of the dung on her skin. There is something about the precarity of black urban womanhood that she excavates with a kind of clinical calm that contributes to the ineffability of the work.

Sopotela renders complicated relationships between the women in her work: the woman in the domestic worker's overall beckons us into the space after lighting the candle in the cowpat at the beginning of the work, quickly turning into the woman whose vagina holds the flag of the country. The syringe-infested woman on the projection screen behind the artist mirrors the suggestion of the woman in a red evening dress. The woman in the evening dress uses the dung to polish the floor of the stage and, just like that, there is a relational situatedness that is almost bizarre in its ambiguity and obviousness.

Sopotela confirms that the deliberate ways in which she chooses to trigger memories for audience members is a specific strategy to engage the subjectivity of her spectators: 'For me it's about triggering memories ... the smell in the room, the temperature, the captions that that I use ... Because I believe that if you get people to feel that what they are watching has something to do with them that is when you can have a conversation.'[18]

This desire to trigger memories, and her insistence on the work being dialogic, positions Sopotela's methodology and artistic practice as expressions of standpoint theory. This allows for her situatedness to meet my situatedness as a black woman spectator and position what I know in my body as a wellspring of knowledge and imagination. It is with these tools that she unseals the situatedness of spectators in relation to her own, opening up a space in which spectators (even

though privately) can experience themselves as contradictory and non-linear. In her way of casually moving through intersecting identities – moving from pulling the national flag from her vagina, to wearing the clothes of a domestic worker, to giving an audience member cow dung to hold – she demonstrates links between urban black woman subjectivities that are not always apparent to those who do not live them. This allows the possibility of black womanhood to be seen in its nebulous contradictions. She resists the idea that 'we cannot ... escape our external realities' and allows a space in which we can see our fragmentary selves.[19] This creates doubt about the certainty with which I view subjectivity. As Haraway puts it, 'the split and contradictory self is the one who can interrogate positionings [sic] and be accountable, the one who can construct and join rational conversations and fantastic imaginings that change history.'[20]

Sopotela's focus on memories and the triggering of memories hinges, of course, on her own awareness of the contextual situatedness within which she is working. She knows that the use of cow dung, for instance, may trigger memories of a rural past or a rural home from which someone in her situated context may come, and for which they may or may not long. The positioning of the candle in the cowpat evokes not only a sense of rurality, but also a feeling of homeliness, of a connection to land. These triggers bring to my own mind a youthful past in which the integrity of my body was not an issue for debate but was a given, a fact, inasmuch as the blackness and womanness of my body are now, as I sit here, a fact. This use of memory is of particular importance to the work that Sopotela produces because it implicates me as the spectator, and my history, in the world of the work as well as in its contextual intricacies. This reflects the argument that the performance space is useful in destabilising existing tropes about social groups as it is a site 'where the body as subject is present in the performance, both with regard to the performers and audiences.'[21]

Sopotela invokes multiple subjectivities in *Inkukhu*. Upon entering, the audience is confronted by Sopotela in two guises: she is both seated on a bench in a projected video on a screen upstage, and live on the stage kneeling and lighting a candle. Having lit the candle, she disrobes, smears herself with dung and positions the flag inside her vagina as the moving figure on the screen begins to insert needles attached to syringes in her bottom. She later moves to a table downstage where the red dress awaits her, and the self in the video rotates with the self in the red dress.

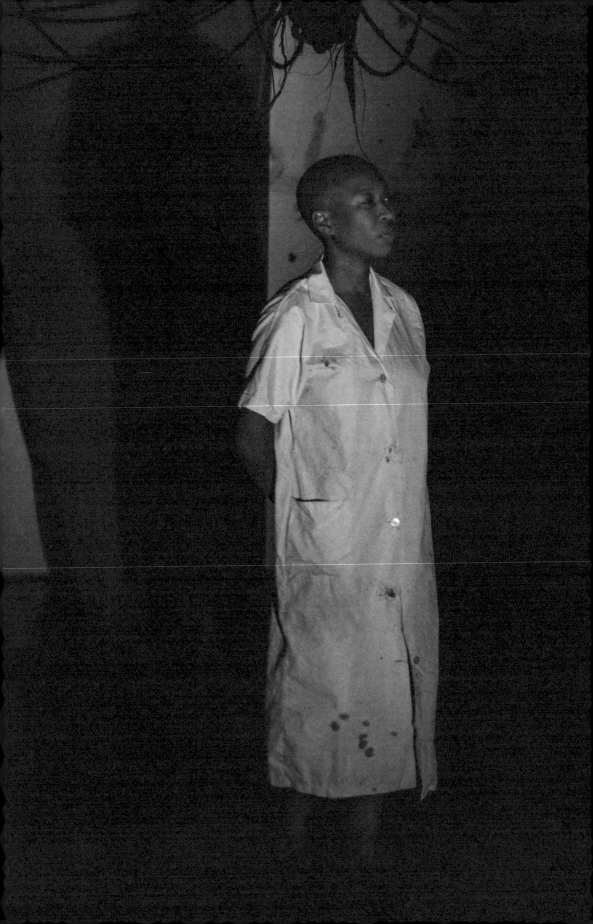

These subjectivities that Sopotela invokes are a function of the ways in which she wants her body to be seen as a shifting, fluid entity. One of the strategies she uses in this regard is the deliberate blurring of her body's assigned meanings and the subjectivities that are most easily assigned to the body on stage. Inasmuch as the work is about abortion, it also becomes a study of how South Africans, particularly what she refers to as black township communities, such as those living in Khayelitsha, deal with the fertility of young women. She positions their bodies as sites of warfare:

> The contraception, especially the one that the young girls use which is depo,[22] it is used to fool the body, to make the body think that it is pregnant while it's not. So now, what this lady was confirming was that, young girls are using contraception much younger than they used to. So let's say that you take a child who is ... eleven years old and you already take them for contraception ... now this twelve-year-old or eleven-year-old body has not fully developed yet, it is still growing it is still taking shape. But if you're gonna ... take it for contraception [the] body is gonna develop in a way that it's gonna think that it's pregnant ... I will say our people because this is a township, this is what I've seen. They ... don't have time to sit down with their kids and talk about sex. So what they do is that, immediately when a child gets their period, they take the child to the clinic to get the depo. So now the body of the child changes ... for me it was about ... how we have taken upon ... using all this western medicine to control, to control these children from having children but we are not looking at the medical [consequences], and then we blame again the girl child for changes in her body.[23]

Figure 5.3. Chuma Sopotela, *Inkukhu Ibeke Iqanda*, 2014.
Courtesy Institute for Creative Arts.
Photograph by Ashley Walters.

I perceive this in *Inkukhu* where Sopotela takes her body through gruelling-to-watch moments. If one takes into account the statistical likeliness of sexual violation in South African townships, and the ways in which the health care system polices young women's access to family planning, abortion and other reproductive health services, one begins to see the connections that Sopotela is threading through her work. This shows itself in her transitioning from woman-in-the-weave, to woman-in-the-overall, to woman-with-the-cow-dung, to woman-in-the-terribly-high-heels, but also through stages of age and growth. Sopotela deals with layers of womanhood and shows us the folds of the layering in such a way that the fact of her black body is not as static as it might be if she simply 'played' a domestic worker or a sex worker in a play. This blurring of the boundaries of character and self is a tool that she wields with great precision and care, perhaps due to her own assertion: 'I do not have to state on stage that I'm black and I'm a woman because that's something obvious. I will state all the other things but that is an obvious fact ... it's a given, it's a fact.'[24]

It is Sopotela's hunch that it is the visual images she presents to the spectator that most powerfully execute the themes she seeks to excavate. Once again, she reveals her rootedness in a feminist sensibility that seeks to confound the limits of 'objectivity' and open up multiple facets of her body's subjectivity. In this way, she speaks directly to Laurel Richardson and Elizabeth Adams St Pierre's notion of 'crystallization' as a form of feministic validity, but also echoes Haraway's suggestion that vision is 'a much maligned sensory system in feministic discourse ... [which] can be good for avoiding binary oppositions.'[25] The reflections in Sopotela's work on the situatedness of experience function to eliminate the danger that Oyěwùmí points to in stating that 'the gaze is an invitation to differentiate.'[26]

SOME CLOSING REMARKS

Sopotela, like Haraway, insists on using the visual to tease out a multiplicity of meanings, while also allowing herself space for commentary. As she puts it: 'I'm not solving but I'm questioning and maybe suggesting different ways of looking.'[27] This intense focus on the visual is very much in line with Haraway's understanding of how sensory tools can be used to make more, perhaps new, meanings. Haraway, like Sopotela 'insist[s] on the embodied nature of all vision and so reclaim[s] the

sensory system that has been used to signify a leap out of the marked body and into a conquering gaze from nowhere'[28] – what Sopotela refers to as 'the gaze of the coloniser.' Haraway goes on:

> This is the gaze that mythically inscribes all the marked bodies, that makes the unmarked category claim the power to see and not be seen, to represent while escaping representation. This gaze signifies the unmarked positions of Man and White, one of the many nasty tones of the word *objectivity* to feminist ears.[29]

Sopotela's use of situatedness as methodology is an interesting aspect of how her work is constructed, and also of how one might construct her work as a spectator. For me, this work is about the infiltration and objectification of bodies. As the war on young black woman bodies still rages in clinics, bars, street corners and taxi ranks throughout South Africa, this is the meaning that the work transmits. Sopotela's methodological framework concerns itself with spectatorship and the societal situations that produce black woman spectators and actors. She deliberately uses the links between them to deflect or undermine the assigned meanings of its performer/creator. All these, and many more I have yet to consider, are aspects of the ways in which Sopotela makes use of sensory triggers to unseal and infiltrate the memory world of the spectator.

In my understanding, this is the power of Sopotela's use of multisensory media – the possibility of triggering what one does not yet have words or tools to excavate. It is precisely in her confounding of the ways in which we expect signs and signifiers to work that Sopotela manages to tease out, and playfully tease, our conceptions of society and how bodies are positioned in it. It is by surprising us with a handful of dung and then leaving it in our hands that we are left to explore the tangle of intersecting issues we had hoped she would disentangle for us – black womanhood in townships, abortion, and ownership over one's body as a black woman.

For me, it is Sopotela's deliberate disregard for the ways in which the spectator may stubbornly hold on to the categories of who fits where, who can be what and who is like whom, that makes her work so singular in its methods and ways of seeing society. It is in her manner of single-mindedly asserting that she is not the dung, not the high heels, not the national flag (though it is buried inside her), not the candle nor the domestic worker's uniform nor the massive chandelier of hair;

she is not the sum of these signifiers and neither is she the absence of them – it is in this probing of unknowability that she manages to both confront and circumvent the gaze.

Sopotela's work responds to and resists the roles that are generally available to a young black woman, particularly in formal theatre productions and spaces. The assigned meanings (the maid/mammy, the Jezebel/victim of circumstance and so on.) by which her body is circumscribed in conventional theatre constitute that which she seeks to speak against, and back to, as she makes her performative artworks. It is this specific, situated and particular way of seeing and describing the folds of black woman subjectivity that lends her work a peculiar and pointed boldness.

Sopotela uses the situatedness of her own position to evoke and provoke intricate and intersectional readings of her work and her body. This works in conjunction with her use of the triggering of memories, both within herself and in the context in which she chooses to make work. This very particular way of seeing herself and her body as an agent that can deconstruct the hegemonic assigned meanings of blackness, womanness, rurality, urbanity and a black township feminism is a useful way to bring to light the intersectional gazes in performance spaces.

Sopotela's work serves to produce more intricate ways of seeing situated bodies who acknowledge their specific contexts both spatially and historically. This allows her to peel away the veneer of 'objective' positivist hegemonic thinking and produce a bold statement of her particular positionality. Her deliberate use and undermining of memory, gaze and the performance space allow her to theorise and make work beyond the confines of hegemony. As she herself says: 'I feel like it is a gateway for me to speak, it is a gateway for me to make a conversation. But it's also in knowing that I cannot be anything else, I cannot make them not see unless I make myself disappear.'[30]

1. Chuma Sopotela, e-mail discussion with the author, February 2016.
2. Rafael E. Núñez, Laurie D. Edwards, and João Filipe Matos, 'Embodied Cognition as Grounding for Situatedness and Context in Mathematics Education,' *Educational Studies in Mathematics* 39, no. 1–3 (1999): 45.
3. Chuma Sopotela, telephonic discussion with the author, 22 March 2017.

4. Marcel Stoetzler and Nira Yuval-Davis, 'Standpoint Theory, Situated Knowledge and the Situated Imagination,' *Feminist Theory* 3, no. 3 (2002): 316, accessed 20 March 2017, doi:10.1177/146470002762492024.

5. bell hooks, *Ain't I a Woman?* (Boston: South End Press, 1981).

6. Laurel Richardson and Elizabeth Adams St. Pierre, 'Writing: A Method of Inquiry,' in *The SAGE Handbook of Qualitative Research*, 5th ed., eds. Norman K. Denzin and Yvonna S. Lincoln (Thousand Oaks: SAGE Publications, 2017), 959–978.

7. Richardson and St. Pierre, 'Writing,' 963.

8. Richardson and St. Pierre, 'Writing,' 961.

9. Donna Jeanne Haraway, *Simians, Cyborgs, and Women: The Reinvention of Nature* (London: Routledge, 1991), 190.

10. Haraway, *Simians, Cyborgs, and Women*, 190.

11. Sopotela, telephonic discussion.

12. Paul C. Taylor, *Race: A Philosophical Introduction* (Cambridge: Polity Press, 2013), 60.

13. Oyèrónké Oyěwùmí, *The Invention of Women: Making an African Sense of Western Gender Discourses* (Minnesota: University of Minnesota Press, 1997), 1.

14. Sopotela, telephonic discussion.

15. Phala Ookeditse Phala, *Kafka's Ape* (unpublished adaptation of Franz Kafka's *A Report to an Academy*, 2015), 1.

16. Phala, *Kafka's Ape*, 1.

17. Stoetzler and Yuval-Davis, 'Standpoint Theory,' 321.

18. Sopotela, telephonic discussion.

19. Phala, *Kafka's Ape*, 1.

20. Haraway, *Simians, Cyborgs, and Women*, 193.

21. Yvette Hutchison, 'Post-Apartheid Repertoires of Memory,' in *South African Performance and Archives of Memory* (Manchester: Manchester University Press, 2013), 172.

22. She refers here to the contraceptive injection commonly sold or prescribed under the name Depo-Provera.

23. Sopotela, telephonic discussion.

24. Sopotela, telephonic discussion.

25. Haraway, *Simians, Cyborgs, and Women*, 188.

26. Oyěwùmí, *The Invention of Women*, 2.

27. Sopotela, telephonic discussion.

28. Haraway, *Simians, Cyborgs, and Women*, 188.

29. Haraway, *Simians, Cyborgs, and Women*, 183–201.

30. Sopotela, telephonic discussion.

'A Different Kind of Inhabitance': Invocation and the Politics of Mourning in Performance Work by Tracey Rose and Donna Kukama

GABRIELLE GOLIATH

The sanctioned disposal of Patrice Lumumba, whose figure constituted for some a Cold War threat to western political and economic interests in the newly independent Congo, involved nothing less than the planned and comprehensive elimination of an offending body. With the tacit support of the United States's Central Intelligence Agency (CIA) and the United Kingdom's Secret Intelligence Service, MI6, Lumumba and his ministerial colleagues, Maurice Mpolo and Joseph Okito, were tortured and summarily executed on 17 January 1961. Four days later, Belgian police commissioner Gerard Soete and his brother Michel dismembered the bodies and dissolved them in sulphuric acid in an effort to eliminate all trace of the corpses.[1] Extending to its limit the semantic operation of assassination, enacted in this systematic dismemberment and erasure was what Adriana Cavarero might describe as a physical as well as ontological violence of attempted human nullification.[2]

Whilst on a residency in Brussels in 2015, artist Tracey Rose enacted a commemorative performance titled *Die Wit Man* ('The White Man'), marking the 55th anniversary of Lumumba's death. Writing about the work, Sean O'Toole reflects, 'How do you mourn a life that was not just snuffed out but purposefully disappeared with corrosive acid?'[3] For Rose, this demanded a form of ritual incantation, a persistent pronouncement of the name 'Patrice Lumumba,' repeated over 600 times by the artist whilst journeying on foot from the WIELS

Centre for Contemporary Art to the Church of Our Lady of Laeken, home to the Belgian royal family crypt.

The seven-kilometre route of this subversive pilgrimage was made arduous, not only on account of the distance covered and the ongoing litany of Rose's vocal announcement, but also because of the laden trolley she pulled along the way. Loosely recalling the kinds of floats and processional statues held aloft in Catholic celebrations of saints and martyrs, propped up in this makeshift trolley was a crude wooden effigy of stumps and branches, an arcane cipher for Lumumba himself, who has, despite his physical nullification, attained for many an iconic status. For artist Tshibumba Kanda-Matulu, he was the 'Lord Jesus of Zaire.'[4] And as Sean Jacobs observes in a more contemporary moment, 'Lumumba today has tremendous semiotic force: he is a social media avatar, a Twitter meme and a font for inspirational quotes – a perfect hero (like Biko), untainted by any real politics.'[5]

Emanating from Rose's trolley and providing a sonorous and mantric backtrack to her incantation was a recorded monologue – a woman's voice reading out the names of political activists and martyrs, such as Ruth First, Thomas Sankara, Harvey Milk, Malcolm X, Huey Newton, Harriet Tubman, Samora Machel and Martin Luther King Jr. For O'Toole, the bodies of these figures, although to some degree elevated, were nevertheless reduced to 'objects through which the 20th century's pitiable politics was enacted.'[6] As he observes, citing WEB Du Bois and Frantz Fanon, black bodies became, and still are, the abject site par excellence of this violence, subject to the objectification[7] – or as Aimé Césaire describes it, 'thingification' – of colonisation.[8] In refusing (or at least seeking to work around) this material and symbolic violence of human nullification, of especial pertinence to Rose's *Die Wit Man* is her particular insistence on absence. And this absence is the absence of *loss*, not the absence of an object or thing, but of the named human subject that was and must be Patrice Lumumba.

In this chapter, I look to ways in which both Rose and fellow South African artist Donna Kukama draw on invocation through modes of ritualistic performance as a means of resisting the erasure and violation of bodies routinely subjected to forms of physical, ontological and structural violence. Reflecting on recent performative works, I show how, in diverse applications of invocation, absence and loss become key sites and subjects for performance. In these ritualistic treatments of loss, I observe possibilities for working around the kinds of symbolic

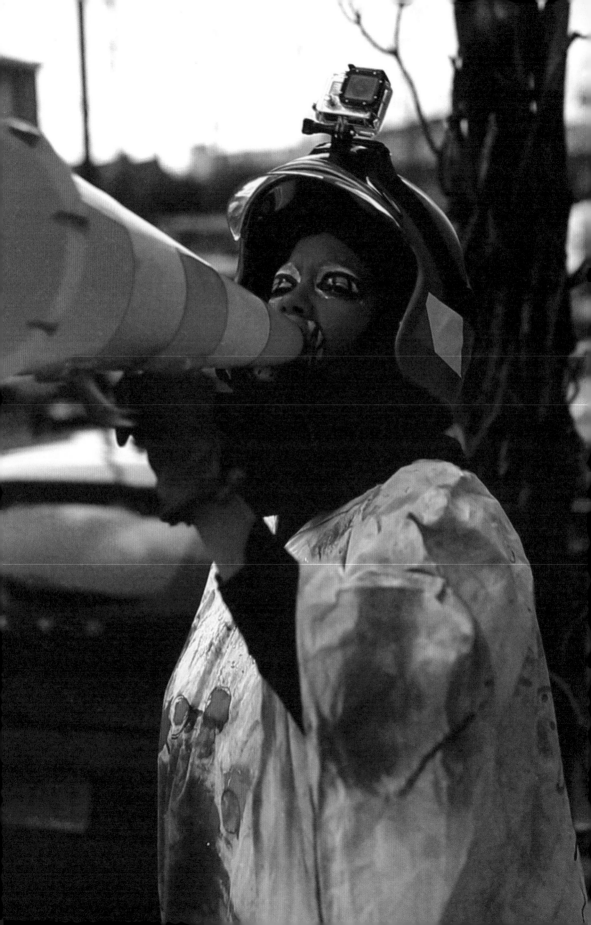

operations through which traumatised black, brown, queer and vulnerable bodies are systematically objectified and, for all their hypervisibility, rendered indistinguishable. The imperative to mourn becomes significant here, as something both social and political – granting recognition, as Kylie Thomas insists, to subjects otherwise unacknowledged in the political sphere.[9] Looking at the individual, but critically related, approaches of Rose and Kukama, and their relation to ideas around grievability, I argue for ways in which, through performative works of invocation, loss is sustained as a requisite condition for community as well as political agency. Necessarily, these reflections are situated within (but also without) a contested post-reconciliation context in South Africa – one marked by the vestigial traces, gross disparities and as-of-yet unreconciled traumas of colonialism and apartheid, as well as socially entrenched structures of patriarchal power and the normative outworking(s) of rape culture.

My considerations of these performative works, and the ways in which they make possible affective and ethically challenging encounters with the trauma of others, take their impetus in part from Sara Ahmed's reading on the contingency and sociality of pain, and the ethical demands and collective politics of its 'shareability.'[10] My objective in this is to show how such postcolonial and intersectional approaches to the traditionally western canon of trauma theory find expression, as well as complication, in significant works by contemporary black women artists in South Africa. I write this from the perspective of an artist vested in this politics, and as a dialogue with peers critically engaged in the necessary and irreconcilable work of mourning.

In considering the problem of pain, Ahmed insists on its essentially social and interrelational character, as a condition situating bodies in relation to one another and within a world of others. In this conception, pain is not limited to the interior experience of individuals but informs, and is informed by, encounters with the

Figure 6.1. Tracey Rose, *Die Wit Man*, 2015.
Courtesy Dan Gunn Gallery, London.

surfaces, objects and bodies of the environments they inhabit. She observes, 'So the experience of pain does not cut off the body in the present, but attaches this body to the world of other bodies, an attachment that is contingent on elements that are absent in the lived experience of pain.'[11] The nature of such attachment, which is to say the relation of bodies in pain to other bodies in the world, is complex. The injury of pain is always such that the pain one feels is never, and can never be, felt by another – if it is to be shared, it must be on terms other than commensurate experience.

For Ahmed, this kind of relation demands the necessary acknowledgement of a certain impossibility: the 'impossibility of "fellow feeling."'[12] Consequently, as she insists, empathy, when understood as a claim to another's pain – or as Jill Bennett might say, as 'overidentification' – is a violence in itself.[13] This is not to suggest that suffering bodies have no bearing on others, but rather that the sociality of pain – complicated by the irreducibility of its experience – calls for an alternative ethics of empathic response. In this regard, Ahmed observes:

> The impossibility of feeling the pain of others does not mean that the pain is simply theirs, or that their pain has nothing to do with me. I want to suggest here, cautiously, and tentatively, that an ethics of responding to pain involves being open to being affected by that which one cannot know or feel. Such an ethics is, in this sense, bound up with the sociality or the 'contingent attachment' of pain itself.[14]

For Elaine Scarry, the experience of physical pain is essentially language-destroying, alienating the subject to the extent that, as she argues, 'to have pain is to have *certainty*; to hear about pain is to have *doubt*.'[15] Identifying this tenuous relation between language and pain, Veena Das nevertheless insists on pain's claim on the other – whereby experiences of pain cry out, demanding an acknowledgement that such pain *could be mine*.[16] The idea that experiences of pain, loss and trauma – as essentially irreducible – resist language and the possibility of representation is foundational to the field of trauma theory. Cathy Caruth, Dori Laub, Shoshana Felman and others have, since the 1990s, advanced an understanding of trauma premised less on the traumatic event itself (the instance of violence) than on the structure of its reception. Central to this is the idea that, for the victim,

the experience of trauma, in its excessive violence, exceeds and suspends their capacity to process it in the moment; it is by necessity repressed, and encountered belatedly and inadvertently in repercussive psychological episodes.[17] Consequently, acknowledging the unrepresentability of trauma is established as a necessary precondition to meaningful and ethical engagement with the experience of others.

Ahmed's conception of the sociality of pain critically extends this ethical prerogative to bodies for the most part excluded from the privileged narratives of modernity and the historical ruptures that have generally been the focus of trauma studies, with its primary concentration on the Holocaust and other social catastrophes impacting on the experience and politics of the west, like the Vietnam War and 9/11. The exclusionary premise of this event-based model – failing as it does the more quotidian and incremental traumas of racism, sexism and homophobia – is unsettled by feminist, intersectional and postcolonial considerations. In this regard, Ahmed asks that we open ourselves to the historical and residual traumas of slavery, colonialism and apartheid (as inseparable from experiences of modernity), and so reconsider the ethical demands of our relation to suffering black, brown and queer bodies. This involves for her a 'different kind of inhabitance,' a form of relationality and collective politics, premised not on some absolving drive for social cohesion, 'but on learning to live with the impossibility of reconciliation, or learning that we live with and beside each other, and yet we are not as one.'[18]

This mode of encounter, one open to the inherent difficulties and 'impossibilities' of relating to marginal, traumatised and suffering bodies, resonates keenly with the kinds of ethical demands Judith Butler attaches to the notion of grievability. For Butler, whose seminal question concerning which lives are 'grievable' makes intrinsically political the relative nature of empathic relation, it is *loss* rather than shared experience that makes a tenuous 'we' of us all.[19] She acknowledges the manner in which the loss of certain lives and the suffering of some are registered and marked as grievable, whilst the peripheral deaths and distant agony of others go unrecognised. Thomas, for example, points to the many thousands of black South African lives claimed by HIV/AIDS as being hypervisible in death, and yet rendered invisible on account of a collective failure to mourn.[20] As subject to the ethical demands and relational ties of such a tenuous 'we,' Butler situates herself as politically determined as much by those lives grieved as by those disavowed by

the privileged remove of her 'First Worldism.'[21] Situating ourselves in a world of others, called for here is an acknowledgement of loss – and of the social, political and explicitly *human* imperative for collective works of mourning. Embracing a positionality of 'unknowingness,'[22] and perhaps seeking out something of the alternative inhabitance conceived of by Ahmed, Butler reflects:

> For if I am confounded by you, then you are already of me, and I am nowhere without you. I cannot muster the 'we' except by finding the way in which I am tied to 'you,' by trying to translate but finding that my own language must break up and yield if I am to know you. You are what I gain through this disorientation and loss. This is how the human comes into being, again and again, as that which we have yet to know.[23]

If language falters and inevitably fails in its attempts to articulate the irreducibility of trauma and pain, how do we begin to think about the possibilities of what art can and cannot do? For Griselda Pollock, confronting this representational limit demands of art a necessary shift from the mimetic promise of representation – as a foundational premise of art in a traditionally western sense – to its more affective operations.[24] In this respect, the objective of art is not to make trauma comprehensible (through representation), but rather, by involving the viewer in a more performative mode of witness, to sustain as a necessary tension its incomprehensibility. Rather than faithful transmission, what art affords in such contexts are 'occasions for encounter' between viewers (or participants) and the unrepresentability of trauma.[25] In facilitating these kinds of intersubjective and affective encounters, Peggy Phelan stresses the particular and specifically embodied opportunities presented in performance:

> Performance, which also 'takes' no object, is an important expressive system often overlooked by philosophers attempting to account for the capacities and incapacities of language ... In returning to the agony of trauma, art might provide a means to approach its often radical unknowability, in part because art does not rely exclusively on rational language, narrative order or naïve beliefs in therapy.[26]

Following Phelan, I would like to suggest that to engage with performance is to shift and make apparent the conditions and politics of affective aesthetic encounters

with trauma. What does the body in space – live, gestural, active, sweating, breathing, black, brown, white, queer, able, disabled, absent, present, accessible, inaccessible – afford us? Is it a tool artists use to get a point across, to demonstrate, to address our desire to make sense of? Or, as socially embedded, does it facilitate something more difficult and complex; forms of intersubjective encounter that unsettle an otherwise presumed passive witness; situations in which to work through, to sound and make felt the inexplicable, the irreducible? Here, viewers become implicated subjects – their bodily presence involving them in ethical, political and often uncomfortable situations.[27] These are the terms: established by interrelation, by the sociality of essentially human encounters. And it is in this sense, I propose, that performance makes possible alternative (or rather decolonial and intersectional) meetings whereby, in affective encounters with the experience of others, we must concede to that which we can never make sense of, but must nonetheless engage with. The unknowing inherent in such facilitated encounters does not, however, do away with what we have been shown and subjected to, confronted, shocked, surprised or even bored by. Rather, it is to appreciate and process the different registers of affect generated by our relation to performing bodies and the political space that is the shared bearing we have upon each other.

Here perhaps, in the performative moment, in this shared space of human interaction, we see the possibility for a 'different kind of inhabitance.' Working within this space, I am particularly interested in how, through ritual modes of invocation, loss is made central, and becomes, as it were, the productive object of performance. Resisting the impulse to fix and give form, this entails working with absence – a sustaining of loss as loss, in all of its irresolution and irreducibility.[28] For Jay Pather – speaking into a specifically South African and decolonial context – this means resisting the impulse to narrate and resolve, which he understands as an aspirant and nationalist ideology of transformation and reconciliation.[29] Instead, Pather encourages an embrace of the non sequitur, proposing a certain acknowledged irresolution as necessary to approaching current and historical situations of trauma.[30] As Ahmed insists, it is our duty and task to respond to that which is beyond fellow feeling, '*to learn how to hear what is impossible.*'[31] And it is here that Tracey Rose appears, rounding a corner with her trolley and megaphone, invoking by name, again and again, the absent person of Patrice Lumumba.

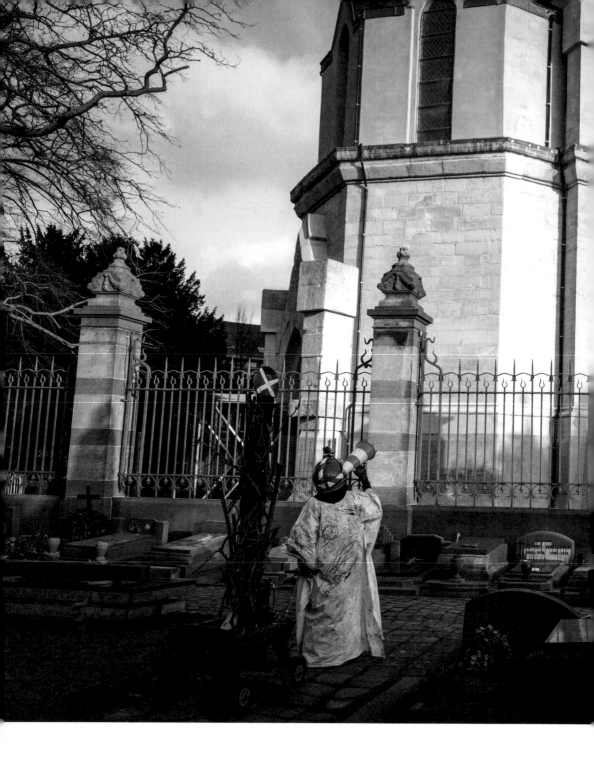

Figure 6.2. Tracey Rose, *Die Wit Man*, 2015.
Courtesy Dan Gunn Gallery, London.

As an artist, Rose considers herself a kind of shaman or medium, channelling voices and invoking the presence of subjectivities rendered silent and invisible by what she understands as the discursive structures of white supremacy. For her, "'Art is a way of life. Artists are the neo-shamans of the world. You've taken away all the druids, the healers and the witches.'"[32] Here, art is deployed as alchemic practice: a casting of spells, a saying of prayers. Drawing from African masking and performance traditions, her embodied practices become more than aesthetic or demonstrative acts but are imbued with a self-claimed spiritual and socio-political power. In the case of *Die Wit Man*, her calling upon the name of Patrice Lumumba, as well as those in the recorded litany emanating from the trolley, is a sincere and impassioned incantation calling into service the 'existence of revolutionaries in the spiritual realm.'[33]

In this respect, Rose sees herself as a stand-in of sorts, inhabiting within the present a certain landscape of loss, and conjuring through invocation historically subversive political presences. For her, invoking the 'effective ancestral power of these venerated spirits' disrupts the 'frequencies and vibrations' of an established order of white, heteronormative, North-Atlantic hegemony.[34] Whilst received with seeming ambivalence by passersby on that cold and windy day in Brussels – as suggested by the video footage – Rose's performed invocation of these political presences nevertheless confronts those passersby with the uncomfortable possibility of their lived complicity in a social and political paradigm inextricably entangled with the violent legacies of slavery, colonialism and apartheid. As Paul Taylor reminds us, the project of modernity was not simply complicated or compromised by such racialised and systemic violence, but was in fact 'constituted by it in deep and abiding ways.'[35] In facilitating affective and ethically demanding encounters with subjects of this violence, Rose's *Die Wit Man* resists the kind of disavowal reflected in the position taken, for example, by the European Union foreign ministers' General Affairs Council in July 2001, wherein the wrongdoings of slavery and colonialism were effectively relegated to the past, divesting them of any demand for redress in the present.[36]

Whilst channelling an alternate, spiritual dimension of loss, Rose is nevertheless keenly aware of the body she inhabits and its movement in time and space. In this respect, Kellie Jones observes that the 'insistent subjectivity' Rose brings to her work through exercises of conscious embodiment effectively subverts the

objectifying ethnography of colonialism as a scopic regime.[37] Black, female and of the ex-colony, Rose wilfully assumes a position of self-styled alterity in *Die Wit Man* – an otherness at once marginal and threatening. Shambolic and trampish in her dress, but also helmeted and sporting a devilish red face, hers is the guise of an 'angelic demonic figure,' the kind of apocalyptic street preacher, soothsayer presence that ruffles the everyday routines of privilege.[38]

In this sense and thinking of Stuart Hall, Rose's position of address is that of a body historically displaced but now intentionally present, the tone of its voicing shrill, rasping and declamatory.[39] Embodied here is a kind of paradigmatic reversal, a speaking back, as the rage and spillage of the ex-colony becomes, in Rose's relentless incantation, the speaking voice of history – and one that reverberates off the surfaces of a white, colonial geography. Amplified through a DIY megaphone, there is a kind of hailing involved here, a calling forth and a calling to, as people are drawn into an encounter with historically subversive political presences; not with a view to resolution, closure, reconciliation, but to a needed acknowledgement of the 'open wounds of trauma.'[40] Brought about in this sense, through ritual performances of invocation, is, I propose, something of the sociality and collective politics of Ahmed's directive to respond to that which is beyond fellow feeling, and to learn to hear that which is 'impossible.'[41]

Significant to this is Rose's intentional use of naming as a means of calling forth, or invoking, specific individuals. In mediating historic and current traumas, her approach is non-narrative; not a telling of stories, but rather an affirming of socially and historically marginalised and delegitimised subjectivities, and of their present political agency. Her attempt to stand in is thus not metonymic in nature – as embodying collective experience – but a kind of performed channelling of absent presence. Critical here is the extent to which the specificity and individual demand of such invocation works against the kind of ambiguous and abstracting tropes that often attend narratives of trauma associated with Africa. Pollock observes: 'Stereotypically, Africa is home to the perpetrators and victims of wars between nations, civil wars and ethnic conflicts within nations … and significant episodes of atrocity such as riots, massacres and genocides. The effects of these conflicts, including hardship, poverty, displacement, exploitation, murder, torture, rape and disappearances are too numerous to catalogue comprehensively.'[42]

In this myopic frame, wherein Africa constitutes a singular sublime trauma – continental in scope – it is easy for the individual experience of violence to register as normative, unextraordinary, just another item in a running commentary of human misery. Demonstrated in this prescriptive relegation is a certain politics of the unrepresentable, and the kind of radical realignment of the social sciences that is, for Georges Didi-Huberman, called for when human lives are rendered indistinguishable: locked in the absolute categories of the 'unsayable' and 'unimaginable.'[43] In Rose's *Die Wit Man*, however, the unsayable is spoken out, the unimaginable invoked, and in such a way as to make possible specific, individualised encounters with historical and present traumas. Enacted in this way is something of the intersectional and postcolonial revisiting of trauma theory advocated by Stef Craps as a means of redeeming the cross-cultural, ethical and political possibilities of making shareable unsayable and unimaginable experiences of trauma.[44] And this is why naming becomes such an important gesture, as the invocation of specific human presences makes possible opportunities for intersubjective encounters. For Rose, such encounters involve a social and spiritual relation to channelled ancestral spirits.

For Jacques Derrida, on the other hand, the naming of those deceased facilitates a more inward encounter, which translates and is shared in the context of personal and collective memory. Reflecting on the death of his friend Roland Barthes, and the speaking of his name, Derrida observes: 'When I say Roland Barthes it is certainly him whom I name, him beyond his name. But since he himself is now inaccessible to this appellation ... it is him in me that I name, toward him in me, in you, in us that I pass through his name.'[45] Whether experienced as a direct spiritual encounter or as a reanimating of personal and collective memory, what is significant, I believe, to the litany of naming performed in Rose's *Die Wit Man* is the specificity and bearing implied in the invocation of erased individuals like Patrice Lumumba, Rosa Luxembourg, Sara Baartman, Chris Hani, Mohammad Mosaddegh...

Naming as a kind of calling forth is central also to Donna Kukama's performance work *Chapter B: I, Too*. Performed at the São Paulo Biennale in 2016, the piece involved Kukama and a translator who together performed a kind of commemorative roll call.[46] Reading from a long scroll, the translator repeatedly announced through a loudhailer a list of names, referencing people from diverse transnational contexts: murdered, raped or attacked on account of their being black, queer or trans. As each name was pronounced, Kukama would crumple up a corresponding scroll of

brown paper, the scrunching sound of which was miked and amplified. Given the duration of the piece and the overwhelming number of names, this was exhausting work. For Kukama, endurance performance is something largely located in the 1960s when 'people were putting their bodies through stuff, for the sake of putting their bodies through stuff'[47] – think Bruce Nauman pacing around his studio, or repeatedly knocking his head against a wall. In *Chapter B: I, Too*, however, the demand for endurance becomes meaningful in its referentiality, as speaking to 'bodies that have endured experiences, violent experiences.'[48]

Kukama's use of the scroll calls to mind, but also subverts, the rolls of honour that mark lives lost – usually those of white male combatants – in conflicts like the World Wars and Vietnam. Significant here is the function of the monument as a site of memorialisation and, as Annie Coombes observes, as one animated and reanimated through performance.[49] In Kukama's case, of course, the monument itself *is* a performance – one embodied and spoken, registered not in the timeless matter of granite, marble and concrete, but in the ephemeral material of breath and voice, as the wearying labour of the artist and her collaborator. This is a monument unfixed, embodying as performance something of the precarity, alterity, marginality, periphery and exclusion of those named. Spoken out one at a time, each name is granted its own moment, its own resonance, presence, and sense of bearing – recalling the individual life worlds and experiences of those commemorated and reasserting their agency in the present. Achieved in this performed memorialisation is, I believe, a kind of ethical and radical work of recovery called for by Anthony Bogues, demanding a grappling with dead and erased bodies that 'speak':

> I believe that it is a critical task of radical thought today to work with the speech of those who have been historically excluded from the history of thought. It means coming to grips with the speech and practices of bodies who, because of various historical and social conditions, were never seen as alive, erased bodies that existed in what Frantz Fanon has called a 'zone of nonbeing.'[50]

For Kukama, and specifically in the case of *Chapter B: I, Too*, giving voice to those silenced by forms of physical, ontological and structural violence involves the ritual invocation of absent presences. Rather than through narrative or processes

Figure 6.3. Donna Kukama, *Chapter Y: Is Survival not Archival?*, 2017.
Courtesy Institute for Creative Arts.
Photograph by Ashley Walters.

of historical revision, it is in naming that absent bodies are performed and are, in the context of an affective and ethically demanding encounter, allowed to 'speak.' Here again, and recalling Ahmed, invocation facilitates a voicing, and in turn a listening, to the 'impossible' of pain.

The imperative and politics of this 'impossible' work, which I consider a form of collective mourning, is extended in Kukama's *Chapter Y: Is Survival not Archival?*. Moving to one of several multimedia stations laid out in a darkened room of the Iziko South African National Gallery (ISANG), Kukama knelt beside an overhead projector, the back-lit surface of which was blackened by a thick deposit of soil.

Surrounded by a hushed and closely gathered audience, Kukama proceeded to carefully inscribe a sequence of names into the soil, which were then projected, one by one, onto the wall above. Having spelt out a name, she would then systematically efface its illuminated lettering, blowing over the soil and so enacting a haunting and repetitive cycle of erasure. Written and written out in this ritual gesture were the names of women raped and killed in the Western Cape. Some, like Anene Booysen, were well known as subjects of widely mediated cases of gendered violence, whilst others recalled lesser-known cases involving sex workers and lesbian, gay, bisexual, transgender, queer and intersex (LGBTQI) individuals.

This unsettling register of erased individuals was a direct allusion to the nature of rape as a violence of inscription and effacement, recalling what Mieke Bal describes as the semiotics of rape.[51] Implicit in the physical act of rape, Bal emphasises, is its operation as a form of language – or 'body language.'[52] She notes, 'As a speech act, it is the "publication," the public appropriation, of a subject. It turns the victim into a sign, intersubjectively available.'[53] As such, Bal identifies the goal of rape as 'the destruction of the victim's subjectivity' as, in addition to the appropriation of their body, their semiotic competence is usurped.[54] In other words, rape marks a transfer of meaning from perpetrator to victim, robbing the victim of their capacity to articulate or voice themselves. Understood as a mode of inscription and erasure, rape does a violence that registers internally and externally, psychologically and sociologically. For Bal, the result is that, in assimilating the semiotic violence of rape, the victim is no longer addressed, or spoken to, but *spoken*.[55]

Kukama's performed gesture is, in this sense, a demonstrative act, symbolically speaking to forms of physical and ontological violence, in which the narratives of violated subjects are subsumed, overwritten, erased.[56] At the same time, in its public naming, it works to invoke and so reaffirm the subjectivities of those consigned to such de-subjectifying violence. The ephemerality of the inscription and effacement she performs presents a call, or perhaps an *imperative*, to remember. The affective and ethical demand of such recall resonates with what Anna Chave describes as a radical remembrance, wherein primary experiences of rape – suppressed within social contexts and institutional discourses – are brought to the fore and renegotiated. Chave observes how, in countering forms of systemic erasure, 'the act of remembering can count among the more radical acts historians and artists can perform ... especially when the material salvaged is material a society aims to keep buried.'[57]

Kukama's performance was especially pertinent in that it constituted a direct and site-specific response to the contested exhibition *Our Lady*, which opened at ISANG on 11 November 2016. A public outcry arose in response to the inclusion in the exhibition by co-curators Kirsty Cockerill, Candice Allison and Andrea Lewis of a photographic work by artist Zwelethu Mthethwa who was, at the time, on trial for (and has subsequently been convicted of) the murder of sex worker Nokuphila Kumalo in 2013. Two separate petitions voiced the critique of artists, curators and equal rights organisations. Vocal amongst these was the Sex Workers' Education and Advocacy Taskforce, otherwise known as SWEAT, who, on the night of the exhibition opening, staged a performance at the entrance to the Gallery. Lining the front steps, masked figures bore placards with the names and stories of murdered sex workers. Promoting the #SayHerName campaign, one read: 'My name was Thulukanyo. I was a sex worker. I was in my 20s. My mutilated body was found in the bushes. My killer has not been found.'[58] Another: 'My name was Desiree Murugan. I was a sex worker. I was 39 years old. I was found dead. I was decapitated. My trial is ongoing.'[59]

Responding to the contentious site of the *Our Lady* exhibition, Kukama's *Chapter Y: Is Survival not Archival?* became both a response to this critical dialogue as well as a form of site-specific excavation. Treating the space as a kind of palimpsest – a site of inscriptions, erasures and reinscriptions – the guided sequence of her episodic interventions (a play on the exhibition walkabout) brought attention to residual traces and absences, and their relation to both the colonial architecture and archive of the Gallery itself, as well as to socially embedded formations of patriarchal power and rape culture in South Africa. Speaking of her process, of performance as a way of navigating the gaps and aporias of the archive, she reflects: 'How do we write histories without using a language that is direct, already used, and already known? How does performance become a mode of research? I don't want to say knowledge production, because that seems a bit fake, but something in between ... where we create and produce ways of looking, ways of reading.'[60]

From the start, Kukama's intervention troubled the epitome of femininity seemingly encapsulated in the title *Our Lady*, a title she literally masked with torn strips of masking tape. Headlamp attached, she then directed the audience through a low-lit immersive environment of whirring fans, buzzing radios, ambient sound and video bytes. In addition to those names projected and erased on the

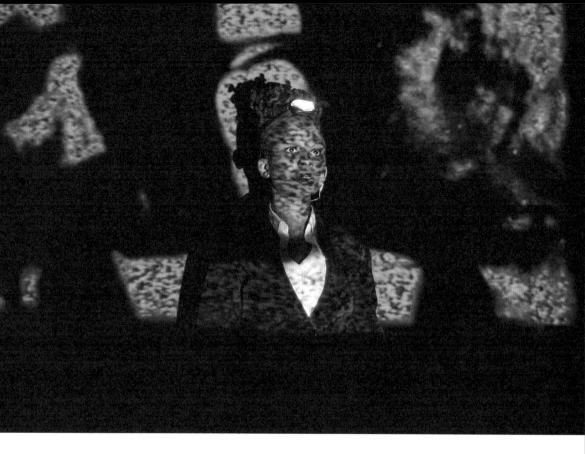

Figure 6.4. Donna Kukama, *Chapter Y: Is Survival not Archival?*, 2017.
Courtesy Institute for Creative Arts.
Photograph by Ashley Walters.

overhead projector, she violently scrawled the names of individual survivors of gendered violence on a blackened wall – the screeching chalky sound of which was distressingly amplified. She reflects: 'The names that remained on the walls are those of people who are living in Cape Town, and are accessible. I didn't want to leave a trace of someone that is not there, but rather those that are still present.'[61]

Responding to the violence perpetuated in *Our Lady* – through the elision of Nokuphila Kumalo's name and the unqualified inclusion of Mthethwa's work – Kukama's layered interventions contend with the multiple ways in which rape, as a violation of actual bodies, is reformulated in the ways we speak, image, write, sound and perform its violence (importantly, along lines of race, gender and sexuality).

This active deconstruction of rape's cultural encodement, through the invocation of named individuals, speaks to the necessary and political work of recognition demanded by Pumla Dineo Gqola. In her book *Rape: A South African Nightmare* Gqola traces a history of white supremacy – from slavery to colonialism to apartheid – observing in this historical continuum the construction of racial stereotypes wherein black men are established as rapists, and black women as hypersexual and resultantly 'impossible to rape.'[62] Reflecting on the extent to which this social determination renders black women 'unrapable,' she observes:

> Making Black women *impossible* to rape does not mean making them *safe* against rape. It means quite the opposite: that Black women are safe to rape, that raping them does not count as harm and is therefore permissible. It also means that it is not an accident that when Black women say they have been raped, they are almost never taken seriously and in many instances are expected to just get over it.[63]

This idea of who is and who is not rapable relates to what Jane Bennett observes as rape's believability. Bennett explains that the extent to which the testimony of a rape survivor is believed is contingent upon the correlation of that testimony to a societal notion of what a rape ought to look like.[64] In this sense, the violence of rape is perpetuated in the social sphere through mechanisms of representation, by means of which experiences of rape are framed. The believability of rape is thus predetermined by conditioned notions of what constitutes rape, and who can and cannot be raped. Significant to this is how individuals like Nokuphila Kumalo, a black sex worker, are delegitimised as victims and rendered invisible by the violence of rape, as perpetuated through gendered and racialised systems of representation. If one is to reveal the mechanisms that work to delegitimate and so make possible the elision of rape narratives, then a certain work of recovery becomes imperative. For Lynn Higgins and Brenda Silver, this involves a return to the material violence of rape and the actual bodies it inscribes.[65] But what of bodies that have been reduced to signs – physically and discursively erased, rendered peripheral, unrapable, ungrievable, and relegated to that 'zone of nonbeing'? Called for here, I propose, is a return not only to the body, but to subjectivity – which is to insist on the credibility of suppressed rape narratives, but more fundamentally, the grievability of these lives.

In the facilitated encounter of *Chapter Y: Is Survival not Archival?*, Kukama inhabits, and calls others to inhabit, a productive space of loss; to negotiate the absent presence of named individuals; to listen to silenced voices that speak to the present and to present persons. Similarly, in *Die Wit Man*, Rose's ritual incantation of 'Patrice Lumumba,' and her accompanying roll call of erased radicals, enables affective and intersubjective encounters with invoked subjects of present and historical traumas. Significant to this is how loss becomes a condition for community, and mourning is established as socially and politically productive work – not in the sense of healing or closure, but as a necessary and sustained *irresolution.*[66] For Thomas, this involves facing up to that to which we cannot be reconciled and to those whom we have not yet mourned.[67] Implied here is a different kind of inhabitance, one premised on the sociality of pain and its inherent ethical and political demands. This is an inhabitance made possible, I propose, by artists like Kukama and Rose, whose works of ritual invocation enact something more than the mediated witness associated with representations of violence, through which black, brown, queer and vulnerable bodies are systematically objectified. Performed, rather, as a call to the critical work and collective politics of mourning.

1. For details on the assassination of Patrice Lumumba, including the involvement of the CIA, MI6 and Belgium, see Harry Stopes, 'Did Britain's MI6 Have Patrice Lumumba Murdered?' Africa is a Country, 13 May 2013, accessed 20 March 2017, http://africasacountry.com/2013/05/did-britains-mi6-have-patrice-lumumba-murdered/.

2. Adriana Cavarero points to a violence that extends beyond the killing of a body and to the dehumanising violence through which the singularity and recognisability of that body is effaced. See Adriana Cavarero, *Horrorism: Naming Contemporary Violence* (New York: Columbia University Press, 2009), 9–12. Needless to say, it would take something more than such a physical dissolution of the body to disentangle the subjective presence of, in this case, Patrice Lumumba from the network of social roles and relations in and through which he lived, was known, and continues to be remembered. For a clear discussion of this embodied perspective see Lisa Blackman, *The Body: The Key Concepts* (Oxford: Berg, 2008), 34. More specifically, however, my position in this chapter is that it is in response to such violence that the work of mourning is rendered political, as in

contexts of loss and bodily erasure, practices of invocation and commemoration seek to reconstitute the possibility of recognition.

3. Sean O'Toole, 'Chaos Queen – South African Artist Tracey Rose's Searing Performances Raise Tough Questions around History and Race,' *Frieze Magazine*, 4 May 2016, accessed 6 April 2017, https://frieze.com/article/chaos-queen.

4. Sidney Kasfir, *Contemporary African Art* (London: Thames & Hudson, 2000), 25.

5. Sean Jacobs, 'Patrice Lumumba (1925–1961),' Africa is a Country, 17 January 2017, accessed 20 March 2017, http://africasacountry.com/2017/01/patrice-lumumba-1925-1961/.

6. O'Toole, 'Chaos Queen.'

7. O'Toole, 'Chaos Queen.'

8. Aimé Césaire, *Discourse on Colonialism* (New York: Monthly Review Press, 1972), 6.

9. Kylie Thomas, *Impossible Mourning: HIV/AIDS and Visuality after Apartheid* (Johannesburg: Wits University Press, 2014), 9.

10. Sara Ahmed, *The Cultural Politics of Emotion* (Edinburgh: Edinburgh University Press, 2014).

11. Ahmed, *The Cultural Politics of Emotion*, 28.

12. Ahmed, *The Cultural Politics of Emotion*, 39.

13. Jill Bennett, *Empathic Vision: Affect, Trauma, and Contemporary Art* (Stanford: Stanford University Press, 2005), 9.

14. Ahmed, *The Cultural Politics of Emotion*, 30.

15. Elaine Scarry, *The Body in Pain: The Making and Unmaking of the World* (New York: Oxford University Press, 1985), 13.

16. Veena Das, *Life and Words: Violence and Descent into the Ordinary* (Los Angeles: University of California Press, 2007), 40.

17. In this regard, Cathy Caruth observes: 'Trauma is not locatable in the simple violent or original event in an individual's past, but rather in the way that its very unassimilated nature – the way it was precisely not known in the first instance – returns to haunt the survivor later on.' Caruth, *Unclaimed Experience: Trauma, Narrative and Meaning* (Baltimore: Johns Hopkins University Press, 1996), 4.

18. Ahmed, *The Cultural Politics of Emotion*, 39.

19. Judith Butler, 'Violence, Mourning, Politics,' *Studies in Gender and Sexuality* 4, no.1 (2003): 9–37, accessed 20 January 2017, doi: 10.1080/15240650409349213.

20. Thomas, *Impossible Mourning*, 9.

21. Butler, 'Violence, Mourning, Politics,' 33.

22. Butler, 'Violence, Mourning, Politics,' 19.

23. Butler, 'Violence, Mourning, Politics,' 36.

24. Griselda Pollock, *After-Affects/After-Images: Trauma and Aesthetic Transformation in the Virtual Feminist Museum* (Manchester: Manchester University Press, 2013), 19.

25. The emphasis here is on a necessarily intersubjective relation whereby works of art – figurative or not, material or ephemeral – have the capacity to, as Pollock observes, 'bring human subjects closer to the possibility of recognizing and being affected by the pain that is other, and to assenting to receive and hence transform some of its burden.' Pollock, *After-Affects/After-Images*, 19.

26. Peggy Phelan, 'Survey,' in *Art and Feminism,* ed. Helena Rickett (London: Phaidon, 2001), 45.

27. Seeking to trouble the victim/perpetrator dichotomy, Michael Rothberg proposes the term 'implicit subject' as a way of speaking to forms of trauma that are incremental and non-spectacular, but nonetheless global in reach, having a bearing upon us all. Michael Rothberg, 'Preface: Beyond Tancred and Clorinda – Trauma Studies for Implicated Subjects,' in *The Future of Trauma Theory: Contemporary Literary and Cultural Criticism,* eds. Gert Buelens, Sam Durrant and Robert Eaglestone (New York: Routledge, 2014), xv.

28. Derrida quoted in Thomas, *Impossible Mourning*, 124.

29. Jay Pather, 'Negotiating the Postcolonial Black Body as a Site of Paradox,' *Theater Journal* 47, no. 1 (2017): 159, accessed 20 March 2017, doi: 10.1215/01610775-3710477.

30. Pather, 'Negotiating the Postcolonial Black Body,' 159.

31. Ahmed, *The Cultural Politics of Emotion*, 35.

32. Tracey Rose quoted in Liz Bolshaw, 'Performance Artist Tracey Rose Focused on Leaving a Legacy,' *Financial Times,* 27 March 2015, accessed 6 April 2017, https://www.ft.com/content/a5eeea24-ce34-11e4-86fc-00144feab7de.

33. Tracey Rose, interview with the author, April 2017.

34. Rose, interview.

35. Paul C. Taylor, *Black is Beautiful: A Philosophy of Black Aesthetics* (Hoboken: Wiley Blackwell, 2016), 85.

36. Ahmed, *The Cultural Politics of Emotion*, 117–118.

37. Kellie Jones, 'Tracey Rose: Postapartheid Playground,' *Nka Journal of Contemporary African Art* 31 (2004): 26–31, accessed 6 April 2017, doi: 10.1215/10757163-19-1-26.

38. Rose, interview.

39. Stuart Hall, 'Cultural Identity and Cinematic Representation,' *Framework: The Journal of Cinema & Media* 36 (1989): 68–82, accessed 9 April 2017, http://www.jstor.org/stable/44111666.

40. Thomas, *Impossible Mourning*, 141.

41. Ahmed, *The Cultural Politics of Emotion*, 35.

42. Pollock, *After-affects/After-images,* 19.

43. Georges Didi-Huberman, 'Images in Spite of All: Four Photographs from Auschwitz, 2003,' in *Documentary: Documents of Contemporary Art,* ed. Julian Stallabrass (London: MIT Press, 2013), 155.

44. Stef Craps, 'Beyond Eurocentrism: Trauma Theory in the Global Age,' in *The Future of Trauma Theory,* eds. Gert Buelens, Sam Durrant and Robert Eaglestone (New York: Routledge, 2014), 46.

45. Jacques Derrida, *The Work of Mourning,* eds. Pascale-Anne Brault and Michael Naas (Chicago: University of Chicago Press, 2001), 46.

46. For Kukama, the translator 'is not there as a professional, but rather as an extension of [my] voice, [intended] to localise [the performance]. So it is not only about direct translation, it always has to be someone who to some level understands my position as a black woman.' Donna Kukama, interview with the author, April 2017.

47. Kukama, interview.

48. Kukama, interview.

49. Annie Coombes, *History after Apartheid: Visual Culture and Public Memory in a Democratic South Africa* (London: Duke University Press, 2003), 12.

50. Anthony Bogues, 'And What about the Human? Freedom, Human Emancipation, and the Radical Imagination', *boundary 2* 39, no. 3 (2012): 29–46, accessed 18 February 2017, doi:10.1215/01903659-1730608.

51. Mieke Bal, *Reading Rembrandt: Beyond the Word Image Opposition* (Cambridge: Cambridge University Press, 1991), 90.

52. Bal, *Reading Rembrandt,* 90.

53. Bal, *Reading Rembrandt,* 90.

54. Bal, *Reading Rembrandt,* 91.

55. Bal, *Reading Rembrandt,* 91.

56. Cavarero, *Horrorism,* 9.

57. Anna C. Chave, '"Normal Ills": On Embodiment, Victimization, and the Origins of Feminist Art,' in *Trauma and Visuality in Modernity,* eds. Lisa Saltzman and Eric Rosenberg (Hanover: University Press of New England, 2006), 143.

58. SWEAT (Sex Workers' Education and Advocacy Taskforce), live intervention on the occasion of the opening night of the exhibition *Our Lady* (Iziko South African National Gallery, Cape Town, 1 December 2016).

59. SWEAT, live intervention.

60. Kukama, interview.

61. Kukama, interview.

62. Pumla Dineo Gqola, *Rape: A South African Nightmare* (Johannesburg: MF Books, 2015), 5.

63. Gqola, *Rape*, 5.

64. Jane Bennett quoted in Gqola, *Rape*, 25.

65. Lynn Higgins and Brenda Silver, 'Introduction: Rereading Rape,' in *Rape and Representation*, eds. Lynn Higgins and Brenda Silver (New York: Columbia University Press, 1991), 4.

66. In this regard, Butler observes how 'Loss becomes condition and necessity for a certain sense of community, where community does not overcome the loss, where community *cannot* overcome the loss without losing the very sense of itself as community'. Judith Butler, 'Afterword: After Loss, What Then?' in *Loss: The Politics of Mourning*, eds. David Eng and David Kazanjian (Berkeley: University of California Press, 2003), 468.

67. Thomas, *Impossible Mourning*, 123, 127, 142.

State of Emergency: *Inkulumo-Mpendulwano* (Dialogue) of Emergent Art When *Ukukhuluma* (Talking) is Not Enough

NONDUMISO LWAZI MSIMANGA

When the emotion becomes too strong for speech, you sing, when it becomes too strong for song, you dance.

Unattributed musical theatre proverb

For as we begin to recognize our deepest feelings, we begin to give up, of necessity, being satisfied with suffering and self-negation, and with the numbness which so often seems like their only alternative in our society. Our acts against oppression become integral with self, motivated and empowered from within.

Audre Lorde, *Sister Outsider: Essays and Speeches*

'I can't believe I still have to protest this shit,' read a popular sign at the Women's March in Washington DC on 21 January 2017 – the first full day of Donald Trump's presidency. In South Africa, one of several mass marches calling for the resignation of then President Jacob Zuma before the end of his full term was held on 12 April 2017. A signal of this same feeling could be seen on a protester's placard stating, 'Not this shit again.' These emotions are carried by a force of enough-is-enough in response to the repetition of acts of aversion by the presidents of both the United States and South Africa. Both presidents were accused of sexual assaults prior to

taking office. 'This shit' indicates disgust – an emotion that covers a wide spectrum of feelings from revulsion at expired food to moral abhorrence. In *The Book of Human Emotions*, Tiffany Watt Smith describes disgust as a liminal emotion that occurs 'when boundaries dissolve, meaning breaks down and things slide "out of place."'[1] Disgust is the response of a subject who is not able to make sense of events. Emotions 'are meaningful contributions to the way one understands the world. Our emotive behavior represents the choices one makes when confronted by extreme situations.'[2] Emotion generates a space akin to postcolonial theorist Homi K. Bhabha's notion of 'the "third space" which enables other positions to emerge ... which are inadequately understood through received wisdom.'[3] For Jean-Paul Sartre, emotion is a means to apprehend the world and transform it by changing the self.

Emotion is the knowledge of things not fitting. It alters space for the creation of new knowledge, as Sara Ahmed suggests in her performative thesis *Living a Feminist Life*: 'Think of this: how we learn about worlds when they do not accommodate us. Think of the kinds of experiences you have when you are not expected to be here. These experiences are a resource to generate knowledge.'[4] She calls this not-fitting-as-generative-of-new-knowledge a 'sweaty concept.'[5] She charges that the specific be used to confront the 'universal.' Disgust, as with all emotions, serves a subject's shift of their relation to the world – the world that does not make sense – in order to signal the necessity to change the qualities of this world. Emotion, in the intentional activity it triggers in the subject, is an event that allows for comprehension of the problems of the past through the present and directs the subject's response towards the future. Disgust entails a subject's looking at the 'shit' from an event in the past, working inside the liminal space of not-being-able-to-make-sense of the given societal structures, and transgressing that which has been apprehended by that subject. Disgust is disruptive. It is an emotion of protest.

Defining South Africa as a protest nation, an arguable definition of many democratic nations (including the United States) in the contemporary epoch, Jane Duncan states that 'protests are an essential form of democratic expression.'[6] She adds:

> Protests. Occupations, strikes, marches, disrupting meetings, even jamming shopping tills by filling trolleys full of goods and refusing to pay for them. Hardly a day goes by without such protests taking place in some part of South

Africa. Protestors tap into a rich protest culture in the country that dates back to the epic struggles against exploitation and oppression under apartheid. Past and even present-day South Africa has truly become a country defined by its protests: a protest nation.[7]

Contemporary South Africa is in a democratic state of emergency marked by daily disruptions to its flow. Citizens question oppressions, old and new. The state of emergency, then, is the current state of almost-daily protests – the sweaty space of events – that make us question, and continue to (re)define, who we are in democracy. This state of being can be particularly emotive when protests, such as the anti-Zuma marches, recur over an extended period of time. A different *inkulumo-mpendulwano* (dialogue) is called for when parliamentary talking is no longer enough.

When emotion overflows or disrupts flow, it expresses protest. Sartre states that emotion creates a magical world when one cannot make sense of occurrences in reality; emotions occupy the world of magic so that magic may stimulate a subject's reaction to the overwhelming moment.[8] Emotion thus constitutes a magical world. It is a world of events in that it reconstitutes the world and transforms it into one where the only response available is a body in-belief-of-magic, as Sartre suggests.[9] The state of the person in an emotional response is one of believing that the situation can have no other recourse but the altered one. Everything inside of their perception of the stimulant is different to the reality they know – so they know in a new way, the emotional way, which can alter their perception in the instance in which they cannot see how to change their situation. Emotion precipitates transformation. This change is of perception.

In Audre Lorde's terms, deep feeling is a movement away from the numbness of being overwhelmed. In the feminist conception of Lorde and Ahmed, as well as the Sartrean humanist existentialist definition of emotion, it is the very feeling of freedom that accompanies the sense of responsibility human beings may experience in relation to other human beings. Lorde understands feeling as a deep knowledge that creates the space for new knowledge. For Lorde, the erotic is reclaimed as a feminine force that flows through her body and her being with an animating sensitisation to all aspects of life. It invigorates and charges her activities with life-giving potential.

Experientially (as each of the previously cited authors write from the perspective of a lived experience) and appropriate to the understanding of

emotion as knowledge, the analysis in this chapter is interwoven with personal impressions, as jotted down in my journal entries from the Institute for Creative Arts (ICA) Live Art Festival in 2017. These first impressions, as I have called them, probe the paradox of emotion as an overwhelming event and yet one that is necessary to revolt. In *The Cultural Politics of Emotion*, Ahmed analyses how feelings are ascribed to collectives in the political construction of their being, and that this construction of certain beings as soft, and others as hard penetrators of softness, is gendered.[10] Knowledge construction has (en)gendered this problematic dichotomy, and so my self-conscious inclusion of emotive experiences is an attempt at writing in a third space where an-other position may emerge; a liminal space.

> *First impressions*: Saturday, 11 February 2017. It is sometime before 9 pm. It has cooled since yesterday, but I am clammy underneath my vest. I have been walking through the exhibitions at [Youngblood] wanting to stop people. Stop people from walking past Zanele Muholi's documentary video *Babhekeni / Look at Them*; when they walk past without, well, looking at them. I want to stop all the joyous hubbub in front of the bar area where the videos are displayed, creating an aisle of reflections on pain. A saxophone hums mournfully from one of the installation-videos. On a wall around a corner – staring at us with stark eyes from a body that is painted darker than its hue – is a photograph of Muholi accessorised by wooden clothes pegs. She stares at me. Muholi's image can't stop them. I am lost.[11]

As an anti-rape activist myself, my emotions arise from this subjectivity. The feeling of being lost that night was a quiet despair that the footage from Muholi's November 2016 performative work on gendered violence, *Babhekeni / Look at Them*, was being ignored for the relief of cold beer on another hot day. The desire that I felt for Muholi's image to magically move people to show more care for her documentary exhibition was a desire to overcome my own sense of helplessness as an activist. The feeling raised questions about what a work of art actually does when it is activist in orientation: what activity does art engender through its protest? What kinds of protests were being performed in the space?

Ahmed brings to this conversation her notion of sweaty concepts. She writes of creating new ideas as the necessary homework of feminist life. Feminist ideas,

in her conceptualisation, are manifested because of the need to shed light on injustices that continue – like the 'shit' that still needs to be protested against daily in the emergent being of South Africa's democracy. Like Lorde's *Sister Outsider*, Ahmed's sweaty concepts look at the world from the perspective of not being treated equally; from being an outsider. This concept is useful in dialogue with performance art activism that stages acts of resistance without an over-reliance on explanatory words. Ahmed pays homage to Lorde in her development of the notion of a sweaty concept, which she describes as 'another way of being pulled out from a shattering experience.'[12] Sweaty concepts reflect on emotional experience, but they also act as trigger-diversions (not re-enacting triggering events) by creating a third space in performance – not of the spectacle of events but the space of the magical. Emotion, in the feminist paradigm articulated by Lorde and Ahmed, is emergent. It is generative protest because it engenders new action and connects the micro to the macro in a way that is reminiscent of the 1960s feminist performance art slogan: the personal is political.

PERSONAL-POLITICAL

> *Without introduction or preamble [the most famous and highly respected member of the faculty] said to me with a triumphant smirk, 'Miss Piper, you're about as black as I am.' One of the benefits of automatic pilot in social situations is that insults take longer to make themselves felt ... What I felt was numb, and then shocked and terrified, disoriented, as though I'd been awakened from a sweet dream of unconditional support and approval and plunged into a nightmare of jeering contempt ... Finally, there was the groundless shame of the inadvertent impostor, exposed to public ridicule or accusation. For this kind of shame, you don't actually need to have done anything wrong. All you need to do is care about others' image of you, and fail in your actions to reinforce their positive image of themselves. Their ridicule and accusations then function to both disown and degrade you from their status, to mark you not as having* done *wrong but as* being *wrong.*
>
> Adrian Piper, 'Passing for White, Passing for Black'

Adrian Piper's reflection on her experience at a reception for new graduate students theorises the thematic influence of much of her work – race and prejudice. In a performative video installation entitled *Cornered*, Piper is able to state her own problems with what she calls 'passing for white' in a half-hour speech act on what it means, emotionally, to have to endure racial commentary from people who assume she is white if she has not stated that she is black. In another work, *My Calling (Card)*, Piper handed out cards calling out racial prejudice as she encountered it in public places. Her art is protest. Her protest is sweaty in concept. It allows her to perform what she was not able to do in the *dépaysement*, the unsettling feeling of being an outsider, in which the graduate reception encounter held her captive.[13] She performs being cornered and being angry in a manner that confronts her social reality and subverts the expectation of these emotions, taking the 'thrownness' of her experience of 'being-in-the-world' and casting the emotion back onto its object: whiteness.[14]

The Heideggerean use of the notions of thrownness and being-in-the-world inform the concept of emotion as an event. Thrownness is linked to the existential notion that you find yourself already in the world, no matter the time and space. It is accompanied by feelings of despair or anxiety, but these become useful in the humanist responsibility that connects humanity.[15] 'A sweaty concept comes out of a description of a body that is not at home in the world,' Ahmed states.[16] A work of performance art might recreate this sweaty orientation by manifesting our thrownness in a situation. A situation, as understood by Ahmed, is the way in which we understand the world. Emotion is a particular apprehension of the world. By positing that the situation of being is a thrownness, Heidegger reveals that aspects of being are understood in the emergency of the emotion or event that makes you question who you are. This notion of the emergency of being is explored by Richard Polt who outlines why the term *Ereignis*, often translated as 'event,' is more complex than its direct translation suggests, for the event is a question regarding existence rather than a simply defined concept.[17] *Ereignis* is a sweaty concept because it is a conceptual repositioning of how we apprehend the world, or a world. From the space of the sweaty concept, this apprehension of an event that makes you question who you are is 'a description of how it feels not to be at home in the world.'[18] In a world where your very being is made wrong, the personal is indeed political.

The work of protest is evinced by the sweaty concept because the description has as its function the discourse of change. In engaging practically with attempts to shift the politics that cast you outside the world, you generate these perspirative ideas. A new conception of the world emerges. These generative ideas are discussed in this chapter in relation to Mamela Nyamza's *DE-APART-HATE* (which explores what Nyamza calls a 'DE-APART-HATE process') and Gabrielle Goliath's invocation of an absent-presence in *Elegy*. These concepts sweat because they are critical thoughts born from 'being outside' in a time of existential emergency.[19] They sweat because they put into performative action both 'the practical experience of trying to transform a world' – as Nyamza's work as an activist relaying her subjectivity shows – as well as 'the practical experience of coming up against the world,' as Goliath's true-story commemorations of deceased subjectivities enact.[20]

DE-APART-HATE: *INKULUMO-MPENDULWANO* (DIALOGUE)

First impressions: *Friday, 10 February 2017. It is after 9 pm but the heat in Cape Town is still oppressive. The entrance to Hiddingh Hall is bustling with festivalgoers and I walk into the space with my mind still fluttering from all the performances earlier in the evening. I am in my thinking space when I walk past a man standing at the door, greeting all the people coming in. Mamela Nyamza in a tight black leather dress with white tulle is making her way past the rows of chairs to my left. I look to my right and the man in the white shirt and black suit is dancing in her direction. They are singing and he beats a Bible. I try to focus on them moving through the audience but the audience is so enraptured in singing along to this isiXhosa hymn that I join in the happy singing. I don't know all the words but the spirit is alive.*

Personal journal entry, 10 February 2017

The DE-APART-HATE process, as put forward by Mamela Nyamza in this work, highlights the need for 'honest dialogue.'[21] Dialogue is proposed as the counter to systemic issues. When the lights dim, the performers sit on a rainbow-coloured bench, and in the unspoken dialogue between Nyamza and her co-performer, Mihlali Gwatyu, there is a distinct impasse. The pair is in a church, and after

the elated praise-singing they assume the restrictions of silence and subdued behaviour. The rainbow seesawing bench on which they sit is continually set off balance, then reset by the power play between them. They are both in the situation of trying to understand their place, together and individually, in the church. The ironic seesawing between the singing and the silence has a visual frequency as they suddenly shuffle on and off the bench. The South African postapartheid refrain of the rainbow nation seems to creak with every unstable resetting of the bench. The lengthy silences seem to open a crack between the dress-gendered bodies. In what feels like the rising frequency of the pitch of silence onstage and in the audience, the rainbow might evoke – in the same instance – Gay Pride and the silencing of queer subjectivities that still occurs in the church.

The piece works with the balance between enraptured hymn-singing, during which the pair seems thoroughly filled with the spirit, and lengthy silences that open greater chasms of space between the performers. The audience is thrown into complicity in the sequences of joyful worship as they are encouraged to sing out loud. The congregants then become awkward witnesses to the silences, which they fill with shuffles and coughs. When the two performers eventually get off the bench to stop the seesaw, Nyamza goes onto all fours and Gwatyu climbs onto her back with a Bible in hand. The sound of a womxn in the audience making a glottal 'mmm' registers a distinct emotional shift in the experience of the piece.[22]

Gwatyu, a man standing on a womxn's back reciting references to biblical verses, though not the verses themselves – Ephesians 6:5 (the obedience of servants), Deuteronomy 32:8 (the division of land), 1 John 8:7 (the reprimand of sinners for casting stones) – reveals that there is homework to be done in order to carry forward the thinking process begun in the performance, as at church. As he doesn't read the verses, but performs them with a fervour that elicits laughter from some, there is conflict in the space. The necessary dialogue is initiated by the emotive involvement of the audience as participants, but they are not told precisely what struggle they are being pulled into. Instead, the congregants are given homework. Ahmed insists on the necessity of homework in feminist life because protest is daily and requires critical thinking in the most intimate spaces in order to transform them.[23] And so, before the piece is complete with all its cited biblical references and corresponding 'Amen, hallelujah(s)' from Nyamza, she hoists her dress up to reveal her legs, and pulls a Bible out from between

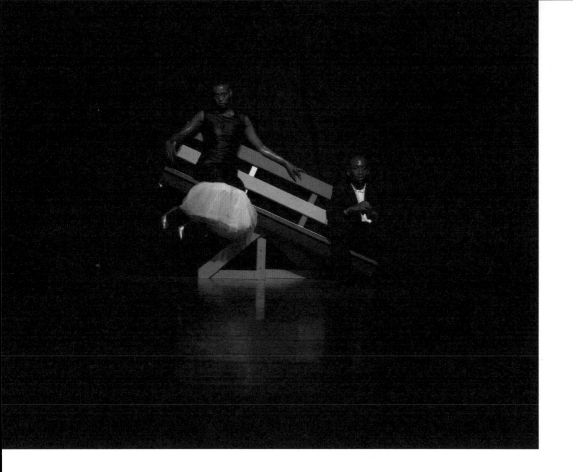

Figure 7.1. Mamela Nyamza, *DE-APART-HATE*, 2017.
Courtesy Institute for Creative Arts.
Photograph by Ashley Walters.

them. She reads out one more reference, Leviticus 18:22. In doing the homework it reads: 'You shall not lie with a man, as with a woman: it is an abomination.'[24] Nyamza, too, does not speak the verse, only its reference, but she does respond to it in improvised ad-libs. She sits on top of the bench, which is now overturned and placed over the length of Gwatyu's body, burying him underneath her. Her legs wide open with the Bible in front of her vagina, she flips the pages. The Bible eventually gets tucked between her legs and she grinds on it, rotating her pelvis until the book falls. Before walking off stage, she sings again with the audience in what seems like uncomfortable collusion.

Figure 7.2. Mamela Nyamza, *DE-APART-HATE*, 2017.
Courtesy Institute for Creative Arts.
Photograph by Ashley Walters.

The piece has both celebrated and confronted the church. It is unclear what to feel. Nyamza layers meanings so that her DE-APART-HATE process requires continued discourse on the different ways in which some people are cast outside the institutions of church and state. The work addresses who does not fit into society, who is considered deviant. This is in line with Nyamza's self-described intention in creating her work. She has noted: 'As an artist, when you create a debate then your job is done.'[25] She does not aim at coherence; she creates a space of incoherence through the allegorical means of the visual and aural seesaw. Nyamza, as allegorist, reveals the subjective meanings given to materials in the performance:

When I'm starting I'm on a high. I want you to feel this rhythm, this feeling of being at church, this song – so we're on a high. I take you with me because when the piece comes down, it's bad ... Then at the end, I switch this thing of church ... I'm confusing them because it's like after all that now I'm going to do that. I'm playing with frequency! And then, it's like what the fuck?[26]

The effect of the allegory is, as Erika Fischer-Lichte citing Walter Benjamin states, that the material's meaning alters through the performance, and in so doing what arises is a sense of incoherence as to what the symbol(s) mean in the social myth presented.[27] The high point in the loud singing is initially celebratory, and the silence allows for contrast and complexity to emerge. It is unclear at the end whether the mood in the audience is one of celebration. The dialogue negotiates changing affects in relation to the objects, the performers and the highly involved audience. It is a sweaty dialogue that shifts from commiseration to being cast outside the communal world of the performance. You have to ask what your role is in the many imbalances of this rainbow nation. At a new point of emergency in the country, the question is again: who are we? The protest is, 'Not this shit again.'

Nyamza herself speaks in numerous expletives when she discusses the work. It is emotionally charged with the need for something to be done and the frustration of still needing to protest the many different problems with which the piece is layered. She says: 'This DE-APART-HATE process has made me to speak out loud because how can I be denied access in my own country? It's still triggering. I'm at that stage where I can say, "Fuck you, fuck you all!"'[28] As an artist who regularly performs internationally, she is angered by the lack of access to performance spaces in her own country. When the piece finishes, a number of Fees Must Fall student activists take to the stage to re-end the performance themselves. They continue singing but no longer church hymns. They sing marching songs – a highly emotive call to protest action in a circle of terrific energy.

Howard Tuttle observes that, for Heidegger, 'Dasein [Being-there] possesses the pre-thematic ability to "be with" (Mitsein) others in an understandable relation.'[29] Nyamza's discourse is sweaty because it takes the intimate knowledge of coming from the church to reveal a Dasein that experiences being outside even in the space in which this being has grown up. 'It [the performance] was triggered by this need to perform in my own country. I felt hated at home,' Nyamza, says.[30] DE-APART-

HATE is about a realisation that the feeling of instability in South Africa's politics is the feeling of sitting on a seesaw bench. The work's emotional thrust creates a community, a *Mitsein*, that understands this chaos as the emergency of their own being in this shared space. It's a *Verstehen* (empathic understanding) that, through allegory, creates many meanings but results in *inkulumo-mpendulwano* (dialogue) that interacts with the variety of things-still-needing-to-be-protested.

According to Fischer-Lichte, 'the associative generation of meaning can ... be described as an instance of emergence.'[31] Visible responses from the audience in their emotive reactions to Nyamza's performance create a feedback loop that becomes part of the performance. In emergent performance, consciousness is located in an in-between space of making meaning outside of a merely rational state. Meanings are revealed to perception rather than willed into being. Consciousness interacts with the world, and the world – as the complex system that it is, one of chaos and paradoxical order – defies simple coherence. It is in this way that protest apprehends the world as something that can be changed, by placing the individual in an understanding of the macro-structure as something with which they are interwoven and can change by shifting their individual (micro) relation to it. A new possibility arises in defiance of the feeling that 'I can't believe I still have to protest this shit.' As Fischer-Lichte observes: 'The perceiving subjects find themselves on the threshold which constitutes the transition from one order to another; they experience a liminal state' between chaos and order.[32]

ELEGY: UKUKHULUMA (TALKING) IS NOT ENOUGH

First impressions: *Saturday, 11 February 2017. One of the womxn steps up but puts her hand over her mouth as she continues to make the single stream of sound. It is sore. I think: the pain is exceeding. She affects me with that shift. This same womxn, when she returns, stares at us intently as though she would pull out a knife and stab us if she had the weapon. She is like anger contained; because she is restricted to only making this single sound? The sound is relentless. Another womxn stands and stays longer than the rest, on the step. I ask myself: 'how long can one cry?'*

Personal journal entry, 11 February 2017

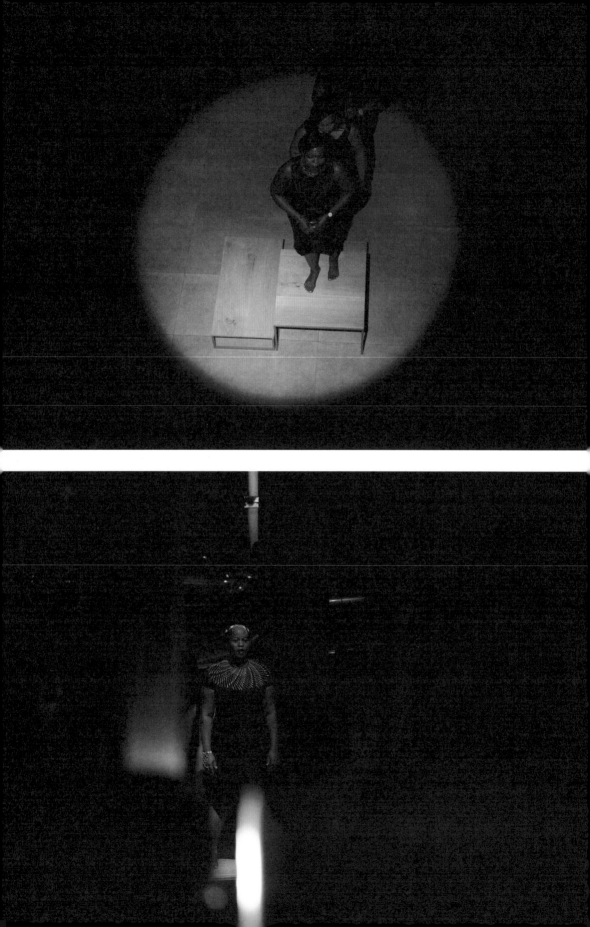

In Sylvia Walby's paper on the importance of complexity theory in understanding the interaction between the individual and social systems, she defines emergence as 'the relationship between micro- and macro-levels of analysis; and the concept of system.'[33] Walby goes on to argue that the micro and macro co-evolve rather than affect one another in a linear fashion. The interaction 'involves selection and temporality.'[34] Systems adapt to their environments by choosing what to respond to and this is temporal and dynamic. It does not occur in a predictable manner. 'The temporal lag in the changes within systems as a result of their interaction is not merely inevitable, but is key to understanding the nature of social change,' Walby continues.[35] It is for this reason that thinking around 'impact' needs to be reconsidered, and 'dynamic change' is offered in alignment with the idea of emergence.[36] Change can be quick and sudden. Change can also lag in time and force us to ask why we still have to protest the same thing after so long.

Elegy is a durational performance in which a small group of female vocal performers sustain a single note, one after another, in an act of mourning. Each iteration of the work is created in memory of a woman who has been killed in South Africa; the performance I observed was in commemoration of Noluvo Swelindawo who was brutally murdered in 2016. In an hour-long performance, six vocalists dressed in black walk barefoot up and down a two-step plinth. The vocalists sing one B-flat note in a continuous stream of sound, so that the note does not stop and start between each vocalist, but is sustained as a single, elongated vocalisation – 'a sung cry.'[37] The six womxn step up and down the plinth in a circular motion, their movement, as a group, mimicking the circularity of the sound. The notion of emergence in protest performance art is experienced in *Elegy* with fresh sweat. Like despair, the durational work is a form of performance that is both 'painful and liberating' in its lengthy duration.[38] During *Elegy* I asked myself, 'how long can one cry?'

Figure 7.3. and 7.4. Gabrielle Goliath, *Elegy - Noluvo Swelindawo*, 2017.
Courtesy Institute for Creative Arts.
Photograph by Ashley Walters.

Fischer-Lichte writes in a chapter entitled 'Emergence of Meaning' that 'perception affects the spectators physically ... But they do not "understand" it.'[39] Claude Lanzmann, the creator of the Holocaust film *Shoah*, writes about the work as a refusal of understanding – the only possible ethical framework when encountering trauma.[40] Even while her ethical position, in this regard, is guided by the work of Ahmed, Goliath shares this thought, which acknowledges that the ethics of presenting trauma require a sense of one's inability to stand in another's shoes.[41] *Elegy* can be experienced as an event of emergency where one cry rings like a siren for an entire hour. *Elegy* can cast you into an in-between state of feeling and meaning-making, of presence and representation, of the individual and the community. As an elegy, it is an expression of a feeling, grief, at the loss of

ELEGY
NOLUVO SWELINDAWO

Figures 7.5. Gabrielle Goliath, *Elegy – Noluvo Swelindawo*, 2017.
Courtesy Institute for Creative Arts.
Photograph by Ashley Walters.

the person being eulogised. As a protest against the deaths of the rape victims it honours, it puts meaning into the audience's hands, and it is those gathered who make meaning from their feeling, or not. It is protest that acknowledges that effect, like affect, is non-linear; and makes its protest gesture anyway.

Social change involves 'selection and temporality,' as Walby articulates. In *Elegy*, Goliath invokes and brings Noluvo Swelindawo's presence into the space. She also represents her by performing her absent-presence as a cry that is continuous. 'I sadly speak of *Elegy* as a work without end,' Goliath says as she ponders the idea that it cannot end until womxn, particularly womxn of colour, can exist in the world without fear of rape.[42] She speaks of the idea of 'global mourning' when she talks of having taken the work to the United States, and the

other subjectivities that suffer the scourge of rape, but acknowledges that, from her own subjectivity as a womxn of colour, 'certain bodies are more vulnerable than others. Certain subjectivities are just more vulnerable. They lead more precarious lives.'[43] Goliath mourns that 'violence subsumes subjectivity.'[44] The elegy, given with a single note, refutes easy consumption.

The ritual of commemoration is unlike a court testimony. It grieves for a lengthy period without pause. The sound seeps into a third space of being – a state of loss. The time given to the grief and the continuous siren it rings, along with the abrupt and unexpected ending, create the possibility of a space that stays with the loss rather than quickly, or rationally, attempting to resolve it. Noluvo Swelindawo's name is printed on the wall of the gallery. It is lit by a halo of soft gallery lighting and remains present throughout the piece. It reads as though she is the title of the piece and the author of the piece. Her existence and violent erasure is the very reason the work exists. *Elegy* creates space for reflection, the audience's reflection on Noluvo Swelindawo. The lament creates a critical space to consider how this subjectivity was erased, the significance of her naming and the refusal to forget her. The kind of protest Goliath produces is a 'return to that site of loss' that refuses to understand the pain with any simple cause-and-effect modality.[45] It is reflective.

Trauma defies logic. Goliath says that one cannot understand Noluvo Swelindawo's pain without going through it. In trying to write down a list of the feelings recalled from the event of *Elegy*, I could not source a single definitive emotive state to describe my experience. I could only attempt to imagine what Noluvo Swelindawo experienced in reality. During this work, the audience did not commiserate with their own song or sounds but stood, sat, or left the space in silence. *Elegy* is 'active resistance to the platitudes of knowledge, [and] this refusal opens up the space for a testimony that can speak beyond what is already understood.'[46] *Ukukhuluma* (talking) is not enough. In emotions lie the plethora of meanings we are yet to understand. Emotions reveal the excess of what we cannot understand. I discover, in the *Book of Human Emotions*, the word *fago*. It is, in Catherine Lutz's anthropological observations of the poetic grasp of life for the Ifaluk people, an emotion with no English equivalent: it '"is uttered in recognition of the suffering that is everywhere, and in the spirit of a vigorous optimism that human effort, most especially in the form of caring for others, can control its ravages."'[47]

Noluvo Swelindawo is specific. The paradox of interpreting *Elegy* through emotion is that, by returning to the site of loss, Goliath makes feeling *fago* possible

by calling on the spirit of the womxn whose identity and existence have been expunged. For her, 'it is a way of generating affect' by creating an encounter with the name, the story of the body that was erased.[48] It becomes a critical encounter to counter erasure, by invoking the absent-presence.[49] Goliath says she has to sound the call for her performers in telling them what they will be doing: '"You are going to sonically sound a body-form; an absent-presence,"' she tells them on first meeting. '"You are invoking through this performance an absent-presence that is an individual that you are commemorating." And that is where quite a shift happens.'[50]

The moment of asking a question for which there may never be an answer is one we may apprehend as a call to action. As Fischer-Lichte argues, 'Our emotions offer the most decisive motivation for our actions.'[51] The immeasurable emergence of actions generated by these performances of protest brings a different approach to how performance can be understood and how the emergency-that-is-being operates. It creates events of emotion that understand being-in-the-world as a thrownness and presents it from the sweaty space of being-outside-the-world. The necessity of emotion for action in a world of chaos and complexity makes the work as complex as the systems with which it interacts, the environ from which the work has itself adapted and emerged – South Africa. It is subjective and creates an event for being-with-the-world as a revolutionary congress where the individual can shift their perception of, and relation to, the world.

TRANSFORMATION

As Sartre writes, during the event of an emotion you perceive the world in a state of magic, and the affect colours not only the present conception of the already-passing moment; the future is painted in the colours of that emotion too.[52] It is this new hue of the future that engenders the need for change. In the revolution of being as a performative happening, the revolution occurs in a different orientation to the world. As Fischer-Lichte writes: 'When the ordinary becomes conspicuous, when dichotomies collapse and things turn into their opposites, the spectators perceive the world as "enchanted." Through this enchantment, the spectators are transformed.'[53] Transformation in performance takes place through the creation of a new reality, a new time, a new space that puts the world of the performance in immediate dialogue with the real world of emotion: magic.

Sartre invests in emotions a purposive method of consciousness for apprehending the world when the world cannot be understood in analytic ways. He stresses that 'emotion is not an accident, it is a mode of our conscious existence, one of the ways in which consciousness understands (in Heidegger's sense of *verstehen*) its Being-in-the-World.'[54] In performance art 'the world may also confront us as a nonutilizable whole; that is, as only modifiable without intermediation and by great masses. In that case, the categories of the world act immediately upon the consciousness, they are present to it *at no distance*.'[55] Protest and performance art have been in dialogue since the avant-garde performances of the 1960s. Protest collects a mass in order to manifest something new. The protest of performance art gives rise to emergent possibilities – a potential space for new forms of dialogue between protest and performance, participants and performers, and our being-in-the-world with our being-with-the-world. Its perception is sweaty. It engages us from a place of being-outside-the-world to create a dialogue from which the new emerges and transformation can occur, magically. In this performative event, we can ask who we are and defy understanding to analyse the world anew.

1. Tiffany Watt Smith, *The Book of Human Emotions: An Encyclopedia of Feeling from Anger to Wanderlust* (London: Profile Books, 2015), 82–83.
2. Rena Kurs, 'The Interface between Sartre's Theory of Emotions and Depersonalization/ Derealization,' *Journal of Rational-Emotive & Cognitive-Behavior Therapy* 35, no. 4 (2017): 5, accessed 7 August 2017, doi: 10.1007/s10942-017-0267-1.
3. Jonathan Rutherford, 'The Third Space: Interview with Homi Bhabha,' in *Identity: Community, Culture, Difference*, ed. Jonathan Rutherford (London: Lawrence and Wishart, 1990), 211.
4. Sara Ahmed, *Living a Feminist Life* (Durham: Duke University Press, 2017), 10.
5. Ahmed, *Living a Feminist Life*, 12.
6. Jane Duncan, *Protest Nation: The Right to Protest in South Africa* (Pietermaritzburg: University of KwaZulu-Natal Press, 2016), vii.
7. Duncan, *Protest Nation*, 1.
8. Jean-Paul Sartre, *A Sketch for a Theory of Emotions* (London: Routledge, 2002), 50–51.
9. Sartre, *A Sketch for a Theory of Emotions*, 52.

10. Sara Ahmed, *The Cultural Politics of Emotion* (Edinburgh: Edinburgh University Press, 2014), 2.

11. Nondumiso Msimanga, Journal, 11 February 2017.

12. Ahmed, *Living a Feminist Life*, 18–19.

13. Watt Smith, *Book of Human Emotions*, 69.

14. Martin Heidegger, *Being and Time*, trans. John Macquarrie and Edward Robinson (Malden: Blackwell, 1962).

15. Richard Polt, 'Meaning, Excess, and Event,' *Gatherings: The Heidegger Circle Annual*, 1 (2011): 36, accessed 16 May 2017, doi: 10.5840/gatherings201112.

16. Ahmed, *Living a Feminist Life*, 13.

17. Polt, 'Meaning, Excess, and Event,' 26–53.

18. Ahmed, *Living a Feminist Life*, 18.

19. Heidegger, *Being and Time*.

20. Ahmed, *Living a Feminist Life*, 13–14.

21. Gordon Institute for Performing and Creative Arts (GIPCA), *Live Art Festival 2014 Programme* (Cape Town: GIPCA Live Art Festival, August–September 2014), 14.

22. 'Womxn' is an inclusive gendered spelling. It acknowledges trans, femme, and othered womxn; rather than just females.

23. Ahmed, *Living a Feminist Life*, 7.

24. Leviticus 18:22 (King James Version).

25. Mamela Nyamza, interview with the author, 23 March 2017.

26. Nyamza, interview.

27. Erika Fischer-Lichte, *The Transformative Power of Performance: A New Aesthetics* (London: Routledge, 2008), 145.

28. Nyamza, interview.

29. Howard N. Tuttle, *Human Life is Radical Reality: An Idea Developed from the Conceptions of Dilthey, Heidegger, and Ortega y Gasset* (New York: Peter Lang, 2005), 115.

30. Nyamza, interview.

31. Fischer-Lichte, *The Transformative Power of Performance*, 143.

32. Fischer-Lichte, *The Transformative Power of Performance*, 148.

33. Sylvia Walby, 'Complexity Theory, Globalization, and Diversity,' paper presented to conference of the British Sociological Association, University of York, 2004, 1, accessed 23 March 2017, http://www.lancaster.ac.uk/fass/resources/sociology-online-papers/papers/walby-complexityglobalisationdiversity.pdf.

34. Walby, 'Complexity Theory', 9.

35. Walby, 'Complexity Theory', 9.

36. Walby, 'Complexity Theory', 9–10.

37. Gabrielle Goliath, in interview with the author, 31 March 2017.

38. Watt Smith, *Book of Human Emotions*, 70.

39. Fischer-Lichte, *The Transformative Power of Performance*, 156.

40. Cathy Caruth, *Trauma: Explorations in Memory* (Baltimore: Johns Hopkins University Press, 1995), 154.

41. Goliath, interview.

42. Goliath, interview.

43. Goliath, interview.

44. Goliath, interview.

45. Goliath, interview.

46. Caruth, *Trauma*, 155.

47. Catherine Lutz quoted in Watt Smith, *The Book of Human Emotions*, 105–106.

48. Goliath, interview.

49. Goliath, interview.

50. Goliath, interview.

51. Fischer-Lichte, *The Transformative Power of Performance*, 154.

52. Sartre, *A Sketch for a Theory of Emotions*, 54.

53. Fischer-Lichte, *The Transformative Power of Performance*, 180.

54. Sartre, *A Sketch for a Theory of Emotions*, 60–61.

55. Sartre, *A Sketch for a Theory of Emotions*, 60–61.

Space is the Place and Place is Time: Refiguring the Black Female Body as a Political Site in Performance

SAME MDLULI

This chapter explores the idea of black visuality as located within the Rhodes Must Fall (RMF) and Fees Must Fall (FMF) movements of 2015 and 2016. Both movements were driven by student-led protest actions that took place across South African universities, calling not only for the fall of colonial symbols, such as the Cecil John Rhodes statue on the University of Cape Town (UCT) campus, but, more broadly, for free, quality, decolonised education. Previously, many historically disadvantaged universities protested for free education, but the 2015 and 2016 student protests were significant because, for the first time, this call manifested across the country's major institutions of higher education. In both movements it became clear that the students most affected were black students from previously disadvantaged homes as well as middle-class backgrounds. It also became evident that these students faced being excluded on the basis of race and class, and later, as the protests evolved, on the basis of gender. In an attempt to interrogate the manner in which these intersecting issues were rendered either visible or invisible, I employ what African American visual culture scholar Nicole Fleetwood describes as 'being *moved* by black visuality.'[1]

The notion of black visibility is discussed here in relation to the black female body and its significance as a political site that underscores what Fleetwood sees as 'a clear and visceral moment of being *moved* by black visuality.'[2] In this chapter, black visuality is interrogated through the lens of 'performativity' – a term used

in this context to refer to instances or interventions that push beyond and start to disassemble organised or structured performance pieces. I am interested in the way in which black women's bodies, in particular, acquire political agency in such interventions. Black visuality is, however, used cautiously in order to explore why it may be a problematic and dangerously over-generalised concept. One of these cautions is the use of the word 'black' as a loosely descriptive term to refer to a particular grouping of people. The word has come to encompass many different meanings for different people who identify as black.

The performances discussed in this chapter occurred during the course of the 2015 and 2016 RMF and FMF protests at the campuses of UCT and the University of the Witwatersrand (Wits). While students within the universities' vicinities staged most of the performances, some performances took place outside the campus grounds – a spillage that became emblematic of the student movements' transcendence of the confines of the institution. The racial and class divides that permeate South Africa's social fabric came under the spotlight as a result. The protests also drew attention to the fact that it is black students who are most likely to face financial exclusion precisely because of the social and economic imbalances that generate race and class divides. The notion of black visuality is applied here to the South African context against the backdrop of the student protests as they prompted a rigorous dialogue, linked to global movements such as Black Lives Matter, around persisting forms of racism.

The connections between the history of blackness in the United States of America and South Africa are contextualised using Fleetwood's theorising in *Troubling Vision: Performance, Visuality, and Blackness*, which explores the persisting perception of blackness as a problem in public discourse. Although Fleetwood does not make an explicit link with the South African context, her scholarship provides a constructive way of examining how race and gender, in relation to blackness, are made visual through modes such as film, visual art and performance. Her interrogation of performance and visuality is thus employed because of the way in which it speaks to a collective consciousness that recognises black bodies as representative of a certain kind of violence. Fleetwood calls attention to 'the weight placed on black cultural production to produce results, to do something to alter a history and system of racial inequality that is in part constituted through visual discourse.'[3]

At the core of Fleetwood's study is a probing of 'how blackness becomes visually knowable through performance, cultural practices, and psychic manifestations,' and 'the role of visuality and performance together as they produce black subjects in the public sphere.'[4] In forwarding her thesis that the 'discourse of blackness is predicated on a knowable, visible, and performing subject,' she examines how 'the process of deciphering itself is a performative act of registering blackness as visual manifestation.'[5] Similarly, I argue that the examples referred to in this chapter produce and manifest blackness and black subjects via performative acts. In all instances except one, I note that this idea of blackness and the black subject is made visible by paradoxically painting the black body in white. The discussion of Fleetwood's visual analysis of race and class features in this chapter because it extends beyond the discernible connection between the USA and South Africa; it is anchored in an idea of blackness as something that 'fills in space between matter, between object and subject, between bodies, between looking and being looked upon,' and a commonality that is shared between both locales.[6]

'Blackness,' Fleetwood notes, 'troubles vision in Western discourse.'[7] In each of the performances discussed below, the black female body takes centre stage and emerges as a prominent figure, as 'subject matter,' discussed in relation to space and experience. This sense of space and experience is expressed in Fleetwood's articulation of blackness as something that is both disruptive and familiar – a conflict that I suggest enables a critical exploration of unscripted, spontaneous and unstructured performance interventions, which are interrogated here alongside works of live art conceived and performed more intentionally. In both instances, the position of the black female body is asserted, and the trope of white (in)visibility is interrogated.

In addition to Fleetwood's theorising, this chapter draws on Faedra Chatard Carpenter's writings in *Coloring Whiteness: Acts of Critique in Black Performance* – particularly her emphasis on how whiteness is normalised – in order to explore the American–South African connection through a theoretical framework that examines the representation of the black female body and the institutional and structural ways in which it remains a site of oppression, pain, trauma, violence and suffering.[8] This analysis seeks to reveal how black bodies – particularly black female bodies – embody the politics of representation.

Figure 8.1. Remember Khwezi protest at the Independent Electoral Commission results ceremony, 2016. Courtesy *The Citizen*. Photograph by Jacques Nelles.

In considering events as performance, it is useful to recall the Remember Khwezi protest, staged at the Independent Electoral Commission (IEC) results ceremony in 2016. As then President Jacob Zuma took to the podium to deliver a speech on the African National Congress's (ANC) elections performance, four young black women – Simamkele Dlakavu, Tinyiko Shikwambane, Naledi Chirwa and Amanda Mavuso – stood in front of the stage to enact a silent demonstration. Each woman held up a placard in remembrance of 'Khwezi' (Fezekile Kuzwayo) whom Zuma was acquitted of raping in 2006 after a controversial trial in which Khwezi's sexual history was publicly interrogated. Together, the signs, which the protesters held throughout Zuma's speech, read: 'I am 1 in 3 #, 10 yrs later, Khanga, Remember Khwezi.'[9] I suggest that this act of disruption, played and replayed on national television and social media, is an apt point of departure for thinking about

live art in its unpredictable and impulsive articulations, as well as the performative discourse that has emerged through recent protest action.

The Remember Khwezi protest had precursors in demonstrations such as RUReferenceList that initially began as a Facebook post and subsequently went viral, erupting in protest action in which young black (and white) women displayed anger against gender-based violence, rape and rape culture.[10] However, the Remember Khwezi protest was significant for its implication of a high-profile figure, and its disruption of an official event. The protest can be seen congruently with the UCT intervention by three young black women that occurred towards the end of the FMF protests, discussed in more detail below. Both demonstrations highlight the complex interlinking of power, gender and social politics, and the position of black women in this relationship.

The FMF and Remember Khwezi protests, and the UCT art intervention are suggestive of a new kind of performance language that can be observed in other moments of 'live-ness' and unscripted performativity, such as Tashala Dangel Geyer's YouTube performance.[11] Geyer, an African American woman, painted her body with white paint in a home video that went viral in 2016. Geyer's act of literally whitening blackness not only speaks to Carpenter and Fleetwood's examination of black bodies as social and political sites, but also references Frantz Fanon's *Black Skin, White Masks* in a manner that has deeply layered implications in the postapartheid South African context. The performance paradoxically externalises the internalised white gaze and the attempt to aestheticise blackness for white visual consumption. What is at issue in these works are the kinds of tactics and performative tools employed in highlighting issues of inequality and violence, and – in the case of the student interventions – strategies for applying pressure in order for demands to be met.

Another intervention with symbolic significance took place during the 2015 protests when white students at UCT formed a human shield around their black fellow protesters in order to prevent police from using violence to break up the demonstration.[12] At this symbolic moment, perhaps more than any other, students realised the significance of their bodies in protest actions. The idea of utilising physical bodies to highlight the perpetuation of violence towards black students equally revealed the explicatory nature of whiteness and its invisibility in what Carpenter refers to as the 'presentation of whiteness as normative.'[13] This moment

of performativity exists within the context of the visibility/invisibility paradox. In other words, the ways in which the black female body is employed as a site of political action and social activism exposes a range of contradictions that make the black female body an important interlocutor in apprehending the often-violent environments that such bodies experience, and in which they are made invisible. In concluding, I look at the role of media and social media in the formation of political action and activism. I suggest that, although these platforms have enabled a widespread awareness around issues of race, gender and violence, they have also produced a particular visual consumption of the black female body.

The ideological work of delegitimising women's place in the public sphere has, according to Erica Rand, remained invisible through cultural products such as art, music, theatre and film.[14] Examining the project of depoliticising women, Rand reveals the critical strategies employed in classical imagery to disempower and separate women from political thought. This, she argues, is posited through a portrayal of women as divested of agency in the works of French painters Jacques-Louis David and François Boucher.[15] In works such as the *Intervention of the Sabine Women*, Rand notes how David 'both registers and works to deauthorize Revolutionary female political activism' at a time when women were visible in politics.[16] This is an idea that resonates with the gender struggles that emerged in the FMF movement. During the student protests, a group of young black female activists noted how men were dominating the spaces and conversations where most of the mobilisation was taking place. Women and queer people were often assigned to domestic and administrative work within the movement, further emphasising the ideology that women and queer people belong apart from politics.

The political content of David's paintings underscores the relationship between power, gender and politics. In the case of the student protests, these interlinking issues were brought to the fore through the fact of female power in a male-dominated realm. At the height of the FMF protest actions, a group of radical black feminists emerged who sought to challenge the patriarchy and misogyny within the movement. #MbokodoLead was started on 17 October 2015 by a group of young black female student activists seeking to 'create safer spaces where black women's ideas, political agency and being would be valued.'[17] A divide in the leadership became clear, and a fracture in the mobilisation of students emerged – at the core of which was the disruption that black women, queer and transgender people

inserted into the political space. Intersectionality was therefore often evoked to illuminate the role of black women and queer bodies engaging in extremely restrictive and policed spaces in which men traditionally dictate how and when women are rendered visible or invisible.

Protest action intensified in 2016 against the announcement of a fees increase, resulting in a heavy police and private security presence on campuses across the country. In one of the most brutal confrontations between students and police at Wits University, three women removed their tops and raised their arms in a gesture of surrender against the violent measures police were taking to disperse students outside of the University's Great Hall – measures that included the firing of rubber bullets and stun grenades. The images of the women garnered much social media attention, prompting a range of responses from social commentators who viewed the demonstration, variously, as morally questionable,[18] an act of bravery, and a publicity stunt. What became significant about the debates was the degree of attention they received, highlighting the conflicting perceptions of the visual representation of black women in mainstream media. The repeated circulation of the women's topless torsos seemed to nullify the radicalism of their act through the lens of spectacle, rather than magnifying the issues it sought to raise. The removal of clothes as a form of protest is by no means a novelty, particularly in feminist protest action, but in this instance the act evoked a reaction that had more to do with the visibility of the black female body than its invisibility. This is because black women in South Africa are not meant to be visible.

Carpenter's examination of a theatre adaptation of Toni Morrison's novel *The Bluest Eye* offers a useful lens through which to interrogate the invisible norm of whiteness and the manner in which it functions in South Africa. Carpenter points to how this theatre adaptation 'readily utili[zes] physical bodies and design elements to suggest symbolic meaning.'[19] She notes, too, that symbolic meaning is accentuated by the way in which the play 'purposefully exploits the *absence* of these types of visible elements to comment on racialized *in*visibility.'[20]

In the South African context, discussion about whiteness and racial invisibility has taken place largely through diversity centres embedded within institutions, such as the Centre for Diversity Studies, and Drama for Life in the field of Applied Drama and Theatre – both at Wits University. It can be argued that, although these institutions have created platforms where race discourse can be discussed

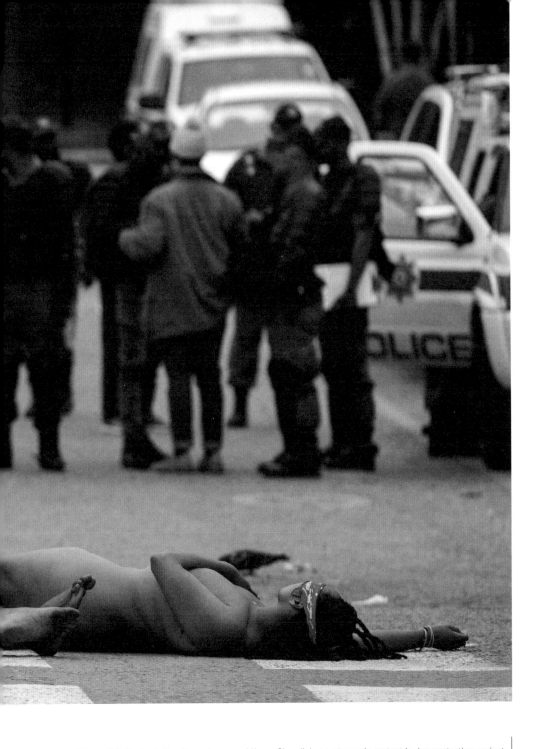

Figure 8.2. Students Qondiswa James and Nsovo Shandlale enact a nude protest in demonstration against institutional racism at UCT and state-sanctioned violence on the University's campuses, 2017.
Courtesy GroundUp.
Photograph by Ashraf Hendricks.

in informed spaces, the dialogue they create tends to neutralise black discourse by glossing over it with ideas of multiplicity, diversity and transformation. Such institutions have thus become complicit in further silencing and sidelining scholarship centred on black discourse. While there is a substantial amount of scholarship emerging from these institutions, it is not entirely clear what impact they have had on public dialogue around racial difference, racial identification and black discourse.

The performances discussed above and below evoke a particular kind of history of the performative role of the black female body in political action, but also of how it is employed as a tool for provoking and confronting trauma and discomfort, and sometimes defusing violence. I approach these issues by exploring gender politics and thinking informed by the culture of gender politics in both past and present political movements.

During the RMF and FMF protests, students often adopted strategies that came in the form of an occupation, a blockade of roads, or a complete shutdown of specific key areas within the university premises, such as administration blocks and libraries. This was coupled with a conscious effort to provide political education, which in many instances came through creative modes of self-expression, such as performances and live art. These artworks commented on the gender dynamics of the student movement, but also the violent nature of the response to the student protests. More importantly, they illustrated the criticality of gender in politics, showing that it does not only play a role in how political action is organised but also informs the way in which political action is executed.

Performativity, in its reading here as unscripted performance, intersects with the history of black discourse and political commentary on blackness and black subjectivity, but it also creates a space where intersectionality is highlighted and therefore illustrates that blackness cannot be read through the singular lens

Figure 8.3. Demonstration at the UCT University Assembly on Jameson Plaza, 2017.
Courtesy VARSITY News.
Photograph by Thapelo Masebe.

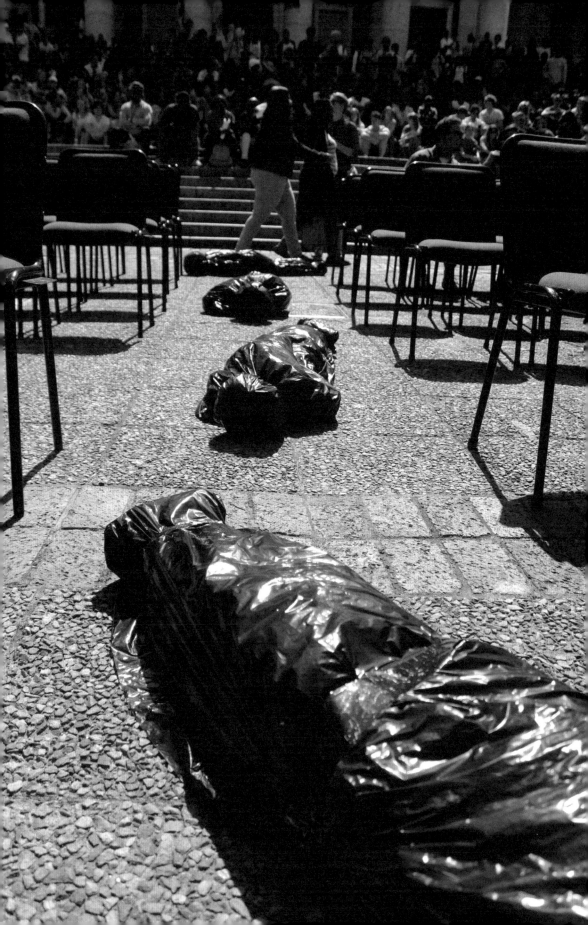

of race. The intersections that occur in the history of blackness in the USA and South Africa resonate through various expressive modes, including the inception of jazz, the Civil Rights Movement and, more recently, Black Lives Matter. The recent resurgence of the conversation between black struggles in the USA and South Africa, primarily via social media, has signalled a renewed approach for black cultural studies. The connection has intensified and mobilised beyond a geographical and historical link between the two locales; the inheritors of this connected history are, in some sense, marked by a cultural and political moment in which critical intellectual black thought has taken precedence. The performance works that occurred during 2015 and 2016 thus belong within a broader picture of mass critical awareness around the representation of black lives, race relations and gender politics, and demonstrate how this political awakening erupted as a result of the persisting violence of the socio-economic climate in both locales.

The similarities between these two geopolitical settings is noted by art curator and writer Okwui Enwezor, who points out that 'the uncanny resemblance of these characterizations [of the histories of both the United States of America and South Africa] is not an accident.'[21] This, he explains, is because 'they are both founded on blackness as anathema to the discourse of whiteness; whiteness as a resource out of which the trope of nationality and citizenship is constructed, and everything else that is prior is negated, defaced, marginalized, colonized.'[22]

Enwezor's observation of the South African context reveals the complexities of navigating a matrix of social and cultural imbalances based on race and racial difference. He observes that, since the democratic dispensation of 1994, whiteness has formulated 'the charged descriptive detail of what strikes at the mortal heart of the "New South Africa."'[23] He notes a need to examine the 'new uses and revindication of whiteness (in subdued and barely registered forms) as an idiom of cultural identity, that is, as a renewed and authoritative presence in the country's iconographic text.'[24] Enwezor is not only cautioning against the construct of the notion of the 'New South Africa' through whiteness; his statement also points to the ways in which the idea itself has developed along deepening racial lines. These racial lines have defined the cultural norms and practices that determine the representation of the other, and established what Enwezor describes as the 'disjunctive, uneasy peace of the "New South Africa."'[25] His description is coupled with an inquiry into 'what images in a decolonizing South Africa should look

like,' questioning 'who has the right to use them,' and who determines 'what the authorizing narrative ought to be.'[26] Enwezor points out that discussions around the use of the black body in art can serve as an opportunity to find 'an ethical ground to use its index as a form of discursive address, for radical revision, as well as to unsettle the apparatus of power that employs it as a structurally codified narrative of dysfunction.'[27] The performances under discussion here stage this work of unsettling apparatuses of institutional and ideological power by interrogating how the black female body becomes 'visually knowable.' Blackness as a kind of performance language common to the interventions noted here resists what Fleetwood calls the *'visual field that structures the troubling presence of blackness.'*[28] In this view, live art is a tool used by creative activists to engage in decolonial work, revising dominant visual narratives and representational practices, and confronting present conflicts and their contradictions.

The RMF and FMF movements made racial lines in South Africa glaringly visible by polarising public opinion in support of, and in opposition to, protest action. The movements also signalled the gradual erosion of the rainbow nation ideal, which envisaged diversity and multiculturalism without radical transformation. Fallist rhetoric has since been co-opted by other movements, such as the Zuma Must Fall marches of 2016 and 2017, suggesting the appropriation and tempering of radical black discourse to serve broader political campaigns.

The term 'fallism' has come to encapsulate a dismantling of institutional racism, and the ideological and physical inheritance of colonialism and apartheid. Fallism is not only synonymous with these movements; it is a term that describes an ideological moment and the struggle to obtain free, quality and decolonised education. It is also important to note that the term has since been used by other groups and political movements, such as #zumamustfall, #guptasmustfall, #datamustfall. There are numerous other student activists that have since defined themselves as fallist in solidarity with the movements. Of all the recent -isms in South Africa, the concept of fallism has been most powerfully influenced by an insurgence against structures of institutional power that have an economic and political hold over ordinary citizens.

Each of the performances of significance to my study challenges the notion of institutional power and public culture. The UCT art intervention and Geyer performance, in particular, enact a troubling accenting of blackness through

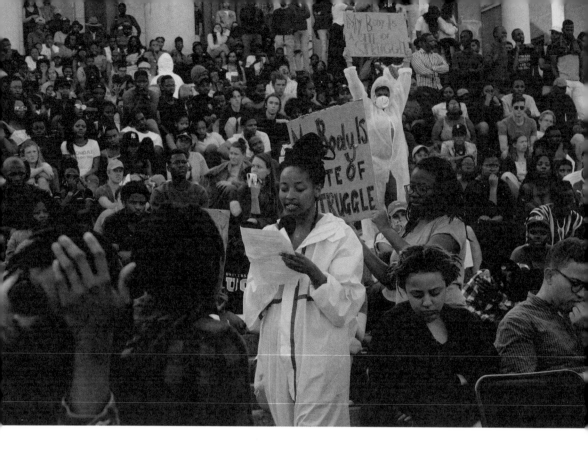

Figure 8.4. Demonstration at the UCT University Assembly on Jameson Plaza, 2017.
Courtesy VARSITY News.
Photograph by Thapelo Masebe.

a crude pursuit of whiteness, satirically (and absurdly) performed in a manner that shockingly, and quite literally, demonstrates the erasure of blackness. This erasure inevitably intersects with specific histories, colonial narratives and taxonomic archives. It is at these intersections that, although not explicitly stated in the performances, I observe questions of an assumed reading of blackness as homogenous, which furthermore evokes Steve Biko's 'quest for a true humanity.'[29] Black consciousness and the quest for a true humanity, Biko explains, is about 'examining why it is necessary for us to think collectively about a problem we never created.'[30] By 'us' Biko is not only referring to black people but humanity as

a whole, and in this sense, he alienates whiteness as something that is inhumane and socially constructed to privilege one set of people economically.

The instances of performativity in which I am interested arise out of a deeply heteronormative, patriarchal and racist system. 'Blackness and black life,' according to Fleetwood, 'become intelligible and valued, as well as consumable and disposable, through racial discourse.'[31] These codes of understanding blackness, Fleetwood suggests, not only become synonymous with blackness in particular ways but do so with a consciousness that 'investigates the productive possibilities of this figuration through specific cultural works and practices, including documentary photography, drama and theatre, performance-based photography, advertising and entertainment culture, and digital media art.'[32] Again Fleetwood is here referring to a particular understanding of cultural work and practices, but one which can be applied to the local context. The interventions presented in this chapter are similarly considered as cultural works and practices that could offer and unravel possibilities for new figurations of understanding the notion of blackness and its subjectivity.

In the above-mentioned YouTube video, Geyer's troubled black figure is evoked through performativity. The video, lasting approximately 12 minutes, was first posted during the protests taking place in a number of American cities, including Tulsa and Charlotte, in the wake of increasing cases of police brutality towards, and killings of, black people. While Geyer's intervention is not a performance piece in the conventional sense, it is important for this discussion as a performative response to a racially and politically charged moment. It is an interesting example, too, of an artwork situated at an ambiguous point on the continuum between an impulsive happening informed by its political and cultural context, and an intentionally choreographed, conceptualised and scripted piece that operates within the visual codes of a more traditional theatrical setting. The video also functions as a reminder of the role and influence of social and digital media. The fluidity of the performance is in tune with the politics of being, and the oscillation between the public and the private. It is illustrative of the way in which the live, performing body manoeuvres between these two spaces, demanding a more conscious response from its audiences in both the physical and virtual realms.

Geyer posted the video of herself on 27 September 2016, taken in what looks like her living room, and shot from a cell phone camera. Its home recording quality

gives a domestic feel, placing it obscurely between the realms of the private and the public. In the video, Geyer paints her entire body white while remaining in dialogue with the audience, speaking into the cell phone camera and reciting a monologue of protest in which she repudiates blackness, but also literally erases it through the act of whitening her skin. Geyer's performance is a deeply political act that makes visible what Fleetwood calls 'the affective power of the circulation of blackness'[33] – the codes that are central to the way in which blackness is produced and reproduced through visual discourse. She suggests that, in order to understand why blackness is troubling to the 'dominant visual field,' a deep consideration of 'the very definition of blackness as problem' is required.[34]

Three young black women, who were at the time students at UCT, echoed Geyer's performance on 21 November 2016. The performance took place shortly after the UCT campus shut down following the suspension of all examinations. In this performance, the students are seen with their bodies painted white with what appears to be either paint or Xhosa traditional powder; their breasts and legs are exposed. The two performances resonate with each other in their visual manifestation of blackness, particularly in the context of the protest. Geyer and the three students' use of white paint to whiten blackness is an act of parody that renders the black female body both invisible and hypervisible. But the performances also present what Carpenter views as an 'opportunity to dramatize the everyday ways in which racial imaginings shape our aesthetics and aesthetics shape our racial imaginings.'[35]

In this sense, the performances address salient issues around race, class and gender based on an aesthetic idea of black invisibility and hypervisibility. In the case of Geyer, the black female body is made hypervisible by the theatrical nature of the performance, as well as its circulation on social media. In the case of the UCT art intervention, the black female body is rendered invisible, highlighting the vulnerability of black women in institutional structures that work to suppress their participation in academic, political and social issues.

These performances work with cultural motifs that engage with a range of approaches centred on interrogating what Fleetwood defines as the 'troubling presence of the black female body both to dominant public culture and to black masculinist debates about race, subjectivity, and visuality.'[36] One of these motifs is the use of performance as a visual language that articulates how the black female

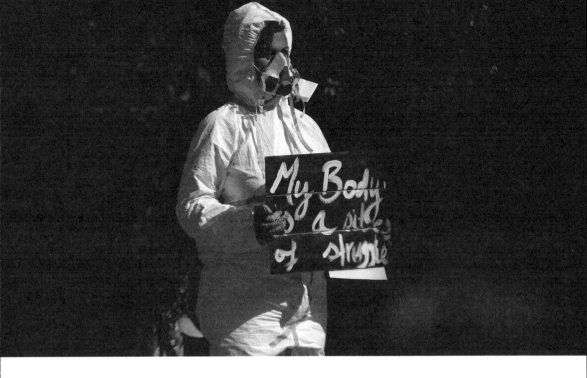

body becomes a political site that in many ways subverts the narrow and restrictive definitions of race and gender.

The application of white paint stages a reinscription of trauma and damage as viewers are made to witness a violent erasure of black identity. Both performances are thus instances in which the black female body exploits its own agency as a tool for resistance and protest action against institutional power. In the visual documentation of the 2016 UCT art intervention, the institutional authority is represented by the colonial building hovering in the background – the specific positioning of the performance no doubt intentional. Next to the women are a number of handwritten placards with messages like '#whiteprivilege' and others

detailing the racial statistics for unemployment, university enrolment, professional wages and access to free education. The performers stand firmly like statues or monuments, mimicking the grand palisade of pillars behind them. While their postures may be seen to represent the unwavering power of black womanhood against white institutional power, their stark white nakedness suggests a sense of vulnerability that speaks to the prejudice and violence inflicted on black female bodies by a racialised society.

In the beginning of 2017, South Africans became more socially conscious of the crisis of the scourge of violence against women and children. This was prompted by many cases of missing (mainly young, black) women made visible on social media. In many of these cases, the missing women were killed by a partner or someone close to them. As a result, #MenAreTrash became a form of protest that spread rapidly online. The hashtag not only sparked a heated debate, with some men responding with the sentiment that 'not all men' are violent, but it also resulted in a march in Tshwane under the banner 'Not in My Name.'

During the march, a woman dressed in a white wedding dress led the procession of both men and women. Her face and arms painted white, she carried the South African flag, a broken umbrella and a suitcase. The details of this performance are vague except that the woman seemed to wear white as a symbol for those who had experienced gender-based violence. While this may be interpreted as a gesture to eliminate any racial connotation, the painted whiteness at the same time brings attention to the question of race when it comes to violence against women. The white paint could also be a reference to innocence and purity, or an ironic rendering given that, statistically, it is black women in South Africa who most frequently experience gender-based violence. In photographs, she seems defiant as opposed to vulnerable, determined rather than timid; she even appears confrontational.

The impact that instances of raw performativity, such as those discussed in this chapter, have on public discourse often goes unnoticed. News coverage and public debate focus on the protest action itself, and academic analyses of live art in South Africa have tended to overlook performative eruptions in politically charged moments, as well as the visual discourse to which they respond and the performative language they articulate. Yet it is through these uncontained performances that the effects of systematic racism are revealed, and the authoritative imprint of whiteness, both institutionally and in public spaces, is made manifest. Never before in postapartheid South Africa have these established

systems and barriers been so severely confronted and deconstructed as in the RMF and FMF movements. Never before has the intersection of racial, class and gender inequalities been more evident than in the spaces of violence and brutality prompted by the student protests.

In the Remember Khwezi protest, the erection of the white human shield, the UCT art intervention and Geyer's YouTube performance, the black body – and particularly the black female body – disrupts public space as a contested site of struggle; remembering becomes a political act; and, in its re-enactment, the physical and psychological appropriation of black bodies and voices is laid bare. The appearance of the black female body in the public sphere is embroiled with the visible/invisible dialectic – as illustrated by the performances discussed here, which incite the viewer to participate consciously in the moment. This moment is defined by a sense of fluidity and ephemerality that has become significant to South African public discourse. Performativity in unscripted spaces is in itself a political act because of the spatial ideology and legacy of apartheid; it is a form of practice that actively and visibly decolonises space.

The theorists referenced in this discussion offer useful tools with which to understand the evolving question of what it means to be a black subject and, particularly, what it means to be a black subject who is also a woman. Historically, black women have rarely featured as agents of political action. In South Africa, this is furthermore entangled with the limited portrayal of the struggle narrative, which marks the political action of women as narrowly represented by the Women's March of 1956. Since then, black women have entered the public domain as political subjects who continue to push boundaries of race, gender and class that move beyond dominant structures of defining blackness and its visibility. The performances discussed here are a significant part of that visuality.

1. Nicole R. Fleetwood, *Troubling Vision: Performance, Visuality, and Blackness* (Chicago: University of Chicago Press, 2011), 3. Although Fleetwood makes this statement in recalling filmmaker Spike Lee's *Do the Right Thing*, it is her justification for beginning with this memory of watching the film that sets the contextual framework for how blackness will be referred to in this chapter; that is the looming consciousness.

2. Fleetwood, *Troubling Vision*, 3.
3. Fleetwood, *Troubling Vision*, 3.
4. Fleetwood, *Troubling Vision*, 6.
5. Fleetwood, *Troubling Vision*, 6.
6. Fleetwood, *Troubling Vision*, 6.
7. Fleetwood, *Troubling Vision*, 6.
8. Faedra Chatard Carpenter, *Coloring Whiteness: Acts of Critique in Black Performance* (Ann Arbor: University of Michigan Press, 2014), 80–116.
9. Greg Nicolson, '#RememberKhwezi: "It worked like a beautiful theatre piece,"' Daily Maverick, 8 August 2016, accessed 1 September 2017, https://www.dailymaverick. co.za/article/2016-08-08-rememberkhwezi-it-worked-like-a-beautiful-theatre-piece/.
10. Deborah Seddon, '"We will not be Silenced": Rape Culture, #RUReferencelist, and the University Currently Known as Rhodes,' Daily Maverick, 1 June 2016, accessed 10 November 2017, https://www.dailymaverick.co.za/opinionista/2016-06-01-we-will-not-be-silenced-rape-culture-rureferencelist-and-the-university-currently-known-as-rhodes/#.WrtcfSN94nU.
11. 'Flat Earth Black Woman Paints Herself White,' YouTube video, 2:24, posted by Lawrence Wright, 25 September 2016, accessed 15 March 2017, https://www.youtube. com/watch?v=b_U8-Rv35G8.
12. Tsholofelo Wesi, 'UCT Protesters Call for "White Human Shield,"' *The Citizen*, 20 October 2015, accessed 10 November 2017, https://citizen.co.za/news/south-africa/827670/uct-protesters-call-for-white-human-shield.
13. Carpenter, *Coloring Whiteness*, 83.
14. Erica Rand, 'Depoliticizing Women: Female Agency, the French Revolution, and the Art of Boucher and David,' in *Reclaiming Female Agency: Feminist History After Postmodernism*, eds. Norma Broude and Mary D. Garrard (Berkeley: University of California Press, 2005), 144.
15. Rand, 'Depoliticizing Women,' 143–145
16. Rand, 'Depoliticizing Women,' 144.
17. Simamkele Dlakavu, '#FeesMustFall: Black Women, Building a Movement and the Refusal to be Erased', in *Rioting and Writing: Diaries of Wits Fallists*, eds. Crispen Chinguno, Morwa Kgoroba and Sello Mashibini et al. (Johannesburg: Society, Work and Development institute (SWOP) and Wits Press, 2017), 110–116.
18. Thando Kubheka, 'Top Cop Questions Topless Tactic during Wits Protest,' Eye Witness News, 5 October 2015, Accessed 10 November 2017, http://ewn.co.za/2016/10/05/Khomotso-Phahlane-slams-bare-breasted-female-during-Wits-protests.
19. Carpenter, *Coloring Whiteness*, 84.

20. Carpenter, *Coloring Whiteness*, 84.

21. Okwui Enwezor, 'Reframing the Black Subject: Ideology and Fantasy in Contemporary South African Representation,' in *Race-ing Art History: Critical Readings in Race and Art History*, ed. Kymberly N. Pinder (New York: Routledge, 2002), 372.

22. Enwezor, 'Reframing the Black Subject,' 372.

23. Enwezor, 'Reframing the Black Subject,' 372.

24. Enwezor, 'Reframing the Black Subject,' 372.

25. Enwezor, 'Reframing the Black Subject,' 378.

26. Enwezor, 'Reframing the Black Subject,' 377.

27. Enwezor, 'Reframing the Black Subject,' 388.

28. Fleetwood, *Troubling Vision*, 3.

29. Steve Biko, *I Write What I Like: A Selection of his Writings* (London: Bowerdean Press, 1978), 96–109.

30. Biko, *I Write What I Like*, 96.

31. Fleetwood, *Troubling Vision*, 6.

32. Fleetwood, *Troubling Vision*, 6.

33. Fleetwood, *Troubling Vision*, 6.

34. Fleetwood, *Troubling Vision*, 7.

35. Carpenter, *Coloring Whiteness,* 92.

36. Fleetwood, *Troubling Vision*, 9.

03.

Rethinking the Archive, Reinterpreting Gesture

don't get it twisted: queer performativity and the emptying out of gesture

BETTINA MALCOMESS

The process of disidentification scrambles and reconstructs the encoded message of a cultural text ... and recircuits its workings to account for, include and empower minority identities and identifications.

José Esteban Muñoz,
Disidentifications: Queers of Color and the Performance of Politics

At an intersection in the Johannesburg inner city, a runner dressed in spandex bends down and enacts a series of provocative, erotic dance movements, as if on a nightclub stage. Inside a Pentecostal church near my studio, where I write this text, I have witnessed the exorcism of female congregants, their bodies convulsing while they speak in tongues, violently pulled and pushed by male priests, sometimes held by their hair. On Jeppe Street, transgender shop singers beckon to passersby to enter retail stores, hailing them in a register between song and speech on bass-distorted sound systems.

Where does a performance end and the self begin? How do these everyday gestures embody our visible selves, inscribing our identities within the symbolic structures that determine and set limits to how we are named, the way we move and the way we look? These modes of everyday performativity are both ciphers of our social belonging and our placement in a scene of visibility: the conditions of being seen. We are placed by the gazes of those who see us, but also by those who fail to see us, who misread, misplace, or make us invisible. And I too am responsible

for how I see, both as a white body out of place here in inner-city Johannesburg but also as the holder of the power of inscription within this text. Each of the descriptions above refers to a moment of witnessed performativity – a word, an action, a gesture – that, in its enactment, potentially produces meaning. These are gestures made to be seen/scene.

This chapter focuses on queer practitioners working in transmedial forms across platforms, from social media to the gallery to public space: FAKA (Fela Gucci and Desire Marea), Athi-Patra Ruga and Dean Hutton (in collaboration with Alberta Whittle). I propose a close reading of gesture within the works of these artists and in the relationship each work stages between the body and an environment. I relate this reading of gesture to concepts drawn from the work of Diana Taylor: 'repertoire,' 'transfer' and 'scenario.'[1]

Two ideas from postcolonial thinkers frame what I refer to as the emptying out of gesture in this work: 'opacity' and 'intimacy.' I draw here on Edouard Glissant's notion of the right to opacity as a condition for postcolonial relational identity as against the essentialism of the desire for the other's transparency.[2] Achille Mbembe addresses the positioning of the African subject in western knowledge as defined by intimacy, itself a symbolically violent act of possession inherent in the act of looking.[3] I am interested in the way that these artists stage their own bodies as sites of potential intimacy at the same time as full transparency is refused. I look closely at how this sense of intimacy is produced through a relationship between gesture and scenario, specifically by situating the queer body in a landscape, installation or immersive environment, and the relational placement of the viewers towards or within these scenarios. The emptying out of gesture here is twofold: both an inviting in of the audience, and a refusal of entry, where gesture is both a revealing and recognition of a code, and an ultimate withholding of meaning. This chapter argues that a continual play between intimacy and opacity in the works of FAKA, Ruga and Hutton produces less a politics of queer identity than a queering of the politics of identity. Their works stage the limits of identity politics and, in this questioning, queer the very politics of identity.

In her essay 'The Work Between Us,' Jean Fisher cautions that 'art has been absorbed into discussions of cultural context that treat it and the artist as a subcategory of social anthropology.'[4] I extend this caution to think through, and against, the presentation of performative queer practices as simply staging queer

identities, where bodies become bodies that matter through their decodability as 'other.'[5] I work through the politics (and indeed the limits) of visibility through the writing of Judith Butler, Sara Ahmed, Lauren Berlant, Jack Halberstam and José Muñoz, as well as the important work of bell hooks.

FAKA, Ruga and Hutton walk a fine line between staging the body as an image that both invites and negates possible consumption. Crucially, I position this argument against the discourse of the queer body as a site of social trauma, or lack.[6] Instead, I propose the right to opacity that is embodied in the gesture without a code. Opacity opens up a possibility for thinking queer subjectivity outside of lack, and here I draw on an example from film: Marlon Riggs's astonishingly relevant 1989 film, *Tongues Untied*.

All too often, the performing body, queer and especially black, is reduced to a signifier of non-being and a site of symbolic violence. Halberstam's reading of Muñoz's work on queer identity and race points towards the potential for queer 'wildness' to reinhabit and reappropriate the cultural signifiers of difference through a process of disidentification and repetition. Halberstam quotes Muñoz: '"disidentification scrambles and reconstructs ... the encoded message's universalizing and exclusionary machinations."'[7] However, Halberstam cautions that in this act of re-encoding signifiers of queer and black bodies, 'the risk is that the replaying of racialized tropes of wildness and primitivism, of disorderliness and belatedness, will simply flow right back into the discursive machinery that produces bodies of color as perpetually out of line, out of time, out of whack, and out of work.'[8]

Common across all the works I explore is the use of masquerade and concealment, which simultaneously undoes and reproduces binaries of race and gender. Common also is the placement of bodies in natural landscapes, and the shifts of the same bodies into the interior spaces of galleries and constructed environments. In several instances, queer bodies are almost trapped in a series of gestures that repeat and mimic within environments that contain or limit their movements. I see this work as, at times, staging a literal immobility – an inability to move except within the discursive limits that inscribe the queer body as a site of lack. I argue that these acts of repetition stage not lack or trauma, but the very conditions and limits of becoming visible. As such, they stage the limits of the promise of recognition within identity politics.

Deploying Taylor's concepts of 'transfer' and 'scenario' and the idea of 'queer wildness' drawn from Halberstam and Muñoz, I suggest that a new relationship between land as political category and a queer politics of identity emerges across the works discussed. I demonstrate what I call a queering of the political promise, which, in situating the queer body as a figure of wildness within landscape settings, fundamentally troubles the category of the natural, inscribed as it is within the double hegemonies of whiteness and colonial patriarchy.

By isolating and focusing on certain gestures in the work of these artists as they are staged in different viewing contexts, I probe moments of transparency, and often violent exposure, in which the queer body is inscribed with a kind of intimacy. What I would like to find are those moments of opacity that promise, rather than perform, queerness as a project and a politics of becoming. Here, gesture is not merely a matter to be inscribed with social meaning but an act of transfer with the potential to inhabit its own opacity.[9]

OPACITY AND INTIMACY: THE EMPTYING OUT OF GESTURE

For the 2016 Stevenson gallery group exhibition titled *SEX*, FAKA build a dark room. Lying on separate beds that are more like plinths, or at times together, they embody the movements of sex clubs, erotic dancers and intimate sexual acts, masturbatory or with an invisible other, whether an onlooker or a body. The gallery viewer is invited to enter the space, but most people hover hesitantly at its edges looking in, often uncomfortable, and then leave to see the rest of the exhibition.

At a 2010 interdisciplinary colloquium entitled *pre-post-per-form*, Ruga runs on a treadmill to a hard techno song while carrying another performer. Smoke machines emit steam intermittently until the room in Cape Town's Evol nightclub takes on the haze of a Friday night. The image produced by the relation between bodies makes reference to the famous press photograph of Mbuyisa Makhubu carrying the body of Hector Pieterson, who was fatally shot by police in the June 1976 Soweto student protests. Not everyone in the audience recognises the historical reference to this press photograph, which played a significant role in the campaign against apartheid. One significant detail is altered here: the performer Ruga carries is white. As the performance continues, Ruga's exhaustion becomes increasingly visible, even as the room fills up with steam. The audience is inextricably part of

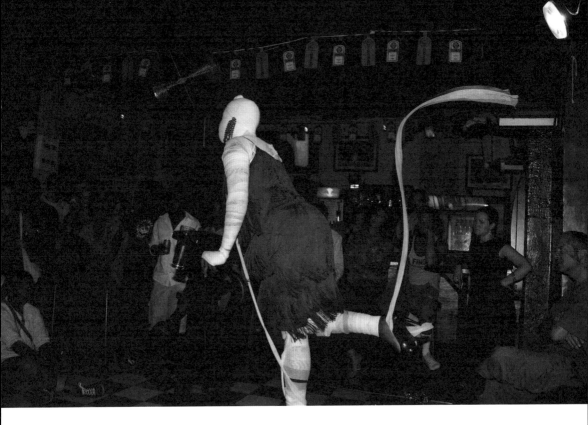

Figure 9.1. Athi-Patra Ruga, *Prelude to Ilulwane*, 2010.
Courtesy Institute for Creative Arts.
Photograph by Moeneeb Dalwai.

the club atmosphere, feeling the sweat of the performers, the weight of one in the other's arms, and the endurance of the repetition of a single gesture.

At what moment do we, as viewers of these works, inscribe the bodies of the performers as queer bodies, as raced and classed bodies? At what point do we read or mark them as ciphers of social recognition within the unspoken boundedness of identity – as white, black or brown bodies, male or female, religious or secular, privileged or classed, contemporary or historical? In each of the scenarios described here, the gestures of the performers are full of the potential both to signify (or perform) identity and, at any moment, to be emptied out of meaning. It is this play

between opacity and intimacy that presents the body as that which cannot simply be inscribed with a singular meaning.

In the 1989 documentary *Tongues Untied*, Marlon Riggs's seminal essay film about queer black life, there is a section titled 'snap Diverology' in which the narrator offers viewers a 'basic lesson in "Snap!"' A series of descriptions of different snaps follows, seeming to be an exercise in the vocabulary and syntax of the snap as gesture in queer black life: 'Grand Diva Snap,' 'Domestic Snap' and so on.[10] What is striking, however, is that the meaning of each snap is never explained. The narrator cautions the viewer, 'don't get it twisted ... precision, poise, placement ... you must perfect each for a grand snap statement.'[11] The visual demonstration that follows is a choreographed series of snaps, very similar in form to the timing of dance and physical theatre. The gesture is demonstrated, filmed and named, but the 'statement' made by each snap is never translated, its signified effect is never revealed. Rather, what emerges is a rhythmic relationship between snaps, which operates sonically, not linguistically. This refusal of the translation of the snap into a legible or singular meaning is the exemplary act of an emptying out of gesture, producing a particular experience of opacity.

The gestural languages and references in the works of Hutton, FAKA and Ruga, I argue, invite inscription with social meaning; however, what we see is not necessarily what we 'get,' to play once again on the title of this chapter, 'don't get it twisted.' As Riggs's narrator explains, we should focus less on meaning than 'precision, poise, placement,' suggesting that gestures like the snap ascribe meaning as not simply containable within the symbolic order. However, there is a logic here that is rhythmic and temporal in the same way that a musical composition contains a logic beyond the merely symbolic or semiotic.

What I mean to imply by a gesture that is both full and emptied of meaning is that we need to begin to understand the language of gesture as a notation that is in excess of signification, and thus in excess of consumable meanings. Here, one is reminded of bell hooks's critique of the film *Paris is Burning*, which she sees as participating in 'the way consumer capitalism undermines the subversive power of the drag balls, subordinating ritual to spectacle.'[12] She counterposes this to Riggs's *Tongues Untied* where drag performance is placed within a network of social rituals in which performativity is seen as a necessary and everyday strategy for self-actualisation within a structure that does not recognise black queer subjects. Thus,

gesture as coded social ritual suggests a much more powerful politics that moves beyond consumable images of queerness or race. In her critique of the film's white, albeit queer, filmmaker Jennie Livingston, hooks is unforgiving, saying that she reproduces the balls as a consumable spectacle for an outside audience.[13]

To return to FAKA: while inviting viewers into the darkroom they have constructed within the gallery, the duo in fact refuses us the pleasure of looking, precisely because we too are seen, caught in the act of looking by viewers on the other side of the open booth. The very architecture of this structure, painted entirely black within the white cube gallery, disturbs any easy pleasure in consuming the artists' bodies as an image of queerness and blackness. At the same time, a viewer who happens upon the scene may walk away feeling as if they have recognised the meaning of the gestures and filed these as consumable images of queerness associated with sexual excess – what Muñoz and Halberstam refer to as 'queer wildness.'[14] Thus the work may appear at first site/sight to evoke an easy reading of queerness and, it might also be noted, of a consumable black body, exposed and inviting viewers into a contract that appears to stage intimacy. However, their refusal to reach the endpoint of climax, the inexhaustibility of their pleasure and its audible sounds spilling into the rest of the space, makes the experience one without closure.

To understand the effect of this lack of closure and the importance of the way in which the constructed scenario of each work under discussion places both the body of the artist and the viewer in a particular contract of intimacy and opacity, I turn to the work of Diana Taylor.

ACTS OF TRANSFER: REPERTOIRE AND SCENARIO

In her book *The Archive and the Repertoire*, Taylor argues for the treatment of performance as 'a way of knowing, not simply an object of analysis.'[15] She asks whether performance is 'that which disappears, or that which persists, transmitted through a nonarchival system of transfer,' which she calls 'repertoire.'[16] Taylor's project focuses on ritual and performance and everyday gesture in Latin America, but it holds much potential for thinking about live art practices and everyday queer performativity. The repertoire is that which 'enacts embodied memory: performances, gestures, orality, movement, dance, singing – in short, all those

acts usually thought of as ephemeral, nonreproducible knowledge.'[17] The literal meaning of the repertoire as inventory holds potential for discovery and storage that is embodied, requiring 'presence': 'people participate in the production and reproduction of knowledge by "being there," being a part of the transmission.'[18] It is important to understand that the repertoire is not a fixed set of actions or objects, but rather the 'repertoire both keeps and transforms choreographies of meaning' over time.[19]

Taylor introduces another key term for her method of analysis: 'scenario.' This is traditionally the term referring to '"a sketch or outline of the plot of a play, giving particulars of the scenes, situations etc."'[20] For Taylor, this is never original, it is rather 'a portable framework' bearing the 'weight of accumulative repeats ... the scenario makes visible ... what is already there: the ghosts, the images, the stereotypes.'[21] It is what structures our understanding of gestures and bodies; 'positioning our perspective, it promotes certain views while helping to disappear others.'[22] It is the scaffolding for a range of possibilities, narratives and actions.[23]

I have drawn on two major strands of Taylor's schematisation of the scenario. Firstly, Taylor explains the necessity that 'the scenario forces us to situate ourselves in relationship to it; as participants, spectators, or witnesses, we need to "be there," part of the act of transfer. Thus, the scenario precludes a certain kind of distancing.'[24] It is for this reason that I focus in part on live art works that I myself have witnessed. However, I also look at works that include some kind of transfer of scenario and work into other spaces and media. Taylor's last point is that 'a scenario is not necessarily mimetic ... it usually works through reactivation rather than duplication. Scenarios conjure up past situations, at times so profoundly internalized by a society that no one remembers the precedence ... Rather than a copy, the scenario constitutes a once-againness.'[25] She hence poses the question of how we are called upon to participate in such scenes: as 'witnesses, spectators, or voyeurs.'[26] Most importantly, it 'physically places the spectator within the frame and can force the ethical question: *the signifier*, we recall, "*cannot be detached from the individual or collective body*." What is our role "there?"'[27] This last point of Taylor's returns us to questions of intimacy and the inscription of meaning.

The translation, or following Taylor, transmission of live art into photographic and video documentation means that performing bodies can too easily be

inscribed within restrictive and often exotic desires for authentic otherness by a hegemonic gaze hungry to consume bodies that are tradable as bodies seen to matter within varied circuits of economic and symbolic value, from galleries to social media. In this sense, the kind of intimacy and even empathy staged in photographic and filmic registers can function as a violent reinscription of the visible body within codes of exotic queerness, wildness and blackness, whether as camp, parody, drag or clowning, thus recuperating the radical, transgressive potential that defines the works of FAKA, Ruga and Hutton into a consumable queer image. The question of how the viewer is placed within the framing of the scenario is at the heart of my reading of their work.

My particular interest here is in four works that place the body of the performer in a scenario that draws on tropes and mythologies of landscape, both as natural and constructed spaces of nature, but also peripheral areas of the urban. In the next section, I work through three performance works to reveal what I refer to as a queering of the political promise through a recurring repertoire of gestures and scenarios that stage queer bodies as tropes of 'wildness' that disturb categories of the natural. I suggest that the act of transfer embodied in this work stages queer identity at the limit point of the political, and in this act queers the politics of promise. Hence, I argue that a relationship between land as political category and a queer politics of identity emerges across the works discussed.

QUEERING THE LANDSCAPE

PART I: AT LAND

Dean Hutton is a photographer and visual and performance artist who has become best known for their controversial project *Fuck White People*, which is an iteration of their public performance project *Goldendean*. Kwanele Sosibo makes the incisive observation that conservative white audiences are alienated not only by Hutton's offense against whiteness, but by the fact that Hutton's body does not conform to binary gender and feminine beauty stereotypes: 'By virtue of Hutton's physical transformation and embracing of their body image along with the myriad ways it challenges the constructed aesthetics of white beauty, Hutton is striking a severe blow at the heart of whiteness.'[28]

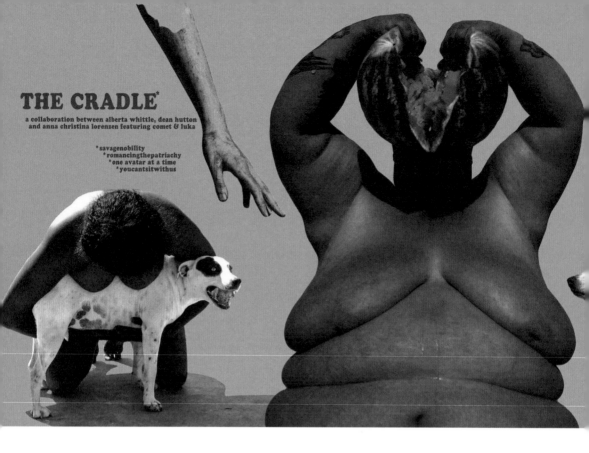

THE CRADLE*
a collaboration between alberta whittle, dean hutton
and anna christina lorenzen featuring comet & luka

*savagenobility
*romancingthepatriachy
*one avatar at a time
*youcantsitwithus

Figure 9.2. Dean Hutton and Alberta Whittle, *The Cradle*, 2015.
Courtesy the artists.

My focus is an earlier collaborative project by Hutton and artist Alberta Whittle, with Anna Christina Lorenzen, and Comet and Luka (the latter being Hutton's two dogs, who feature in the video works). Entitled *The Cradle *savagenobility romancingthepatriarchy one avatar at a time youcantsitwithus*, the work was produced in 2015 at the GoetheOnMain project space in Johannesburg. The piece had several components, including videos of *in situ* interventions shot at the Cradle of Humankind, a nature reserve an hour outside of Johannesburg. The final work consisted of an immersive environment set up at the Goethe project space with a live performance element. In the exhibition text, the artists begin: 'What does it mean to be natural? Are queer bodies unnatural? Are black bodies supernatural? And who can access all of this nature?'[29]

This is followed by a quote from Frantz Fanon's *The Wretched of the Earth*: "'Imperialism leaves behind germs of rot which we must clinically detect and remove from our land but from our minds as well.'"[30] This opening statement and the quote clearly situate the work within a political reading of landscape as 'land' – a highly contentious and politicised category within the contemporary South African imagination, where continued white land ownership and the failure of redistribution persists as a key failure of the postdemocratic period and an indicator of a more general failure of material redress.

The second aspect of the politics of land here is as a category of the natural versus the constructed or cultural. As such, performing the queer body within the landscape becomes a way to undo assumptions at the heart of gender binaries. Judith Butler argues against the category of sex as natural: 'If gender is something that one becomes – but can never be – then gender is itself a kind of becoming or activity, and that gender ought not to be conceived as a noun or a substantial thing or a static cultural marker, but rather as an incessant and repeated action of some sort.'[31] The notions of repetition and mimicry are at the basis of gender performativity, which, in this chapter, relates to ideas drawn from Taylor, where queer performance replays a repertoire of gestures within a transferable scenario.

Hutton and Whittle explain how they create avatars that they become, but can never be. Each avatar repeats a set of actions and gestures throughout different scenarios that not only work against gender norms but also assumptions around race. Can we make a translation from the performance of heteronormativity to the performance of whiteness as a coded repertoire? Ahmed cautions against oversimplifying race as a performative or constructed social category. In a text exploring the politics of 'passing,' she argues: 'The difference between a black subject who passes as white and the white subject who passes as white is not then an *essential* difference ... rather it is a *structural* difference that demonstrates that passing involves the re-opening or re-staging of a fractured history of identifications that constitutes limits to a given subject's mobility.'[32]

Ahmed's caution here proves instructive for a reading of Hutton's work, where Hutton's position of white privilege within their *Fuck White People* project has itself been a point of contention in readings of the work. Hutton's Goldendean avatar is a figure that confronts a double hegemony, simultaneously citing and disrupting tropes of white patriarchy and white capital with the use of gold paint: 'Birthed

on the minedumps of eGoli the avatar of Goldendean gleams and glamours us, inciting a frenzy of gold lust, gold fever and golden showers. Much like gold itself, the spectacle of Goldendean challenges the arbitrary values we place in the normative body. Our gaze cannot help but devour Goldendean.'[33]

We need to think carefully through the terms by which Goldendean makes visible both racial and gendered difference in different contexts, how they re-open and restage 'a fractured history of identifications' where whiteness remains a site and sight of privilege and value. Goldendean is a character that Hutton has placed in several public interventions and situations, including Ghana's Chale Wote festival. Here, the queer white body is paraded in a public space during a contemporary performance and art festival in the area of Jamestown, Accra. The area is dense and its community depends on precarious income from fishing, under threat due to the presence of foreign fishing industries.

Hutton's gold body paint plays with the idea of value, where the precious metal's colour appears to make the white body even more precious. At the same time as it brings attention to the way that whiteness remains the unsignified marker of value against which all visuality is measured, and while Hutton is exposed and certainly vulnerable in the piece, their ability to move through a space such as Jamestown brings into sharp relief the way the queer, gender-non-conforming white body, while precarious, remains protected and granted a mobility not possible for black queer bodies in the same space. Thus, the lived experience of black bodies here can be read as backdrop to the spectacle of white queerness. In a sense, the work is caught up in the very risk of replaying the very signifiers it attempts to disrupt. As Halberstam and Muñoz both caution, disidentification always risks reinscription and reidentification. Hutton appears to be aware of this risk.

PART II: AT SCENE

In the collaborative work with Whittle, *The Cradle*, manifested both as a series of *in situ* video pieces and an installation, Goldendean as avatar plays similarly with gender binaries. Hutton wears an ancient cattle bell around their waist, which acts as both phallic signifier and encumbering attachment, suggestive of the weight of the 'natural' category of sex carried by the artist and imposed by the gaze. The bell was in fact purchased at a market in Accra and serves as a potent symbol in Ghanaian traditions, where masquerade and procession can be witnessed in several

festivals throughout the year.[34] Hutton continually repeats the action of ringing the bell while sweeping the soil that is spread throughout the upper floor of the gallery space. These repeat gestures of ringing and sweeping seem to both enslave and empower the artist within a series of reproductive, domestic labours that are, at the same time, sonic and visual markers of authorship. Intermittently, the artist rubs their hair (also covered in gold paint), which flakes off onto the floor. The audience's experience of the space is strongly centred on Hutton's figure and their actions, which both engage and ignore us. Our placement in the scenario, barefoot and literally touching the soil of the landscape (apparently brought from the Cradle itself), is as witness and participant in the work's act of transfer.

Whittle's avatar also radically troubles categories of race and gender: 'the mythological figure of Mammmmmyyyyywaaaata, rooted in belief systems from West Africa, carried over the Middle Passage in the memories of the enslaved, she arrived in the Caribbean ready to transform again.'[35] Painted blue, Whittle sits next to a plastic basin of water on the lower level of the gallery, giving viewers hand-written fortunes and whispering secrets to audience members who are beckoned closer, folding R10 notes into the shapes of paper aeroplanes or boats, and giving these away or withholding them. Nearby, a fountain flows with water that is slightly inky and off-colour. The projected video works form a totally immersive environment and feature Whittle, Hutton and Hutton's dogs at the Cradle of Humankind nature reserve. The footage shows Hutton and Whittle performing a series of gestures that mimic exercise routines but also fashion shoots and music videos. Whittle does yoga positions with a children's blow-up ball, while Hutton appears to 'dry hump' a log. Here, too, Hutton wears the bell, which is ceaselessly rung by the movement of their hips. In one shot, one of the dogs eats raw meat on a perfectly green, mowed lawn.[36]

Within the immersive exhibition environment, viewers are caught within the field of these gestures, the sound of the bell and Hutton's continual sighing, and the projected images. We were asked to remove our shoes and to walk on the soil in blue medical shoe covers. In some moments, Hutton rubbed their hair, spraying flecks of gold into the sparsely stage-lit space, where pools of spotlighting illuminated some areas and left others dark. It was a quiet and affecting durational performance, which created a kind of intimacy. The placement of Goldendean and Whittle's *Mammmmmyyyyywaaaata* within the aptly titled nature reserve, the

Figure 9.3. Dean Hutton and Alberta Whittle, *The Cradle*, 2015.
Courtesy the artists.

Cradle, appears to set up the scenario that associates the feminine with nature as an object to be pacified, owned, controlled and inscribed within the gaze of white patriarchy. With the history of displacement of indigenous black populations from ancestral land under both colonial and apartheid rule, the relationship of the South African imagination to land makes this reference to 'nature' and the idea of a point of origin a complex political question.

In their exhibition statement, Hutton and Whittle take a directly political position:

> The Cradle of Humankind, Maropeng and the Lion and Rhino Park are potent sites in which intersectional oppressions are organised, segregating access through its enforced preservation and commodification. The gatekeepers of these institutions insist that expensive admission fees, and access to land prohibit access to the predominantly black local populace, who are considered trespassers on this stolen land. Instead these bastions of knowledge and heritage become the reserve of whiteness, embodied by the avatar of the Great White Hunter.[37]

Scenes of leisure within natural settings encoded with violent settler imaginings of empty territories are invoked, as are the works of novelist JM Coetzee in which the images of dogs serve as a metaphor for a haunted and haunting settler imagination, along with the taming of wildness suggested by the suburban mowed lawn. Hutton and Whittle are acutely aware of the multiple scenarios invoked here, and how their playful and provocative repertoire of gestures both irreverently quotes and undoes these scenarios. This work stages a queering and hence troubling of the white settler scenario of the right to land, an imaginary and material object of ownership and enjoyment to be feminised, tamed and possessed. Halberstam draws on Muñoz to think about wildness as a necessary strategy for queer transgression, embodying the "'spirit of the unknown and the disorderly'" against the orders of the natural and the knowable.[38] Halberstam argues for an association between 'wildness' and 'queer failure.'[39] Wildness suggests the failure of signification and inscription, as that which 'exceeds meaning,' the disruption of colonial and masculine orders of knowledge and control 'through temporal and spatial and bodily excess and eccentricity.'[40]

Hutton's continual ringing of the bell is impossible to read without thinking of the role of the slave bell in regimenting the daily lives of labouring black subjects, but it also resonates with cattle bells – a means of locatability and a reminder of the control of the non-human body. Hutton's wearing of the bell functions as a mask of their natural sex, and as a grotesque phallic signifier, a suggestion of camp and queer anachronism, a body out of time and place. The ringing of the bell is a double irony which entraps the artist's body within a frame of legibility as other, as marked by their own difference, while simultaneously rendering their body opaque and illegible, almost without gender or discernible code. This is a radical disturbance of the orders of visuality as they are structured by the fictions of the gender binary and of the natural versus the wild. And yet, despite this troubling of the binary, the avatar, in the repetition of the repertoire, seems caught within the very framing they attempt to disturb, both as a gendered and racialised subject, unable to escape their inscription within a social framework as a queer, white and privileged body.

PART III: MASKING, MASQUERADE AND MIMICRY

What emerges in the work of Ruga and FAKA is how their use of masking, masquerade and mimicry in their gestural repertoire points to the intersectional nature of identity as composed of both the fictions and truths of race, class and gender.[41] In referring to 'truths,' I imply the resilience of the structural conditions and constraints by which queer (especially black and brown) bodies are identified as 'other,' but also the structural realities that position white queer bodies as privileged and protected.

I turn now to two works that traverse both natural and urban environments – Ruga's *The Future White Woman of Azania* (2015) and FAKA's *From a Distance* (2015). While these works are not solely instances of live art, they speak to various live art projects by the same artists in which similar scenarios and repertoires resurface. The common scenario across these works and the Hutton-Whittle collaboration is a placement of the body in masquerade within an exterior landscape.

My reading of *The Future White Woman of Azania* (abbreviated in the catalogue as *FWWA*) focuses on a series of photographic stills that feature the artist in a full body costume made of multicoloured balloons, which cover their entire torso, leaving only their legs, in pink tights and heels, visible. This figure reappears across a series of

works and live performances – as studied in Andrew Hennlich's contribution to this collection. I limit my discussion to the series of photographs shot for the Standard Bank Young Artist Award during the Grahamstown National Arts Festival, where Ruga won in the performance art category. It should be noted that this iteration of *FWWA* is not a live performance; it was produced for direct translation into a photographic series. In this particular act of transfer the viewer is still positioned in relation to a scenario and the artist's gestures within the space of the frame.

This series sees the artist move through the peripheral townships and settlements around Grahamstown during the major arts festival period. The artist moves from the peripheral areas into the town centre, and is observed and documented via a turn-of-the-century camera obscura located in the Observatory Museum in the town centre. In the photographs the *FWWA* is seen looking out onto the landscape through a pair of binoculars, making visible the apparatus as condition of the gaze. The work features the *FWWA*'s movement through the urban and semi-urban landscape passing fascinated or bewildered residents, who are in turn captured in the images. This is not an empty natural landscape but a peopled, partially urbanised one. Tropes of apartheid's violent divisions between rural and urban, township and town, citizen and subject are legible in this journey. Signs of underdevelopment and poverty in the peripheral townships are visible against the clean white streets of the town centre. As Ruga moves through the spaces, their legs and the balloons also become visibly marked, deflated, worn and dusty from the journey. A strange sense of waiting pervades the scenes as residents stare blankly at the colourful stranger who silently passes through, struggling a little to maintain balance on uneven dirt roads.[42]

In this variation of the landscape scenario, Ruga's is a minimal gesture, the act of simply walking, made vulnerable by their exposure and poor visibility – literally seeing through the disguise of the balloons, which also restrict their breathing, suggesting claustrophobic endurance. The balloons are contradictory signifiers here – on the one hand celebratory, on the other ostentatious and almost too bright against the faded greens, the grey-brown gravel and washed-out house paint. It is in this contradiction that the power of the work's disruption inheres. In contrast to political campaigns that promise economic freedom, radical economic transformation and land redistribution, the *Future White Woman* seems to function as an aspirational image of privilege and entitlement associated with white

heteronormative femininity. Yet, the location of the promise of status deferred to the future makes this image elusive and transitory.

The work plays with naming and masking to point to the fictions and structural truths of whiteness's association with wealth and class privilege, but also to the fictions of the political promise of economic freedom and transformation. Here, Lauren Berlant's notions of 'promise' and 'attachment' are instructive. Berlant asks why we remain attached to objects that are bad for us and ideas that we know are ultimately fictional promises of future happiness and fulfilment. Berlant argues that thinking about subjects as defined by traditional psychoanalytic categories of desire and lack are less productive ways to understand contemporary subjectivity than the twin notions of promise and attachment.[43] The question of land and wealth redistribution is a current and urgent political question in postapartheid South Africa, indexed by continuous student and service delivery protests and the emergence of calls for radical economic reform. The failed political promise of the rainbow nation has effectively been replaced by the promise of economic freedom.

Ruga's *FWWA* queers the political promise of the fading mythology of the rainbow nation, deferring this scenario to a future that is trapped in an image of the past, an aspiration attached to the fiction of whiteness and the promise of Azania, the decolonial future utopic state and counter-mythology to South Africa. Ruga's body is masked by the costume but also highly vulnerable as a black queer subject moving through marginalised peripheral urban areas with high incidences of hate crimes against queer black bodies. Here, the hold of whiteness over the political imagination of space, body and self is both made visible and disrupted by the queering of the fiction of the ever-deferred political promise.

In an entirely different medium – one that circulates not through an exhibition format but through the online platform of YouTube and other social media – the duo FAKA produce the music video *From a Distance* for their dance track of the same title. Articulate across a variety of artistic platforms, from fashion to dance music, they are equally well known as deejays/music producers and visual artists. Highly sensitive to popular cultural codes, they give the following ironic subtitle for the music video: 'A Gqom-Gospel Lamentation for Dick,'[44] hence queering two strongly heteronormative local music styles: *gqom*, being a fast-tempo kwaito house style emerging from KwaZulu-Natal, and gospel, a hugely popular and diverse national genre.

From a Distance once again stages the scenario of the queer body within the natural landscape, this time unnamed but recognisable as the grasslands described locally as bush or veld. The piece plays with the citation of popular local music videos, especially gospel, but also with stereotypes of feminine fashion models and drag. The video editing works intentionally with basic editing effects like split-screen and other framing insert devices that proliferate in self-produced music videos on self-publishing sites like YouTube. The artists wear identical Afro wigs, died a burnt orange colour and are shirtless. Desire Marea wears a mustard miniskirt over tights, while Fela Gucci wears femme purple trousers and a scarf bow tie. The two adopt poses that mimic portrait photography, fashion modelling and low-budget music videos. Their poses do not extend into movements, thus the repertoire is not really one of dance, but of the still image, perhaps less fashion magazine spread than Instagram post – another channel they employ for their work. What is interesting here is the deploying of recognisable popular codes that are replayed and disidentified by the simplicity of queer signifiers: their wigs, their clothing and their femme and trans gestural repertoire. The radicalness of FAKA's queering of popular music codes is in the double hybridisation of their bodies as both masculine and feminine and of two disparate music genres: *gqom* and gospel. The radical queer gesture here is in the act of transfer that situates this work within the popular imagination via social media and YouTube, highly accessible spaces of consumption.

In their gallery interventions, these deejay and performer personas convert the gallery environment into the club space, and here it is often the duration of the work that disallows easy consumption. These long interruptions are

Figures 9.4, 9.5 and 9.6 FAKA, *From a Distance*, 2015.
Courtesy the artists.

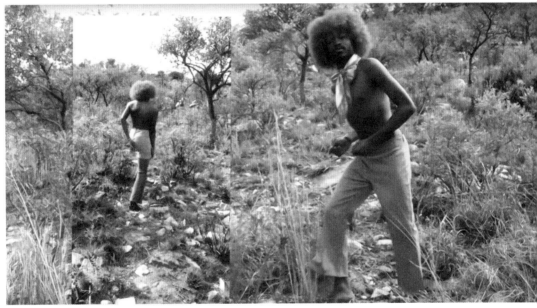
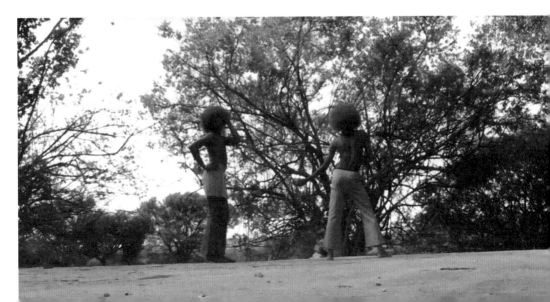

uncontainable irruptions of popular codes within the confines of the white cube dedicated to the avant-garde, that which is art for art's sake. This queering of popular codes visible in *From a Distance* is interesting precisely because it may be seen by an audience outside of FAKA's following. It is the label 'Gqom-Gospel Lamentation' that produces the confusion of codes and a potential for double reading and disruption.[45] Once again, we encounter a scenario where two popular musical repertoires are re-encoded, hybridised and replayed in excess of their original meanings.

The choice of location in a non-specific natural setting outside of the city of Johannesburg (where both artists live and work) once again invokes the scenario of the queer body within the landscape. The video begins with a zoom-in from an intentionally cheesy animation of a satellite image of the earth from space, headed by the phrase in simple yellow font: 'lord is watching us.' The animation imitates a Google Earth zoom onto the continent, then South Africa and the title appears: 'From a Distance,' followed by a fade into the opening shot of Fela Gucci in character mimicking a catwalk pose in the landscape.

The mimicry of gestures from music and fashion both disrupts and reproduces popular codes, and in doing so, troubles a moral ordering of bodies and landscapes. The religious reference to the gaze of the lord implies an at-once disciplinary and paternal gaze that imposes onto bodies a moral order and, as such, determines categories of natural and unnatural behaviour. For queer bodies that fall outside of this frame – as unnatural, immoral, ambiguous and unclean – the gaze of the lord is not protective but a potential threat of exposure where becoming visible or coming out engenders potential discipline, even violence. Hate crimes against queer black bodies are prevalent in South Africa, and queer bodies often move through public spaces at great risk.

FAKA's lyrics for the 'lament' unapologetically use explicit language, which makes direct homosexual and trans references, to trouble both religious expectations of gospel, and the heteronormative, often explicitly sexual, generic conventions of *gqom*. The song is also musically and tonally very daring and arresting. The repertoire of gestures in this scenario is a play with queer wildness and queer failure to disrupt the very idea of the natural and the moral order. The framing of the video by this religious imperative is at odds with the title phrase, 'from a distance,' which references a kitsch American gospel pop song,

made famous by actor Bette Midler in a 1990s rendition. Again, a popular code is appropriated and replayed. 'From a distance,' is a phrase that in fact frames our viewing of the work, inviting us to gaze onto these 'unnatural' bodies in a 'natural' landscape without distance, to come up close. Yet, as in their installation and performance at the Stevenson gallery, FAKA invite us in only to refuse us entry; the work is simultaneously intimate and opaque. Gestures that appear to make queerness visible are merely mimetic repetitions of cultural codes drawn from a wide range of sources.

The mimicry of the feminine gesture in FAKA's repertoire echoes the exercise routine performed by Whittle and Hutton at the Cradle site. The two collaborations reproduce a repertoire of heteronormative bodily discipline, but now as mimicry, as imitation and blank parody. Here, the queer body liberates the landscape from the hegemonic gaze by queering the gesture, but it is also at the cost of their own transparency, their own exposure. They are made vulnerable in the instant they become visible, and yet this visibility depends on a series of repetitions that empty their own gestures of meaning. They become opaque ciphers of the very gestures that entrap them in the binary fictions of race and gender: the gold and blue body paint, the bell, the pinks and yellows of the balloons worn by Ruga, FAKA's clothing and wigs. Ruga's balloon costume masks as it reveals the ethnicity and gender of their body as they move through the territory between urban and rural, feminine and masculine. As I have stated, this continual play between intimacy and opacity is not legible as a simple rendering of a politics of queer identity, but rather presents a queering of the politics of identity. What I mean here is that each work's staging of queer visibility is, to return to Ahmed, the 're-staging of a fractured history of identifications.' The becoming visible of the queer subject is always on condition of its recognition as a body defined by sexual difference that is also raced and classed, thus exposing the structural limits by which marginal bodies are seen as bodies that matter.[46]

CONCLUSION: TOWARDS A QUEERING OF THE POLITICS OF IDENTITY

I have traced out an emerging queering of the politics of land, social space and the body in South African performance practices. Hutton, Whittle, Ruga and FAKA, I argue, work through a sophisticated system of repetition, citation and

mimicry to effect a queering of the political promise of land and identity. My final provocation is this: where and how is it possible to extend this repertoire from one based on citation to produce a language that has its own grammar, that is not caught within a repeating and repeatable scenario that re-enacts or mimics tropes of heteronormative binaries, white privilege and patriarchy? These acts of repetition stage the very conditions and limits of becoming visible for the queer body, and the vulnerability of queer black and brown bodies. However, at many points the work's act of transfer to the audience, whether live, contemplative or digital, holds the potential for a queer politics of identity that is not limited to an emptying out of gesture, but instead promises a new form.

I would like to end with a return to the 'snap!' sequence from *Tongues Untied*, from which the title of this chapter is drawn. Here, a grammar of gesture emerges that is able to articulate its own rhythm, performing an act of transfer while inhabiting its own opacity. This sequence of gestures is a living performative practice that cannot be translated, owned, reproduced or consumed. The one who gets it 'twisted' is the one who fails to recognise that this is the *promise*, not the fiction, of queer becoming.

1. Diana Taylor, *The Archive and the Repertoire: Performing Cultural Memory* (Durham: Duke University Press, 2003).
2. Edouard Glissant, 'Transparency and Opacity,' in *Poetics of Relation*, trans. Betsy Wing (Ann Arbor: University of Michigan Press, 1997), 111–121.
3. Achille Mbembe, *On the Postcolony* (Berkeley: University of California Press, 2001).
4. Jean Fisher, 'The Work Between Us,' in *Trade Routes: History and Geography: Second Johannesburg Biennale Catalogue*, eds. Okwui Enwezor and Colin Richards (Johannesburg: Greater Johannesburg Metropolitan Council, 1997), 20–23.
5. The phrase 'bodies that matter' draws on the title of Judith Butler's book *Bodies that Matter: On the Discursive Limits of 'Sex'* (New York: Routledge, 1993).
6. See Peggy Phelan, *Unmarked: The Politics of Performance* (London: Routledge, 1993).
7. José Esteban Muñoz quoted in Jack Halberstam, 'Wildness, Loss, Death,' *Social Text* 32, no. 4 (2014): 143, accessed 5 May 2017, doi: 10.1215/01642472-2820520.
8. Halberstam, 'Wildness, Loss, Death,' 143.

9. Taylor, *The Archive and the Repertoire*.

10. *Tongues Untied*, directed by Marlon Riggs (USA; San Francisco: Frameline and California Newsreel, 1989), DVD.

11. Riggs, *Tongues Untied*.

12. bell hooks, *Reel to Real: Race, Class and Sex at the Movies* (New York: Routledge, 1996), 289.

13. hooks, *Reel to Real*. See also: Butler, *Bodies that Matter*, 27–56.

14. Halberstam, 'Wildness, Loss, Death,' 145.

15. Taylor, *The Archive and the Repertoire*, xvi.

16. Taylor, *The Archive and the Repertoire*, xvii.

17. Taylor, *The Archive and the Repertoire*, 20.

18. Taylor, *The Archive and the Repertoire*, 20.

19. Taylor, *The Archive and the Repertoire*, 20.

20. *The Oxford English Dictionary* quoted in Taylor, *The Archive and the Repertoire*, 28.

21. Taylor, *The Archive and the Repertoire*, 28.

22. Taylor, *The Archive and the Repertoire*, 28.

23. Taylor, *The Archive and the Repertoire*, 28.

24. Taylor, *The Archive and the Repertoire*, 32.

25. Taylor, *The Archive and the Repertoire*, 32.

26. Taylor, *The Archive and the Repertoire*, 32.

27. Taylor, *The Archive and the Repertoire*, 32.

28. Kwanele Sosibo, 'Is "Fuck White People" fucking itself?' *Mail & Guardian*, 3 February 2017, accessed 12 May 2017, https://mg.co.za/article/2017-02-03-00-is-fuck-white-people-fucking-itself.

29. Dean Hutton and Alberta Whittle, 'The Cradle,' 2point8, accessed 12 May 2017, http://www.2point8.co.za/interventions/the-cradle-savagenobility-romancingthepatriarchy-one-avatar-at-a-time-youcantsitwithus.

30. Frantz Fanon quoted in Hutton and Whittle, 'The Cradle.'

31. Judith Butler, *Gender Trouble* (London: Routledge, 1990), 112.

32. Sara Ahmed, '"She'll Wake Up One of These Days and Find She's Turned into a Nigger": Passing through Hybridity,' in *Performativity and Belonging*, ed. Vikki Bell (London: SAGE, 1999), 93.

33. Hutton and Whittle, 'The Cradle.'

34. I witnessed this first hand during the procession of the twins during the Homowo Festival of the Ga people of Jamestown, Accra in 2017. This is also the location of the Chale Wote festival.

35. Hutton and Whittle, 'The Cradle.'

36. Video documentation supplied courtesy of Dean Hutton and Alberta Whittle.

37. Hutton and Whittle, 'The Cradle.'

38. Michael Taussig quoted in Halberstam, 'Wildness, Loss, Death,' 137.

39. Halberstam, 'Wildness, Loss, Death,' 146.

40. Halberstam, 'Wildness, Loss, Death,' 140.

41. Influential texts on my reading of mimicry in this section include, Vikki Bell, 'Mimesis as Cultural Survival: Judith Butler and Anti-Semitism,' in *Performativity and Belonging*, ed. Vikki Bell (London: SAGE, 1999), 133–162.

42. Athi-Patra Ruga, *The Future White Woman of Azania Saga Catalogue* (Cape Town: WHATIFTHEWORLD, 2015).

43. Lauren Berlant, *Cruel Optimism* (Durham: Duke University Press, 2011), 23–25.

44. FAKA (Desire Marea and Fela Gucci), 'From a Distance,' YouTube video, 3:50, 8 November 2015, accessed 15 May 2017, https://www.youtube.com/watch?v=2doHNuXe534.

45. FAKA, 'From a Distance.'

46. Here, I return, once again, to Butler's title *Bodies that Matter* in order to make a provocation against how value and meaning are ascribed to the queer body as desirable wildness in artistic practice and popular culture.

Performing the Queer Archive: Strategies of Self-Styling on Instagram

KATLEGO DISEMELO

GENDER PERFORMANCE AND MEDIA IN A DIGITAL VISUAL PRESENT

Albert Silindokuhle 'Ibokwe' Khoza busies himself with several tasks in the centre of a quadrangle. His indifference to the curious eyes staring at him is impeccably studied. He begins the ceremony by burning *impepho* (incense used in ancestral ceremonies and rituals). Plumes of smoke dance across the quad and around his body, encasing him within a grey, permeable vitrine. His buxom figure is squeezed into a beaded Dinka corset,[1] but its wire frame does not restrict his self-assured movements as he saunters from one corner to the next. He carries the bowl of *impepho* in one hand, while lifting the seams of a white tulle skirt in the other, ensuring that he does not trip. Ever so deftly, he begins throwing calcified animal skulls onto the ground. It is difficult to discern which animals these once were, or what their atrophied bones are supposed to signify in this moment. Waiting silently, the audience is left wondering if this is some sort of ancestral divination by a trained sangoma, or an aesthetically stylised performance. Gradually it becomes apparent that these aspects of the artist's persona are mutually co-constitutive. This performance, *Take in Take out (to live is to be sick to die is to live)*, explores several elements of Ibokwe's identity: his blackness, his queerness, his traditional and ethnic heritage. But how might such a moment – so poignantly inflected by intersecting elements – be archived? What are the possibilities, platforms, or avenues through which this moment could be captured for posterity, while sustaining its dynamism and fluidity as live art?

Social networking websites have enabled South African performance artists such as Ibokwe to archive and disseminate their work. These artists use social media platforms to brand and stylise their personae in different ways, thus extending their live art practices into hyperreal and technologically mediated domains. This chapter pays critical attention to the social networking practices and self-representations of black queer South African artists Ibokwe, Umlilo and FAKA on Instagram. A theoretical premise foregrounded in this discussion is that the quotidian consumption and use of this social medium is itself a performance. These artists perform various aspects of their identities online, thus constituting a mode of queer artistic and archival production. Our conception of the archive, in particular the queer archive, has to go beyond assumptions of its geo-spatial specificity (comprised of historical papers and photographs, or located in a physical building). The queer archive, I argue, is a living, dynamic and hyperreal entity; it exists within real, mediated time. In what I call our 'digital visual present,' our conception of the world is saturated by digital images, produced and consumed at unprecedented speeds. The dissemination of live art – itself ephemeral and immediate – moves and keeps apace with the circulation of images in this digital visual present via an archive that is fluid and shifting.

To claim that sexual and gender identity categories are performative is to place them within discursive frameworks that are both citational and reiterative.[2] A precondition of their intelligibility is their alignment with normative practices and desires within a specific social milieu.[3] The performativity of sexual and gender categories relies upon a regime of interrelated discourses and acts through which they are crystallised over time. Heteronormativity often proffers legitimacy to subjects who exhibit these normalised behaviours and desires, or, at the very least, display the capability of reproducing them.[4] However, social media and popular cultural forms have provided dynamic avenues to queer this heteronormative regime of intelligibility, and to 'disturb the order of things.'[5] This chapter pays particular attention to ways of *undoing* gender through social media,[6] highlighting those practices of popular cultural mediation that expose heteronormative gender and sexual identity categories for the ideological fictions that they are. These mediated forms of genderfuckery on social media can be conceived as further reconfigurations of the queer archive.[7]

The attempt to understand our gender and sexual identities necessitates a discussion of mediation and visual culture. The feminist critique by bell

hooks of mainstream media constructions of various identity categories (race, class, gender and sexuality) within the context of white supremacist capitalist patriarchy is instructive.[8] Likewise, Rosalind Gill's critique of post-feminist media representations helps us to tease out the seductions of mainstream media which propagate seemingly progressive images that, in fact, serve the commercial ends of neoliberal capitalist heteropatriarchy.[9]

This chapter borrows, in part, from these theoretical interventions in order to argue for the necessity of paying critical attention to transgressive performances of identity categories within mainstream visual culture. I analyse the ways in which Umlilo, FAKA and Ibokwe use Instagram to problematise mainstream (hetero- and homonormative) visual culture. By engaging in a visual discourse analysis of their Instagram posts, I argue that these artists' online self-styling and curatorial practices constitute the performance of a queer archive – one that is contemporaneous and in constant, fluid process.

WHO ARE THESE QUEERS ANYWAY?

Dubbed South Africa's 'Kwaai Diva,' Umlilo (Siya Ngcobo) is a musician whose visual aesthetics have set them apart from their counterparts.[10] Their stylistic choices are characterised by 'elements of tribal, vintage, and nu-wave futurism,' but also by their androgynous blurring of gender lines, which are still heavily policed in the fashion and music industries.[11] Umlilo's musical body of work similarly refuses categorisation as it incorporates elements of minimalist synth and techno styles, deep-house, trip-hop, rap, trap and pop. FAKA, which means 'to insert' in any of the Nguni languages, is a performance art duo comprised of Desire Marea (Buyani Duma) and Fela Gucci (Thato Ramaisa). Their unapologetically kitsch 1990s aesthetic is usually juxtaposed with a chic and street-savvy trendiness. Equally unapologetic in their sometimes overtly sexually charged live performances, the duo has gained local as well as international acclaim over the last two years.

It would be easy to describe the performances and aesthetics of Ibokwe as confrontational. But that would be to miss the point of their contextual significance. Trained in dance, theatre and traditional medicine, Ibokwe (isiXhosa for 'sacrificial goat') is steadfast in his commitment to exploring the many aspects of his identity

through his art practice. He refuses any descriptive nomenclature, explaining: 'I don't like the term "performance artists," and I can't really call myself an activist since I don't know what it takes to be one.'[12] One description he does not shy away from, however, is that of traditional healer, and that is what he proudly seeks to display and interrogate in his performance practice.

NEOLIBERAL INFLUENCERS AND QUEER VISIBILITY ON INSTAGRAM

Social media analysts and researchers tend to focus on the dialectic among media consumption, production and ownership within the context of global consumer markets. This strand of scholarship stresses the neoliberal capitalist dimensions of social media networking and production. In particular, this research emphasises that self-styling and self-branding by bloggers and professional Instagram users ought to be seen as a form of labour within a post-Fordist and neoliberal capitalist context. Crystal Abidin highlights the tacit labour that is involved in the production and posting of selfies and other commercialised visual images on the Instagram feeds of professional bloggers, known colloquially as 'Influencers.'[13] These scholars argue that the visual images on Influencers' social media posts are representative of the neoliberal ideal of the enterprising worker-subject who has melded their work with their life's passion.[14]

There is also a strand of research that sees social media work as a politicising discourse.[15] Arguing from a feminist perspective, Magdalena Olszanowski harshly critiques Instagram's contradictory and confusing policies regarding the censorship of nude images of female bodies but not violent ones – policies that allow the company to remove users' images and profiles as it sees fit.[16] Censorship, she argues, has a consequential role in that particular subaltern communities are built and maintained on Instagram.[17] In a similar vein, Maritza Rico argues that 'the power that Instagram has to suppress nude images, or images that depict the realities of the female body can have a detrimental effect on conversations about visual art, sex education and sexual politics.'[18]

Within this substratum of social media research, some scholars view the social networking site as having opened up a niche space for the negotiation of alternative identities and queer sexualities. Brandon Miller makes the claim that 'online disinhibition allows for some men to find queer space that is safer and

more readily accessible than the queer space offered to them in their everyday, non-virtual world.'[19] With regards to the self-styling and marketing strategies of well-known queer celebrities, Stefanie Duguay posits that 'Instagram's rhetoric encourages selfies that avoid offending through assimilation with mainstream discourses.'[20] The analyses below contribute to these discussions by thinking through theoretical interventions around the everyday practices and performances of the self and disidentification, as outlined by José Esteban Muñoz.[21] Most importantly, this chapter provides a way to reconceive the queer archive, not in any normative sense, but as a new strategy for utilising the social media that saturate our globalised digital and visual present.[22]

CURATORSHIP AND ONLINE PERFORMANCES OF GENDERFUCKERY

UMLILO: VISUAL QUEERNESS AND FEMININE PERFORMATIVITY

> *Like, for me ... my identity is pretty much entrenched in everything that I do, the way I dress, you know, what I do with my hair, the way I present myself to the public, whether I'm performing, or whether I'm just taking a taxi, or ... it's something that I'm always hyper-aware of ... that there's this femme body walking in this public space.*
>
> <div align="right">Siya 'Umlilo' Ngcobo, interview with the author, 28 February 2017</div>

It is hard to miss Umlilo's appearance. Never one to shy away from daring fashion choices, Umlilo uses visual aesthetics and curatorial prowess to subvert established norms of gendered and sexualised representations. Be it a neon-coloured weave, or dyed dreadlocks sculpted into a crown, Umlilo's hairstyles are always a fashion and political statement. They usually complement full, glittery lips with a pair of refractor sunglasses.

I first saw Umlilo perform in 2017 at a Queer Art Night hosted at Industry, a now-defunct queer nightclub in downtown Johannesburg. These creative arts events incorporated genres such as dance, music, fashion and performance poetry. On this particular evening, Umlilo performed the song 'Umzabalazo' ('Struggle'). The song pays homage to the Fees Must Fall movement, which highlighted the reality

that queer identities are always already imbricated in the politics of race, class, physical and mental health, as well as nationality. In so doing, Umlilo aestheticised queerness as 'a politics of the flesh,'[23] staging a performance and interrogation of queerness that is embedded in materiality and the lived experiences of real-world actors, institutions and structures.[24] The song, as well as Umlilo's gender non-conformity, functions as a paean to the *undoing* of gender,[25] evincing an exploration of performances of gender and sexuality outside of the heteronormative masculine/feminine binary. The performance was a reminder that queerness is not an abstracted subject position, but one that should stand in active opposition to the ideological machinations of mainstream heteronormativity.

By making pointed reference to the widespread student protests that engulfed South African university campuses between 2015 and 2016, Umlilo brought 'the politics of specificity' to bear on this performance – the specificities of the inequalities that the majority of South Africans face on a daily basis.[26] Through this performance, they chose to queer affective politico-economic discourses of the Fees Must Fall movement. This moment constituted a stylised interrogation of the intersectional oppressions related to black gender non-conforming subjectivities – particularly from poor and working-class contexts. Umlilo's performance was imbued with gestural as well as sartorial cues, reminding the audience of the importance of thinking critically about the ideological implications of sexual deviance and marginality within the (supposedly democratic) postapartheid South African political economy. It was a significant moment that provided a counter-discourse to homogenising queer identity narratives, which are often commodified and thus reduced to a global gay identity.[27]

Capitalist visual and consumer culture is saturated with commodified images of global gay identity – homogenising images that reinforce racist, classist, ageist and ableist ideologies. This is a discursive regime and representational praxis that marginalises bodies that do not fit the gay, white, cisgendered, male, affluent and able-bodied ideal.[28] It elides difference and social and cultural specificity while masquerading as cosmopolitan and neoliberal upward mobility. Moreover, such homonormative representations often reduce queerness to fixed and apolitical gender and sexual identity categories, which do not seek to dismantle (or even transgress) the representational praxis of heteronormativity but rather assimilate into them.[29]

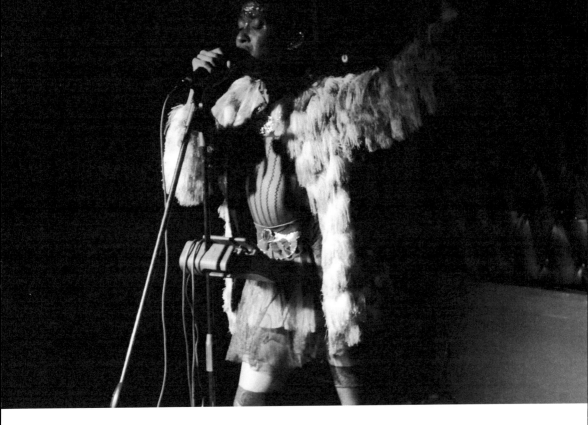

Figure 10.1. Umlilo, 'Umzabalazo,' 2017.
Photograph by Katlego Disemelo.

In an image Umlilo posted on Instagram from their 'Umzabalazo' performance,[30] the artist stands in the foreground bathed in neon blue light, holding a microphone. The background is darkened by shadows. Their left arm is raised high in a clenched fist reminiscent of the anti-apartheid call – 'Amandla' (power) – a signification of collective will to power and self-determination. They wear a tulle miniskirt with a mesh vest exposing the skin of their chest. The accompanying caption included the hashtags: #performance #stage #instapic #photography #fashion #modelling #visuals #style.

We see Umlilo in mid-performance in this image, performing genderfuckery as well as an intersectional politics through dress and gesture. Borrowing from Erving Goffman's conception of performance as 'all the activity of a given participant on a given occasion which serves to influence in any way any of the other participants,' I argue that the act of posting this image on Instagram is, in itself, a performance.[31] The hashtags serve to point the reader to specific semiotic and visual codes – the fashion, the (modelling) gesture or pose, the artistic tone and style of photography. Moreover, Umlilo's act of posting this image is intended to influence the reader to view them through a particular lens: first, as a pioneering, fashionable, queer performance artist, and, second, as a specific kind of queer subject who is engaged with broader intersectional socio-political issues.

Social media scholars stress that posting photographic images online for the purposes of networking and sharing can be seen as actual work, and not just frivolous engagement with online media.[32] Umlilo attests to this:

> I consume stuff from Facebook, I will read articles, I will still share my work, it [has been] also very pivotal in sharing my work. But I find with Instagram, it's a lot more distilled, and ... it's a space where I can really explore my more artistic side without all the noise... It's generally a very visual curation of your life ... It's a space that pushes me to market myself and my work using the latest multimedia updates and improvements ... I always have to think a hundred times about what I'm posting.[33]

Umlilo puts a considerable amount of thought and time into their online curatorial processes, and makes a concerted effort to keep up with the latest multimedia trends in order to utilise this platform to its full potential. Such curatorial self-consciousness and stylisation constitute what could be described as a disidentificatory performance of the queer self. In his seminal book, *Disidentifications: Queers of Color and the Performance of Politics*, José Esteban Muñoz proposes a theoretical model for interrogating the different ways queer people of colour (art practitioners in particular) represent and negotiate the politics of subjectivity.[34] Disidentification, he argues, is 'a hermeneutic, a process of production, and a mode of performance' that is 'about cultural, material, and psychic survival. It is a response to state and global power apparatuses that employ

systems of racial, sexual, and national subjugation. These routinized protocols of subjugation are brutal and painful. Disidentification is about managing and negotiating historical trauma and systemic violence.'[35]

Although the human rights of lesbian, gay, bisexual, transgender, intersex, queer, and other gender-non-conforming (LGBTQI+) citizens are outlined in section nine of the South African Constitution, state-sanctioned and quotidian forms of trans- and homophobia still persist. Numerous LGBTQI+ citizens have recounted stories about homophobia, discrimination and violence from members of the South African Police Service, health service providers, authorities within the education sector and cabinet ministers.[36] Moreover, patriarchal attitudes, femicide, as well as homo- and transphobic hate crimes are so pervasive that they have become normalised.[37] The corrective rapes and brutal murders of poor and working-class black lesbian-identified womxn have become frequent fodder for media and social outrage.[38] This is the socio-cultural context within which Umlilo's performance art and online curatorial self-styling emerges. By stylising and branding themselves – proudly, flamboyantly and transgressively – within this obviously racist and homonormative representational schema, Umlilo uses Instagram as a space to create a countercultural visibility and perform an intersectional black queer politics – disidentificatory strategies of survival that work within and against a homophobic, racist, homonormative and heteropatriarchal media and cultural landscape.

FAKA: SEXUAL FLUIDITY AND ONLINE SELF-STYLING NARRATIVES

Unabashedly kitsch, FAKA celebrate everything about ghetto-chic aesthetics from the 1990s to the present. They are equally celebratory of their blackness and gender-fluid identities. Their fashion and stylistic choices, performances, and cultural politics destabilise the anti-black, elitist hubris which permeates the contemporary South African art world, as well as the commodified global gay culture. It is not unusual to witness the duo barge through classist gallery spaces with their torn fishnet stockings, cheap synthetic wigs, a mix of loud *gqom*-techno music and lascivious dance moves. FAKA's unapologetic bravado enables them to stake a critical claim to public queer, gender-non-conforming visibility – be it on stage, in gallery spaces, on the street or via social media.

An important aspect of the theoretical model of disidentification is that it provides a hermeneutics for interrogating contemporaneous social formations

and practices that work within and against dominant and heteronormative structural systems. I read FAKA's artistic practices, including their stylistic choices on Instagram, as performances of disidentification that create subversive meaning within the alienating context of neoliberal white supremacist consumer capitalist heteropatriarchy.[39]

To present oneself as effeminate in a black male body is dangerous and sometimes fatal in contemporary South African society. Through the lens of African patriarchal hegemony, the many forms of queerness and gender fluidity are seen as instantiations of western decadence.[40] I briefly outlined above the homo- and transphobic social milieu within which queer and gender-non-conforming people negotiate their fluid identities. People of colour who perform trans, butch and feminine masculinities occupy a particularly precarious position in such a society. In South Africa, people who do not conform to established gender norms have to survive the daily oppressions that are the socio-economic hangover of apartheid and endure persistent homo- and transphobic physical and emotional violence. In stylising their gender-fluid visibility (both online and offline), FAKA carve out a space within which to negotiate and survive 'the power *and* shame of queerness.'[41]

FAKA's provocative live performances often seek to scandalise by forcing onlookers to recognise their own pretensions and performances within designated art spaces. In 2016, they staged a live sex show (they were nude and simulating male-to-male sex acts) at the Stevenson gallery's group exhibition *SEX* in Johannesburg. There were no pretensions of suggestiveness here; no innuendo or allusion to the possibility of pleasurable sexual acts between two males. It was just *there*. This is exactly what the artists wanted to bring into the sacrosanct art space – a frankness and sexual diversity that is often taken for granted within supposedly progressive art institutions.

FAKA thus occupy an ambivalent position within the elitist South African art world in that they seem to challenge it from within. As black queer subjects, FAKA do not aim to occupy these spaces as tokens of multicultural pluralism,[42] but engage in such performative interventions in order to make visible the specificities of their black, queer, gender-fluid subjectivity. Their disidentificatory performances and curatorial self-styling constitute what Roderick Ferguson has described as a 'queer of color critique' that aims to 'debunk the idea that race, class, gender, and sexuality are discrete formations, apparently insulated from one another.'[43] FAKA's

confrontational stance is in stark contrast to the exclusionary practices of the art world – galleries and studios patronised, funded and predominantly attended by the middle and upper classes of the white minority population – which includes othered subjectivities and bodies on the basis of unitary identitarian politics, the effect of which is often tokenistic inclusivity.

So it is important that a performance art duo such as FAKA exists to highlight the very systems and structures against which the art world supposedly speaks. However, it should be noted that, as art practitioners and upwardly mobile subjects, FAKA occupy a privileged position in South African society, even if they come from less-than-privileged backgrounds.[44] The ambivalence of their subject positions within artistic spaces – whose exclusions and inequalities they rail against – is thus compounded by the fact that they do not face the same daily struggles for survival as the majority of poor black South Africans.

FAKA have a fascinating knack for styling and marketing themselves online, especially on Instagram. Their curated images stand in sharp contrast to their blatantly tawdry live performances. Take, for example, an Instagram Stories image of FAKA posted on Fela Gucci's Instagram page.[45] The two figures pose together in matching neat Afro wigs. Desire Marea stands close behind Fela, with his right-hand fingers resting softly on the latter's shoulder. Desire wears a mauve lace brassiere, which he uses as an accessory (a necklace or choker), brown, pleated cotton slacks and coral nylon dress socks with elegant high-heeled, open-toed sandals. Fela Gucci, in a tight-fitting, peach-coloured turtleneck, slouches on a wooden chair with his legs wide apart; the viewer is immediately drawn to his crotch. His right hand is raised upward as if he is stroking his wig. A thin belt holds up his tight-fitting, coral, straight-legged pants which expose his brown ankles. His feet are covered by dainty, coral patent-leather pumps. Both figures wear make-up, their shimmering lips and eyelids painted bright green and pink respectively. They pose stone-faced, but not intimidatingly so, as they return the camera's gaze. The linoleum-tiled floor stretches toward the onlooker in varying shades of grey, while a pink-painted brick wall serves as a background.

Derek Conrad Murray argues that an important aspect of a savvy blogger's skill is 'to take the role of curator; the one who understands the [representational] zeitgeist and can make sense of the media deluge.'[46] This is precisely what Fela Gucci does in the above Instagram post. He has taken on the role of curator of

FAKA's brand and visual styling. Everything about the image is well structured, colour coordinated and deliberate. It has the feel of an image in a glossy high-end magazine. Its setting is intended to complement FAKA's styling, sartorial and cosmetics choices. In his book *Visual Consumption,* Jonathan Schroeder demonstrates the integral role played by visual elements and images in relation to consumer culture. He asserts that 'to read images is to call to attention their performative aspects.'[47] This image seeks to draw the reader's attention to specific performative codes, and, in general, its multimodality. The two artists are engaged in a disidentificatory performance of sexual and gender fluidity for which they have gained international acclaim. Their stylistic choices – which can be interpreted as feminine – are juxtaposed with their rather masculine bodies. Their gestures and poise are simultaneously feminine (the colour coordination and fashion styling) and masculine (Fela's slouch and wide open crotch). Similarly, their positioning and gestures reference a kind of family portrait: the seated masculine figure with the supportive feminine figure towering above him. There is an atmosphere of kinship and affection juxtaposed with an intent gaze reflected back at the viewer.

The juxtapositions at work in the image – masculinity/femininity, male/female, pragmatism/ethereality, toughness/softness – suggest a playful ambivalence. Nothing is stable or fixed – even the floor is a kind of optical illusion. There is an interplay, too, of different temporalities. The image is a still digital photograph, but not inanimate; it stretches forward with each moving second and appears, therefore, in constant motion. Using one of Instagram's latest features, this Instagram Stories image was only meant to last for 24 hours – a moment captured in time but reproduced as a fleeting, ephemeral performance of gender fluidity and ambivalence.

Figure 10.2. FAKA, 2017.
Courtesy Superbalist.com.
Fashion Director: Gabrielle Kannemeyer.
Photograph by Bevan Davis.

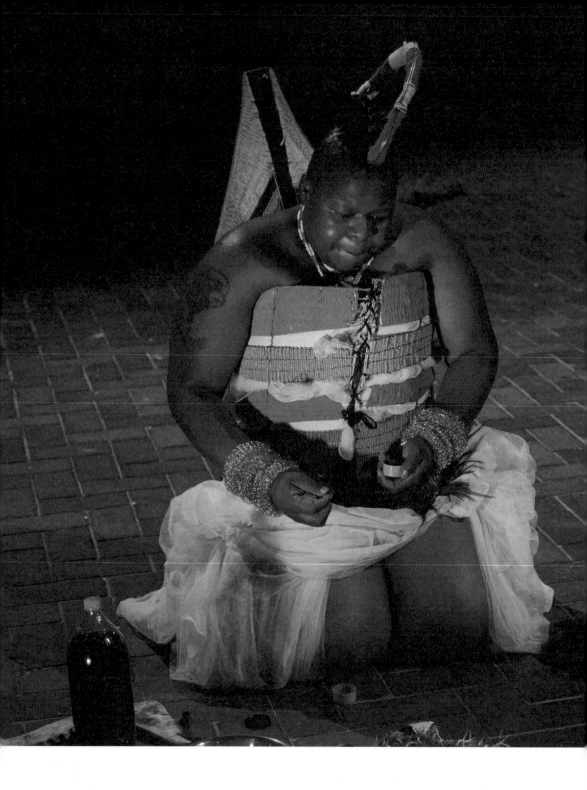

Figure 10.3. Albert 'Ibokwe' Khoza, *Take in Take out (to live is to be sick to die is to live)*, 2017.
Courtesy Institute for Creative Arts.
Photograph by Ashley Walters.

The concepts of fluidity and ambivalence are helpful in that they not only describe the textuality of this particular image-performance, but its content too. Here, I would like to invert Judith Halberstam's famous term and argue that, in this particular image, FAKA perform a *masculine femininity*.[48] They publicly embody a queer masculine femininity on a mainstream social networking site and yet, at the same time, transgress visual culture's heteronormative codes of subjectivity. In this way, FAKA, as in many of their live performances, exist within, but work against, a hegemonic (capitalist media) power structure that tends to invisibilise trans and other gender-non-conforming individuals.[49] Not only are FAKA forging a critical online space of visibility through their engagement on the Instagram platform, but they do so in a matrix of multiple oppressions.

Desire Marea views Instagram as a way to market himself and FAKA, but also as a medium through which to narrate and perform their multifaceted identities: 'I think with Instagram being a storytelling medium, it became a way to write a very beautiful queer narrative for ourselves.'[50] He also attests to the hyperreal and curatorial aspects of the medium: 'It's hyperreality! Like, intensely hyperreal. And highly curated as well. I will not show you anything that is not part of the narrative that I want to express.'[51] Michel de Certeau argues that 'many everyday practices (talking, reading, moving about, shopping, cooking, etc.) are tactical in character.'[52] We tell stories in tactical ways – to someone, with a particular agenda, and for a particular purpose. The act of telling a story becomes, therefore, a tactical performance.

IBOKWE: RITUAL OFFERINGS

Ibokwe's performance piece *Take in Take out (to live is to be sick to die is to live)*, which I experienced at the Institute for Creative Arts (ICA) Live Art Festival 2017, is an interactive, multimodal ritual of memory, and a reflection on the current socio-political climate in postapartheid South Africa. When the performance begins, Ibokwe kneels in the centre of the outdoor performance space, clapping his cupped hands loudly. He is in communion with the ancestors, imploring them to remind us of our traditional African roots. He is soon transported back into the present time-scape. He walks up to a red telephone that rings loudly. 'Hello?' he answers curiously. One of his chief ancestors has called him on the direct line, instructing him to show us a way back to our traditional roots. Some audience members laugh

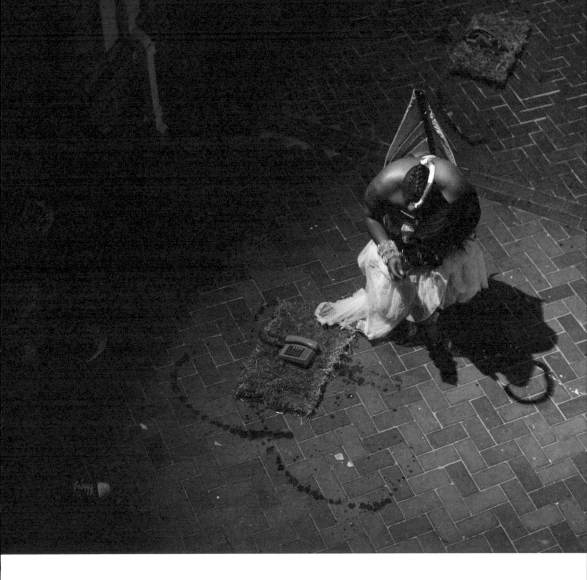

Figure 10.4. Albert 'Ibokwe' Khoza, *Take in Take out (to live is to be sick to die is to live)*, 2017.
Courtesy Institute for Creative Arts.
Photograph by Ashley Walters.

as Ibokwe relays this message in isiZulu; others are expressionless. In spite of their varied responses, the audience is generally drawn into participatory mode during the performance, clapping and shouting 'Siyavuma' (we agree) upon Ibokwe's instruction. He looks intently into some audience members' eyes, intermittently summoning one or two of them to hand him this or that prop, or to help him with his beaded wire corset. He is sassy and humorous. He sashays from one corner of the quad to the next, handing a small bottle of gin to audience members to spill and sip as a libation to the ancestors.

Take in Take out is a disturbing work of live art that evokes discomfiture. For instance, the projection of a Fees Must Fall protest video onto the venue's stone wall provides a slight distraction from the sight of Ibokwe defecating into a glass bowl in the middle of the quad. Likewise, sounds from the protest chants blast loudly from the speakers as Ibokwe gulps down a small bucket of salt water, only to regurgitate the liquid into the same bowl, while Miriam Makeba's voice filters through these numerous sensory stimulations: 'Laugh to keep from crying,' she says in a continual loop as she speaks to an interviewer about the horrors of apartheid. Purging is an important aspect of a traditional healer's work on the body. It cleanses the body as well as the soul of all toxins. So it is with Ibokwe's literal and metaphorical purging. In his dual capacity as healer and art practitioner, Ibokwe offers a prognosis of healing and recovery of which, he suggests, South Africa is in dire need. To dismiss the work as offensive would be too simplistic. It is a complex interplay between performance and ritual, sickness and health, body and spirit; a dense mix of visual and aural multimedia, and traditional sangoma rites and rituals.

Ibokwe says of *Take in Take out*: 'I always say that it's not a performance, really. It's actually an offering, hence it's a ritual. You take whatever you want from it ... With this work, I was really communing with my ancient guides, my ancestors, and asking them why the world is as it is, and how we came to find ourselves amidst all this bullshit.'[53] Amongst many things, the 'bullshit' might be interpreted as endemic government corruption in South Africa, the country's persisting Judeo-Christian moralism and fundamentalism, and the landlessness, dispossession and disenfranchisement of Africans across the continent. This is a dense, broad set of ideas but Ibokwe's performance-ritual references each one, throwing into relief the simultaneous schizophrenia and ennui of the postcolonial condition.

Although Ibokwe posts quite often on Instagram, he is less concerned with the medium's hyperreal aesthetic qualities and innovations than the artists discussed above. As such, his posts are often blurry, spontaneous and incongruous. He does not use image-enhancing features such as filters. His feed reveals a disjointed and spontaneous engagement with the medium, and a humorous personality. A few images are highly stylised and professionally edited (presumably for marketing purposes), while most others seem random, depicting his everyday activities with friends and family.

Nevertheless, some of the images he posts are vocal about his subject position as a black queer sangoma. In 2017, Ibokwe posted a fuzzy image on Instagram of a white male border-control security official in Cologne, Germany. Part of the long caption read: 'Guys its hard hard hard hard being me jesu i must make sure the next time i come back here i must cut all My hair and pictures on my passport i must be bald [sic].'[54] Ibokwe is often misrecognised and therefore stopped at international borders due to his changing appearance. The comment, although not a direct reference to his artistic practice, makes a critical point about the politics of his body and visual presentation in different geopolitical spaces.

Ferguson posits that 'as [modern] heteropatriarchy was universalized, it helped to constitute the state and the citizen's universality.'[55] Within this discursive framework, certain bodies, and the institutions and cultures they come to represent become immediately legible and thus legitimated. This is what constitutes normalising reiterations of gender performativity.[56] Bodies that do not fit within this representational matrix become illegible and incomprehensible, and are thus seen to queer and disturb the order of things. Ibokwe's body is clearly – and queerly – disruptive. His outward appearance disturbs the institutional restrictions of legibility in terms of race, class, gender and citizenship. In this regard, Ibokwe's online presence might be seen to open up a kind of conversational engagement with his presumed audience about the schizophrenia of postcoloniality, queerness and citizenship. Indeed, through this particular post, Ibokwe performs an online queerness that speaks directly to the politics of the postcolonial condition.

PERFORMING THE QUEER ARCHIVE

I have made all of the assertions above not only to show the different self-styling strategies of the three artists on Instagram, but also to argue that these online performances constitute queer archival work in continual flux. In the edited collection *Refiguring the Archive*, Graeme Reid states that 'the way in which lesbians and gay men have been perceived is reflected in the way in which lives and histories have been constructed and documented within the archival holdings of public institutions.'[57] Although his observation leaves out many gender-non-conforming lives, histories and realities, it is true of the way in which marginalised subjectivities are perceived in any socio-political and economic milieu. The way in which queer and marginal lives and realities are archived and documented is intrinsically linked to the predominant discourses of the time. The online performances of gender fluidity, genderfuckery and counternormative illegibility constitute stylised performances of a queer archive that stands within and against the mainstream assimilationist and homonormative representations of idealised and thus commodifiable global gay identity.

But why, you may ask, should we disturb our current conceptions of the queer archive? Before attending to this question, I would like to counter it with Bhekizizwe Peterson's rhetorical one: 'Should we not, initially, occupy ourselves with locating, understanding and foregrounding the various forms of oppositional experiences and knowledge systems that are currently omitted from the archives in their present figuration?'[58] If we are to make meaningful sense of section nine (the equality clause) of the South African Constitution, then we should busy ourselves with looking to the seemingly quotidian experiences, representations and lives of young and old black queer people who are everywhere marginalised because of their race, class, sexuality, physical ability and gender non-conformity. Keguro Macharia cautions that we must constantly question the materiality and contestations of established notions of the queer archive.[59] We should, therefore, interrogate and take seriously popular cultural online trends, musical tastes, colloquialisms and self-styling – the everyday performances of marginalised queer subjectivities. We must take careful stock of those disidentificatory practices of meaning-making undertaken by marginalised queer subjectivities in order to archive *their* stories and realities.

CONCLUSION

I have chosen the above case studies in order to argue that these performers' particular engagement with social media platforms, such as Instagram, should be taken more seriously than is currently the case. I have argued that what may appear as a frivolous engagement with new digital media through photographic images can be reconceptualised as a modality of performance, process and queer archival work. The archive is never a neutral discourse, but it can be more expansive and inclusive than our current conceptions of it allow. If we are to engender an ethics and politics of queerness (and, hopefully, the possibility of political and ideological change), as much discursive and representational dignity as possible must be afforded to those who are marginalised, unseen and unheard within this globalised digital and visual present. It would be more helpful, therefore, to democratise the notion of a queer archive, and understand it as a process in continual and ever-creative flux; a process that challenges and problematises normalising machinations of neoliberal representation and homonormativity. An archive that should, by virtue of its queerness, disturb the order of things.

1. A Dinka corset is a beaded corset originating from southern Sudan.
2. Judith Butler, *Gender Trouble: Feminism and the Subversion of Identity* (New York: Routledge, 1990).
3. Sara Ahmed, *Queer Phenomenology: Orientations, Objects, Others* (Durham: Duke University Press, 2006).
4. Sara Ahmed, 'Orientations: Toward a Queer Phenomenology,' *GLQ: A Journal of Lesbian and Gay Studies* 12, no. 4 (2006): 546, accessed 4 March 2016, doi:10.1215/10642684-2006-002.
5. Ahmed, 'Orientations,' 545.
6. Judith Butler, *Undoing Gender* (New York: Routledge, 2004).
7. June L. Reich, 'Genderfuck: The Law of the Dildo,' *Discourse* 15, no. 1 (1992): 112–127, accessed 11 February 2017, http://www.jstor.org/stable/41389251.
8. bell hooks, *Black Looks: Race and Representation* (Boston: South End Press, 1992).
9. Rosalind Gill, 'Postfeminist Media Culture: Elements of a Sensibility,' *European Journal of Cultural Studies* 10, no. 2 (2007): 147–166, accessed 11 February 2017, doi: 10.1177/1367549407075898.

10. I use the pronouns 'they,' 'them' and 'their' with reference to Umlilo in ethical acknowledgement of their genderqueer identification.

11. Erin White, 'South African Kwaai Diva Shows Off Futuristic Genderqueer Style in Collaboration with Photographer Stuart Hendricks,' Afropunk blog, 18 November 2016, accessed 23 January 2017, http://www.afropunk.com/profiles/blogs/south-african-kwaai-diva-umlilo-shows-off-futuristic-genderqueer?xg_source=activity.

12. Albert Silindokuhle 'Ibokwe' Khoza, interview with the author, 2 March 2017.

13. Crystal Abidin, '"Aren't These Just Young, Rich Women Doing Vain Things Online?": Influencer Selfies as Subversive Frivolity,' *Social Media and Society* 2 (2016): 3, accessed 3 February 2016, doi:10.1177/2056305116641342.

14. Rosalind Gill, 'Life Is a Pitch: Managing the Self in New Media Work,' in *Managing Media Work*, ed. Mark Deuze (London: Sage, 2010), 249.

15. Theresa M. Senft and Nancy K. Baym, 'What Does the Selfie Say? Investigating a Global Phenomenon,' *International Journal of Communication* 9 (2015): 1587–1606, accessed 7 March 2017, https://research-management.mq.edu.au/ws/portalfiles/portal/45391259.

16. Magdalena Olszanowski, 'Feminist Self-Imaging and Instagram: Tactics of Circumventing Sensorship,' *Visual Communication Quarterly* 21, no. 2 (2014): 83–95, doi:10.1080/15551393.2014.928154.

17. Olszanowski, 'Feminist Self-Imaging and Instagram,' 85.

18. Maritza Rico, 'Misogyny in Modernity: Female Body Censorship on Instagram,' Maritza Rico blog, 7 May 2015, accessed 7 May 2017, http://maritzarico.blogspot.co.za/2015/05/misogyny-in-modernity-female-body.html.

19. Brandon Miller, '"Dude, Where's Your Face?" Self-Presentation, Self-Description, and Partner Preferences on a Social Networking Application for Men Who Have Sex with Men: A Content Analysis,' *Sexuality and Culture* 19, no. 4 (2015): 640, accessed 3 February 2017, doi:10.1007/s12119-015-9283-4.

20. Stefanie Duguay, 'Lesbian, Gay, Bisexual, Trans, and Queer Visibility through Selfies: Comparing Platform Mediators across Ruby Rose's Instagram and Vine Presence,' *Social Media and Society* 2, no. 2 (2016): 6, accessed 21 February 2017, doi: 10.1177/2056305116641975.

21. José Esteban Muñoz, *Disidentifications: Queers of Color and the Performance of Politics* (Minneapolis: University of Minnesota Press, 1999).

22. Judith Halberstam, 'What's That Smell? Queer Temporalities and Subcultural Lives,' in *Queering the Popular Pitch*, eds. Sheila Whiteley and Jennifer Rycenga (New York: Routledge, 2006), 17. The author is now more commonly known and referred to as Jack Halberstam.

23. E. Patrick Johnson, '"Quare" Studies, or (Almost) Everything I Know about Queer Studies I Learned from My Grandmother,' *Text and Performance Quarterly* 21, no. 1 (2001): 3, accessed 8 September 2017, doi: 10.1080/10462930128119.

24. Cherríe Moraga and Gloria Anzaldua, *This Bridge Called My Back: Writings by Radical Women of Color* (New York: Kitchen Table: Women of Color Press, 1983).

25. Butler, *Undoing Gender*.

26. Johnson, '"Quare" Studies,' 11.

27. Dennis Altman, 'Global Gaze/Global Gays,' *GLQ: A Journal of Lesbian and Gay Studies* 3, no. 4 (1997): 417–436, accessed 29 January 2004, doi: 10.1215/10642684-3-4-417.

28. Heidi J. Nast, 'Queer Patriarchies, Queer Racisms, International,' *Antipode* 34, no. 5 (2002): 881, accessed 14 February 2014, doi: 10.1111/1467-8330.00281.

29. Lisa Duggan, *The Twilight of Equality: Neoliberalism, Cultural Politics, and the Attack on Democracy* (Boston: Beacon Press, 2003).

30. The author of this chapter took the photograph in question and sent it to Umlilo prior to writing this chapter. Umlilo elected to share the image on their Instagram account.

31. Erving Goffman, *The Presentation of Self in Everyday Life* (New York: Random House, 1956).

32. Abidin, '"Aren't These Just Young, Rich Women Doing Vain Things Online?"' 12.

33. Siya 'Umlilo' Ngcobo, interview with the author, 28 February 2017.

34. Muñoz, *Disidentifications*, 25.

35. Muñoz, *Disidentifications*, 161.

36. In 2017, the deputy minister of Higher Education pleaded guilty to the physical assault of a womxn in a Johannesburg nightclub who called him 'gay.' He later resigned. See Iavan Pijoos, 'Manana Convicted on Three Counts of Assault After Pleading Guilty,' *Mail & Guardian*, 13 September 2017, accessed 1 October 2017, https://mg.co.za/article/2017-09-13-manana-convicted-on-three-counts-of-assault-after-pleading-guilty.

37. Pumla Dineo Gqola, *Rape: A South African Nightmare* (Johannesburg: Jacana, 2016).

38. The term 'womxn' is used as a politically progressive substitute to 'woman' and 'women' in order to include transgender, transsexual, cisgender, and other female-identified subjectivities.

39. hooks, *Black Looks*, 107.

40. Thabo Msibi, 'The Lies We Have Been Told: On (Homo) Sexuality in Africa,' *Africa Today* 58, no.1 (2011): 55–77, accessed 16 August 2017, doi: 10.2979/africatoday.58.1.55.

41. Muñoz, *Disidentifications*, 5 (emphasis mine).

42. Muñoz, *Disidentifications*, 166.

43. Roderick Ferguson, *Aberrations in Black: Toward a Queer of Color Critique* (Minneapolis: University of Minnesota Press, 2004), 4.

44. Desire Marea is also employed as a copywriter for a prominent advertising agency.

45. Instagram Stories is an Instagram feature that allows users to post an unlimited number of images and videos throughout the day. The 'stories' disappear after 24 hours.

46. Derek Conrad Murray, 'Notes to Self: The Visual Culture of Selfies in the Age of Social Media,' *Consumption, Markets and Culture* 18, no. 6 (2015): 497, accessed 14 March 2017, doi: 10.1080/10253866.2015.1052967.

47. Jonathan E. Schroeder, *Visual Consumption* (New York: Routledge, 2002), 62.

48. Judith Halberstam, *Female Masculinity* (Durham: Duke University Press, 1993).

49. With the exception of highly sensationalised and commodified images of drag queens, as seen on LOGO's *RuPaul's Drag Race*.

50. Desire Marea, interview with the author, 28 January 2017.

51. Marea, interview.

52. Michel de Certeau, *The Practice of Everyday Life* (Berkeley: University of California Press, 1984).

53. Khoza, interview.

54. Albert Silindokuhle 'Ibokwe' Khoza, Instagram post, 1 October 2017.

55. Ferguson, *Aberrations in Black*, 12.

56. Butler, *Gender Trouble*.

57. Graeme Reid, '"The History of the Past is the Trust of the Present": Preservation and Excavation in the Gay and Lesbian Archives of South Africa,' in *Refiguring the Archive*, eds. Carolyn Hamilton, et al. (Cape Town: David Philip, 2002), 194.

58. Bhekizizwe Peterson, 'The Archive and the Political Imaginary,' in *Refiguring the Archive*, eds. Carolyn Hamilton et al. (Cape Town: David Philip, 2002), 30.

59. Keguro Macharia, 'Archive and Method in Queer African Studies,' *Agenda: Empowering Women for Gender Equity* 29, no. 1 (2015): 144, accessed 14 August 2017, doi: 10.1080/10130950.2015.1010294.

Effigy in the Archive: Ritualising Performance and the Dead in Contemporary South African Live Art Practice

ALAN PARKER

Our knowledge of the dead comes to us predominantly through our encounter with the archive or, more specifically, our encounter with two particular archival sources. The first is the written archive, where the traces of the dead (transformed into documents) are preserved as a means to store knowledge from the past for access in the future. The second source is the body, occurring through our memories and complex genealogies, by which traces of the dead are passed down from generation to generation through the gestures, stories and practices of our cultures and the cultures of our ancestors. Both the embodied and written archives are spaces where we commune with the dead and are able to apply their knowledge from the past to our discovery of new knowledge in the present.

Within the embodied archive, the performance of cultural ritual emerges as a particularly significant example of the passing down of knowledge through inherited and learned behaviour. Ritual theorist Catherine Bell loosely defines ritual as a series of embodied activities that are perceived to transcend the present by connecting to values, knowledge and traditions that are regarded as ancient and/or timeless.[1] In passing down these ritual behaviours from one generation to the next, importance is often placed on their continued repetition and restoration in a markedly similar way through their framing as 'sacred' activities. Towards this end, often strict socio-cultural rules and regulations regarding who can perform the ritual, how it must be performed, as well as where and when the ritual can

occur, serve to limit and govern the manner in which the behaviour is passed down and restored in future generations. Through this socio-cultural framing, ritual behaviours become imbued with both the knowledge of the past as well as those ideological belief systems from which this knowledge emerges.

The creative reimagining of ritual behaviours through performance thus becomes an exploratory methodology for unearthing new knowledge and insight from the archive through the disruption, subversion and challenging of old knowledge inherent in the rituals themselves. This proposition that new knowledge is gained through interrogation of the old is the point of departure that guides the discussion that follows. In this chapter, I consider some of the ways in which performative engagement with the dead through the reimagining of cultural ritual can be seen to interrogate, disrupt and challenge knowledge passed down from the past. Towards this end, my analysis considers relationships between performance and memory, and historical cultural rituals and their reimagining as ritualising or ritual-like performances. I make a distinction here between the terms 'ritualising' and 'ritual-like' in a manner informed by Bell's distinction between 'ritualization' and 'ritual'.[2]

'Ritualising' is used to denote practices or behaviours that are performed in a ritualistic way or appear to have 'sacred' symbolism, but where the performed behaviour itself may not directly reference existing cultural rituals or traditions. The term 'ritual-like' is used to describe behaviours that appear ritualistic or are recognisable as ritual behaviours connected to 'tradition' but are performed in a 'profane' manner where the functionality of the behaviour is emphasised over any resultant symbolism. In order to further explicate the ways in which rituals concerned with the dead might be reimagined as a means for both artist and audience to self-consciously rethink their knowledge of the past within the contemporary context, three performance works by South African artists Gavin Krastin, Sello Pesa and Igshaan Adams are considered. The specific works selected for analysis are Krastin's *Rough Musick* (2013), Pesa's *Limelight on Rites* (2014) and Adams's *Bismillah* (2014).

PERFORMING MEMORY THROUGH EFFIGY

In his analysis of ritual performances of death in Haiti, Myron Beasley suggests that 'to engage with death is to open the physical body to a series of performative

possibilities.'³ He argues that, by engaging with death, specifically through performance and performative rituals, it becomes possible to 'unravel the realities of the living and the dead' where the physical body becomes both a site for 'interrogating a host of limitless engagements with the spiritual realm' and a vessel for the 'utterances' of the dead.⁴ In a similar vein, Joseph Roach, in the introduction to *Cities of the Dead: Circum-Atlantic Performance*, states: 'The voices of the dead may speak freely now only through the bodies of the living.'⁵

Both Beasley and Roach describe the performing body as a kind of medium, where the living body of the performer becomes a mediator for the 'voices' and knowledge of the dead. Roach identifies 'effigy' as a recurring method through which communities converse with their corporeal genealogies as a means to reinvent embodied knowledge. In this conception, effigy is acknowledged as both a noun and a verb. In its noun form, the effigy concerns a 'specially nominated medium or surrogate' who, on behalf of a community or group, becomes a representative for the source, now absent, from whom memory originates.⁶ Effigies, in this understanding, include 'actors, dancers, priests, street maskers and corpses' and their function is to effigy (as a verb), 'to evoke an absence, to body something forth, especially something from a distant past.'⁷ The performance of effigy can therefore be seen to function on two levels towards facilitating conversation with the dead. The surrogate or medium who assumes the effigial role communes with the memory of the dead directly, through their own body, while simultaneously enabling and supporting a similar communication for those for whom they effigy – the audience.

In his analysis of performances through effigy, Roach observes: 'Memory is a process that depends crucially on forgetting.'⁸ Whether knowledge is stored as a document in an archive or as an embodied gesture within a ritual or performance, forgetting emerges as a crucial aspect of memory. Forgetting is an inevitable (and often intentional) by-product of the written archive's transformation of memory into document where those who archive dictate what is preserved (and thus remembered) and what is forgotten (and thus erased). The embodied archive, however, is equally implicated in processes of forgetting, where the fluid, unfixed and ephemeral nature of the memory stored in the body becomes subject to inevitable alteration, reinvention and change. In both instances, processes of forgetting also become processes of reimagination where, in trying to remember

what has been forgotten, something new is able to materialise in a changed and sometimes restorative form.

Roach identifies three principles that support this conversation through effigy occurring between the bodies of the living and those of the dead. He describes these principles as the 'kinesthetic imagination,' 'vortices of behavior' and 'displaced transmission.'[9] As a means to elucidate the ways in which these principles operate in relation to the performance of memory through effigy, and towards an explication on the potential value in embodied memory's reinvention as a disruption of both written and embodied archival knowledge, I examine these principles in relation to the performance works identified above.

ROUGH MUSICK AND THE 'KINESTHETIC IMAGINATION'

Roach's first principle concerns the actual process of remembering and then performing embodied cultural behaviours.[10] He describes the kinesthetic imagination as the virtual space in which memory and imagination converge, where, in remembering embodied behaviours, their restoration, repetition and performance in the present require a simultaneous 'imaginative expansion.'[11] The repetition of the behaviour thus also constitutes its reimagining and reinvention. In this sense, by remembering a past behaviour, the conversion of this memory into a physical action requires an imaginative process, where a change occurs between the remembering and its actualisation by the body as behaviour. Naturally, there are degrees to the extent of this change, but Roach proposes that even when behaviours are performed with the intention of repeating them in a manner markedly similar to the original learned behaviour (as is the case in sacred ritual), a process of reimagination inevitably occurs.

In the realm of performance-making, the extent of a behaviour's reimagining is arguably open to a greater degree of reinvention, where emphasis can be placed on a creative re-engagement with the behaviour somewhat distanced from strict socio-cultural and/or religious regulations regarding the performance of that behaviour. This is perhaps what Beasley means when he identifies the 'performative possibilities' of engaging with death through the performing body.[12] By engaging with ritual behaviours in the context of ritualising performance (which balances delicately between the 'sacred' and the 'profane'), these behaviours become open

and available to a higher degree of reimagination and critique than might be the case in the purely 'sacred' context of cultural ritual.

Gavin Krastin's *Rough Musick* is a work where this particular approach to the performance of effigy can be observed. The work, in which I was involved as a performer and dramaturge, premiered at the 2013 National Arts Festival as a site-specific performance installed in two adjoining rooms on the campus of St Andrews, a private boarding school in Grahamstown. This specific building is one of the school's oldest, and was converted into a boys' locker room some years ago. Krastin was drawn to the locker room as a performance space due to the work's intended thematic focus on rituals of shaming and potential associations with the boys' locker room as a space where contemporary acts of shaming, particularly in relation to masculinity and sexuality, pervade. While Krastin was conducting research for the work, the antiquated ritual practice of 'rough musick' emerged as a central impulse underpinning the work and subsequently became its title. Originating in medieval Europe, the practice involved the performative shaming of criminals and sexual deviants, often preceding their execution, by banging household objects (such as pots and pans) as a public expression of social exclusion. This cacophony of sound, utilised as an embodied expression of shame, constituted the rough musick.

Krastin's initial intentions in creating the work had less to do with death and more with reimagining historical rituals emerging from a society's need to punish those deemed other. He was particularly drawn to rituals sourced from medieval England because, as a second-generation South African, these practices resonated with Krastin's own genealogical ties to a culture and ancestry that he regards as disconnected from, or other to, his everyday lived experience. He describes the work as 'an ambiguous contemporary re-engaging ... where the pre-Empire white culture of the United Kingdom is rendered exotic and strange, positioning the artist-of-European-descent as ethnically other.'[13] The work is thus deeply connected to a desire by the artist to engage with performance as a means to reimagine cultural rituals and, more importantly, to challenge and disrupt the knowledge and cultural memory at the root of these practices.

While rehearsing the work in early 2013, Krastin's (British) grandmother became unwell, and for months it seemed likely that she would not live for much longer. The trauma and anxiety Krastin experienced in waiting for death were

Figure 11.1. Gavin Krastin, *Rough Musick*, 2014.
Courtesy Institute for Creative Arts.
Photograph by Ashley Walters.

compounded by the unexpected passing of his (British) grandfather two months prior to the first performance of the work. This atmosphere of death, loss and mourning inevitably influenced the creation of the work to the extent that, from my perspective as performer and dramaturge, *Rough Musick* became enmeshed with Krastin's personal need to contemplate death, memory, loss and the inherited genealogical behaviours connecting him to his ancestors.

While *Rough Musick* is not overtly a performance of a specific cultural ritual, there is a distinct ritualising that emerges through the work's structure and its combining of various ritualistic behaviours and processes. Cultural anthropologist Victor Turner's three phases of rites of passage, for instance, correspond to the

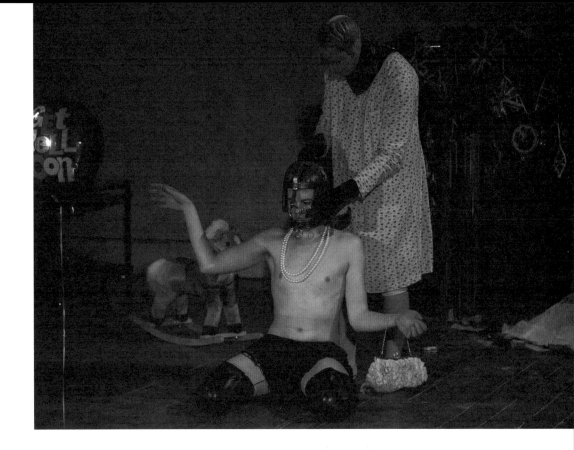

Figure 11.2. Gavin Krastin, *Rough Musick*, 2014.
Courtesy Institute for Creative Arts.
Photograph by Ashley Walters.

progression of practices in *Rough Musick*.[14] Turner's first phase (separation), which signifies the detachment of the deceased from 'an earlier fixed point in the social structure,' correlates with the first section of Krastin's performance.[15] *Rough Musick* begins with the audience in a stone-walled antechamber. My character, with face obscured by a latex mask, sits on a child's rocking horse, wearing pink slippers and the kind of floral nightgown one might associate with an elderly British woman. In this first section of the performance, I remove a black cloth on the floor to reveal the naked body of Krastin, vacuum-packed in a transparent body bag. A bizarre duet occurs where the preserved body of Krastin is manipulated, carried, rearranged and held. There is no exact narrative, and the encounter is one that

fluctuates between functionality and tenderness. At times Krastin's body is handled with care, at other times it is treated as an object. In this encounter Krastin does not feign death. His body is visibly alive and he often moves of his own accord. The encounter serves as a symbolic distancing that situates both of our bodies outside of the binaries of life and death and past and present. Krastin appears both dead and alive, and my character is engaged in mourning but has also moved on.

Turner's second phase (the margin or liminal period), where the subject may 'elude or slip through the network of classifications that locate states and positions in cultural space,' correlates with the majority of Krastin's activity in the performance of *Rough Musick*.[16] Following the duet with Krastin's body, the audience moves into another room. Krastin enters this space, no longer vacuum-packed, wearing thigh-high, goat-heeled boots and an inflatable mask that covers his entire head. He then performs a series of actions which include a dance of seduction, the robbery of three audience members,[17] his adornment in symbols of the British royal family (to a score of *God Save the Queen*) and the burial of a dead dog (to *The White Cliffs of Dover*). During these activities and processes, Krastin is surrounded by symbols of British culture which he passes through as a liminal entity, as someone caught between two sides of a transitional journey. He is both a descendant of British culture as well as its other.

The performance concludes with what Turner describes as the third and final phase of a death-related ritual – the consummation of the deceased's passage into another realm.[18] In the concluding moments of *Rough Musick*, Krastin is attached to a medieval-looking chariot and paraded around the room while the audience are invited to shame his body by creating rough musick with provided pots and pans and by throwing tomatoes and eggs. Krastin's chariot is then wheeled outside and attached to a donkey. The audience are invited outside to bear witness as Krastin's body is pulled down the street, towed behind the donkey.[19]

In performing the work, Krastin positions his own body as the effigy through which this conversation with death and memory occurs, serving a dual effigial role. On a personal level, his role as effigy allows his performance of memory to emerge from, and in relation to, his own physiology and embodied genealogy. Krastin, however, also positions his body, in a depersonalised manner, as an effigy for the audience. In this instance, the artist, Gavin Krastin, is not the effigy; rather he situates his body as a vessel, separate from himself, through which the audience

can effigy. Throughout the performance, Krastin works to dehumanise his own presence and to appear monstrous, abject and other through his movement and costuming as a means to establish, for the audience, an effigy that is real and materially present, but that is not him. As the various ritual behaviours unfold in the work, the audience are regularly offered the opportunity to participate in the ritual. These interactions, however, are not forced. Those present are provided with the necessary tools to shame Krastin's effigy and participate in the remembered (and reimagined) behaviours, but these invitations serve to instigate a decision on the part of the individual audience member as to whether to participate in the shaming of the effigy or to sit back and witness his shaming by others. Krastin's particular engagement with effigy thus also recalls the violence so often associated with effigy (I am reminded of the phrase 'to burn in effigy') where the symbolic surrogate must bear the responsibility, significance and punishment of that which they represent. Each performance of *Rough Musick* reveals divisions within the audience between those who enthusiastically participate in the shaming of Krastin's effigy, those who refuse, and those who seem to participate out of a perceived obligation and appear as unwilling participants.[20]

As a performance that can be seen to reinvent memory, Krastin's *Rough Musick* represents an engagement with Roach's principle of 'kinesthetic imagination,' where memory and imagination converge in the performance of restored embodied behaviours. Krastin references an array of antiquated rituals, practices, symbols and behaviours sourced from his genealogical connection to a British ancestry, inherited through his grandparents, which necessitate reimagining because their origins have become other to Krastin's own space of existence. The ritual practice of rough musick represents the most obvious reimagination of behaviour in the work. As described above, Krastin sets up a performative context where the audience are asked to participate in the shaming of his effigy through the restoration of this behaviour in a contemporary setting. The actual behaviour, if reduced to the physical actions of throwing food or creating sound through banging, remains relatively unchanged. The reimagination of the behaviour occurs, instead, in relation to Krastin's body and his role as effigy in the restoration of the behaviour. Building up to his ritualised shaming, Krastin alludes to several crimes (predominantly against heteronormativity) associated with his body that might justify his shaming. Firstly, his visual aesthetic through costuming is one that strongly references fetishised

sexuality and BDSM practices.[21] Secondly, his appearance throughout the work is notably gender fluid. Although naked in the vacuum-sealed plastic body bag, Krastin's genitals are tucked in, in such a way that the audience are unable to identify a penis and instead are presented with a fleshy 'mound' where his genitals should be. In a similar way, Krastin's other costumes in the work could be described as 'genderfuck' in the sense that he wears thigh-high boots, a tasselled skirt and costume jewellery (heteronormatively considered female apparel) but is bare-chested and thus also visibly male. Thirdly, Krastin commits three 'legal' crimes in the performance, namely the sexual harassment of three male members of the audience, the stealing of their money, and his fraudulent impersonation (and mocking) of Queen Elizabeth II (and the lineage of British monarchs she represents).

When Krastin offers the audience the opportunity to participate in the restoration of the rough musick behaviour, the practice becomes reinvented through his ambiguous framing of the effigy to be shamed. It is unclear for what, exactly, Krastin's effigy is being shamed and punished. Is it because of his otherness? Is it because he has deviated from heteronormative understandings of sex, sexuality and gender? Is it because he is a criminal who has stolen, seduced and mocked another? Or because he is a descendant of a culture that has (historically) stolen, seduced and mocked the other? In deciding to participate in his shaming, the audience become complicit in these questions.

Another interesting example of reimagined behaviour occurs when Krastin buries the life-like corpse of a small dog in white chalk. He carries the chalk with a shovel from a large pile in the corner while *The White Cliffs of Dover* plays in the background. This action of burial is difficult and strenuous for Krastin to perform because his shoes are challenging to walk in, his mouth is gagged with an inflatable sex toy and his head is locked inside a heavy metal cage. The image is saturated with nostalgia, struggle and ambiguous significance for the outside observer, but for Krastin the activity becomes a performance of memory and the symbolic, reimagined repetition of a familiar behaviour – the burying of the dead in the symbols of culture. The dog becomes another effigy and, through surrogation and projection, assumes a multitude of other absences. The act is reimagined as the burial of cultural ancestry, of antiquated traditions, beliefs and sensibilities and, more personally, of Krastin's own familial dead. Krastin translates the emotional difficulty of dealing with loss into an overtly physical hardship. While transporting

the white chalk across the room, he struggles to balance and walk, he uses his wrists and forearms to hold and manipulate the shovel, and he struggles to breathe because of the gag in his mouth and the heavy head cage. The physical act of burying the dog becomes another physical punishment that his body must endure.

As Krastin reperforms the antiquated rituals of his ancestry, these rituals are able to take on new significances, for him (privately) as well as for those who observe and participate in their reimagination. Adrienne Sichel writes: '*Rough Musick* functions as a requiem for victims of gender violence and as a site-specific intervention in which unsettling tactile performance taps into psychological playgrounds and intellectual hinterlands.'[22] Krastin creates an encounter between an audience and his effigy, where the contemporary significances and politics of shaming are unearthed, and where his own ancestral, genealogical and psychological hinterlands are questioned and explored.

LIMELIGHT ON RITES AND 'VORTICES OF BEHAVIOR'

Pesa's *Limelight on Rites* represents a similar performative interrogation of the tension between the rituals of one's ancestors and their significance in the present. Originally created in 2010, the work has been performed in various forms, manifestations and locations. I experienced the performance at the 2014 Institute for Creative Arts (ICA) Live Art Festival in Cape Town, and after watching archival footage of earlier versions, it is clear that these iterations differ substantially. My analysis here is particular to the live performance that I experienced.

Limelight on Rites is a loud, visual-visceral performative deluge of ritual-like activity and behaviour. I use the term 'ritual-like' because the experience of the work feels devoid of ritual, even though many of the activities directly reference ritual behaviours one might expect to encounter at a funeral or ceremony of mourning. Pesa creates a volatile space in which multiple behaviours, sourced from both historical and contemporary funerary practices, as well as social urban behaviour, intersect and overlap with each other. The work is fundamentally a critique of rituals of the dead that questions the efficacy and intentions of contemporary rites of burial in a time where "'death is big business,'" its rituals commercialised and commodified.[23] The work also surfaces complex questions surrounding the conflict between indigenous cultural traditions (and knowledge) and urban, westernised

rituals of death and burial. In this way, *Limelight on Rites* is also an embodied and performative interrogation of knowledge and cultural ancestries through a questioning of inherited genealogical behaviours in relation to contemporary practices and contexts. The work becomes, through the clash of these behaviours, a critique on the relevance of adapted, appropriated or westernised behaviours in relation to their significance within the nexus of postcolonial, third-space identities and complex notions of self.[24]

The performance begins before the audience members enter a large reception room inside the Cape Town City Hall. As they filter in, house music plays very loudly from a sound system in the centre of the room and two men (one being Pesa) dance joyously around a coffin set atop a gurney. At one point, Pesa begins to move the coffin, rolling it around the room as if it were a dance partner. While this unfolds, another performer, dressed as a businesswoman, sits at a desk at the periphery of the room where she flips through a notebook and, intermittently, leaves the room while talking loudly into her phone. Steadily, other behaviours emerge, congealing with the music, the activities of the office worker and the strange dance between the living and the dead (represented through the coffin). Another woman appears and begins to hand out pamphlets for a funeral policy; a man sets out plastic chairs in rows for the audience; another woman approaches individual audience members and performs a kind of libation with wine, fruit, flowers and a candle; a couple make their way around the room, introducing themselves to audience members; a piece of artificial lawn appears and artificial flowers are arranged on top of it; a table of food is carried in and people begin to feast. The performance devolves into chaos as these diverse behaviours rub up against each other in a shared space and time, creating what Roach describes as a 'behavioral vortex.'[25] This vortex, Roach explains, 'is a kind of spatially induced carnival, a centre of self-invention through the restoration of behaviour,' within which different behaviours converge and cross-pollinate to create new, reimagined behaviours.[26]

The ritual behaviours in *Limelight on Rites* seem disconnected from each other; there is no apparent logic, narrative, nor perceivable structure in the progression from one rite to the next. In terms of Turner's three phases of ritual progression, *Limelight on Rites* seems to get stuck at the separation phase. As such, the behaviours themselves take on a task-like quality even though the performers appear visibly invested (in terms of energy and intention) in what they are doing. Christine

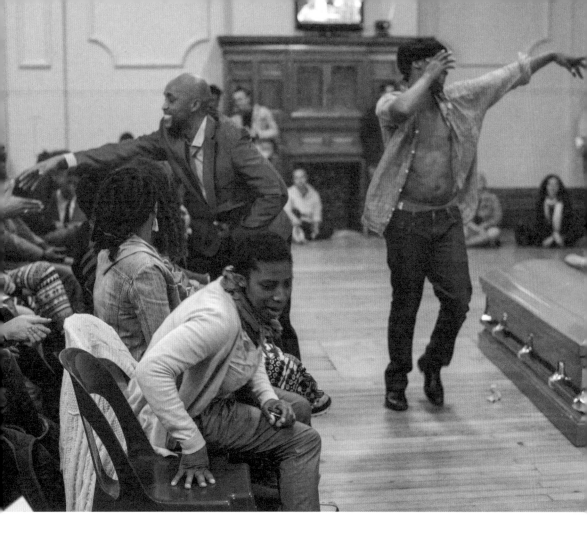

Figure 11.3. Sello Pesa and Ntsoana Contemporary Dance Theatre, *Limelight on Rites*, 2014.
Courtesy Institute for Creative Arts.
Photograph by Ashley Walters.

Davis notes, 'funerals exist in a liminal space in which the everyday becomes the sacred.'[27] In Pesa's vortex, however, these 'sacred' behaviours seem incapable of enabling transcendence and remain disturbingly 'everyday.' I suggest that this is not the result of the performers' reframing of the ritual behaviours as pedestrian tasks, but rather emerges from the audience's inability to interpret, understand and connect meaningfully (through ritual communitas) to the behaviours as they unfold. Typically, funerary rituals 'pull us in through our bodies, through their smells, sights, sounds, and feelings' to establish a 'spiritual connection with both the recently and the long deceased.'[28] *Limelight on Rites* does the opposite: it pushes us away. Pesa's vortex is a sensory smorgasbord of conflicting sounds, sights and smells, with visual images that unsettle and confound. The work problematises an extra-daily, spiritual experience of the ritual behaviours as they happen. The audience is thus able to engage experientially with the performance as an event, but not with the rites themselves.

Within Pesa's vortex of behaviour, a palpable sense of emptiness begins to emerge as various familiar behaviours are re-embodied, reperformed and ultimately reinvented through their intersection with each other. These rituals, although understood individually as practices intended to commune with, honour and remember the dead, ultimately fail in this intention. There is too much excess, too much noise and too much activity for any of these behaviours to invoke the presence of the dead. Instead, each ritual becomes empty, devoid of sacral significance and disconnected from its intended socio-cultural function. As each rite unfolds, intending to call forth a presence, what emerges is more absence.

Absence is further invoked through Pesa's particular engagement with effigy. Unlike *Rough Musick*, the effigy in *Limelight on Rites* is not the body of the artist. The effigy appears in the form of the coffin and thus remains a kind of visible absence. We do not believe that there is a dead body inside the coffin, but the image of the coffin, as a container for the dead, is enough to render Pesa's interaction with it macabre and unsettling. The coffin thus creates a vacancy that the audience can potentially fill through effigy. This invitation to fill the absence of the dead is, however, simultaneously hindered by the pervading sense of emptiness created through the vortex of memory. As such, the dead remain absent from *Limelight on Rites*, and the conversation with the dead that effigy and ritualised embodied behaviours usually allow does not occur.

Pesa's absent effigy in the form of the empty coffin thus also becomes a symbol and mirror in the work for the absent presence of the ancestors who seem to ignore the calls of these ritual behaviours within the performance. By erasing the corpse in this funeral ritual, Pesa's image of the empty coffin becomes a visual manifestation of Anthony Bogues's notion of the black body as a 'vanishing subject' in western history. Like the western (written) archive's erasure of black bodies, Pesa's effigy effigies all those 'living corpses' who 'rest without histories or names' because they 'were never seen as alive' by the racist history of western thought.[29] There is a pervading sense in the work that these restored ritual behaviours, distinctly altered by western influence and capitalism, are polluted and thus incapable of engaging with the traces of the dead who are erased from the past as well as the present. Denied an invocation of the dead, Pesa's ludic space instead becomes a place in which the audience is asked to reflect critically on, and acknowledge, experientially, the absence of the erased dead, and to consider, from within a flurry of death-related ritual, a place of memory where rituals and their behaviours fail. Pesa's work is a performative expression of the death of these rituals themselves, and a critique on the limitations and failures of ritual practices irrevocably disconnected from the dead.

BISMILLAH AND 'DISPLACED TRANSMISSION'

Unlike *Rough Musick* and *Limelight on Rites*, where specific ritual behaviours are significantly altered through their embodied reperformance, Adams's *Bismillah* presents a reimagining of ritual where the behaviours themselves remain largely unchanged. Performed by the artist and his father, Amien Adams, the work involves the re-enactment of an Islamic funerary ritual where the living body of Adams is ritualistically cleansed and wrapped for burial by his father. The ritual occurs in the basement of the 1820 Settlers Monument in Grahamstown – a subterranean, crypt-like space – and is witnessed by a small audience of onlookers. The title *Bismillah*, meaning 'In the name of God,' is specific to this instantiation of the work as it was also performed under the title *Please Remember II* in a gallery space in Cape Town in 2013.

In this work, the disruption and critique of knowledge embedded in behaviour is extended through Roach's principle of 'displaced transmission,' which concerns

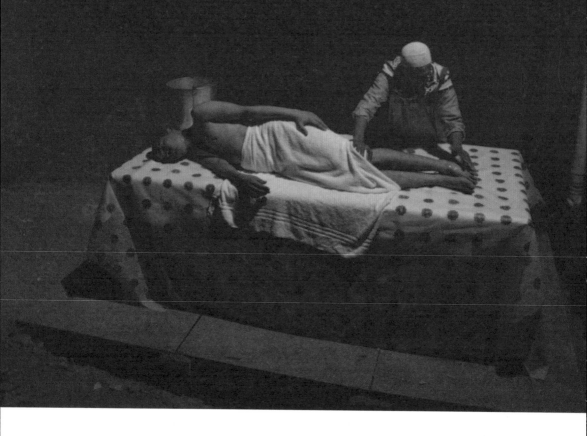

Figure 11.4. Igshaan Adams, *Bismillah*, 2014.
Performed at the National Arts Festival as part of the BLIND SPOT
Performance Art Programme curated by Ruth Simbao.
Photograph by Ruth Simbao.

instances where historic cultural behaviours are reinvented through their relocation and translation into different spaces, changing conditions and/or unfamiliar contexts or environments. By engaging with cultural ritual in the context of performance (whether ritualising or ritual-like), a displaced transmission of the originating behaviour inevitably occurs because the ritual behaviours, which may or may not be performative in their original context, become framed within a performance paradigm and are thus placed in conversation with the politics of space, the body, representation and spectatorship. Similarly, the specific site, performance space and/or public place within which ritual behaviours are restored affect the ways in which these behaviours hold or transmit meaning because spaces have their own politics, conditions and socio-cultural symbolisms regulating acceptable and inappropriate behaviours.

In *Bismillah*, Adams does not reimagine the ritual behaviours directly. His father performs the burial ritual as it would usually be performed. His gestures and words seem rooted in memory and culture as he carries out the ritualistic cleansing and wrapping of the body. The reinvention of this embodied behaviour emerges from the combined relocation of the ritual into a different context (that of performance) and into a different space (a basement beneath a monument). The ritual is changed through its engagement with a performance paradigm. I use the term 'performance' particularly in a Schechnerian sense where the repetition of the ritual constitutes 'twice-behaved behaviour.'[30] In its original context, the ritual would take place between a male family member and the body of the deceased and would only be performed once. As Adams undergoes the ritual while still alive, the behaviour can occur multiple times: his body is cleansed and wrapped and then recleansed and rewrapped when the work is performed again.

Similarly, the presence of an audience at a ritual that is not intended to be observed reframes the originating ritual as a kind of performance. Traditionally, the ritual is a private, intimate and strictly familial encounter shared between two bodies, one living and the other dead. Adams's reinvention engages multiple living bodies and, although the ritual between the artist and his father is performed as though both are unaware of the audience, the presence of strangers surfaces a degree of voyeurism that relocates the encounter into the realm of spectacle and display. This evokes an atmosphere of ambiguity and discomfort for observers, which is arguably augmented for those who are foreign to Islamic culture, and

for whom the voyeurism of the gaze becomes complicated by what might be perceived as the otherness and exoticism of the behaviours themselves. This level of discomfort complicates the watching of the ritual and encourages an active, critical spectatorship. Rat Western suggests that *Bismillah* is 'both a private ritual between two people ... and something broader about death and loss.'[31] In this way, *Bismillah* moves beyond a mere voyeuristic display of ritual by creating an environment of ambiguity and a critical, contentious space that raises questions about the proximity between the living and the dead and the nature of our own socio-culturally conditioned responses to dead bodies as abject entities.

In performing *Bismillah*, Adams becomes the effigy, positioned as a surrogate to fill the vacancy created by the absence of the original, which, in this case, is his own dead body. As in *Rough Musick*, Adams's effigy serves a dual role. On one level, Adams is able to experience, through effigy, an embodied understanding of inherited cultural behaviours normally reserved for the dead while he is still alive. Curator Ruth Simbao notes: 'Making no forced attempt to "act dead," Adams calmly keeps his eyes open ... he is both dead and alive ... he is simultaneously blind and sighted.'[32] Adams thus consciously positions his own body, a hybrid identity constituted from both visible and invisible racial, religious and sexual identities, in conversation with his genealogy, represented through the ritual and his father. It is significant that Igshaan and Amien Adams, although related, 'do not have a strong history of intimacy.'[33] In this way, the artist's intimate engagement with his father in *Bismillah* forms part of what he refers to as a '"search for the authentic self"' within his broader body of work.[34] As effigy, Adams is able to experience, consciously and critically, an expression of cultural memory reimagined as a means to explore the self.

On another level, Adams also effigies, for those who witness the performance, an invocation of a proximal, intimate and corporeal interaction between the living and the dead. As Western observes, 'Adams's body becomes a site of projection and therefore a *zone of contact* for the audience. It is a site in which to contemplate death and other dead bodies – ones they have seen and ones they have not been permitted to see because modern culture, in general, spends less time with its dead.'[35] This invitation for the audience to contemplate the dead by projecting their own memories or experiences of death onto Adams's body is compounded by the second layer of displaced transmission within the work, namely its relocation to a

basement beneath a national monument. Built in Grahamstown in 1974, the 1820 Settlers Monument stands as a memorial to the first British settlers in South Africa and, like a cemetery, it lies outside of the city's limits. In witnessing Adams's effigial performance of death, onlookers had to arrive at, enter through and descend beneath this designated place of memory which, through Adams's conversation with the dead, becomes a space where an intimate, embodied and experiential encounter with the dead is able to occur.

Performed in a small, dark and cold space below the ground, the environment resonates strongly with sacred spaces one associates with death, such as the crypt, grave and tomb. The performance space thus seems appropriate to the context of the ritual. However, the space is also unfamiliar in that it is unusual to witness or participate in funerary rites in spaces like these. While rituals of mourning are often characterised as 'public performances of private sorrow' and involve community, family and a shared expression of grief and loss, it is less common for these communal practices to occur *below* the ground.[36] The passage of the dead from the church, temple, mosque, public square or homestead to their resting place beneath the ground is not an aspect of ritual practices commonly witnessed by those outside of the direct family. The relocation of the ritual and the positioning of Adams's living body as effigy in this crypt-like space creates a charged, unsettling and immersive environment in which the audience experiences the work.

The ambiguity of the performance space thus further complicates the liminal nature of Adams's performance for the spectator. The environment encourages the audience to effigy through the body of Adams, shifting the potentially voyeuristic role of the audience into a space where larger questions about death, the dead and personal behavioural encounters with both begin to emerge. The displacing of the ritual into this particular space is crucial to Adams's reframing of the ritual, as both displacements work together and against each other to create an environment where Adams and the audience are able to engage intimately with the dead through effigy. The ritual's relocation allows the behaviour to 'pull us in through our bodies' and establish a 'spiritual connection with both the recently and the long deceased.'[37]

CONCLUSION

As *Rough Musick, Limelight on Rites* and *Bismillah* demonstrate, whether contained within the symbolic behaviours of ritual or the genealogical corporeality of performance, the body is both a vessel and medium for the *living* memory of the dead. The invocation of the dead through embodied, effigial acts of performance thus reinforces the role of the body as an archive of the dead and its value as a vector of 'performative possibilities' through which knowledge from the past can be reconsidered and its traces within the present moment reimagined. By performing *with* the dead we are able to disrupt the power of both the written and the embodied archives of cultural memory, superseding the limitations of both by unlocking, releasing and actualising, into the present, the always-speaking, always-changing voices of the dead.

1. Catherine Bell, *Ritual Theory, Ritual Practice* (New York: Oxford University Press, 1992), 147.
2. Bell, *Ritual Theory*, 90.
3. Myron M. Beasley, 'Vodou, Penises and Bones: Ritual Performances of Death and Eroticism in the Cemetery and Junk Yard of Port-au-Prince,' *Performance Research* 15, no. 1 (2010): 44, accessed 8 December, doi: 10.1080/13528165.2010.485762.
4. Beasley, 'Vodou, Penises and Bones,' 44.
5. Joseph Roach, *Cities of the Dead: Circum-Atlantic Performance* (New York: Columbia University Press, 1996), xiii.
6. Roach, *Cities of the Dead*, 36.
7. Roach, *Cities of the Dead*, 36.
8. Roach, *Cities of the Dead*, 2.
9. Roach, *Cities of the Dead*, 26–28.
10. My analysis of Krastin's work is informed by my participation in the performance and its creative process.
11. Roach, *Cities of the Dead*, 27.
12. Beasley, 'Vodou, Penises and Bones,' 44.
13. Gavin Krastin, *Rough Musick Programme* (Grahamstown: National Arts Festival, July 2013).
14. Victor Turner, *The Ritual Process: Structure and Anti-Structure* (New York: Cornell Paperbacks, 1977).

15. Turner, *The Ritual Process*, 94.

16. Turner, *The Ritual Process*, 95.

17. Following his dance of seduction, Krastin pulls three male members of the audience out of their seats and seductively rummages through their pockets taking any money that he finds. This money is used later in the performance as an offering to the dead that Krastin places on the white chalk grave of the buried dog.

18. Turner, *The Ritual Process*, 95.

19. Only the original performance in Grahamstown involved the use of a donkey. Subsequent iterations concluded with myself pulling Krastin and the chariot out of the performance space.

20. This statement is based on my observation of certain audience members in various performances who would agree to participate in the shaming of Krastin's body but without committing fully to this role. These audience members would, for example, volunteer to throw an egg or tomato at Krastin but deliberately miss him.

21. Many of the masks, props and costume apparel that Krastin wears are sourced from retailers and online stores that specialise in fetish, bondage and sex-related products. BDSM is a combination of the abbreviations B/D (bondage and discipline), D/S (dominance and submission), and S/M (sadism and masochism).

22. Adrienne Sichel, 'Not so Medieval After All,' *Tonight*, 23 July 2013, accessed 8 December 2017, www.iol.co.za/entertainment/celebrity-news/local/not-so-medieval-after-all-1551121.

23. Sello Pesa quoted in GIPCA, *Live Art Festival 2014 Programme* (Cape Town: GIPCA Live Art Festival, August–September 2014), 30.

24. This notion of 'third-space identities' is borrowed from Homi K. Bhabha's theorisation of the 'Third Space.' See Homi K. Bhabha, *The Location of Culture* (New York: Routledge, 1994).

25. Roach, *Cities of the Dead*, 28.

26. Roach, *Cities of the Dead*, 28.

27. Christine Davis, 'A Funeral Liturgy: Death Rituals as Symbolic Communication,' *Journal of Loss and Trauma* 13 (2008): 415, accessed 8 December 2017, doi:10.1080/15325020802171391.

28. Davis, 'A Funeral Liturgy,' 411.

29. Anthony Bogues, 'And What about the Human? Freedom, Human Emancipation, and the Radical Imagination,' *boundary 2* 39, no. 3 (2012): 33–34, accessed 1 December 2017, doi: 10.1215/01903659-1730608.

30. Richard Schechner, *Performance Studies: An Introduction* (London: Routledge, 2002): 29.

31. Rat Western, 'At the Risk of Being Sincere: Participation and Delegation in South

African Contemporary Live Art,' in *Risk, Participation, and Performance Practice: Critical Vulnerabilities in a Precarious World*, ed. Alice O'Grady (London: Palgrave Macmillan, 2017): 199.

32. Ruth Simbao, 'Cleansing via the Senses as Eyesight Follows the Soul: Igshaan Adams' *Bismillah* Performance,' in *Igshaan Adams*, eds. Christine Cronjé, Jonathan Garnham and Hannah Lewis (Cape Town: blank projects, 2015): 124.

33. Western, 'At the Risk of Being Sincere,' 199.

34. Igshaan Adams quoted in Western, 'At the Risk of Being Sincere,' 198.

35. Western, 'At the Risk of Being Sincere,' 198.

36. Davis, 'A Funeral Liturgy,' 419.

37. Davis, 'A Funeral Liturgy,' 411.

Suppressed Histories and Speculative Futures

To Heal a Nation: Performance and Memorialisation in the Zone of Non-Being

KHWEZI GULE

On either end of High Street in Grahamstown, in the Eastern Cape, sits the Cathedral of St Michael and St George and the Drostdy Gateway, the entryway into Rhodes University. As such, High Street is marked by the two pillars of western hegemony: knowledge and religion. Along this axis, there are monuments that attest to a history of conquest. This scene provided the backdrop for Sikhumbuzo Makandula's performance *Ingqumbo* ('Wrath') on 17 September 2016, which began with Makandula burning his altar boy uniform.[1] Makandula's site-specific provocation of religion and history brought to mind an impression gleaned from the seven years I spent as chief curator of three memorial sites in Soweto:[2] in South Africa, there is a belief that tangible and intangible symbols are required, as well as narratives about what is distinctive about the nation, for the idea of nationhood to hold. One such narrative has been the process of national reconciliation – a central theme in post-1994 nation-building.[3] Memorials and commemorative events weave symbols and narratives together in the hope of inspiring patriotism.

In this chapter, I argue that these forms of memorialisation have not been successful in forging a unified national identity. My focus here is on a mistrust of the founding narrative of national reconciliation; the disjuncture between the high ideal of a prosperous nation and the continued marginalisation and dispossession of Black people;[4] and state-adopted commemorative practices that do not speak sufficiently to an embodied knowledge of historical events and our interpretation of these events in the present. The work of artists like Makandula and others, explored below, provide fertile ground for critiquing

current modes of memorialisation, as well as the very notion of nationhood. But they also suggest different ways of remembering. Drawing on traditional African religious practices in order to retrace the relationship between the physical and the metaphysical realms (suturing the relationship between the political and the spiritual) and to bring different vocabularies to our visual culture, these artists instantiate counter-narratives of memorialisation and mourning that work against a post-1994 memorial culture, which eclipses and erases complex histories and the influence of traditional practices.

MISTRUST IN THE NARRATIVE OF RECONCILIATION: THINGS NOT FORGOTTEN

Monuments represent some of the most visible ways in which a state can demonstrate its power. It is therefore not surprising that when a regime is toppled, so too are its statues and monuments. It is this troubling of memory and representation that Makandula tackles in *Ingqumbo*. Although the African National Congress (ANC) government resolved to preserve monuments and museums of the colonial and apartheid era as a way of reassuring white citizens that their heritage and history would be protected in the new South Africa, on the ground there is no consensus that these edifices of racial superiority ought to remain. The town of Grahamstown, in its architecture, monuments, building and street names, retains much of its colonial character, which is in part protected by heritage legislation.

In *Ingqumbo*, Makandula led his audience to four historical sites on Grahamstown's High Street, starting with the Cathedral of St Michael and St George, followed by the Elizabeth Salt Monument, the original 1820 Settlers Monument,[5] and ending at the Drostdy Arch, in a procession reminiscent of the Stations of the Cross.[6] A number of artists have drawn an analogy between Christ's suffering and the persecution of Blacks under apartheid. Makandula's symbolic acts of remembrance, performed at colonial sites that mark the defeat of the amaXhosa in Grahamstown, thus evoke a kind of historical and spiritual pilgrimage in which the audience becomes a religious congregation. The recurring use of the altar boy regalia in Makandula's work speaks of the degree to which Black people have adopted Christianity, but also of the role that Christianity has played in their dispossession. This tension is further complicated by the confluence of Christianity and certain traditional practices, which points to shared histories and fields of influence within Black communities.

For instance, there is the practice in Black Christian homes of washing one's hands in a mixture of cow dung and water (*umswane*) before mourners enter the house of the bereaved after a funeral has taken place.

Ingqumbo could refer to the anger of ancestors whose land was taken through conquest. But there could be a number of reasons for ancestors' anger according to many cultural belief systems in the South African context, including the desire for ancestors to be remembered. One of the ways in which ancestors register their anger at being forgotten is by visiting misfortune on their descendants, or by removing their protection from their descendants' daily lives. The only way to remedy the situation and to demonstrate that sense of remembrance is to perform rituals, which typically include the burning of *impepho* (incense used in ancestral ceremonies and rituals), sacrificing an animal, the brewing of beer, and invoking the ancestors' names in reverence and to beseech them to bring good fortune to the family. In isiZulu tradition, this remembrance ritual is called *umsebenzi* (labour), which although focused on the immediate family, also involves relatives and the community. As such, *umsebenzi* not only serves a spiritual purpose, but also reinforces familial and communal bonds, and becomes an antidote to forgetting.

If one accepts the idea, as do proponents of Black Consciousness, that the colonial framing of the Black subject is someone who is outside of civil society or, as Frantz Fanon put it, who inhabits the 'zone of nonbeing,'[7] then there is some basis for arguing that this colonial framing remains in place in post-1994 South Africa. Although I do not identify with the sentiment that nothing has changed since the advent of democracy, I also do not accept that power relations between Black and white have changed in a fundamental way. There is little doubt that, in material terms, Black people remain in poverty while white people continue to be socially and economically privileged. The term 'previously disadvantaged' has become a euphemism for the various forms of subtle and overt social and economic marginalisation of Black people. One of the ways in which this social marginalisation continues to exist is in the form of knowledges that are deemed illegitimate or lacking in value, and thus not worthy of reflection, or of recording.

Traditional religious practices are often represented in the academy, in popular culture and in public discourse as superstition, as exotic, incomprehensible, illogical, ahistorical and irrational. The implications, therefore, of Makandula's performance touch on suppressed histories at a national level, or perhaps on the

level of public discourse, and also on the level of ritual and the spiritual. By bringing into focus that which has been forgotten or suppressed, and by foregrounding Black subjectivity, not simply as a product of apartheid and colonialism but as a fundamental questioning of power, Makandula's work becomes an act of *umsebenzi*. These emergent practices also suggest a different way of memorialising. If Makandula's intention is indeed to perform a type of ritual cleansing, as I suspect it is, then it seems that referring to his work as performance might no longer be appropriate. His interventions are perhaps better conceived as ritualised acts of remembrance, which serve as catalysts for healing.

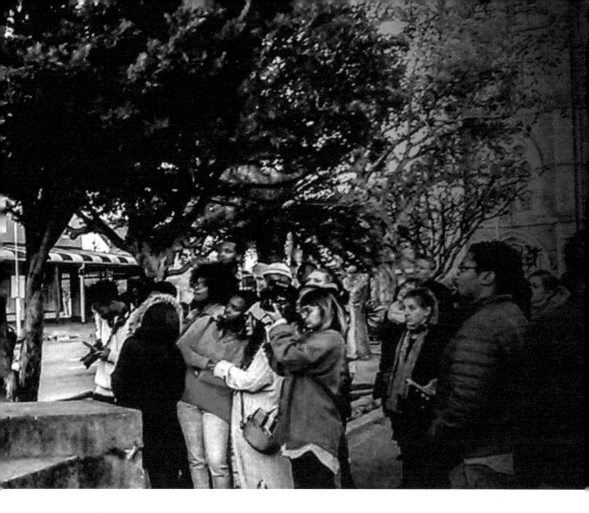

Figure 12.1. Sikhumbuzo Makandula, *Ingqumbo*, 2016.
Courtesy the artist.
Photograph by Gcobani Sakhile Ndabeni.

A work similarly concerned with the imperative to remember, or which is perhaps an injunction against forgetting, is Churchill Madikida's exhibition *Liminal States*, held at the Stevenson gallery in 2004, which featured a video installation of a pair of hands washing, or perhaps smearing, blood onto themselves. The hands continuously merge with and separate from each other, producing something like a Rorschach drawing. The title of the piece is *Blood on my Hands*. Much of Madikida's exhibition dealt with the difficult subject of Xhosa initiation. Poised at the ten-year anniversary of the advent of democracy in South Africa, and in the shadow of initiation deaths that were dominating news at the time, the exhibition

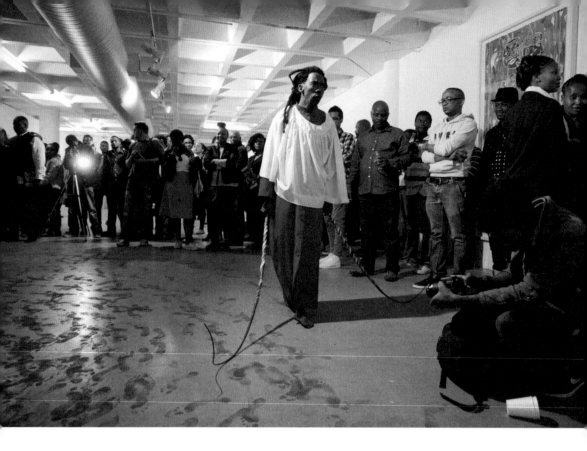

expressed a degree of ambivalence in relation to Madikida's cultural traditions, but also regarding the construction of masculinity within such practices.

Ambivalence, of course, describes a state of in-betweenness, of liminality, of transition. In the case of the initiation ritual, it is the transition from boyhood to manhood. In the training of a traditional healer or sangoma, it represents a state of transition from initiate to conduit between the living and the ancestors. In both senses, this state of liminality represents, for the initiate, a place of danger, hence the requirement for seclusion. In the context of southern African cultures, including the Nguni, spaces of liminality are spaces charged with both good and malevolent spirits that can potentially inhabit the initiate; there are constant fears of contamination.

The role of ritual slaughter is a pivotal part of ancestor veneration for the sangoma and the initiate. But in *Blood on my Hands*, the blood also symbolises something else – the historical baggage that can never be expunged, and with which South Africans have to contend one way or another. At the time of the exhibition, South Africa was still in a transitional period and it seemed, at least on the surface, that the country had successfully negotiated the most treacherous political terrain and was justified in celebrating ten years of democracy. At the time, it would have been hard to fathom just how precarious and vulnerable the state of affairs really was. It would have been hard to believe, except for minor signals, such as Madikida's work, that little more than 20 years into this new nation, questions would once again be raised about the feasibility of the postapartheid state.

MAKING OF A NATION

Contemporary South African artists frequently reference nationhood and nationalism in the context of disjuncture and contradiction. The most glaring of these contradictions is the insistence by the state that the quality of life for the Black majority has improved since the advent of democracy, set against service delivery protests that are a constant feature of South African life.[8] The recurring incidents of xenophobic violence that have erupted in South Africa throughout the democratic dispensation are particularly poignant illustrations of the disconnect between state rhetoric that espouses tolerance and unity, and visceral responses to daily problems.[9] A further glaring disjuncture is the projection of a caring state that provides free housing and basic education and yet perpetrates state-sanctioned violence, such as the Marikana massacre of 2012, during which members of the South African Police Service shot and killed 34 striking miners. These examples illustrate in material terms the misalignment of interests between the South African government and the poor citizenry it purports to serve.

Such misalignments manifest in symbolic terms too. The booing of then President Jacob Zuma at Nelson Mandela's memorial service in 2012, the vandalism of public memorials, such as that of Cecil John Rhodes, and the resurgence of militant student politics could be viewed as isolated acts of discontent. But taken in sum, they indicate that a growing section of the South African citizenry is no longer only protesting about bread and butter issues, but attacking visible symbols

of the state. Memorials, monuments, museums and commemorative events post-1994 owe much of their genealogy to western forms of commemoration. Added to this, both state and corporate-sponsored forms of commemoration speak to a universalist worldview rather than to a specific, localised sense of history.

Aesthetic forms that are mobilised in this kind of memory work tend to rely on the monumental, statuesque, 'look but don't touch' formalist approach. On the other hand, African communities in South Africa have vastly different means of commemoration (touched on further below), which are steeped in indigenous religious practices. Considering that this significant segment of the population, in varying ways, venerates ancestors, there is something missing in the ways in which we have attempted to forge a national identity. This is partly due to the fact that, under the democratic dispensation, the state has sought to make its power and legitimacy visible through symbols that have largely ignored traditional practices in South Africa.

MISTRUST IN THE TRUTH AND RECONCILIATION PROJECT

The work of South Africa's Truth and Reconciliation Commission (TRC), established in 1995, focused on the visible and most brutal episodes in the nation's evolution to democracy. The role of the TRC was threefold: firstly, to bring out the truth of what happened in the struggle for liberation, and either grant amnesty or prosecute those who failed to disclose their role in apartheid's atrocities; secondly, to give limited reparations to the families of the victims; and finally, to foster a process of healing through dialogue, offering closure to families whose loved ones were killed or imprisoned during the anti-apartheid struggle. On a larger scale, the work of the Commission was meant to hold a mirror to South Africa as an emerging nation in order for citizens to confront the horrors of the past and hopefully put them to rest. The vision was that, through forgiveness, reconciliation would ultimately occur.

The religious symbolism of the TRC – including the fact that many of the testimonies and the Commission itself were presided over by Archbishop Desmond Tutu – may have been coincidental, but it is significant that the reconciliation process, laden with so much emotion, involved the very institution that many South Africans have tended to turn to in times of distress. The church, most notably the South African Council of Churches, was one of the most vocal means of

resistance against apartheid, and churches such as Regina Mundi in Soweto played an important role as places where funerals of comrades were held, as well as where commemorations of significant political events like the 1976 Soweto Uprising take place. The significance of the church in processes of healing and reconciliation is part of the Jekyll and Hyde kind of role that this institution has often played with respect to Black people in the colonial world.

The TRC's approach, based on restorative rather than retributive justice, was a departure from the Nuremberg style of dealing with issues of post-conflict justice.[10] There have been numerous critiques of the TRC process, most notably from Professor Simon Gikandi, whose main contention is that the process of reconciliation was earned at the expense of memory.[11] In his 2014 lecture at the University of the Witwatersrand (Wits), Gikandi detailed one of the most charged moments in the TRC hearings, when Tutu implored Winnie Madikizela-Mandela to confess wrongdoing in reference to the 1988 killing of Stompie Seipei in her home in Soweto.[12] In the lecture, Gikandi emphasised that, in order to extract an expression of remorse from Madikizela-Mandela, Tutu had to erase the events that led to the tragic killing of the teenager. Gikandi also argued that the TRC demanded a duality – either victim or perpetrator – that was blind to the complexity of subjectivity under apartheid. In other words, it fostered a form of forgetting that overlooked the legacy of colonialism, both socially and economically.[13] Therefore the incoming government had the tremendous responsibility of fundamentally changing people's lives materially but also in symbolic and metaphysical terms.

RECALLING BODIES OF HISTORY

The language of memory-making is replete with the imagery of sacrifice. It is often said that the democratic dispensation ought to be protected because it was bought at a high price – the blood of many. Persecution, pain and suffering, whether religious or political, are seen as part of a divine plan. Perceived through a Judeo-Christian lens, martyrdom is not simply victimhood, or suffering merely misfortune, but the fulfilment of a higher purpose. The adoption of Christianity by colonised people also meant that liberation movements saw their own oppression under colonial rule as part of a God-given plan. It is not surprising, therefore, that victims of the 1976 Soweto Uprising are often characterised as martyrs who laid

down their lives for a better South Africa. This view allows sufferers of religious and political discrimination to see their suffering as the holy fire that purifies their hearts, and as a necessary conduit to salvation. However, if one takes the view that colonial and apartheid violence is gratuitous and arbitrary, then the argument that suffering is redemptive no longer holds. Scholars such as Frank B. Wilderson III suggest that the world is inherently anti-Black and therefore there are no consequences attached to Black death; Black suffering is the inescapable consequence of the disposability of Black bodies.[14]

Writing about his friend and colleague, Landless People's Movement activist Sipho Makhombothi, whose dying wish was to be buried among his ancestors, Andile Mngxitama tells of how his friend's remains were buried by comrades under the cover of darkness on a white-owned piece of land where Makhombothi's forebears had been buried.[15] The family that owned the land sought, and was granted, a court order to evict Makhombothi's remains.[16] In southern African traditional religious practices, the soul of the deceased is tied to their place of death and burial. The ability of the soul to join the realm of the ancestors depends on the observation of burial rites and performance of rituals. In the case of Makhombothi's remains, the exhumation of the body represented for the surviving family members a tragedy and a denial of cultural and religious rights.

South Africans who subscribe to traditional religious beliefs also believe that people who meet untimely deaths – including the victims of apartheid's murderous regime whose remains were never recovered, and whose deaths were never marked with appropriate rituals to bring their souls back home – continue to roam the land, bringing misfortune to family and strangers alike. They further believe that many of the social ills that afflict South African society can be attributed to the countless restless souls who were victims of state violence. For this reason, taking care to honour the past, which the ancestors embody, is a means of guaranteeing the future. Preserving the memory of the dead is not merely a symbolic exercise; it has a direct impact on the material world, and on an individual's health, financial well-being, relationships, communities and politics.

Before the advent of democracy, funerals had ceased to be private rituals for family members and neighbours. If the funeral was for a person who identified as a comrade, the ceremony became a public affair where political conscientisation and mobilisation took place. The singing of struggle songs and recital of poetry

spoke of an admixture of dirges and more militant songs. In the twilight of apartheid, the assassination of Chris Hani, along with the 1992 massacres in Bisho and in Boipatong, introduced the practice of national mourning to the public consciousness. But it was not until the democratic dispensation that the mourning and remembrance of activists-turned-politicians and struggle icons became a state-run affair. With the state control and choreography of public rituals, some of the more visceral responses to grief, loss and remembrance were muted. In the process, commemorations became alienating.

Both the memorial service and the official state funeral of former president Nelson Mandela attest to the gap that developed between officials who presided over the affair and the people who attended the event. Of particular interest to me was the manner in which the private grief of the family became a public spectacle – their tears and stoicism, whether real or performed, were captured on television for all to see. How does a nation, and an ill-defined one at that, grieve collectively? What rituals might a nation observe, and what symbols might it create to find meaning around such events? In his essay 'A Difficult Justice: Reparation, Restoration and Rights,' Charles Villa-Vicencio argues that since material reparations were not feasible at the end of apartheid, symbolic reparations such as museums needed to be put in place.[17] In addition, calls for economic and social justice are often demands for tangible means to improve people's lives – through, amongst other things, free housing, free water and electricity, as well as the provision of sanitation and free education. However, social justice also takes less tangible forms. Ritual cleansing, which is performed by traditional healers, is mostly absent from state-sponsored commemorative events. In South Africa, state rituals, which have tended to aim for cultural neutrality, overlook the fact that they contain colonial memes and, as a result, alienate the majority of the population.

RECALLING BODIES II: ON TRADITIONAL COMMEMORATIVE PRACTICES

Makandula performed *Inzwi* at the Visual Arts Symposium eMonti in 2015, during which he wore his altar boy red tunic and rang a small bell resembling the altar bell used in Catholic and Anglican services. Makandula's incantation, '*buyinsani uMbuyisa*,' references Mbuyisa Makhubu, the young man who carried the limp body of Hector Pieterson, iconically captured by photographer Sam Nzima, after police opened fire at protesting students on 16 June 1976. Makhubu went into exile

in the immediate aftermath of the Soweto Uprising, and after some years spent in Botswana, he left for Nigeria, where he disappeared. His fate is still unknown. Makandula's incantation invokes the memory of Makhubu. In it, the artist uses the root of Mbuyisa's name, *buyisa*, which means 'to return something/bring back/ restore' in order to implore to an unspecified audience: 'bring back Mbuyisa.'

For many families of the victims, as well as the student activists of the Soweto Uprising, 16 June is a day to visit gravesites to lay wreaths, and for family and extended family to gather. For families that were affected by the Soweto Uprising, including the Makhubus, the commemoration of 16 June is also an occasion to raise long-standing unresolved issues of the transition phase of South Africa's democracy, such as reparations, land redress and contestations over the meaning of 1976. On 16 June 2014, the Makhubu family, along with local members of opposition party the Economic Freedom Fighters, marched to the Hector Pieterson Museum to demand the return of Mbuyisa as well as compensation for the use of Mbuyisa's image inside the Museum. It would appear that the state, on the other hand, has opted to rely on a singular narrative of history that presents legislative apartheid as the focal point of the liberation struggle. In this singular narrative, the ANC is author of South Africa's liberation struggle, which is at odds with the contestation that exists over the representation of historical events and their meaning. The ANC government's insistence on this master narrative has often had the effect of inadvertently silencing the voices of the very constituency it purports to represent.

Another poignant performance of witness and remembrance was Sethembile Msezane's 2015 intervention *Chapungu – The Day Rhodes Fell*, which took place at the removal of the Cecil John Rhodes statue from the University of Cape Town's Upper Campus. The work followed Msezane's Public Holiday Series, which comprised several public interventions performed on commemorative days in the South African calendar, including *Untitled (Heritage Day)* in 2013 in which Msezane stood on a plinth outside Parliament with the bronze statue of Louis Botha in the background. Msezane explains that, in this series of works, she was concerned with reinscribing women's bodies into South Africa's memorial landscape.[18]

Chapungu recalled the history of the soapstone birds from Great Zimbabwe that were looted by the British in the late 1800s. According to Msezane, Zimbabwean legend has it that, until all the stolen birds are returned, there will forever be suffering in Zimbabwe. One chapungu bird is still housed in Cecil John Rhodes's

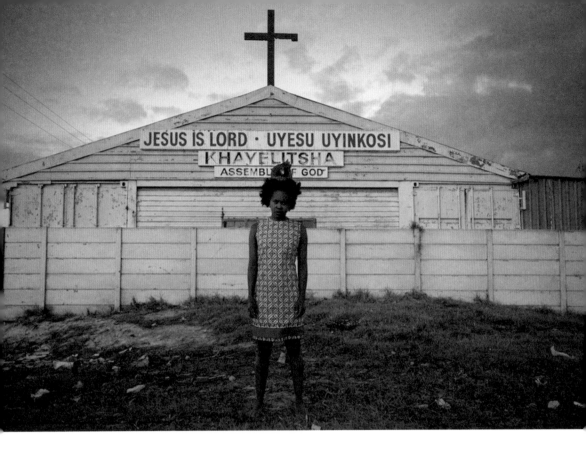

Figure 12.3. Buhlebezwe Siwani, *iSana libuyele kunina*, 2015.
Courtesy the artist.

estate.[19] As in Makandula's work, the idea of restoration and return is central to enabling healing. The performance brings together the spiritual and material worlds, historical and cultural analysis.

The work of Buhlebezwe Siwani, an artist who has also undergone training as a traditional healer, similarly engages with the relationship between religion and spirituality. In the performative installation piece *Inzilo; Ngoba ngihlala kwabafileyo* ('A time of mourning; I live with the dead'), Siwani explores 'ways in which black women mourn culturally, and the artist as sangoma – living between two worlds, as a medium who cannot mourn, because "what is alive is dead, and what is dead is alive."'[20] In this liminal position as artist-sangoma, Siwani ritualistically prepares

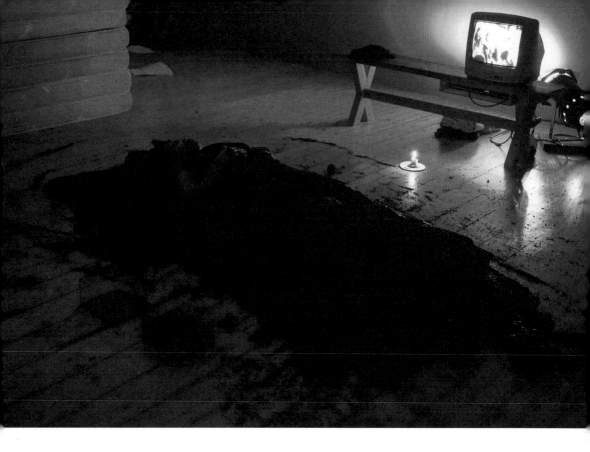

Figure 12.4. Buhlebezwe Siwani, *Inzilo; Ngoba ngihlala kwabafileyo*, 2014.
Courtesy Institute for Creative Arts.
Photograph by Ashley Walters.

her own burial on a bed of soil. In a 2015 performance titled *Uthengisa unokrwece elunxwemene* ('She sells seashells by the seashore'), part of the *!KAURU: Towards Intersections* exhibition curated by Thembinkosi Goniwe, Siwani washed seashells in a blue powder mixed with white ochre, also used for ceremonial purposes, which she then handed to audience members. For Siwani, the association with the sea is important because of its therapeutic purposes, both physically and spiritually.[21] In handing out shells to her audience during the performance, Siwani attempts to trigger in the recipients latent memories of a forgotten and erased history – in particular, the fate of those Africans who went through the Middle Passage, many of whom died at sea.

Siwani refutes the possibility of national healing on the grounds that there are many things that were not dealt with during the transition period.[22] She notes the anger that Black people felt, and still feel, in the face of injustice, and further argues that Christianity has caused a division between believers and non-believers. Until those rifts have been dealt with and Black people have been restored to a true knowledge of themselves, they will be incapable of healing.

STRATEGIES FOR RECOVERY: BEYOND STONE AND BRONZE

Ntyilo Ntyilo – A Vocal Museum is a project by performer Masello Motana that seeks to reflect on the history of Black music in South Africa. Often presented in a musical concert format, the performances are typically free and performed in spaces within Johannesburg and its surrounding towns and settlements where large numbers of people congregate – including schools, churches and minibus taxi terminals. The songs are interspersed with Motana's monologues, which contextualise each song's linguistic, cultural and historical genesis. She begins with children's playground songs and progresses to South African jazz standards. This flows into struggle and resistance songs and culminates in songs of popular culture and contemporary music genres, such as kwaito and house. An interesting feature of *Ntyilo Ntyilo* is that the repertoire of songs changes from one venue to the next and even the songs themselves are never performed in exactly the same way. The project also demonstrates the continuity in musical traditions from one generation to the next and, more importantly, the continuity in the ways in which Black people in South Africa have used culture to inscribe themselves onto history. What emerges is a kind of memorialisation, a celebration of heritage, that does not rely on bricks and mortar to shape and sustain it.

A 2011 performative intervention by Keleketla! Library at Na Ku Randza, a series of public interventions staged by the Johannesburg-based collaborative platform the Center for Historical Reenactments,[23] involved screenprinting T-shirts on the streets of Doornfontein with the inscription: 'Foreigners Please Don't Leave Us with the Tourists.' The T-shirts were distributed to people departing on a bus to Zambia. The self-deprecating inscription undermines the saviour complex that often underlies artistic interventions in the inner city. It also subverts the value system that situates European tourists as more desirable and welcome than

immigrants from African countries, and that sees African immigrants as parasitic while regarding European immigration as valuable. The intervention was also a response to the continuing xenophobic attacks on African immigrants and those from the Indian subcontinent. I find the gesture commemorative in that it is a form not only of witnessing but of honouring people who are most vulnerable and who bear a great deal of prejudice on a daily basis.

That performance might point us towards, or indeed shape, a memorial culture more meaningful than the physical permanence of bronze and stone was again made evident on 28 July 2014, when an unidentified woman undressed in front of the colossal statue of Nelson Mandela in Mandela Square in Sandton, Johannesburg and proceeded to hug and caress it.[24] The performance, if indeed that is what it was, provoked questions, voyeurism and indignation from patrons, security guards, passersby and workers in the shops surrounding the Square. There was much speculation about the woman's intentions, as well as her sanity, suggesting she lacked authority over her actions. And yet it would be hard to claim that there was no element of spectacle, whether desired or not, implied in her act.

Her nudity presents spectators, those who were present and those who witnessed the event secondhand, with a challenge: how do we read her interaction with 'Mandela'? The removal of clothes to reveal her bare body might suggest vulnerability, and her approach that of a daughter, especially given that South Africans often refer to Mandela as *uTata* (father). But her nakedness might also be interpreted as a sensual act. Some news sites reported that she saluted the statue before undressing, possibly in a mocking gesture of deference.[25] These contradictory signals leave the meaning of this act open-ended. There is certainly a play of contrasts – the woman's tiny frame dwarfed by the six-metre-tall statue; her living, moving body against the statue's cold, static pose. Perhaps the performance is less about the woman than it is about the various – and, in this postdemocratic moment, increasingly contradictory – things that Nelson Mandela has come to symbolise.

The lasting impression of the woman's public evocation of ambiguous and contested histories, in spite of its fleetingness, rubs up against the questionable impact of antiquated, but concretised, forms of memorialisation in South Africa. Therein lies a subtle critique of society's obsession with the worship of lifeless effigies of national heroes embodied in public monuments. I also read the performance as an attempt to reconcile the irreconcilable – the performer's human ordinariness

set (quite literally) against Mandela's larger-than-life stature and almost God-like status in South African public culture. As such, the performance provides an allegory of South Africa's present predicament: the high hopes and expectations commensurate with a nation that has only recently emerged from a brutal regime juxtaposed with the anger and hopelessness of unfulfilled expectations.

Diverse forms of commemoration in which individuals, families and communities participate must accompany the different ways of mourning and healing that need to take place in this country. These commemorative forms do not, and need not, speak to state-sanctioned efforts at nation-building. Central to the work of healing is the need to upturn the prevailing social order and restore Black subjects, still languishing in the zone of non-being, to themselves.

CONCLUSION

In this chapter, I have illustrated the varied ways in which South African art practitioners wrestle with the political, social and spiritual forces that shape our lives. They seek to speak back to western memorial culture and claim a counter-history by redefining spatial relationships, refusing the impulse of capital to erase and forget. These artists, in enacting self-reflexive practices and resisting the allure of nostalgia written into master narratives of history, create a different kind of commemorative culture. Do I believe that these practices are, in and of themselves, transformative? Far from it. It will require a much bigger social consciousness and movement to effect change on this scale. Nevertheless, contained in these nascent attempts at constructing a narrative that counters the struggle history to which we have become accustomed are seeds of a culture that will hopefully have less need for memorial sites of brick and stone, and that will instead become infused with the zeitgeist of the people.

1. *Ingqumbo* formed part of the symposium 'A Luta Continua: Doing it for Daddy – Ten Years On …' hosted by Rhodes University's School of Fine Art.
2. These three sites were the Hector Pieterson Memorial and Museum; the June 16 Interpretation Centre; and the Kliptown Open Air Museum.

3. I make a distinction between the term 'post-1994' and 'postapartheid.' The legislative aspect of apartheid is indeed past and there is a majority Black government in power, but the legacy of apartheid persists in the form of economic disparity, spatial segregation, cultural marginalisation, and so on. Postapartheid implies a rupture with the previous socio-economic dispensation, whereas post-1994 suggests a symbolic break marked by the first democratic elections.

4. The capitalisation of 'Black' in this chapter is deliberate.

5. This is the smaller monument that was erected in 1953, not to be confused with the larger 1820 Settlers National Monument completed in 1974.

6. In Catholic and Anglican tradition, the Stations of the Cross is a series of images representing Jesus's crucifixion, at which particular prayers and devotions are said, often led by a priest, on holy days, such as Good Friday.

7. Frantz Fanon, *Black Skin, White Masks*, trans. Charles Lam Markmann (London: Pluto Press, 1986), 10.

8. The phrase 'service delivery protests' in common parlance in South Africa has come to represent different kinds of protests by poor sections of the population against, for instance, unfair allocation of free housing, slow or inadequate delivery of government services, as well as government decisions that communities feel have been taken without sufficient consultation.

9. Of the violent attacks against African immigrants living in South Africa, the most prominent occurred in 2008, 2015 and 2017. The wave of attacks in 2008 left 56 people dead. See: 'Xenophobic Violence in Democratic South Africa,' South African History Online, 17 April 2015, accessed 26 May 2017, http://www.sahistory.org.za/article/xenophobic-violence-democratic-south-africa.

10. Mahmood Mamdani, 'Justice Not Revenge: Examining the Concept of Revolutionary Justice,' lecture presented at the British Museum, London, 31 March 2017, accessed 26 May 2017, http://mosaicrooms.org/event/said-lecture-2017/.

11. Simon Gikandi, 'After Apartheid: Race and Public Memory,' (lecture presented at Wits University, Johannesburg, 27 March 2014).

12. Gikandi, 'After Apartheid.'

13. Gikandi, 'After Apartheid.'

14. Frank B. Wilderson III, 'Biko and the Problematic of Presence,' in *Biko Lives! Contesting the Legacies of Steve Biko*, eds. Andile Mngxitama et al. (New York: Palgrave Macmillan, 2008), 95–114.

15. Andile Mngxitama, 'Not Only Our Land but Also Our Souls,' *Chimurenga Chronic*, 12 May 2014, accessed 17 November 2017, http://chimurengachronic.co.za/not-only-our-land-but-also-our-souls/.

16. Mngxitama, 'Not Only Our Land.'

17. Charles Villa-Vicencio, 'A Difficult Justice: Reparation, Restoration and Rights' in *To Repair the Irreparable: Reparation and Reconstruction in South Africa*, eds. Erik Doxtader and Charles Villa-Vicencio (Cape Town: David Philip, 2004), 66–87.

18. Ntombenhle Shezi, 'Elle Meets Sethembile Msezane,' *Elle South Africa*, 8 April 2015, accessed 25 May 2017, http://www.elle.co.za/elle-meets-sithembile-msezane/.

19. Sethembile Msezane, 'Sethembile Msezane Performs at the Fall of the Cecil Rhodes Statue 9 April 2015,' *The Guardian*, 15 May 2015, accessed 25 May 2017, https://www.theguardian.com/artanddesign/2015/may/15/sethembile-msezane-cecil-rhodes-statue-cape-town-south-africa.

20. GIPCA, *Live Art Festival 2014 Programme* (Cape Town: GIPCA Live Art Festival. August–September 2014), 14.

21. Buhlebezwe Siwani, interview with the author, 9 October 2017.

22. Siwani, interview.

23. The Center for Historical Reenactments was formed by Gabi Ngcobo, Kemang Wa Lehulere and Donna Kukama in 2010.

24. Palesa Radebe and Mpiletso Motumi, 'Woman Embraces Madiba Statue ... Naked,' *The Star*, 30 July 2014, accessed 26 May 2017, https://www.iol.co.za/news/south-africa/gauteng/woman-embraces-madiba-statue-naked-1727658#.U9iTTWPA3tg.

25. Radebe and Motumi, 'Woman Embraces Madiba Statue ... Naked.'

Astronautus Afrikanus:
Performing African Futurism

MWENYA B. KABWE

The audience enter the lobby of the Rhodes (the University Currently Known as Rhodes) Main Theatre, the bright and functional overhead lights giving nothing away. They have come to see *Astronautus Afrikanus*.[1] A small desk marks the makeshift box-office station outside the glass double doors at which they receive nametags. They might rightly suspect at this point that the performance will not take the usual form accommodated by this theatre. Each audience member is renamed with the prefix Afro, such as Afroholic, Afrobeat, Afromystic.[2] Yet, unknown to them, these names serve to make easier work of a head count in the event of an emergency evacuation. It is May 2015 in Grahamstown, and Eskom has taken to regular unplanned electricity outages, in addition to its regular planned blackouts.[3] The Rhodes Must Fall student protests are also gaining momentum. Fela Kuti plays in the lobby, perhaps only noticeable to those not engaged in conversation about their nametags, wondering out loud what form the invitation to join the characters listed in the programme will take. These characters are similarly named – AfroMogolo, AfroCyann, AfroTiptap, AfroGeo, and so on. The music of Kuti ensures that the ambience is upbeat but suggests, too, that the events to come are cognisant of the rising temperatures of the student movement.

The doors close and some members of the audience register that the music has stopped and that characters in grey overalls with individualised *chitenge* detail have assembled at the top of each set of stairs leading from the ground floor of the large lobby to the upper entrance of the Rhodes Main Theatre. The following automated security briefing is announced:

Welcome to the Pan-African Space Station Shuttle Launch of Craft number PASSLC201513126. Our aircraft is under the collective command of *Astronautus Afrikanus*, descendants of the great Edward Nkoloso's first flight crew and members of the Zambian National Academy of Science, Space, Research and Philosophy. You will conduct your launch observation visit independently and without guidance, and with that in mind, we ask you to pay particular attention to the following safety information.

You have been issued with an access pass. Please ensure that it is visibly on your person at all times. In the event of an emergency that requires an evacuation, such as a fire or a loss of power, these passes will act as a safety tag allowing us to account for you as a member of today's observation visit.

You are on board a working space station and while every effort has been made to ensure your safety, you are responsible for your own well-being and expected to be respectful of the equipment and staff that you will encounter. Please note that from the end of this sound sequence you will be unguided and at liberty to explore the workings of the space station in your own time. For your safety, unauthorised areas will be clearly marked.

Remember, there are worlds out there they never told you about.[4]

CONTENT, FORM, CONTEXT

This chapter is interested in the 'terrain of possibility'[5] in the interaction of performance, African futurism and processes of decolonisation. To ask a question articulated by Jill Dolan: 'How can performance model – not just in content or form or context, but through the interaction of all three – ways of communicating in a public sphere that might encourage us to take mutual responsibility for reimagining social behavior?'[6] In the works under investigation here, the *content* occupies a broad aesthetic terrain known variously and contentiously as African speculative fiction, African futurism, African science-fiction, Afro(politan) futurism and Afro-sf, to name a few. Tegan Bristow, who settles on *Post African Futures* for the title of her 2015 exhibition, explains how the emergence of these new terms signal alternatives to 'Afrofuturism',[7] as coined by Mark Dery in *Black to the Future*:

Afro-Futurism in Africa was brought by the Euro-American art and design world as a way to define and functionally contain work coming out of Africa that explored digitality and technology. Apart from this labelling, this was being treated with some caution locally because Afro-Futurism was mostly an African-American movement. Identifying practice from Africa in this way negated the possibility of there being uniquely African criticism present in the work.[8]

This chapter will not dwell on the various interesting alternatives that African creative practitioners have proposed to Afrofuturism, but instead locates the discussion in the terrain of postcolonial science fiction and frames the works under investigation as expressions of decolonial creative practices. While the instability of the terms 'postcolonial' and 'science fiction' themselves are well registered,[9] the interest here is in foregrounding ways in which Africa is imagined and might imagine itself in and into the future as strategies to 'radically disturb our current assumptions of what constitutes natural order and thus force our attention back onto how we live now.'[10]

The works discussed below take the *form* of live performances. As a popular term, 'performance' is used, sometimes questionably, to describe a wide range of activities in several interlinked disciplines in the humanities and social sciences.[11] In the slippery spaces between theatre, performance and fine art, an artwork in which the body as visual image is a primary medium of expression may variously be termed a performance, or a work of performance art, live art, or visual theatre. The artists discussed in this chapter would not necessarily be identified, and do not always self-identify, as performance artists. They are not always performers in their own works as artists (as distinct from characters played by actors), and their works are staged in a range of venues, including theatres.[12] The common features of these works are that they are visual, durational and in conversation with the spaces in which they occur. Ideas and images – visual, aural, spoken – are saturated in, and amplified by, the immediacy of the live encounter between audience and performer; they are conceptually rich and intentionally provocative about the times in which they are made. Audiences slide in and out of the roles of spectators and participants and are often permitted a greater degree of agency, unrestricted by the theatre's conventional rules of behaviour, timeframe and presentation. The audience experience is driven less by engaging with the artwork as a commodity

to be consumed or absorbed than it is by a visceral encounter with embodied meaning and the live presence of the art(ist). In the words of art historian RoseLee Goldberg, these performances are 'live, of the moment ... portray[ing] personal or collective histories, politics, class, science, the social order of the art world and of the world.'[13]

The particular postcolonial *context* in which the performances occur, or in which they are reflected, is the student movement known as Rhodes Must Fall that ignited South African universities in May 2015 after a student at the University of Cape Town (UCT) defiled a campus statue of Cecil John Rhodes with human waste.[14] Nigel Gibson, renowned scholar of Frantz Fanon, offers the following:

> In South Africa, the university is an institution established to reproduce colonial ideology. Any critical politics of pedagogy and curriculum must also include its geography, its location and buildings, its accessibility, gates, barriers and dividing lines (literal and figurative) as well as its classrooms; challenging the very structures of the university (its disciplines, academic ranks, administration, exams, grades, and daily culture, including all its social-spatial relations).[15]

The large-scale student protests which started in March 2015 under the hashtags #RhodesMustFall and then #FeesMustFall, and which continued into 2016 and 2017 in South African universities across the country, have forcefully raised a number of urgent issues pertaining to the neocolonial education project as it continues to play out in lecture halls, seminar rooms, labs and studios. The ensuing call to decolonise education has arisen from a collective mobilisation against institutional racism and sexism, the continued privileging of Eurocentric modes of teaching and learning, and the commodification of education to demand 'free, quality, decolonised education and [express] dissatisfaction with the rate and depth of change two decades after South Africa's democratisation.'[16]

It must be noted that the passing of the Bantu Education Act of 1953 was one of the first major catalysts of student activism in South Africa, and the Rhodes Must Fall and Fees Must Fall protests exist within this long line of student organising in the country's political history.[17] As educators and students in this context, the work of sorting through the baggage of the very term 'decolonisation' to arrive at its current resonances – as well as the work towards practically implementing the

long-overdue repairs, changes and overhauls to well-established systems based on an array of material and ideological exclusions – is challenging to say the least.

This chapter is based on the dramaturgical coincidence of making a performance with students as the 2015 student movement was starting, and as black students were once again fighting for their freedom from oppressive economic and educational legacies. I am not well placed, and it is entirely too soon, to make any determinations about what strategies are and will be useful for the emergence of a radical, decolonised future as envisioned by the student movements. In that direction, however, this chapter is interested in the questions of what enables and sustains a space of possibility in a present that is urgent, dire and historically loaded, in order for a radical future to be realised. The key problematic that I wish to frame is expressed by Dery's critique of the potential irrelevance of futuristic thinking in a time of crisis. He asks, 'Can a community whose past has been deliberately rubbed out, and whose energies have subsequently been consumed by the search for legible traces of its history, imagine possible futures?'[18] This chapter is written in a non-linear manner with sections that attempt to immerse the reader in the production of *Astronautus Afrikanus*, bearing in mind the 'excess of articulateness' of works of art, where written words prove lacking.[19] Acknowledging this excess here is to destabilise the traditional expectation of written words to do all the necessary explaining.

These sections are punctuated by discussions of performances staged by artists who live and/or work in South Africa – namely Kapwani Kiwanga, Thenjiwe Niki Nkosi and Pamela Phatsimo Sunstrum. Although common in their general form as live performance works and African futuristic content, the pieces vary vastly in modes of presentation. These performances have been selected for what they might reveal at the nexus of understanding performance as socially, politically and aesthetically engaged public practice, and for what they suggest about the potential political traction of African futurism, with its multiple terms and interpretations, as an expression of decolonial creative practice. The conversation between *Astronautus Afrikanus* and the other works is intended to be porous in order to signal the array of possibilities that are offered when thinking speculatively about Africa through artistic mediums.

The long blow of a kudu horn marks the end of the safety briefing and the Afronauts descend the steps that flank the lobby. They mingle with the 'observation visitors' and greet them as per their newly assigned names. They direct the visitors towards the various worksites in the space station at which the technicians are now harnessing useful materials to sustain human life on another planet, designing wearable technology, completing sketches of alternative spacecrafts and generating fuel from unlikely sources for the rocket launch. Some members of the audience eagerly follow the actors, keen for whatever their enrolment in the fiction will require them to do. Others linger longer in the lobby, do a double take at the now visible security personnel, or consult their programmes for some indication of what to expect next, how to proceed as members of the observation visit, and where to go first.

The map in the programme sketches the areas of the Rhodes Main Theatre complex that are part of the stage world, those that are out of bounds, as well as emergency exits and assembly points. The map mainly serves to locate the 11 worksites – spread between the theatre foyer, side lobbies, workshop dock, wings, stages, dressing rooms and auditorium – which include spaces such as The Particle Stability and Acceleration Lab, The Star Blanket, The Light Refraction Travel Lab, The Design Lab, The Nkoloso Tribute Room, Rocket Core and the Main Control Chamber. The audience is free to encounter these sites and the technicians who activate them at their own discretion – an invitation that seems at once liberating and daunting. If, for need of some context, they start in The Nkoloso Tribute Room, they find themselves in one of the dressing rooms of the theatre, dimly lit and redesigned as a memorial to Edward Mukuka Nkoloso, whose story is the source of the production.

A Zambian schoolteacher in the 1960s, Nkoloso was convinced that Zambia would beat the Russians and Americans to space. So strong was his conviction, that he started a space-training programme in a secret location not far from Lusaka, which he called the Zambia National Academy of Science, Space Research and Philosophy.[20] This was in 1963, a year before Zambia's independence from British colonial rule, and Nkoloso was said to be training a group of young people to become the first Afronauts to reach the moon. Any visitor to the Tribute Room would hear a choral version of Zambia's unofficial national anthem 'Tiyende

Pamodzi,'[21] as if played on the visible record player. They would see, behind a red velvet rope, items associated with Nkoloso's quirky appearance – including a Second World War helmet, purple cape and combat boots on an undressed costume rail, the kind often found in theatre dressing rooms. The room also holds paper rocket models, images from Christina de Middel's *The Afronauts*,[22] piles of fabric from a Lusaka market and an odd assortment of controversial hardcover coffee table books about Africa and Africans. One might attribute the slightly musty smell to the dressing room shower rather than the supposed age of the artefacts in the room.

MAP OF THE SPACE STATION
Key:

(1) Entrance Foyer
(2) The elemental energy extraction ritual
(3) Particle Stability & Acceleration Lab
(4) LRTL: Light Refraction Travel Lab
(5) Framework
(6) Keeper of History / Knowledge of Story Telling
(7) Nkoloso Tribute Room
(8) The Design Lab
(9) The Star Blanket
(10) The Zasa Lab
(11) The Rocket's Core

OUT OF BOUNDS

In the event of an emergency, please note the following:

EMERGENCY EXIT

EMERGENCY ASSEMBLY POINT

Figure 13.1. Map of the Rhodes Main Theatre complex provided in the *Astronautus Afrikanus* programme, 2015.

Figure 13.2. Clipping from *The Ottawa Journal*, 28 October 1964.

ZAMBIA'S COSMONAUT

Edward Mukuka Nkoloso, in spaceman's helmet and ornate cloak, interrupts a telephone conversation in Lusaka, Zambia, to talk to Zambia's No. 1 cosmonaut, Godfrey Mwango. Zambia is Africa's newest nation, formerly known as Northern Rhodesia, a British protectorate. Nkoloso, self-appointed Zambian minister of space research, boasts, "I'll have my first Zambian astronaut on the moon by 1965." He estimates he'll need almost $2 billion to place him there.

ROCKET A BIT WOBBLY

Zambia Warns Russia, U.S. We'll Beat You to Moon

By DENNIS LEE ROYLE

LUSAKA, Zambia (AP) — Edward Mukuka Nkoloso has designated himself Zambia's minister of space research, and says the United States space. I also make them swing from the end of a long rope. When they reach the highest point I cut the rope — this produces the feeling of free-fall."

a project of this magnitude," he said. "Some of our ideas are way ahead of the Americans and Russians and these days I will not let anyone see my rocket plans."

UNSEATING RHODES (THEATRE)

In another context, the location of *Astronautus Afrikanus* in and around the Rhodes Theatre complex might simply have contributed to an interesting theatrical experiment in immersive performance, particularly for students at the Rhodes Drama Department who are accustomed to using the venue in much more conventional ways. Against the backdrop of Rhodes Must Fall, however, which was gaining significant momentum at the time of the production, the immersive, site-specific use of the Rhodes Main Theatre complex, with all its implicit and explicit codes for good behaviour, took on a much more politically resonant charge in the making of the work.

Several members of the cast were directly involved in the student protests and brought a hypersensitivity to the issues of colonialism as they were presented by Nkoloso's story and by the unfolding student movement. At the time, the notion of African futures was seen by the students as a useful strategy for imagining alternative realities. Historically, the questionable use of thinking futuristically has been associated with 'an ethical commitment to history, the dead and the forgotten,' thereby maintaining that in light of the colonial erasure of black African truths, the political project of creating 'countermemory' was significantly more urgent than the project of creating 'counterfutures.'[23] The genre of science fiction is, in fact, known to be historically steeped in tropes of colonialism. The anti-colonial use of science fiction, however, arose from a subversion of the primary signifiers of both colonialism and science fiction – those of the alien/stranger/other/extraterrestrial/foreigner and wild, uninhabited land ripe for taming/taking/settling. The retrospective framing of *Astronautus Afrikanus* as a decolonial project is in light of the particular intervention made by postcolonial science fiction where these shared tropes are parodied and 'their very power ... turned back on itself.'[24]

While held by the conceptual container of African futurism, the working process of the production was greatly preoccupied with the practical tasks of making the production work by, for instance, creatively problem-solving how audiences would experience the performance if they were not sitting facing the stage. Throughout this process, parallel conversations about the work and the student protests were dominated by the sense that African futurism is in fact not about the future, but about the dreams, nightmares, conflicts, opportunities and realities of the moment in which the work is being made.[25] This continued to bring to the fore contesting

ideas of the usefulness of African futuristic thinking depending where on the past/present/future continuum one's political project is located.

Gareth White describes immersive theatre, broadly, as 'performances which use installations and expansive environments, which have mobile audiences, and which invite participation.'[26] The conventional use of a traditional proscenium theatre space reveals a relatively small amount of its overall structure and capacity to an audience, hiding from view the messier work areas of the backstage, wings, workshops and dressing rooms. These spaces are interlinked, but audience access tends to be regulated in order to maintain the theatrical illusions of the stage under the lights perceived from the darkened auditorium. For Nick Kaye, 'site-specificity is linked to the incursion of "surrounding" space, "literal" space or "real" space into the viewer's experience of the artwork.'[27]

The maze-like quality of the *Astronautus Afrikanus* performance space made for an understanding of the more expansive environment as a found space rather than one with clear designations for its use. This was the case both in the making of the work, as we (re)discovered the potential for the Theatre's spaces in locating each installation, as well as for the spectator-participants who were tasked with finding the installations located in generally unexplored areas of the building. Our aim was to invite the audience to experience the interior architecture of multiple adjoining theatre workspaces that were transformed but not disguised.

Kaye notes that 'the location, in the reading of an image, object, or event, its positioning in relation to political, aesthetic, geographical, institutional or other discourses, all inform what "it" can be said to *be*.'[28] In the case of *Astronautus Afrikanus*, the 'space invasion' performed in the Theatre, and at the University named after the colonialist whose contested memorialisation had sparked the protests, made for an important intervention into the site's colonial history and context, throwing into sharp relief the student movements' calls for transforming institutional culture. This alternative use and experience of the Theatre became a site of interrogation and a metaphor for unseating institutional structures still steeped in colonial ideology. An exercise in 'undermining [the] conventional oppositions between the virtual space of the artwork and "real space" of its contexts,' this became a strategy to challenge the assumed stabilities of the site and, by extension, the University as a whole.[29]

Kapwani Kiwanga's *Afrogalactica* series (2011–2015) is an example of a performance that does destabilising work by futuristically challenging the archive and knowledge production in Africa, which resonates with the call to revise university curricula. Kiwanga is a Canadian-born, Paris-based artist whose work represents 'different types of intelligence: sensual, temporal and spatial.'[30] Kiwanga's *Afrogalactica* series is a trilogy of performance works in which she performs a speculative interpretation of African history to make projections about the future.

The first in the series, subtitled *A Brief History of the Future*, pays tribute to Kwame Nkrumah's role in envisioning a Pan-African future. Kiwanga's theatrical world imagines 2058 as the year that the United States of Africa (the USAF) comes into being – the centennial anniversary of the 1958 Pan-African conference in Accra, Ghana, where Nkrumah proposed his model of a federation of African states.[31] Interestingly, in light of the uneasy proposition of African futurism, Kodwo Eshun notes: 'When Nkrumah was deposed in Ghana in 1966 it signaled the collapse of the first attempt to build the USAF. The combination of colonial revenge and popular discontent created sustained hostility towards the planned utopias of African socialism.'[32]

The third in Kiwanga's performance series, subtitled *Deep Space Scrolls*, was performed at the 2015 Goethe-Institut African Futures Festival in Johannesburg and is of particular interest here. Kiwanga is trained as an anthropologist, and her performances take the form of an academic presentation in which she reads from notes and supports her points with PowerPoint images and video and audio excerpts. From her arrival on the podium, however, there is a heightened sense of theatricality that disturbs one's expectations of a typical conference presentation. Kiwanga adopts some of the visual tropes of the futuristic genre by appearing quite androgynous and wearing an elegant monochrome jumpsuit. Her hair is slicked into a tight pompadour and she sits still throughout her lecture, which she delivers in an emotionally detached, deadpan manner.

There is no irony apparent in her combining of rigorous historical research and fictional texts.[33] She surveys the controversial official discourse of ethnographic literature that credited non-Africans for the building of Great Zimbabwe,[34] and goes on, not only to assert that Great Zimbabwe was built by local African populations, but also to fictionalise the location as the site of an observatory

tower from which this population studied the stars. In the vein of postcolonial science fiction, Kiwanga's creative practice embraces history, memory, tangent and fragment to create coherent futuristic narratives that offer a productive framing for current conversations in South Africa about what it might mean to decolonise knowledge. Moreover, Kiwanga's proposal of a counter-history makes a speculative intervention into history and culture, challenging the very meanings of terms such as 'civilization' and 'knowledge.'[35]

POST AFRICAN FUTURES: VENTURING BEYOND MEMORY

While *Astronautus Afrikanus* was running in Grahamstown in May of 2015, the *Post African Futures* exhibition opened at the Goodman Gallery in Johannesburg. Curated by Tegan Bristow, an interactive media artist and academic, the exhibition formed part of her research in African digital and communication technologies. In the exhibition catalogue, she describes her research context as emerging from 'a fundamental lack of understanding of how Africa is culturally positioned in terms of media and technology. There seems to be a default assumption that the digital is a Western technology and its influence and use is therefore Western too. This ... negates the consequence of neo-colonialism through communications technologies.'[36]

Artists Pamela Phatsimo Sunstrum and Thenjiwe Niki Nkosi, who responded to the invitation and call to action to participate in *Post African Futures*, constructed a collaborative performance installation work titled *DISRUPTER X PROJECT: NOTES FROM THE ANCIENTS*, the third installation of *DISRUPTER X*, which began in 2013. Conceived as a response to debates about how museums have archived and continue to archive African art, the futuristic protagonist in the legend that unfolds through the series is described as 'a soldier in the Disrupter Army' who fights against 'The Agency,' an oppressive force which controls the whole world by turning living things into programmable, interchangeable pieces of data.[37]

The first iteration of the legend, *IF YOU DO IT RIGHT*, was staged as an intimate two-person performance at Honolulu performance space in Nantes, France in 2013. The second, presented in an indoor skate park in Bayreuth, Germany in 2014, was entitled *DISRUPTERS, THIS IS DISRUPTER X*. Unlike in *Astronautus*

Afrikanus, where the audience was self-guided, in this interactive performance they were led through the narrative through a series of multimedia scenes staged around the skate park. The third iteration was the performative installation at the *Post African Futures* exhibition where Nkosi and Sunstrum performed as The Archivists, two characters who are the custodians of the Legend of Disrupter X. The diorama depicted the lifeless terrain of mine dumps and included artefacts and traces of The Legend, including an audio recording of an operatic rendition of the story, a video display of Disrupter X's lineage and a short video loop from the original Agency broadcast system.[38]

Both Sunstrum and Nkosi are creative researchers who work in multiple artistic mediums. Born in Botswana, Sunstrum works in drawing, installation, animation and performance and, while currently based in Johannesburg, she has lived in several other parts of the continent as well as in Asia and North America. Nkosi is a Johannesburg-based filmmaker, painter and video artist who was born in New York and has also lived in Zimbabwe. Her interest in art as social practice has prompted her to investigate political, social and architectural power structures.[39] Together, Sunstrum and Nkosi work to imagine alternatives to existing reality.

Sunstrum's interest in memory as a way of transcending time and geography to 'approach paradises that are yet-to-be known, yet-to-be-seen, yet-to-be,' speaks of a commitment to imagining alternative futures.[40] Of her studio practice she writes: 'I am interested in reclaiming and re-ordering narratives of power via an imaginative or speculative occupation of geographies (space) and histories (time). An integral aspect of this pursuit is my practice of "venturing beyond."'[41]

Figure 13.3. Pamela Phatsimo Sunstrum and Thenjiwe Niki Nkosi, *DISRUPTERS, THIS IS DISRUPTER X,* 2014. Courtesy the artists. Photograph by Simon Rittmeier.

Figure 13.4. Pamela Phatsimo Sunstrum and Thenjiwe Niki Nkosi, *DISRUPTERS, THIS IS DISRUPTER X,* 2014. Courtesy the artists. Photograph by Thenjiwe Niki Nkosi.

Nkosi's creative practice includes an interrogation of terms such as 'knowledge,' 'knowledge production' and 'sites of knowledge' with their exclusionary institutional baggage. She suggests instead that 'it may be useful to think of every moment as having the potential to be a site of knowledge production. Sites can be interactions.'[42] In her 2016 essay 'Radical Sharing,' Nkosi makes direct reference to the Rhodes Must Fall and Fees Must Fall student protests as precisely these sites of knowledge, indicated not only by the physical locations of student demonstrations, but also in the contentious discussions and debates surrounding them, and in the forms that the protests have taken – from embodied modes of song, chants and placement of bodies, to placards and written demands.[43]

INSIDE *ASTRONAUTUS AFRIKANUS* (ONCE MORE)

At the sound of the kudu horn, the visitors are ushered into the Main Control Chamber, and the Afronaut technicians and security personnel communicate the magnitude of the impending rocket launch in the way they eagerly brush past the visitors to take their places at the front of the stage facing the auditorium. Red and white security tape keeps everyone on the correct side of the open trapdoor in the stage from which a deeply set, faint, white light illuminates the torso-level cloud of billowy plastic orbs secured to each other, and to an invisible pulley with bright red wool. The orbs are not inflated enough to be mistaken for balloons, and with little trace of their original use as supermarket fresh produce bags, this strange, ethereal, luminous structure gives the stage space, now occupied by the audience who have spilt onto it from all sides, an otherworldly quality.

The horn continues in celebratory blasts while each Afronaut is called by name and lineage from the sound and lighting booth on the upper level at the back of the auditorium, now lit as the rocket's flight deck. In a grand, poetic roll call, each Afronaut is praised for their mythical and technical contributions towards this momentous and long-awaited launch. The Afronauts take their places in the rocket's interior, facing the audience in the raked auditorium to form the shape of a tall triangle indicating the trajectory of the rocket. The countdown begins and the room is flooded by what sounds like an approaching thunderstorm. Amidst this growing sound, the mechanics of the machine that is soon to launch can be heard. The light from the trap door intensifies and the cloud of white, billowy plastic

orbs appears to catch fire. At blast off, several things happen at once: a final blast of sound ejects the plastic cloud into the air, taking the blinding firelight with it; there is a blackout in the flight deck and the Afronauts disappear from view. After several silent beats, the sound of Fela Kuti creeps into the hush. A door opens into the passage leading back to the main entrance, and as the audience leave, they may hear the quietly determined soundscape of rocket-building work beginning again.

RECLAIMING NKOLOSO: A CONCLUSION

In a short video available online, in which he appears to be wearing a cape and a standard-issue Second World War helmet, Nkoloso is interviewed by a British reporter. When asked to identify his spacecraft, he points to two empty oil drums stacked on top of each other with a small oval window. His Afronauts are captured doing jumping jacks as part of their training programme and rolling each other down a series of bumpy hills in empty oil drums to simulate weightlessness. The interviewer calls Nkoloso and his team 'a bunch of crackpots.'[44]

In the context of the 2015 student uprisings, to which the cast of this project was negotiating their degrees of allegiance, this last diminishing utterance by the interviewer was heavily critiqued in an early rehearsal. The discussion of the video centered on what students read as the deep levels of disregard and ridicule of not only Nkoloso and his project, but by extension African ingenuity. The students read the comment of the British interviewer – and, by extension, the west – as delegitimising Nkoloso's capacity to dream as big as the superpowers of the day. As one of the few pieces of available archival footage of Nkoloso, the video was seen as writing him and his project into history as largely illegitimate and comical. They perceived the tropes of representation here as threatening to rupture the connection between Africanness and intelligence, ingenuity and knowledge-making. These readings set an early agenda for our project as one that was concerned with 'challenging debilitating discourses on Africa.'[45]

In the process of reclaiming the figure of Nkoloso from the pejorative image cast by this video, he was initially read as an African futurist. Our own working definition of the term included the opportunity to engage in a politics of the future that ceases to construct black Africanness in opposition to what Alondra Nelson describes as 'technologically driven chronicles of progress.'[46] Our starting point

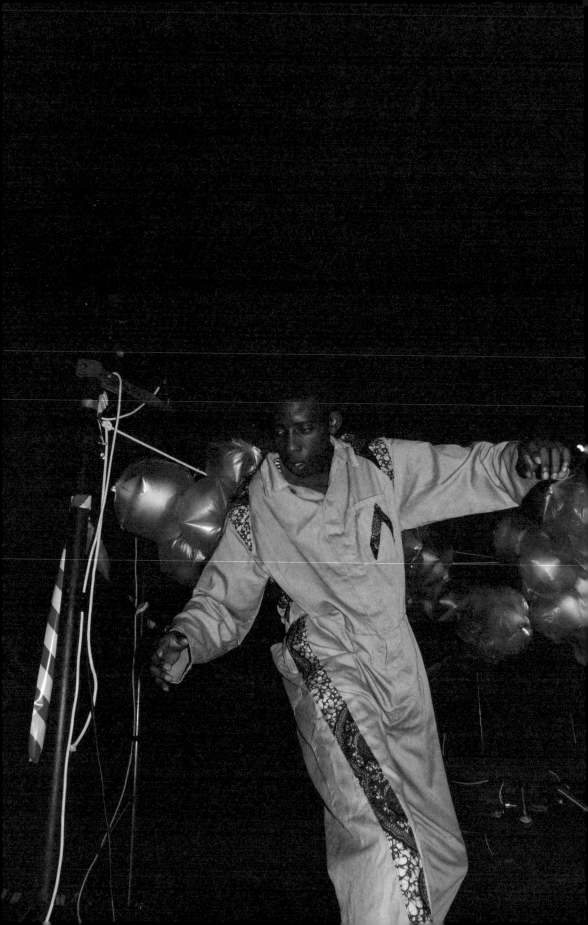

was to reclaim Nkoloso as a utopian visionary and African futurist – ahead of his time in his ability to see a Zambian mission to the moon as a metaphor for the expansive and deeply hopeful future of an independent Northern Rhodesia. He planned to launch the rocket from Independence Stadium to coincide with the very first hoisting of the Zambian flag.

Nkoloso as a figure is not so easily heralded, however, and, as Namwali Serpell writes in her 2017 *New Yorker* article, it is still difficult to know 'whether his space program was serious, silly or a sendup.'[47] The possibilities also opened for us to read Nkoloso as much more subversive. He became not only an eccentric visionary, taking the metaphor of Zambia's independence literally to new heights, but also a trickster and satirist. In this reading, the cast imagined Nkoloso's space programme as a front for underground revolutionary activity, his cape and helmet a disguise, and the antics of his training programme a successful distraction from his clear-headed leadership of an anti-colonial student movement.

With all these possibilities afloat, he became the *Astronautus Afrikanus* creative and intellectual ancestor, committing us to exploring how themes and images of space and space travel become an 'imaginal machine for thinking and organizing to get out of this world that we want to leave behind.'[48] The production was conceptualised as being driven by the ancient and futuristic, and how these supposed poles might meet in the present. Nkoloso's space rocket became a kind of connecting device, metaphorically connecting the ground to the sky, the ancient to the future, the practical to the potential. It was this commitment to the potential that we were most inspired by, and out of which came a series of questions that framed the production's devising process, as captured in the director's note:

Figure 13.5. Mwenya B. Kabwe, *Astronautus Afrikanus*, 2015.
Photograph by Jonathan Georgiades.

It seems that now more than ever we are presented with the opportunity to re-member ourselves. To put ourselves back together and imagine ourselves as Africans, differently. Thinking about how we as theatre makers might do this in the face of oppressive legacies opened up a host of questions that led us, the cast and crew, to re(discover) the Edward Mukuka Nkoloso in us all. We asked ourselves, what happens if we start from the premise that we know; that we are full of knowing and our capacity for curiosity about ourselves, each other and the world we share, is great. We asked what happens if we consider indigenous African knowledge systems central rather than alternative; status quo rather than subversive; common practice rather than subordinate, sceptical, inferior and the domain of the 'less educated'?[49]

On 25 October 1963, almost a year before Zambia gained independence from British colonial rule, Kwame Nkrumah asked the following questions which bear asking again in the different time and place that is contemporary South Africa, and which are echoed in numerous university contexts that continue to grapple with the legacies of colonial structures:

What sort of Institute of African Studies does Ghana want and need to have? In what way can Ghana make its own specific contribution to the advancement of knowledge about the peoples and cultures of Africa through past history and through contemporary problems? For what kind of service are we preparing students of this Institute and of our Universities? ... To what extent are our Universities identified with the aspirations of Ghana and Africa?[50]

Among the major issues that the student movements have raised is a desire to know differently from what has historically been valued by institutions. In this light, the process of making *Astronautus Afrikanus* involved a series of ongoing conversations with the cast of 11 students about knowledge production in a university setting – what it means to know, who determines what is constituted as knowledge, how it is validated and what kinds of knowledge systems are delegitimised and how.

As a result, the students' self-directed research processes included detailed engagements with family members, more and less available historical records and

their own ideas of African knowledge-making. This research formed the basis of generating their performance material and Pan-African space station characters as technicians, each working with a particular expertise in the collective work of the space station. Among them we had Afropythonisam, a student studying dance and physics who harnessed energy from each of the four elements; AfroMogolo, an old man (played by a female law and drama student) who drew energy from the stars with his stationary bicycle as an experiment in creating renewable energy, and AfroCyan and AfroSechat, second- and third-year drama and psychology students who ran tests on lunar soil samples in the ZASA lab. These were just a few of the cast. Designer Illka Louw ran a series of workshops on materials and objects as the 'texts' of performance, both in relation to the actors but also as performative elements in and of themselves. As the content evolved, so did the form and eventually what was written, as the performance text was a rich assemblage of characters, transformed spaces, objects, costumes, environments and installations until the final rocket launch – a spectacle of light and sound.

Jonathan Dotse notes that:

> Most of us tend to conceive the future in the same terms as the past, which is to say as a linear progression of events in time. However, our imaginings of the future must necessarily be non-linear to truly capture the exponentially diverse array of possible futures ahead of us at any given point in time. We must not think of the future as a string of events waiting to unfold, but a boundless field of possibilities competing to be materialized.[51]

The Rhodes Must Fall and Fees Must Fall movements have erupted as an urgent call to reimagine. The works in this chapter respond to this call by opening up 'fields of possibility' and 'new narratives' that challenge dominant structures with new ideas, images, locations, as well as with new roles and configurations of participants. These projects respond to the critiques of African futurism by working with the possibility of using the future and embracing uncertainty to navigate an often hostile and exclusionary present. At the same time, these performative works indicate that bringing the speculative to bear on the past has everything to do with how we understand the present and, ultimately, with the kinds of new African futures we may actually imagine and bring into being.

1. In May of 2015, I was invited to be the director in residence at the Rhodes University Drama Department in Grahamstown to make a new work with students across years and with my long-time collaborator and friend Lieketso wa Thaluki. *Astronautus Afrikanus* was the work we created, and which I directed.

2. *Afroisms* such as these were created for previous performance projects as a way of playfully locating the works in conversations about how something that might be called 'African-ness' is articulated.

3. Eskom is the South African Electricity and Supply Commission.

4. *Astronautus Afrikanus*, directed by Mwenya B. Kabwe, 21–23 May 2015, Rhodes Main Theatre, Grahamstown. The final line of the security briefing is taken from the last track of Sun Ra's 1978 album, *Lanquidity*. The original track title is 'There Are Other Worlds (They Have Not Told You Of).'

5. Stevphen Shukaitis, 'Space is the (non)place: Martians, Marxists, and the Outer Space of the Radical Imagination,' *The Sociological Review* 57, no. 1 (2009): 99, accessed 20 January 2017, doi: 10.1111/j.1467-954X.2009.01819.

6. Jill Dolan, *Utopia in Performance: Finding Hope at the Theatre* (Michigan: University of Michigan Press, 2005), 28.

7. Mark Dery, 'Black to the Future: Interviews with Samuel R. Delany, Greg Tate and Tricia Rose,' in *Flame Wars: The Discourse of Cyber Culture* (Durham: Duke University Press, 1994), 179–222.

8. Tegan Bristow, 'Introductory Essay,' in *Post African Futures Exhibition Catalogue* (Johannesburg: Goodman Gallery, 21 May—20 June 2016), 0006.

9. Jessica Langer, *Postcolonialism and Science Fiction* (New York: Palgrave Macmillan, 2001).

10. Ulrike Küchler, Silja Maehl and Graeme Stout, eds. *Alien Imaginations: Science Fiction and Tales of Transnationalism* (New York: Bloomsbury, 2015), xiii.

11. Marvin Carlson, 'What is Performance?' in *The Performance Studies Reader*, ed. Henry Bial (London: Routledge, 2004), 68–73.

12. RoseLee Goldberg, *Performance Art: From Futurism to the Present* (London: Thames and Hudson, 1988).

13. RoseLee Goldberg, *Performa: New Visual Art Performance* (New York: Performa Publications, 2007), 13.

14. Jonathan Jansen, *As by Fire: The End of the South African University* (Cape Town: Tafelberg, 2017).

15. Nigel Gibson, 'Thinking Outside the Ivory Tower,' in *Being at Home: Race, Institutional Culture and Transformation at South African Higher Education Institutions*, eds. Pedro Tabensky and Sally Matthews (Pietermaritzburg: University of KwaZulu-Natal Press, 2015), 187.

16. Leigh-Ann Naidoo, 'Contemporary Student Politics in South Africa: The Rise of the Black-Led Student Movements of #RhodesMustFall and #FeesMustFall in 2015,' in *Students Must Rise: Youth Struggle in South Africa Before and Beyond Soweto '76*, eds. Anne Heffernan and Noor Neiftagodien (Johannesburg: Wits University Press, 2016), 180.

17. Heffernan and Nieftagodien, *Students Must Rise*.

18. Dery, 'Black to the Future,' 180.

19. Paul Carter, *Material Thinking: The Theory and Practice of Creative Research* (Melbourne: Melbourne University Publishing, 2004), xii.

20. Unknown, 'Zambia's Forgotten Space Programme,' *Lusaka Times*, 28 January 2011, accessed 6 April 2018, http://www.lusakatimes.com/2011/01/28/space-program/.

21. A song popularised by Kenneth Kaunda in the struggle for Zambia's independence.

22. Christina de Middel, *The Afronauts* (Madrid: self-published, 2012).

23. Kodwo Eshun, 'Further Considerations on Afrofuturism,' *CR: The Centennial Review* 3, no.2 (2003): 288 (emphasis mine), accessed 1 May 2017, doi: 10.1353/ncr.2003.0021.

24. Langer, *Postcolonialism and Science Fiction*, 4.

25. Maud M.L. Eriksen and Mickey Gjerris, 'On Ustopias and Finding Courage in a Hopeless Situation,' in *Science Fiction, Ethics and the Human Condition*, eds. Christian Baron, Peter Nikolai Halvorsen and Christine Cornea (eBook: Springer, 2017), 227–246, accessed 1 May 2017, doi: 10.1067/978-3-319-56577-4.

26. Gareth White, 'On Immersive Theatre,' *Theatre Research International* 37, no. 2 (2012): 221, accessed 20 January 2017, doi: 10.1017/S0307883312000880.

27. Nick Kaye, *Site-Specific Art: Performance, Place and Documentation* (New York: Routledge, 2000), 25.

28. Kaye, *Site-Specific Art*, 1.

29. Kaye, *Site-Specific Art*, 25.

30. Erin MacLeod, 'Kapwani Kiwanga: An Artist Anthropologist,' *Canadian Art* 33, no. 3 (2016), accessed 20 January 2017, http://canadianart.ca/features/kapwani-kiwanga/.

31. Mark Bould, 'Afrofuturism and the Archive: Robots of Brixton and Crumbs,' *Revista Laika* (2016), accessed 20 February 2016, http://eprints.uwe.ac.uk/30411.

32. Eshun, 'Further Considerations,' 288.

33. Kapwani Kiwanga, 'Comprehensive Methodology in Ancestral Earth-Star Complexes: Lessons from Great Zimbabwe,' *Manifesta Journal* 17 (2013): 55–58, accessed 13 November 2017, http://www.manifestajournal.org/issues/futures-cohabitation/comprehensive-methodology-ancestral-earth-star-complexes-lessons-vela#.

34. Gavin Steingo, 'Kapwani Kiwanga's Alien Speculations,' in *Images Re-Vues: Histoire, anthropologie et théorie de l'art*, 14 (2017): 1–3, accessed 1 March 2018, http://journals.openedition.org/imagesrevues/4051.

35. Steingo, 'Kapwani Kiwanga's Alien Speculations,' 1–20.

36. Bristow, 'Introductory Essay,' 0004.

37. Thenjiwe Niki Nkosi and Pamela Phatsimo Sunstrum, 'DISRUPTER X PROJECT: NOTES FROM THE ANCIENTS,' in *Post African Futures Exhibition Catalogue* (Johannesburg: Goodman Gallery, 21 May–20 June 2016), 0013.

38. Thenjiwe Niki Nkosi, e-mail message to author, 13 November 2017.

39. 'Pamela Phatsimo Sunstrum and Thenjiwe Niki Nkosi,' Future Lab Africa, accessed 9 September 2017, http://futurelabafrica.org/product/pamela-phatsimo-sunstrum/.

40. Phamela Phatsimo Sunstrum, 'Leaping Out,' in *African Futures: Thinking about the Future in Word and Image*, eds. Lien Seleme-Heidenreich and Sean O'Toole (Bielefeld: Kerber Culture, 2016), 141.

41. Sunstrum, 'Leaping Out,' 149.

42. Thenjiwe Niki Nkosi, 'Radical Sharing,' in *African Futures: Thinking about the Future in Word and Image*, eds. Lien Heidenreich-Seleme and Sean O'Toole (Bielefeld: Kerber Culture, 2016), 256.

43. Nkosi, 'Radical Sharing,' 257.

44. '1964: Edward Nkoloso's Space Program,' YouTube video, 1:02, 2 June 2016, accessed 15 March 2017, https://www.youtube.com/watch?v=abVrYdYNAyU.

45. Steve Odero Ouma, 'The African Renaissance and Discourse Ownership: Challenging Debilitating Discourses on Africa,' in *African Intellectuals and Decolonisation*, ed. Nicholas M. Creary (Athens: Ohio University Press, 2012), 117.

46. Alondra Nelson, 'Introduction: Future Texts,' *Social Text* 20, no. 2 (2002): 1, accessed 13 November 2017, doi: 10.1215/01642472-20-2_71-1.

47. Namwali Serpell, 'The Zambian "Afronaut" Who Wanted to Join the Space Race,' *The New Yorker*, 11 March 2017, accessed 15 September 2017, https://www.newyorker.com/culture/culture-desk/the-zambian-afronaut-who-wanted-to-join-the-space-race.

48. Shukaitis, 'Space is the (non)place,' 98.

49. Mwenya B. Kabwe, *Astronautus Afrikanus Programme* (Grahamstown: Rhodes Main Theatre, 21–23 May 2015), 2.

50. Kwame Nkrumah, 'The African Genius,' in *Reclaiming the Human Sciences and Humanities through African Perspectives, Vol. 2*, eds. Helen Lauer and Kofi Anyidoho (Accra: Sub-Saharan Publishers, 2012), 909.

51. Jonathan Dotse, 'We Know We Will,' in *African Futures: Thinking about the Future in Word and Image*, eds. Lien Seleme-Heidenreich and Sean O'Toole (Bielefeld: Kerber Culture, 2016), 24.

'Touched by an Angel' (of History) in Athi-Patra Ruga's *The Future White Women of Azania*

ANDREW J. HENNLICH

In the dialectical, the past of a particular epoch ... appears before the eyes of [a particular present epoch] in which humanity, rubbing its eyes, recognizes precisely this dream as a dream. It is in this moment that the historian takes upon himself the task of dream interpretation.

Walter Benjamin, *The Arcades Project*

[After the xenophobic attacks] our African dream shattered.

Athi-Patra Ruga, interview with the author, 2014

On a long road in Grahamstown, South Africa, a curious explosion of colour erupts from the browns and olives of the landscape. A figure whose gender, face and, by extension, identity are unseen strides down a dirt road in bright pink tights and red stiletto heels, covered from the waist up in brightly coloured balloons. Connoting childhood joy, lightness and floatation, in a South African context the balloons appear to further reference Desmond Tutu's metaphor of the rainbow nation – yet they will soon erupt in a violent and cathartic act of mourning, undoing such metaphors of joy. Upon arriving in Grahamstown's city centre, the as-yet-unidentified figure scales a memorial plinth where a statue, bearing a dedication to the 'Men of Albany' who perished in the Anglo-Boer War, rests. In this busy public square, the curious figure, elevated atop the plinth, begins to rupture the balloons.

Each burst balloon releases dye, the weight of which had burdened the wearer, sloshing to and fro on the long march, and which seeps into the stone like blood, staining this official marker of history.

The balloon creature's intervention, entitled *Performance Obscura*, finds its creator and enactor, performance artist Athi-Patra Ruga, confronting the deep schisms of public memory, national identity and history in postapartheid South Africa. *Performance Obscura* interrupts the everyday life of the city, confronting the authority and permanence of the monument, and replacing it with a very different kind of public practice – the ephemerality of the procession that draws from a long line of traditions, including the *toyi-toyi*, strike or funeral march, as well as the hybrid and festive Kaapse Klopse minstrel parade in Cape Town. *Performance Obscura* 'counter-penetrates' history – as Ruga has characterised many of his previous projects – in an attempt to mark the women and Xhosa people 'pushed out of history.'[1] However, Ruga's counter-penetration does not simply list the Xhosa dead in the history of British and Boer colonisation. Instead, he speaks through absence, visualising their pain, pointing to their perpetual erasure, and destabilising the authority of stone with tempera and water. *Performance Obscura* subsequently speaks through an unstable and polyvalent signifier – the balloons – whose ephemerality ironically undermines the authoritative power of the statue's historical register. Ruga's attack on the monument exposes how sovereign power constructs identity-based subject positions whose authority legitimates erasure and marginalisation in the construction of historical narratives.

Here Ruga simultaneously makes reference to the erasure of black histories in the Anglo-Boer War, but also, through the balloons, to the xenophobic violence in

Figure 14.1. Athi-Patra Ruga, *Performance Obscura*, 2012.
Courtesy the artist and WHATIFTHEWORLD.

postapartheid South Africa that undoes the metaphors of inclusivity projected by the rainbow nation. Ruga explains how the balloons come to represent the pain of these identity-based exclusions: 'Identity is a mind fuck. You're not white enough, you're not black enough, you're not gay enough. So when I wear the balloons, it brings me to tears because not only is it physically painful but I'm weighed down by identity. As the balloons pop, I'm deflating all of these constructed ideas and revealing the true person.'[2]

As Ruga's performances using the balloon figures grew in their collaborative nature, he began to understand the metaphoric capacity to empower the performer to tell their own narratives – a 'destruction of preconceptions [that] history, biology, heritage and birth impose on us.'[3] These creatures, whose gender and identity is concealed from the viewer until the balloons are popped – a physical and metaphorical rupture – take on a political dimension in Ruga's practice. He terms these characters 'avatars'; their genesis lies in his participation in the Johannesburg club scene of the early 2000s and in his interest in conceptual fashion. The avatar serves an apotropaic function by shielding the performer from trauma and is equally empowering: the avatar's malleability releases its performer from judgments based on the certainty of biology, race, gender, nationalism and citizenship. In the act of spilling the balloons' contents, the discharge of talcum, dye and confetti represents a deconstruction of language's force to fix meaning. Unclassifiable and uncontainable, the release, which makes reference to mythological shapeshifting as an example of the avatar's malleability, empowers the performer to both fashion their own history and propose alternative futures.[4]

Performance Obscura is one of several works, including performance, tapestry, sculpture, video, photography and stained glass, that comprise Ruga's 'saga,' *The Future White Women of Azania* (FWWoA, 2010–2016). At its core, *FWWoA* is an allegory of postapartheid nationalism where Ruga becomes an elder, a mythmaker or historian, whose job it is to tell the history of the non-dynastic line of queens who rule the lands of Azania. As the only male who lives with the Azanians, Ruga is held captive to witness and testify to the history of their exile. Drawing from references that stretch from precolonial Xhosa history to postapartheid South Africa, Ruga's saga is an example of philosopher Walter Benjamin's model of history as a constellation – where the past comes into visibility, as a monad, through its relationship to the present.[5] This history is not experienced as a linear progression, but rather as a 'shock' that interrupts progress and draws from the past as a code to guide revolutionary energy in the present.[6]

As a constellationary history, *FWWoA* constructs a memory-politic that draws attention to the elision of narratives of the past from South Africa's postapartheid identity, the histories of which enable a critique of the present. For example, Azania becomes an allegorical structure that both references the term as a place name signifying a dream of liberation during the anti-apartheid struggle, and marshals this concept to investigate its realisation in what literary scholar Anthony O'Brien terms a postapartheid 'normalization': a politics characterised by a surface of 'ballot box democracy, parliamentary representation, liberal capitalism, cultural pluralism and the Enlightenment discourse of rights.'[7]

The dialectical nature of Ruga's critique – attentive to the demands for justice for his ancestors and the need for radical transformation in the future – reveals Benjamin's work as a useful lens through which to examine Ruga's public engagement with the narratives of South African history. *FWWoA*'s critique is driven by a politics of redemption that aims to shatter the ideologies of what Ruga calls 'rainbowism'.[8] Similarly, Benjamin's philosophy of history resists notions of progress that conceal a lack of meaningful transformation.[9] Moreover, given Ruga's drag-inflected performances and his metaphoric references to the overlap between Holocaust memory and colonial/apartheid history in South Africa, the role judgment plays in the work of Benjamin (who died trying to escape the Nazis) and in Ruga's performance practice is vital. By emphasising the logic of judgment as a sovereign form of fixing and fating a subject to identity, the camp as an institution, whose repressive identity-based logics of exclusion and containment are central to *FWWoA*, also brings Benjamin and Ruga's political critiques into conversation.

Further, the employment of camp in Ruga's performances evokes Susan Sontag's explication of the term as a love of 'artifice and exaggeration' that 'overstrains' judgment.[10] The suspension of judgment that the use of camp engenders in Ruga's performative critique of identity-based exclusions in South Africa's history recalls Benjamin's work on judgment, in which he postulates the coming potential of a 'divine violence' that suspends the law-making/preserving functions of sovereignty for the 'not-yet-attained condition of the just man.'[11] As with Benjamin's messianic narrative of law, which attempts to upend the authority of legal exclusions, Ruga turns towards Xhosa messianism to represent the violence of identity in South Africa's colonial, apartheid past, but equally so, to make a pledge for the liberation of future generations.

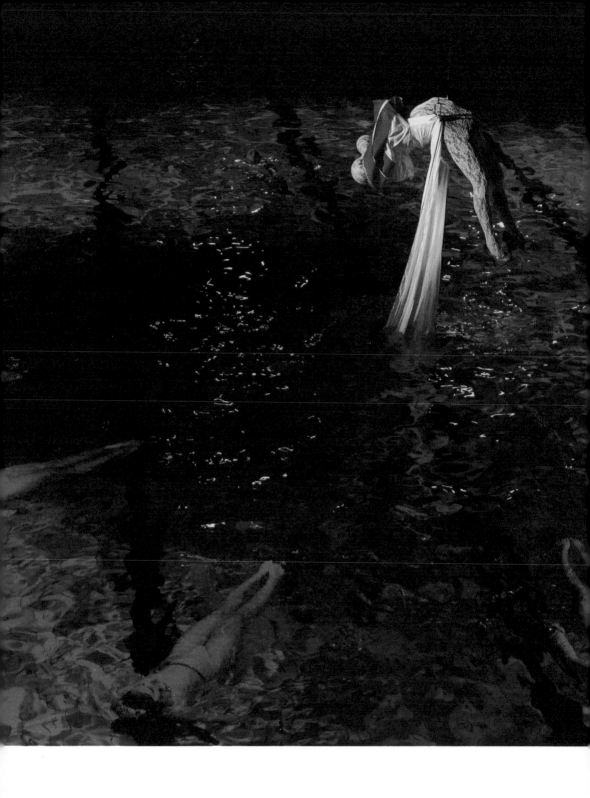

Figure 14.2. Athi-Patra Ruga, *Ilulwane*, 2012.
Courtesy Institute for Creative Arts.
Photograph by Ashley Walters.

Azania's allegorical capacity derives from its status as a symbol of a liberated South Africa during the anti-apartheid struggle. However, the term has a specific history that complicates such dreams. The place name 'Azania' first appears in *The Periplus of the Erythraean Sea* (40 AD) to refer to the lands of southern and eastern Africa. By designating the lands of Africa as 'Azania,' Ruga understands the label as one example in a long history of constructing Africa as uninhabited until European colonial contact.[12] By the 1970s, Azania had taken on new signification, having been appropriated by both the Pan-Africanist Congress of Azania (PAC) and the Black Consciousness Movement to represent the dream of black rule in southern Africa.[13] As David Dube wrote in 1983:

> Azania is the name that is used by a broad section of African revolutionaries and progressive forces who support the Azanian Revolution and are working for the overthrow of racist South Africa. Azania means a black man's country. 'South Africa' on the contrary is the name that was given by white settlers to the southern tip of Africa to consolidate their political, economic and military oppression and suppression of the indigenous black population.[14]

Subsequently, Azania's history is a paradoxical one, encapsulating the continent as permanently emplaced in a primitive state of development, as Ruga sees the term via *The Periplus*, and as the object of a utopian dream which was meant to have been realised in South Africa's 1994 multiracial elections.

By using Azania as the framework for a critical history of South Africa, *FWWoA* reveals the silencing of black voices that extends back to the first moments of colonial contact, while also addressing the impossible and unrealised ideologies of forgiveness, reconciliation and redemption practised in a postapartheid South African Azania. As Ruga explains, Azania becomes a problematic dream in the postapartheid reality: '[My] generation was spoon-fed the rainbow nation and now we're disillusioned.'[15] Ruga's commentary on disillusionment references a vast number of complex social problems difficult to appropriately assess in the context of this chapter. However, my understanding of the problems of the rainbow nation ideology draws from both O'Brien's description of a liberal postapartheid 'normalization' and Grant Farred's description of contemporary South Africa as having a 'historical but not material

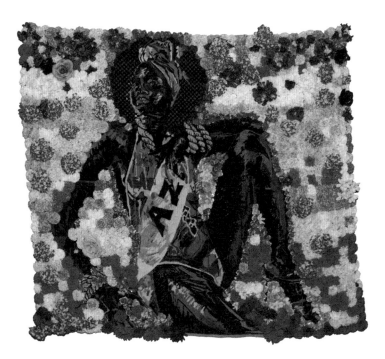

Figure 14.3. Athi-Patra Ruga, *Uzuko*, 2013.
Courtesy the artist and WHATIFTHEWORLD.

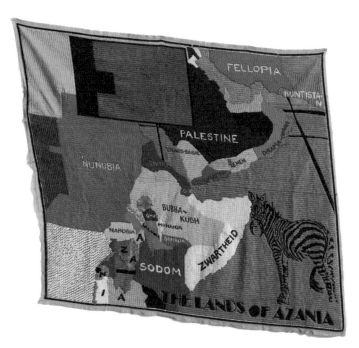

Figure 14.4. Athi-Patra Ruga, *The Lands of Azania (2014–2094)*, 2013.
Courtesy the artist and WHATIFTHEWORLD.

difference' to the apartheid regime.[16] Farred, like Ruga, writes with the desire to locate a 'not-yet counterpartisan' whose coming presence will prove capable of challenging the sovereignty of South Africa's present political structure.[17]

For Ruga, whose practice faces the ruination of the Azanian dream whereby the historical triumphs of apartheid's end give way to the material urgencies of the present, the *FWWoA* saga chronicles the struggles of the non-dynastic line of queens who inherit the mantle of the Versatile Queen Ivy. Noticeable by her bright-green coiffure (bearing some resemblance to pop singers Rihanna and Beyoncé) and the sabre-toothed zebra she uses to traverse Azania, the Versatile Queen Ivy exposes Ruga's long-standing interest in pop culture. Throughout *FWWoA*, Ruga develops the signifiers of an Azanian national identity: national seal, crest, flower, Constitution and even its beauty queen in *Uzuko*, a petit point and silk flower tapestry of Miss Azania, one of the central symbols of 'any self-respecting nation.'[18] Born from the campy sensibility of the pageant as a hyperbolic performance of national identity, *Uzuko* renders the beauty queen an object of national identity, just as Frédéric Auguste Bartholdi and Gustave Eiffel's *Statue of Liberty* (1886) or Eugène Delacroix's *Liberty Leading the People* (1822) map patriotism on women's bodies. More severely, women's bodies are represented as a site of conflict and violence in narratives of civic fundament, as in Jacques-Louis David's *Intervention of the Sabine Women* (1799).[19] Ruga's service to the Azanians as a chronicler in some ways repeats this narrative, and yet, concerned with the ways in which the queens are depicted as passive, Ruga depicts himself as decapitated during the Azanians' journey into exile; a move that evokes the power and agency demonstrated by Judith and Salome in the biblical narrative, a tale of Judeo-Christian history.

The symbols of the Azanian Kingdom must lay claim to a territory. Ruga gives form to the homelands from which the Azanians were forced in *The Lands of Azania (2014–2094)*. This tapestry map depicts Azania as it is represented in Marvel's *Black Panther* comic-book reworking of eastern Africa, which serves as a setting for the comic's allegory of apartheid South Africa.[20] *The Lands of Azania* also includes insets of the national animal, a sabre-toothed zebra, and the Azanian flag, appropriated from the comic book's iconography. Ruga reworks the map, giving several countries new names, comically exposing how language's discursive force frames nationalist ideology. For instance, the renaming of Ethiopia as 'Bubba-Kush,' for Ruga's preferred strain of marijuana, suggests Ethiopia as a Rastafarian Zion, and

Egypt becomes Ńunubia, emphasising the country as essentialised in the narrative of Ancient Egypt that is popular throughout the black diaspora.[21]

Throughout the geography of Azania, Ruga further explores the overlaps of exile and diaspora in the African and Jewish communities. The Pan-Africanism of Ńunubia and Bubba-Kush in their Garveyite aspirations for return, and the Rastafarian use of metaphors of Zion and Babylon as signifiers for exile, equally suggest a Jewish narrative of displacement, the nationalist discourse of which becomes complicated by the reference to Palestine that Ruga stitches into the map.[22] Entwining these two histories repeatedly in *FWWoA*, Ruga reveals the miscibility of metaphor, which equally suggests the necessity of overcoming the exclusionary and often-violent frameworks of nationalism. The comparisons between Jewish Zionism and the Azanian return to South Africa, metaphorically played at in *Black Panther* and the *Lands of Azania*, surface in Ruga's photograph *Night of the Long Knives I*. He takes the title from the wave of assassinations in the summer of 1934 which helped Hitler consolidate power in Germany, and which was later repurposed as part of a paranoid fantasy among conservative white South Africans that a wave of violent and murderous retributive acts for apartheid would follow Nelson Mandela's death.[23] Ruga's photograph hardly depicts an image of violent retribution. Instead, employing a backdrop akin to a junior-school class photo, Ruga situates another ballooned figure atop a sabre-toothed zebra surrounded by plastic plants. On the right side of the scene, he displays the completely 'unbotanical' Azanian national flower: a pile of hats 'plonked together.'[24] The artificiality of the image underscores the constructions that undergird the essentialisms of metaphor, but it also exposes how nationalism refashions the natural to project a sense of control.

South Africa's national flower, the protea, contains many of the same paradoxes of nationalism explored in *FWWoA*. Adored for its diversity of species and its specificity to South Africa – 92 per cent of species are located in the Cape Floristic Region – it features in the national crest as a symbol of the beauty of the land and is the emblem of the national cricket team. The flower's name derives from the Greek god Proteus, known for his ability to shapeshift and foretell the future – a paradox of both being able to see what is to come and using his adaptability to escape the demands of prophecy – calling to mind the shapeshifting nature of the avatar. Turned towards South African nationalism, the avatar ironically comes to

symbolise a singular and distilled image of the nation. Likewise, the references to shapeshifting as a means of escaping the need to tell the truth could metaphorically suggest the complexities of truth-telling in the Truth and Reconciliation Commission and the 'normalization' of postapartheid democracy that eclipsed the need for material redress after 1994.

As a flower, the protea embodies a narrative of distillation via white nationalism in South Africa, as landscape architect Jeremy Foster describes. Botanical research during the 1920s and 1930s, exemplified in the designation of the Cape Floristic Region, binds the terrain of South Africa to 'European-imperial science and culture,' Foster explains.[25] The mythologies of South African national identity are further explored in Ruga's tapestry *Invitation... Presentation... Induction....* The work features balloon-clad figures in battle with three individuals dressed in loincloths with an Azanian flag motif, and clutching spears and cowhide shields (traditionally associated with Xhosa and Zulu peoples). Victim and aggressor are ambivalent in the image, undermining the 'us versus them' narrative so redolent in the Voortrekker Monument frieze, given the tapestry's visual similarity to the Battle of Blood River panel of the frieze.[26] Constructed during the 1938 centenary of the Great Trek and the foundation of the Boer Republics, the Voortrekker Monument signified the struggles and dominion of Afrikaner nationalism in South Africa. Annie Coombes describes the memorial as establishing 'the emergence of the Afrikaner as the founding ethnic group of a new nation, "the white tribe," and the "divine right" of the Trekkers to the land.'[27] Coombes continues, describing the Great Trek re-enactments which reached their terminus on the grounds of the Monument as 'a calculated attempt to invent a coherent Afrikaner identity where none actually existed, borrowing the language of theatre so successfully deployed by the National Socialists in Germany and epitomized by the Nazi rallies at the Nuremburg stadium.'[28]

The Memorial (as well as the performance and re-enactment processions) codified Afrikaner national identity, just as Ruga draws from the hybridity of the Klopse or the dissent of the *toyi-toyi* to codify Azanian national identity. But like *Performance Obscura*'s spillage of dye, Ruga's practice suggests a destabilising of meaning that is anathema to the rigid geometries of the Voortrekker Monument. Coombes's analogy, amplified by Ruga's reference in *Night of the Long Knives*, reveals a reworking of metaphor that reconsiders the domains of nationalism in National Socialist and apartheid contexts.

Returning to *Lands of Azania*, read through the historical and narratological connections between apartheid and Nazism, Michael Rothberg's concept of 'multidirectional memory' – which 'thinks of the public sphere as a malleable discursive space in which groups do not simply articulate established positions but actually come into being through their dialogical interactions with others' – provides valuable insight into the ethics of comparative history.[29] Rothberg argues that the interrelationship between exilic peoples, in particular the Jewish and African diasporas suggested in *The Lands of Azania*, gains strength from 'negotiation, cross-referencing and borrowing.'[30] Memory comes into visibility through continued interaction and transfers, which resist an exclusive and competitive framework that asserts the primacy of one's own suffering.[31] Instead, through multidirectional memory, the articulation of cultural trauma draws strength from and supports the history of the other's narrative.

Paul Gilroy makes similar claims in *The Black Atlantic*. At a methodological level, he notes the significance that Jewish thinkers (including Benjamin) gave to themes of 'suffering, tradition, temporality, and social organization of memory' – themes equally vital to narratives of slavery and to articulating anti-racist thought. This common ground, Gilroy argues, should serve as a warning against ideologies of the Holocaust's historical singularity and Israeli nationalism, or a romanticised 'Nubianism' of the pharaohs that renders silent 'those they held in bondage.'[32] Taken together, multidirectionality – drawing attention to the overlaps in historical memory in *FWWoA* – undermines the exclusivity of national identity and posits exile as a new framework of solidarity; one that pushes beyond the national exclusivity depicted in *Lands of Azania*.

Exile as a shared history figures as a central theme in *FWWoA*. Ruga further references Jewish exile in *A Land without a People ... for a People without a Land*, which repurposes an adage derived from nineteenth-century Christian writers that has come to symbolise Jewish Zionist aspirations to return to the lands of Palestine.[33] In this narrative, which inevitably and asynchronously foretells the violence following the 1947 Partition of Palestine (and to further the sharing of metaphors, the Israeli occupation is often referred to as 'apartheid'), Ruga depicts the Azanian routes of return – what he refers to as 'processions' – with swirling arabesque arrows in a seeming inversion of the spread of diaspora. This return, Ruga continues, 'could lead to conflict.'[34]

Returning to the Holocaust metaphors that Ruga advances in *Night of the Long Knives*, these images of conflicts often result in the construction of the camp as a biopolitical tool to manage those who fall outside of the 'right to have rights' in a given nation-state.[35] The camp, as represented throughout South Africa's history, reveals South Africa's connections to the 'concentrationary' forms of exclusion central to modern nation-states.[36] It calls to mind, for instance, the concentration camps of the Anglo-Boer Wars, temporary refugee camps that were constructed in the wake of the 2008 xenophobic attacks in South Africa, and proposed detention camps at South Africa's border similar to those used in the United States of America and Australia. While anti-immigrant hostility may have occasioned Ruga to proclaim the 'shatter[ing]' of the African dream, the most explicit example of the concentrationary in *FWWoA* is the Bantustan.[37]

Born and raised in the Republic of the Transkei, one of two Xhosa homelands established by the apartheid government to isolate black South Africans in semi-autonomous nation-states, Ruga became a daily border crosser, unable to remain in South Africa but permitted to attend school there.[38] The Bantustan becomes a clear example of the camp, a geography of emplacement and exile simultaneously, classifying and segregating people according to ethnic distinctions and removing them from the political and legal frameworks of South Africa. While the Bantustan signifies exclusion and the denial of citizenship within South Africa, Ruga describes growing up in Umtata as anything but exclusive: 'Greek and Portuguese immigrants from their various post-WWII fascist regimes; there were black exiles who came from the republic into the Bantustan and as a result there was a sense of globalism that has touched every work that I have made. However, this dispossession becomes a need, a sense of both belonging and not belonging.'[39]

The camp demonstrates a literal state of exception, placing people, as in the case of the Transkei Xhosas, in a defined spatial enclosure to justify restrictions on movement and the denial of voting rights. However, as mentioned at the start of this chapter, Ruga's practice also evokes a different meaning of camp that engages with fashion, popular culture and decorative production which inform the 'illusive sensibility' Sontag associates with the term.[40] Camp, in Sontag's understanding, remains exogenous to the natural world – à la *Night of the Long Knives'* plastic garden – exposing a world where things are not what they seem; instead they yield individuated, flamboyant and polyvalent interpretive understandings.[41]

Importantly, Sontag's theorisation of camp, which can suspend the certitude of judgment, becomes a method of arresting the 'normalization' of political life in South Africa through *Performance Obscura*'s intervention. Suspending judgment, camp's practice upends the fated determinism that judgment pronounces,[42] be it in the authority of a pass book, or the identity-based judgments of 'black enough' or 'queer enough.' This desire to upend judgment, theorised through 'divine violence,' strikes to the core of Benjamin's work, as Alison Ross has argued. Benjamin consistently constructs moves outside of the universalising frameworks of judgment as fate – marshalled through semblance, understood here in the pronouncements of race or nationalism examined in *FWWoA* – which renders life as impotent (mere-life).[43]

Subsequently, when Benjamin explains divine violence in an image of messianic redemption, it challenges the mythic forms of ideology that sovereign rule creates, and instead marshals 'pure power over all life for the sake of the living.'[44] Violence as an interruption of judgment in *Performance Obscura* reveals a belief in the rainbow nation destroyed in the 'anti-woman' and 'anti-African xenophobic attacks.'[45] And so we can read the catharsis of the popped balloons as a kind of response, a destruction, that seeks to overcome these traumas.[46] Ruga's interruption, read through Benjamin, ruptures the framework of the present, but does so without determining what its outcomes may be. Instead it calls attention to the necessity of transformation, succinctly explained by Ruga's description of *FWWoA* as 'unleash[ing]' a 'madness' that exposes the 'human condition ... especially the lack of our dreams and wants.'[47]

THE ANGEL OF HISTORY

The dream, which signifies the need for radical transformation that attends to the material needs of South Africans, provides the very code for liberation. As Benjamin argues:

> In the dream in which each epoch entertains images of its successor, the latter appears wedded to elements of primal history – that is, to elements of a classless society. And the experiences of such a society – as stored in the unconscious of the collective – engender, through interpenetration with what is new, the utopia that has left its trace in a thousand configurations of life, from enduring edifices to passing fashions.[48]

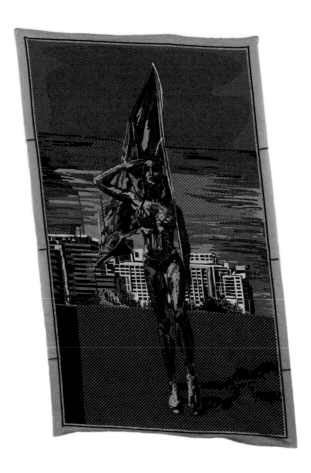

Figure 14.5. Athi-Patra Ruga, *Touched by an Angel*, 2012.
Courtesy the artist and WHATIFTHEWORLD.

Benjamin's dream image poses a complex relationship between present and past, where primitive forms of classless society provide the blueprint for a liberation that is remade through the mediations of the technological and material conditions of the present. Accordingly, Benjamin's work understands the interpretation of history as a dialectic that both remembers the past and works towards its redemption. The task of interpreting it creates a real 'state of emergency' that stops the linear progression of time represented in the postapartheid 'normalization' O'Brien critiques.[49] Exemplifying this radical practice of interpreting history, Ruga

turns back to the anti-colonial resistance of the Xhosa Cattle Killing of 1857 to attend to the 'not-yet' demands for justice.

My comparison of Ruga and Benjamin acknowledges the role of divine violence, underscored by the importance of messianism, in advancing a radical project of history in their work. The blueprints Benjamin considers, and which Ruga finds in the history of the Cattle Killing and other forms of precolonial traditions, reflect the struggles of Benjamin's famed metaphor of the 'angel of history,' who floats as a moth, attempting to repair the wreckage of the past, and yet is prevented from doing so as it is forcibly hurtled forward by the violence of progress.[50] The angel, like the critical historian, or in Ruga's case the artist as avatar, must unite these codes of the past in the present. Their enjoinment does not provide a utopia, but it potentiates a radical change, what Benjamin explains as opening the 'small gateway in time through which the Messiah might enter.'[51]

Ruga gives us a different angel of history bound to the traditions of the past and yet gazing towards a future-to-come in *Touched by an Angel*. Here Ruga depicts a sangoma standing on the beach, again as a Rihanna-esque bad girl dressed in a bikini, clutching the Azanian flag in one hand, the other raised in a military salute. Her gaze towards the horizon, Ruga explains, is over an ocean, signifying her power to make a future. And yet, by understanding the functions of the sangoma, whose task of interpretation sifts through the refuse of the past, she draws from history to liberate the future.

Ruga's sangoma is a hybrid – at once traditional and contemporary. She makes reference to *Touched by an Angel*, a mid-1990s American television programme starring Della Reese, in which angels sent by God guide human beings through crossroads in their lives. Ruga interprets Reese's character as a sangoma, also called a 'white woman' in reference to *umcako* – a paste made from white lime that a sangoma applies to their face in an act of purification. (Ruga often fills balloons in *FWWoA* with white talcum or chalk, furthering the metaphor.) Sangomas aid individuals in understanding their relationship to the past, to their ancestors, but also contextualise these ancestral histories in relation to the future. The sangoma, steeped in a practice rooted in the precolonial history of the Xhosa people, finds herself in *Touched by an Angel* gazing out towards the ocean as a future horizon. This gaze suggests the anti-colonial prophesies of Nongqawuse whose narrative of messianic fulfilment – a central theme in Ruga's *Queens in Exile* – came from the sea. Nongqawuse's story

signifies yet another moment in South African history, and in Ruga's practice in particular, where the past is continually made anew in the present.

In 1857, responding to an outbreak of lung sickness and displacement from ancestral lands by the British after the Eighth Frontier War of 1850–1853, Nongqawuse prophesised that the ancestors would rise from the dead, bringing with them new and healthy cattle, if the Xhosa spoiled their grain and killed their herds. Many of their cattle were sick, making them appear impure. Rather than fostering a new formation, as in the 'new' South Africa, Nongqawuse's prophecies advocated starting over again. As the dead were to return, present and past were to be united, as in Benjamin's reading of the past as a dream-image for redemption in the present. This is reflected in Xhosa cultural understandings of newness. Newness, JB Peires argues in his authoritative history of the Xhosa Cattle Killing, is a cyclical recurrence.[52] Earlier, Bonnie B. Keller argued that the aim of the cattle killings was to make 'a more promising future [that] may take certain values from the past but will not completely duplicate it.'[53] And more recently, in a study of the afterlives of Nongqawuse's prophecies, Jennifer Wenzel compares this history to Benjamin's messianism, where the philosopher's work 'is instructive both for its sense of the *historical* potential of unrealized hopes in the past and for its relevance to the idea of afterlives as an *interpretive* practice.'[54] Nongqawuse's prophecies were 'not merely anticolonial but also *acolonial* – impossibly, simultaneously, pre- and postcolonial.'[55]

In *Queens in Exile*, Ruga turns his attention more explicitly to the narrative of Nongqawuse. For instance, *The Pledge/Young Queen* features a group of children dressed in grey jumpers and white dress shirts – school uniforms – all with arms crossed in a gesture that appears to carry deep sadness and disappointment, and yet in its universal expression, also suggests collective protest. Beneath these children is a sea of churning waves, suggestive of the water from which the dead would arise in Nongqawuse's prophecies. Above the children we see Ruga wearing a headdress of bones, reprising a role as Versatile Queen Ivy, and perhaps a sangoma. *The Pledge* bears witness to the violence of education, including instruction in English for an isiBhaca speaker, accompanied by the message of Christianity and the militarised role of rugby and cadets in Ruga's schooling. Given Ruga's emphasis on Nongqawuse within the narrative of *Queens in Exile*, the colonialist discourses of education evoke the British aims of Xhosa submission, culturally and territorially, during the Frontier

Wars. The piece also becomes a prophecy orientated towards the future: Ruga sees the tapestry as a pledge to his nieces and nephews for a liberation to come.[56] In this way, *The Pledge* also comes to address the histories of the Soweto Uprising and the Black Consciousness Movement, and moves to the recent demands for decolonial education by the Fees Must Fall and Rhodes Must Fall movements. *The Pledge* reveals a history whereby 'the whole horizon of the past ... come[s] together in the constellation of a single moment.'[57] By uniting the horizon of the past with the material demands of the present, Ruga steadfastly refutes a post-apartheid liberalisation; the utopic rainbow nation becomes a literal *no-place*.

Instead of the utopia of Thomas More's island, a terrain that also features in the Azanians' saga of exile, *FWWoA* becomes a continually unfolding event; at once visually complex in its message, and in its public interventions, communicating in a universal language. The public witnessing of *Performance Obscura* makes meaning of the event just as much as my work as a critic does. As Ruga's work creates a rupture whereby present and past are united in an urgency to reframe the now, his seemingly joyous and brightly coloured intervention returns to Benjamin's description of the messianic as a 'festival purified of all celebration.'[58] In Ruga's work, that festivity is manifest in the avatar's dual responsibility as mythmaker and carrier of history, and as in *The Pledge*, holding a solemn vow to liberate the future. The seductive beauty of *Performance Obscura*, as with all of Ruga's works, subsequently gives us a critical history, steadfastly refusing to leave South Africa's past as forgotten in the ideologies of progress that define its present condition.

1. Athi-Patra Ruga, 'Queens in Exile,' YouTube video, 1:08:28, from a public lecture given at the Michigan Theatre, University of Michigan Ann Arbor, 10 November 2016, accessed 8 September 2017, https://stamps.umich.edu/stamps/detail/athi_patra_ruga.

2. Helen Jennings, 'Athi-Patra Ruga's Displaced Characters and Unsettling Narratives Mark Him Apart in South Africa's Art Scene,' Nataal Gallery Talks, accessed 5 November 2017, http://nataal.com/athi-patra-ruga/.

3. Cathy Byrd, 'Athi-Patra Ruga on Global Human Rights,' 10:36, from an interview for Fresh Art International, 24 March 2016, accessed 15 July 2017, http://www.freshartinternational.com/2016/03/24/fresh-talk-athi-patra-ruga/.

4. Ruga, 'Queens in Exile.'

5. Walter Benjamin, 'On the Concept of History,' in *Walter Benjamin: Selected Writings, Vol. 4*, eds. Howard Eiland and Michael W. Jennings, trans. Harry Zohn (Cambridge: Belknap Press, 2003).

6. Walter Benjamin, 'On the Concept of History,' 396.

7. Anthony O'Brien, *Against Normalization: Writing Radical Democracy in South Africa* (Durham: Duke University Press, 2001), 3.

8. 'Over the Rainbow: in Conversation with Athi-Patra Ruga,' *ART AFRICA*, 1 December 2016, accessed 8 September 2017, https://artafricamagazine.org/over-the-rainbow-in-conversation-with-athi-patra-ruga/.

9. Benjamin, 'On the Concept of History,' 390, 392.

10. Susan Sontag, *Against Interpretation and Other Essays* (New York: Delta Books, 1966), 287.

11. Walter Benjamin, 'Critique of Violence,' in *Walter Benjamin: Selected Writings, Vol. 1*, eds. Marcus Bullock and Michael W. Jennings, trans. Edmund Jephcott (Cambridge: Belknap Press, 1996), 250–251.

12. Ruga discusses *The Periplus* in Catherine Annie Hollingsworth, 'Athi-Patra Ruga with Catherine Annie Hollingsworth,' *The Miami Rail*, 21 June 2016, accessed 1 September 2017, http://miamirail.org/performing-arts/athi-patra-ruga-with-catherine-annie-hollingsworth/. Most scholars, including Wilfred H. Schoff, who translated *The Periplus* into English, believe the author of the text to be unknown.

13. Black Consciousness was a broad anti-apartheid movement formed in 1969, which drew from Fanonian anti-colonialism, the US Civil Rights Movement and anti-capitalist revolutionary discourse. The Pan-Africanist Congress of Azania is a political party, founded in 1959, notable for having organised protests against pass laws during apartheid.

14. David Dube, 'Introducing Miss Azania,' in *The Rise of Azania: The Fall of South Africa*, ed. David Dube (Lusaka: Daystar, 1983), 3.

15. Jennings, 'Athi-Patra Ruga's Displaced Characters.' While Ruga speaks here of Azania as a signifier of a dream that has turned into 'disillusion[ment],' the Rhodes Must Fall movement reappropriated the term in its struggle for free decolonial education. In 2016, Rhodes Must Fall activists occupied the University of Cape Town's Avenue Hall, which they renamed 'Azania House' and made a centre for decolonial education. See Carlo Petersen, 'Rhodes Must Fall Occupy "Azania House,"' *Cape Times*, 17 January 2016, accessed 10 November 2017, https://www.iol.co.za/capetimes/news/rhodes-must-fall-occupy-azania-house-1972170.

16. Grant Farred, 'The Not-Yet Counterpartisan,' *South Atlantic Quarterly* 103, no. 4 (2004): 595, accessed 6 October 2017, doi: 10.1215/00382876-103-4-589.

17. Farred, 'The Not-Yet Counterpartisan,' 595.

18. Ruga, 'Queens in Exile.'

19. Ruga, 'Queens in Exile.' Ranjana Khanna gives a detailed reading of the complexities of women's bodies as both necessary and excluded from the framework of hospitality, in part, through the story of the Sabine. See Ranjana Khanna, 'Asylum,' *Texas International Law Journal* 41, no. 3 (2006): 471–490.

20. Mary Corrigall, 'Unpicking the Azanian Seam,' in *Athi-Patra Ruga - The Future White Women of Azania* (Cape Town: WHATIFTHEWORLD, 2014), 93.

21. Byrd, 'Athi-Patra Ruga on Global Human Rights.' Ruga further confirms the Azania/Zion analogy here.

22. Marcus Garvey is well known as a Pan-Africanist who advocated a back-to-Africa approach to dealing with race relations in the United States and Jamaica. Garvey is venerated as a prophet in the Rastafarian movement. On apartheid and Israel, see *Apartheid Israel: The Politics of an Analogy*, eds. Jon Soske and Sean Jacobs (Chicago: Haymarket Books, 2015).

23. David Smith, 'Anxious and Conflicted: Afrikaners Await a Post-Mandela World,' *The Guardian*, 7 December 2013, accessed 12 November 2017, https://www.theguardian.com/world/2013/dec/07/afrikaners-nelson-mandela-south-africa.

24. Ruga, 'Queens in Exile.'

25. Jeremy Foster, *Washed with Sun: Landscape and the Making of White South Africa* (Pittsburgh: University of Pittsburgh Press, 2008), 61–62.

26. The Battle of Blood River was a battle between Boer Voortrekkers and Zulu warriors on the banks of the Ncome River that took place in 1838. The Voortekkers defended their encampment against the Zulu armies in a circled wagon (laager formation), which is a motif referenced in the Voortrekker Memorial.

27. Annie Coombes, *History after Apartheid: Visual Culture and Public Memory in a Democratic South Africa* (Durham: Duke University Press, 2003), 28.

28. Coombes, *History after Apartheid*, 26.

29. Michael Rothberg, *Multidirectional Memory: Remembering the Holocaust in the Age of Decolonization* (Stanford: Stanford University Press, 2009), 4–6.

30. Rothberg, *Multidirectional Memory*, 3–5.

31. Rothberg, *Multidirectional Memory*, 11.

32. Paul Gilroy, *The Black Atlantic: Modernity and Double Consciousness* (Cambridge: Harvard University Press, 1993), 196, 205–215.

33. Diana Muir, "'A Land without a People for a People without a Land,'" *Middle East Quarterly* 15, no. 2 (2008): 55–62, accessed 8 July 2016, https://www.meforum.org/articles/2008/a-land-without-a-people-for-a-people-without-a-lan.

34. Athi-Patra Ruga, e-mail message to the author, 9 June 2017.

35. Hannah Arendt, *The Origins of Totalitarianism* (San Diego: Harcourt, 1968), 296–297.

36. My reading here is influenced by Griselda Pollock and Max Silverman's understanding of the camp as part of a 'concentrationary' universe where the camp's repressive structure exemplifies a system of domination that denies political representation and citizenship. Griselda Pollock and Max Silverman, 'The Politics of Memory: From Concentrationary Memory to Concentrationary Memories,' in *Concentrationary Memories: Totalitarian Terror and Cultural Resistance*, eds. Griselda Pollock and Max Silverman (London: I.B. Taurus, 2014), 2–3. On the temporary camps in 2008, see Morgan Windsor, 'South Africa Xenophobia 2015: Last Camp for Displaced Foreigners to Close,' *International Business Times*, 30 June 2015, accessed 15 July 2017, http://www.ibtimes.com/south-africa-xenophobia-2015-last-refugee-camp-displaced-foreigners-close-1989724 and Cecilia W. Dugger, 'South Africa Plans Shelters for Foreigners Who Fled Attacks,' *New York Times*, 30 May 2008, accessed 15 July 2017, http://www.nytimes.com/2008/05/30/world/africa/30safrica.html.

37. Athi-Patra Ruga, interview with the author, 11 June 2014.

38. Jennings, 'Athi-Patra Ruga's Displaced Characters.'

39. Athi-Patra Ruga, 'The Exile According to the Elder,' artist statement (Tiroche DeLeon Collection, 2014), accessed 13 April 2018, http://www.tirochedeleon.com/item/729458.

40. Sontag, *Against Interpretation*, 276, 278.

41. Sontag, *Against Interpretation*, 280.

42. Walter Benjamin, 'Fate and Character,' in *Walter Benjamin: Selected Writings, Vol. 1*, eds. Marcus Bullock and Michael W. Jennings, trans. Edmund Jephcott (Cambridge: Belknap Press, 1996), 204.

43. Alison Ross, 'The Distinction between Mythic and Divine Violence: Walter Benjamin's "Critique of Violence" from the Perspective of "Goethe's *Elective Affinities*,"' *New German Critique* 121, 41, no.1 (2014): 118–120, accessed 19 May 2017, doi: 10.1215/0094033X-2398642.

44. Benjamin, 'Critique of Violence,' 250.

45. Athi-Patra Ruga, *A Young Retrospective*, artist statement (US Woordfees Festival, Stellenbosch University Galleries, Stellenbosch, March 2017).

46. Walter Benjamin, 'The Destructive Character,' *Walter Benjamin: Selected Writings, Vol. 2, pt. 2*, eds. Michael W. Jennings, Howard Eiland, et al. trans. Edmund Jephcott (Cambridge: Belknap Press, 1999), 542.

47. Ruga, *A Young Retrospective*.

48. Walter Benjamin, *The Arcades Project*, trans. Howard Eiland and Kevin McLaughlin (Cambridge: Belknap Press, 1999), 4–5.

49. Benjamin, 'On the Concept of History,' 392.

50. Benjamin, 'On the Concept of History,' 392.

51. Benjamin, 'On the Concept of History,' 390, 397.

52. J.B. Peires, *The Dead Will Arise* (Bloomington: Indiana University Press, 1989), 130–131.

53. Bonnie B. Keller, 'Millenarianism and Resistance: The Xhosa Cattle Killing,' *Journal of Asia and African Studies* 13, no. 1 (1978): 96.

54. Jennifer Wenzel, *Bulletproof: Afterlives of Anticolonial Prophecy in South Africa and Beyond* (Chicago: University of Chicago Press, 2009), 27.

55. Wenzel, *Bulletproof*, 2–3.

56. Athi-Patra Ruga, e-mail message to the author, 26 September 2017.

57. Benjamin, 'On the Concept of History,' 403.

58. Walter Benjamin, 'Paralipomena to "On the Concept of History,"' in *Walter Benjamin: Selected Writings, Vol. 4*, eds. Howard Eiland and Michael W. Jennings, trans. Edmund Jephcott and Howard Eiland (Cambridge: Belknap Press 2003), 405.

Performance in Biopolitical Collectivism: A Study of Gugulective and iQhiya

MASSA LEMU

In the street performance *Indaba ludabi*, members of the collective Gugulective handed out leaflets containing political messages to passersby.[1] In *Siphi?*, Gugulective stormed the opening of their exhibition in balaclavas, simulating the hijacking of their own art. In *Portrait*, members of the black women's network iQhiya stood motionless on Coca-Cola bottles. In another durational performance *Commute*, iQhiya held a party in a minibus taxi at the Iziko South African National Gallery and, in a later iteration, in the parking lot of the University of Cape Town's Hiddingh Campus. In these diverse performances, black bodies insert themselves into exclusionary spaces and reclaim these spaces that render them invisible. Their bodies enact a decolonial politics of self-assertion in contested spaces. I call this subject-centred, collaborative practice 'biopolitical collectivism.' Biopolitical collectivism is socially engaged participatory art practice that generates subjectivities. While traditional art practices centralise the art object, such as a painting, photograph, video or installation, as the end point of the artistic process and as the locus of aesthetic meaning-making, biopolitical collectivism concerns the production of subjectivities.

Michel Foucault's concept of biopolitics, particularly as it pertains to the work of Achille Mbembe, Maurizio Lazzarato and Antonio Negri, illuminates the ontology and epistemology of biopolitical collectivism. Biopolitics also sheds light on the figure of the postcolonial subject in global capitalism, which is central to contemporary artistic production in Africa. Contrary to the dominant, essentialist art historical discourses that have sought to tie current African cultural practices

to a collectivist past, biopolitical collectivism seeks solutions to contemporary problems inside of contemporary aesthetics. Here, I use the framework of biopolitical collectivism to demonstrate how the works of two South African collectives, Gugulective and the younger iQhiya, deploy a subject-centred, performative art practice that resists the capitalist, racist, and sexist colonisation and subjugation of black bodies.[2] The collectives engage a decolonial aesthetic shaped by their lived contemporary South African experience.

Gugulective, a collective originating from the townships of Gugulethu and Langa on the outskirts of Cape Town, is comprised of Athi Mongezeleli Joja, Zipho Dayile, Lonwabo Kilani, Dathini Mzayiya, Khanyisile Mbongwa, Kemang Wa Lehulere, Themba Tsotsi, Loyiso Qanya, Ayanda Kilimane and the late Unathi Sigenu. Gugulective launched their activist art from a Gugulethu shebeen in 2006. The shebeen, a drinking house traditionally located in black townships and prohibited during apartheid, was a historically and politically significant space for socialisation, as well as for the contestation of class and race in the new South Africa.[3] From the shebeen, Gugulective moved onto the street in *Indaba ludabi* and into the gallery in *Siphi?*, discussed in detail below.

iQhiya takes its name from *iqhiya*, an isiXhosa word for head wrap, commonly worn by African women. Also known as a *doek* or *duku*, the *iqhiya* was adopted by the collective as a symbol of black female strength. The network, as the group describes itself, is made up of 11 black female artists: Asemahle Ntlonti, Bronwyn Katz, Buhlebezwe Siwani, Bonolo Kavula, Charity Matlhogonolo Kelapile, Lungiswa Gqunta, Sethembile Msezane, Sisipho Ngodwana, Thandiwe Msebenzi, Thuli Gamedze and the late Pinky Mayeng. In *Commute* and *Commute 2*, two of their earliest works, iQhiya used the taxi – one of the main modes of transportation between the township and the city in South Africa – to interrogate the visibility and self-determination of black women, as well as to explore a fluid, collaborative artistic practice in which the members' place of meeting and art-making, like the taxi, is mobile and 'never fixed.'[4] For both iQhiya and Gugulective, performance is a crucial articulation of their biopolitical practice.

WHAT IS BIOPOLITICAL COLLECTIVISM?

By employing the term 'biopolitical collectivism,' I seek to highlight aspects of a politically conscious and progressive contemporary African art. It describes socially engaged practices, operating within a neoliberal capitalist environment, which focus on the production of critical subjectivities. I call the performative works under discussion biopolitical collectivism, not as a permanent classificatory tag, but rather in an attempt to highlight the critical strands of the collectives' aesthetic practices. In fact, iQhiya has categorically rejected the 'performance collective' label: in a panel discussion at the Institute for Creative Arts Live Art Festival 2017, iQhiya asserted that the scope of their work is much broader than the title 'performance collective' suggests.[5] Conscious of the straitjacketing effects of labels, I aim instead to conceptualise biopolitical collectivism as a theoretical framework for understanding these 'orgiastic,' anti-capitalist collectivist practices.[6] In other words, iQhiya and Gugulective, rather than being models of biopolitical collectivism, can be said to engage in biopolitical collectivism.

Foucault's ontological framework of power is crucial for understanding the concept of biopolitical collectivism. He defined biopolitics as mechanisms through which regimes of power operate to regulate and discipline bodies. He argued that, instead of conducting a vertical analysis of power starting from its top-down origins in the hands of the sovereign, the king, or the prince, one must study power from below, in the manifold details of its actualisation.[7] As power decentralises, it is appropriate to shift from a study of power from its intention at the point of origin to concentrate on its myriad effects on its targets where it infiltrates bodies. Following this decentralised view of power, Foucault moved away from the traditional view of power as an object that can be possessed, and regarded it instead as a network of relations. Biopower is this decentralised form of power which monitors, controls, reinforces and optimises life by colonising and diffusing through bodies. The optimisation of life through biopower is not for the betterment of life, but rather its exploitation. Foucault termed *dispositifs* the ensemble of apparatuses and technologies through which power achieves its immanence – for instance through education, religion and mass media. Today, biopolitics are the mechanisms for the colonisation, control and optimisation of life in service of capitalist profit, such as humanitarian action, media, biotechnology, the control of pharmaceuticals, or military force.[8]

However, following Foucault, workerist theorists such as Lazzarato and Negri who have examined global capitalist domination see opportunities for resistance within and against biopower. According to Lazzarato, biopolitics, which operate within biopower, are positive, generative counter-tactics internal to biopower.[9] Lazzarato builds on Foucault's fluid, deterritorialised and immaterialist conception of power to observe that 'the fundamental political problem of modernity is not that of a single source of sovereign power, but that of a multitude of forces that act and react amongst each other according to relations of command and obedience.'[10] Nevertheless, as Foucault argued, even ubiquitous biopower can always be, and is, resisted. In this light, both biopower and biopolitics optimise life, but while biopower dominates and exploits bodies, biopolitics resists this domination. The gist of biopolitics lies in this resistance and the constant struggle for freedom.

Historical examples of biopolitical resistance against neoliberal capitalism include the Zapatistas of Mexico against globalisation, active since the 1990s; Italian alter-globalisation activists the White Overalls, who also appeared in the 1990s; the Cochabamba fight against the privatisation of water in Bolivia in the 2000s, and the movement against water and electricity cutoffs in Durban, South Africa, in 2001.[11] The Black Lives Matter movement, which emerged in 2013 in response to police killings of black people in the United States of America, is a further instance of biopolitical resistance. On the cultural front, global examples include: Huit Facettes Interaction, a collective that sought to empower underserved rural communities in Senegal in the 1990s; the Postcommodity arts collective which fights for indigenous self-determination and the rights of undocumented migrants in North America; Project Row Houses, a community platform which has intervened in the gentrification of a neglected African American neighbourhood in Houston, Texas; and Black Women Artists for Black Lives Matter which fights for the visibility, defence and self-determination of black women. Collaborative production in a capitalist environment that fragments and atomises individuals marks these practices. These collectives seek not only to escape commodification and resist biopower, but also to empower subjectivities under biopower.

As the production of autonomous subjectivities is crucial in the struggle against racist and sexist capitalism, the autonomy of individual members, as artists, is key to the modus operandi of Gugulective and iQhiya. A characteristic feature of the two collectives is their fluid heterogeneity, whereby each member pursues

his or her own artistic practice apart from the collectives' collaborative works. The traditional view of collectivism conceives of a community of individuals who sacrifice their personal identities, needs and values for the group. In this view of collectivism, distinct identities merge to form one. By contrast, in biopolitical collectivism, difference is not suppressed; it coexists without being homogenised.[12] For instance, at a structural level, members of iQhiya are recognisable in the art world as individual artists with unique practices, while also working and performing as a group.[13]

The fluidity of biopolitical collectivism is also fundamental at an epistemological level. The typical anthropological view is that precolonial African artistic practice was essentially communitarian. This reading – which the late Malawian philosopher Didier Kaphagawani called 'romanticized representations of African worldviews'[14] – is deeply reductive and potentially damaging to the study of contemporary collectivism because it suggests an essential and enduring collective African impulse to be contrasted to modern western individualism. This understanding of collectivism is insidious because it both denies individual agency and eternally locks Africa in a Manichean, binary relationship with the west in which Africa is cast as other. As Stuart Hall notes, 'individuation, after all, was understood as the gift of the Enlightenment to western modernity. African art, being "less evolved," was supposed to be, by definition, more anonymously collective.'[15] Questioning this episteme, biopolitical collectivism, as articulated in the works of Gugulective and iQhiya, departs from long-held notions of precolonial and colonial collectivism in Africa to deploy aesthetic methods appropriate for contemporary aesthetic and political issues.

As noted above, performance is crucial in the aesthetics of biopolitical resistance. In performance, the struggle against biopower is enacted on the terrain of life itself. The dematerialised praxis of performance, both body-oriented and subject-centred, is therefore an important counter-*dispositif* in biopolitical collectivism's politics of self-reclamation and self-assertion. In their capacity to disrupt the neoliberal capitalist status quo through a corporeal politics, performance and performative interventions gesture towards alternative modes of being. The dematerialised nature of live art – a performance cannot be framed and hung in a gallery – is significant to the ontology of the collectives in question. However, it should be noted that the de-emphasis on object-centred production in my

analysis is not a denigration of object-based practices. Indeed, many performance artists, including members of iQhiya and Gugulective, come from object-centred disciplines, such as sculpture and painting. Rather, cognisant of the heightened commercialisation and privatisation of African art on the global market, my study seeks to shed light on the critical potential of immaterial, collaborative practices to affect, shape and form subjectivities on the continent. In a neoliberal world where the expropriation of cultural objects is rampant, biopolitical collectivism's subject-centred, ephemeral art-making escapes this privatisation. Viewed from a biopolitical collectivist frame, the production of material objects is not pitted in opposition to performance work; rather, the art object diminishes in value in recognition of the significance of the body.

ACTIVATED BODIES

In an act of appropriating and repurposing signs, entitled *Indaba ludabi* – an isiXhosa expression which roughly translates as 'the issue is the war' or 'the news is the war' – members of Gugulective handed out leaflets in the streets of Johannesburg in 2010, inspired by the advertisement strategies of sangomas.[16] Gugulective replaced the language of the sangoma with political messages that addressed issues of black disenfranchisement by patriarchal white supremacy. One leaflet read: 'For black men only ... no circumcision based essentialism, just bring your patriarchal soul. In fact black patriarchy reinforces white supremacy.'[17] In just a few words, this leaflet addresses essentialist notions of black masculinity and how they are tied to broader systems of racial domination. The leaflet suggests that black patriarchy is tied to, and reinforces, white supremacy. Black men who are oppressed by white men and women are complicit in a repressive system that benefits and safeguards white patriarchy when they oppress black women. The back page of the leaflet, titled 'The Dessalines Clinic' in reference to Jean-Jacques Dessalines, the leader of the Haitian Revolution who defeated the French army in 1803, is significant to Gugulective's activist politics of black empowerment. It reads: 'White supremacy is the creator of our catastrophic lives. Land retribution: No more shacks! No more RDP!!! Etc. By any means necessary.'[18]

While the sangoma promises cures for immediate woes such as illnesses, financial debt, distressed marriages and erectile dysfunction, Gugulective's work mobilises

FOR BLACK MEN ONLY Guaranteed

no circumcision based essentialism, just bring your patriarchal soul.

In-fact black patriarchy reinforces white supremacy

Which still hinders progressive Pan Africanist BLACK POWER is your misogynistic and homophobic tendencies. When you see a black homosexual you are repulsed. Worst you capture them and kill them. This shows how narrow your political imagination and how demented your Pan Africanist black power is. NB: You are over-determined from without, you are not a slave because of ideas others have of you but because of your skin, fucking kaffir. White supremacy doesn't think of your sexuality or gender before fucking you up. A kaffir is a kaffir irrespective of anything. Even if you sometimes you accept them like colonialist did to the colonised, you play insecticide DDT, i.e to purge in the name of purification. **vuka darkie.**

Besides you fuelling tribalism, Negrophobia etc. you are a great misogynistic wild pig (those black ones). Black women are your worst enemies. What kind of revolutionary creates casualties out of its own people? So many black women die in tragic conditions because of your egos and patriarchal despotism. So many children and women are victims because of your gluttonous sexual appetites. You do this because you're a fucking man. What a blank notion. **think Mister, think!**

Blacks you are on your own

CONTACT US 078 613 0176 or 071 222 0152

Figure 15.1. Gugulective, front page of flyer distributed in *Indaba ludabi*, 2010. Courtesy the artists.

around long-standing issues of land, race and the failed policies of redistribution, such as the Reconstruction and Development Programme (RDP) implemented by the African National Congress (ANC) government in 1994. The strength of this work lies in its engagement of bodies in a public space through processes of interaction and exchange. Borrowing from the traditional healer's strategies, Gugulective draws from the ordinary citizen's life politics in the same way that the healer provides alternatives to inadequate and overburdened western medical infrastructure. Gugulective is also influenced by the conscientisation tactics of Steve Biko's Black Consciousness Movement of the 1970s, which sought to forge a sense of self-worth and dignity amongst black South Africans, and fight against apartheid's racist politics of white supremacy. *Indaba ludabi* is thus a performative praxis in which Gugulective takes their conscientisation work to the streets.

An understanding of the relational effects of performing bodies in the streets as critical subjective consciousness ties Biko's conscientisation politics and Foucault's subjectivation – in which subjects engage in interactive processes of self-redemption against objectification – to Gugulective's refashioning of subjectivities under white supremacist patriarchal capitalism. As Frantz Fanon recognised, 'the black problem is not just about Blacks living among Whites, but about the black man exploited, enslaved, and despised by a colonialist and capitalist society that happens to be white.'[19] Fanon's analysis of the black experience is linked to Foucault's observation that the objectification of a race is directly tied to its exploitation. In apartheid South Africa, in the chain of dependency between exploiter and exploited, the black body was utilised as a source of labour, but excluded through segregation. The underserved and densely populated township was designed as a temporary residential area for expendable black labour servicing the city. Situated on the outskirts of white areas, these spaces were also intended to quarantine the diseased black body. This compartmentalisation ensured that black South Africans were excluded from opportunities for educational, social or economic advancement in a system of racial subjugation.

The township is a product of this logic of violation which persists today.[20] Black bodies are objectified, subjugated and exploited by white supremacist capitalism. Gugulective subverts this narrative of oppression and logic of violence through a performative intervention that is at once playful in its mimicking of the quick-fix assurances of sangomas and deeply political in its direct engagement with issues

of gender, race and space. Hitherto 'overdetermined from the outside' – by the mechanisms of structural racism and capitalist biopower – resisting black subjects fight to become autonomous subjectivities.[21]

In the 2008 intervention *Siphi?* – isiXhosa for 'Where are we?' – members of the collective arrived at the opening of their exhibition wearing balaclavas in a simulation of the hijacking of the space and, by extension, the takeover of art institutions that had hitherto denied them access.[22] For Gugulective, in postapartheid South Africa where the beneficiaries of an unjust system have retained their material privileges while the victims remain uncompensated, it is imperative for victims to take matters into their own hands and reclaim what belongs to them (as the flyer in *Indaba ludabi* suggests). Gugulective explains that the work

> raises issues of place and space, of our individual and collective identity, and interrogates notions of self not only as individuals but our collective position ... what does it mean to work collectively? What does it mean to be South African? What does it mean to be black? *Siphi?* aims to ask questions and to interrogate issues of identity, place, space, dislocation and otherness.[23]

In *Siphi?* the balaclava-donning artists proceeded to play children's hand-clapping games with art patrons, engaging with serious socio-political issues in a playful yet subversive manner that destabilised the protocols of detached and disembodied gallery spectatorship. In this performance, the group sought to highlight the politics of ownership and access, of the public and the private, through an intimate game that engaged bodies – of both performers and onlookers – in space. Spectators, drawn into the performance, were made to contend with the questions *Siphi?* raised about how people lay claim to spaces: who is entitled and who is not; who belongs in the gallery or the township and who does not; who is included and who is excluded.

Siphi? can be compared to iQhiya's *Portrait*, first performed in 2016, which was inspired by an old black-and-white photograph belonging to iQhiya member Lungiswa Gqunta. The photograph depicts the strength and resilience of Gqunta's mother and aunts under oppression[24] In *Portrait*, members of the collective occupied the gallery space of Greatmore Studios in Cape Town dressed in white, standing mute and menacingly still on red Coca-Cola bottle crates and holding

mock Molotovs – *iqhiyas* stuffed into glass bottles. The artists stood on the crates for as long as their bodies could endure. As a durational performance in which the artists tested the limits of their own endurance, the work embodies the resilience of generations of African women who have survived sexist and racist oppression. The performance also sought to reinsert the bodies of women, whose contributions have been sidelined in official histories, into the anti-apartheid struggle narrative. At the centre of these political and historical resonances, there is the figure of the Molotov-toting black woman portending a revolutionary takeover and demolition of the art institution.

Echoing Gugulective's act of hijacking an exhibition space, the symbolic gesture of the *iqhiya* 'bomb' suggests the potentially imminent threat of the torching of the gallery in militant response to its exclusionary politics. Thus, *Portrait* self-consciously and self-critically restages the visibility of women's bodies in exclusionary spaces. Read together, the work's visual references point to the potential for the radical transformation of these spaces – from the physical space of the gallery and institution to the intangible realm of memory and memorialisation. Members of iQhiya have noted: 'We are just operating in a space that hasn't celebrated black women artists in the same way that it has male artists. Our only pressure is asserting ourselves and giving ourselves the agency to create spaces for ourselves.'[25] The social and economic exclusion of black bodies in art and society at large drive both *Siphi?* and *Portrait*. In South Africa's neoliberal dispensation and beyond, borderlines are drawn in terms of economic class, perpetuating sharp distinctions between wealth and poverty. Under democracy, it remains the case that these economic and class divisions preserve the racial categories of apartheid.[26] In the art world, only a few black women artists have gained access to white-dominated galleries, museums, art schools and other discursive spaces.

In *Portrait*, the marginalisation of the black female body intersects with its commodification. The Coca-Cola crates on which the women stand suggest a kind of new auction block on the neoliberal cultural market. In the cultural market and elsewhere, black women are the subaltern, oppressed by a racist white patriarchy that is perpetuated by sexist black men. By inserting their bodies into the gallery, the subaltern use performance – perhaps the most apt aesthetic idiom at their disposal – to assert themselves in a world that seeks to objectify, commodify and marginalise the female black body.

iQhiya's work is therefore an exploration of the intersecting oppressions that black women continue to face. Critical race theorist Kimberlé Crenshaw's concept of intersectionality, which exposes the ways in which race, class and gender function as 'overlapping systems of subordination,' is crucial to biopolitical struggles.[27] As Crenshaw notes, the elision of differences leads to failure in the struggle against domination.[28] Importantly, an intersectional analysis reveals the multiple and simultaneous forms of subjugation against which *Portrait* works; iQhiya's work also shows that black women have fought with tenacity and resilience against these oppressions on multiple levels. *Portrait* is thus an active refusal of erasure. The work stages an interventionist politics of the valorisation of the female black body, opening up a space, within a historically inaccessible institution, in which black women's bodies are not only present but also respected and celebrated.

As with Gugulective, who use performance to challenge black objectification and exclusion, in iQhiya's work, the black female body intervenes in the politics of its objectification and marginalisation. In the practices of both collectives, the black body is taken from its peripheral position in a hegemonic worldview and centralised in a generative aesthetic practice. Through its all-women composition, iQhiya challenges the power imbalance in the art world. Like the Black Women Artists for Black Lives Matter, the members of iQhiya use their strength in numbers to fight for the visibility of black women – and for representation in art institutions and galleries. They also draw attention to the need to transform these institutions from within, since mere assimilation only affirms white supremacist patriarchy.

CREATIVE PERFORMATIVE PRAXIS

As capitalist domination operates on bodies in myriad ways, biopolitical collectivism adopts an ensemble of counter-*dispositifs* which borrow from the lived experience and resistance tactics of marginalised peoples in townships. The township lived experience is permeated by a praxis that is always creatively in resistance to power. The illegal tapping of water and electricity, and the recycling of commodity products prevalent in townships are some examples. In this respect, Mbembe's 'creativity of practice,' which captures these various tactics of resistance in the postcolony, informs my understanding of *Indaba ludabi, Siphi?* and *Portrait*, as well as *Commute*, discussed below.[29] Creativity of practice can be likened to what

Foucault called "'counter-conducts'" – acts of self-formation, including performing, deflecting, ruses and dissimulation.[30] In South Africa, creativity of practice as it figures in contemporary art should also be studied against the backdrop of forms of resistance and protest, such as the wildcat strike, *toyi-toying* and picketing.[31] The Marikana miners' strike of 2012, which was met with brutal repression when 34 miners were shot and killed by the South African Police Service is a notable example of a tragic event whose images, symbols and signs have profoundly shaped contemporary South African art.[32]

The Marikana strike calls to mind what gender theorists Judith Butler and Athena Athanasiou call 'corporeal citizenship' in reference to interventionist performative acts that insert bodies in public spaces against regimes of dispossession.[33] Socially engaged and activist art is strongly influenced by this practice. In 2015, South Africa saw the rise of what have been called the 'Fallist' movements of disaffected students – initially Rhodes Must Fall at the University of Cape Town (UCT) and Open Stellenbosch at Stellenbosch University, and subsequently the Fees Must Fall movement, which spread across the country's major universities. The student movement sought to decolonise the South African university, and to eradicate institutionalised racism and sexism, transforming the university into an Afrocentric and inclusive learning space.

These movements and their related campaigns incorporated art as a tool for communication in the form of interventions and installations, like the 2016 Shackville protest in which UCT students erected a shack and portable toilet in a particularly visible area of the campus to protest against the University's lack of accommodation for black students. Videos were also used, such as the 2015 short documentary film *Luister*, which exposed black students' experiences of racism at Stellenbosch University.[34] Social media was utilised as a tool for mobilising allies, as well as for the dissemination of crucial information. The movements engaged in social research in order to expose underlying systems of political and economic domination, and to reveal the names of individuals benefiting from and supporting such systems. Open Stellenbosch's 'Outsourcing Fact Sheet' in the End Outsourcing campaign listed private contractors with stakes in university outsourcing and its destabilising effects on university workers. Student activism manifested in marches, demonstrations, *toyi-toying*, campus occupations and blockades, some of which intersected with artworks – for example, the installations and performances

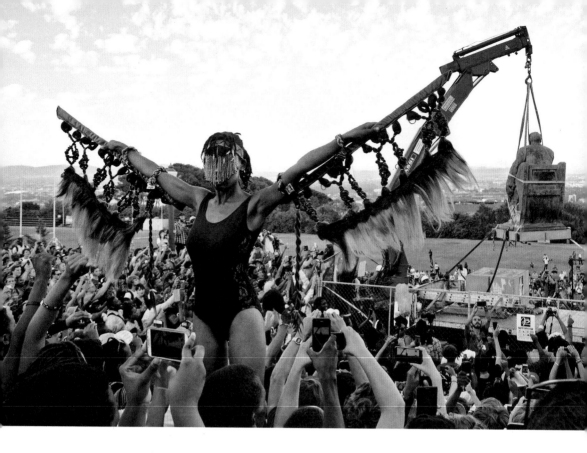

Figure 15.2. Sethembile Msezane, *Chapungu – The Day Rhodes Fell*, 2015.
Courtesy the artist.

of black student movement Umhlangano, who occupied UCT's Hiddingh Campus
during the 2016 University shutdown – and symbolically significant gestures,
such as calling for the renaming of buildings and the burning of paintings. These
movements have had a significant impact on artistic responses to a tumultuous
political moment in South Africa's democratic history.

The work of iQhiya, in particular, ought to be read against the backdrop of this
heterogeneous movement and its diverse creative praxis, which iQhiya shares
in its struggles against oppression. This interconnection of art and activism was
exemplified in the intervention entitled *Chapungu – The Day Rhodes Fell*, performed
by iQhiya member Sethembile Msezane at the removal of the Cecil John Rhodes

statue from UCT's Upper Campus on 9 April 2015.[35] Msezane wore a mask, black leotard and wings tied to her arms in reference to the ancient Zimbabwe bird – a symbol that was misappropriated by Rhodes.[36] Positioned on the University's iconic Jameson steps in front of the crane that lifted the Rhodes statue off its plinth, and encircled by hundreds of students and members of the public gathered to witness and document the event, Msezane assumed the figure of a mythical bird, a goddess watching over a historic moment in the ongoing process of decolonisation. This was an event in which political and artistic biopolitical resistance converged.[37]

BIOPOLITICS OF PERFORMANCE

iQhiya performed *Commute* at the Iziko National Gallery in 2016, and later the same year, *Commute 2* took place in the parking lot of UCT's Hiddingh Campus. In both iterations of the improvised performance, iQhiya invited friends to join them in having a party, the focal point of which was a 12-seater minibus taxi – a common means of transportation in South Africa, serving mainly working-class people in their commute from township to city. High-heeled and dressed in swimsuits, fur coats and short skirts, the women sipped champagne and twerked to Kanye West and Rihanna in a mobile bash that ended at the doors of the National Gallery and, in its second iteration, unfolded outside of the University's early twentieth-century buildings.

Inside the taxi, members spoke over microphones, their voices projected to onlookers via booming speakers. The women talked to, over and amongst one another, moving between casual chats and difficult discussions about the precarity of black women's bodies in South Africa – all the while encouraging passersby to engage or dance with them. In *Commute*, party meets protest, high art meets low culture, the private rubs up against the public, bourgeois clashes with working class in a performance that occupies an ambiguous position between frivolity and the serious struggle for decolonisation and self-determination.

In this performance, iQhiya gives voice, both audibly and visually, to their corporeal vulnerability as black women in the public space of the taxi in which women are objectified, policed and oftentimes victimised.[38] In a constitutional democracy of freedom of expression, movement and dress, women are continuously catcalled, harassed and humiliated in taxis and on the streets. Mode of dress is repeatedly used as an excuse for rape, most infamously in the 2006 rape trial of

former president Jacob Zuma, in which Zuma testified that he interpreted the *kanga* (traditional cloth) that Khwezi wore as an indication of her desire to have sex. Writer Khanya Mashabela noted of *Commute* that 'the performance simultaneously spoke to the shunting of black people to Cape Town's peripheries, and celebratorily flouted the policing of women's bodies and the calls for modesty used to justify the brutalising of women on public transport.'[39]

Like the shebeen, the taxi is a loaded political space. It is a liminal space in the capitalist logic of black labour exploitation and thus, for iQhiya, an important site for contesting black abjection. But it is also a space for challenging black sexism. The word 'commute' has a number of interesting resonances: 'community', 'mutable', but also 'mute.' iQhiya seems to play with all of these meanings – a community of women, but one that is also changeable, adaptable, not easily defined. And by speaking out via their voices, projected over loud speakers, but also via their bodies, the women defy the command to be silent. By flaunting their bodies in an environment that is hostile to the black female body, iQhiya reverts the disciplinary gaze directed towards women's bodies. *Commute* is therefore a defiant act of self-exposure and freedom, in the face of marginalisation and dispossession, which claims black women's visibility and respect. In other words, the work enables 'and enacts a performativity of embodied agency, in which [they] own [their] bodies and struggle for the right to claim [their] bodies as [their own].'[40] In *Commute*, where dancing symbolises struggle and freedom, the power of the performative lies in the exercising of corporeal citizenship.

iQhiya uses performance to rupture a hegemonic discourse that prescribes conceptions of propriety and normativity. To borrow further from Butler and

Figure 15.3. iQhiya, *Commute*, 2016.
Courtesy the artists.
Photograph by Gerald Machona.

Figure 15.4. iQhiya, *Commute 2*, 2016.
Courtesy the artists.
Photograph by Lerato Maduna.

Athanasiou, by flaunting their bodies and voices in the charged space of the taxi in swimsuits and short skirts, the group 'performatively exposes and repossesses the norms of visibility and audibility,'[41] resisting sexism and objectification while reasserting their own subjectivity.

CONCLUSION

In the work of iQhiya and Gugulective, space is *détourned* for a self-assertive, life-forming politics against racial and gendered marginalisation. The occupation and shaking up, or transformation, of the street, gallery, parking lot or taxi becomes crucial for the redemption of subjectivities. As we have seen, the reuse of elements of lived experience is driven by a creative performative praxis that resists and challenges subjugation. In creative praxis, performance is a counter-*dispositif* against neoliberal biopower. The performance work of Gugulective and iQhiya – whether handing out leaflets, playing, dancing, or standing still – disrupts the status quo of institutionalised racism and sexism, and suggests alternative modes of being as a black body. Underpinned by a broader network of global cultural and political struggles against capitalism, fascism and racism, this is a praxis that centralises and activates the body for a decolonial politics. Where a pervasive biopower colonises life through an insidious subjugation of human beings using myriad *dispositifs*, Gugulective and iQhiya's biopolitical performances gesture towards the possibility of free and autonomous black subjectivities – individuals who determine their own identity and social reality.

1. An earlier form of this chapter was first published by Massa Lemu as 'Gugulective as Biopolitical Collectivism' in *Third Text*, nos. 3–4 (2016): 256–263, doi: 10.1080/09528822.2017.1304686.
2. The cross-disciplinary and activist outlook of Gugulective and iQhiya is preceded by groups in other countries such as Laboratoire Agit'Art, which was operative in Senegal in the 1970s, and Ghetto Kota Okola, which was productive in the early 2000s in the Democratic Republic of Congo. These groups' social praxis share iQhiya and Gugulective's drive to use art to redeem the marginalised.

3. When the Suppression of Communism Act was passed by the apartheid regime, it prohibited black people from engaging in any form of political activism. Under these circumstances, places such as the shebeen offered spaces for clandestine political meetings and discussions. For members of Gugulective, the criminalised shebeen – a space deemed for outcasts, misfits and criminals – offered the ideal base from which to reach out to the marginalised. See Massa Lemu, 'The Biopolitics of Gugulective against Neoliberal Capitalism,' PhD diss., University of Stellenbosch, 2017, 83–84, accessed 19 April 2018, http://scholar.sun.ac.za/handle/10019.1/101287.

4. Institute for Creative Arts, *ICA Launch Programme* (Cape Town: ICA Launch, 5 April 2016), 2, accessed 6 November 2017, http://www.gipca.uct.ac.za/wp-content/uploads/2016/04/FINAL-ICA-Launch-programme-with-UCT-logo.pdf.

5. To stress this point, iQhiya created a performance titled *We Are Not a Performance Collective* at the *South-South: Let me Begin Again* exhibition held at Goodman Gallery, Cape Town in 2017. See 'South-South at Goodman Gallery,' ArtThrob, 25 January 2017, accessed 6 November 2017, https://artthrob.co.za/2017/01/25/south-south-at-goodman-gallery/.

6. 'Orgiastic' is a Deleuzian term to describe identities that are in constant flux; that are fluid and non-hierarchical. Gilles Deleuze, *Difference and Repetition*, trans. Paul Patton (New York: Columbia University Press, 1994).

7. Michel Foucault, *The History of Sexuality: Vol. 1*, trans. Robert Hurley (London: Penguin, 1976), 141.

8. Timothy Campbell and Adam Sitze, eds. *Biopolitics: A Reader* (Durham: Duke University Press, 2013), 3.

9. Maurizio Lazzarato, 'From Biopower to Biopolitics,' *Pli: The Warwick Journal of Philosophy*, 13 (2002): 99–113, accessed 19 April 2018, https://plijournal.com/files/Pli_13.pdf.

10. Lazzarato, 'From Biopower to Biopolitics,' 103.

11. Michael Hardt and Antonio Negri, *Multitude: War and Democracy in the Age of Empire* (New York: Penguin, 2004), 135.

12. According to Hardt and Negri, the strength of biopolitical resistance lies in the fact that, rather than homogeneity, difference prevails and collaborates in anti-capitalist production of autonomous subjectivities. Michael Hardt and Antonio Negri, *Empire* (Cambridge: Harvard University Press, 2000), 60–66.

13. Nereya Otieno, 'Meet the Young, Black and Female Collective Challenging South Africa's Art Game,' OkayAfrica, 10 June 2016, accessed 1 April 2017, http://www.okayafrica.com/iqhiya-young-black-female-art-collective-south-africa/.

14. Didier N. Kaphagawani, 'Some African Conceptions of Person: A Critique,' in *African Philosophy as Cultural Inquiry*, eds. Ivan Karp and D.A. Masolo (Bloomington: Indiana University Press, 2000), 75.

15. Stuart Hall, 'Maps of Emergency: Fault Lines and Tectonic Planes,' in *Fault Lines: Contemporary African Art and Shifting Landscapes*, eds. Gilane Tawadros and Sarah Campbell (London: Iniva, 2003), 33.

16. Sangomas often advertise their healing powers through flyers distributed in the streets and posted in newspapers or magazines, as well as through stickers pasted on public transportation such as trains.

17. Gugulective, *Indaba Iudabi*, Johannesburg, 2010.

18. Gugulective, *Indaba Iudabi*.

19. Frantz Fanon, *Black Skin, White Masks*, trans. Charles Lam Markmann (New York: Grove Press, 1967), 178.

20. I borrow the term 'violation' from Noah De Lissovoy, who defines it as a process whereby subjectivities are simultaneously incorporated and excluded in capitalist production. Noah De Lissovoy, *Education and Emancipation in the Neoliberal Era: Being, Teaching, and Power* (New York: Palgrave Macmillan, 2015), 106.

21. Fanon, *Black Skin, White Masks*, 92.

22. Dathini Mzayiya (Gugulective member), in discussion with the author, April 2015, Cape Town.

23. Hebbel Theatre, *Performing South Africa Festival Programme* (Berlin: Performing South Africa, August 2008), accessed 1 April 2017, www.archiv.hebbel-am-ufer.de/media/610_Booklet_PerformingSouthAfrica_03.pdf.

24. Khanya Mashabela, 'In Defense of Art Collectives,' ArtThrob, 4 July 2016, accessed 1 April 2017, http://artthrob.co.za/2016/07/04/iqhiya-in-defense-of-art-collectives/ .

25. Otieno, 'Meet the Young, Black, and Female Collective.'

26. Nomusa Makhubu, 'Open Debate: Ephemeral Democracies: Interrogating Commonality in South Africa,' *Third Text* 27, no. 3 (2013): 415–418, accessed 19 April 2018, doi: 10.1080/09528822.2013.796200.

27. Kimberlé Crenshaw, 'Mapping the Margins: Intersectionality, Identity Politics, and Violence against Women of Color,' *Stanford Law Review* 43, no. 6 (1991): 1265, accessed 19 April 2018, http://www.jstor.org/stable/1229039. See also: Michael Hardt and Antonio Negri, *Commonwealth* (Cambridge: Harvard University Press, 2009), 325–344.

28. Crenshaw, 'Mapping the Margins,' 1242.

29. Jesse Shipley, Jean Comaroff and Achille Mbembe, 'Africa in Theory: A Conversation between Jean Comaroff and Achille Mbembe,' *Anthropological Quarterly* 83, no. 3 (2010): 6543–6678, accessed 19 April 2018, https://muse.jhu.edu/article/394747.

30. Michel Foucault quoted in Maurizio Lazzarato, 'Neoliberalism in Action: Inequality, Insecurity and the Reconstitution of the Social,' *Theory, Culture and Society* 26, no. 6 (2009): 114, accessed 19 April 2018, doi: 10.1177/0263276409350283.

31. The *toyi-toyi* is a form of dance involving feet stomping which is often used in political protests in South Africa.

32. See Khanyisile Mbongwa, *Poetic Procession*, YouTube video, 3:54, from a public performance in St Georges Mall, Cape Town, August 2014, accessed 13 July 2017, https://www.youtube.com/watch?v=0pcykWURKI8. On how the massacre has been featured in, and has influenced, socially engaged art in South Africa, see James Sey, 'Marikana Artwork Provides a Tool for Conscientisation,' *The Conversation*, 4 September 2015, accessed 18 July 2017, http://theconversation.com/marikana-artwork-provides-a-tool-for-conscientisation-46375.

33. Judith Butler and Athena Athanasiou, *Dispossession: The Performative in the Political* (Cambridge: Polity Press, 2013), 144.

34. Contraband, 'Luister,' YouTube video, 34:50, 20 August 2015, accessed 5 November 2017, https://www.youtube.com/watch?v=sF3rTBQTQk4.

35. Otieno, 'Meet the Young, Black, and Female Collective.'

36. The Zimbabwe bird is a soapstone carving of the eagle which was found in the ancient ruins at Great Zimbabwe in 1889 by European bounty hunter Willie Posselt who desecrated the sacred shrine where these carvings lay and later sold them to Cecil John Rhodes. Paul Hubbard, 'The Zimbabwe Birds: Interpretation and Symbolism,' *Honeyguide* 55, no. 2 (2009): 109–110, accessed 19 April 2018, https://www.academia.edu/3983278/The_Zimbabwe_Birds_Interpretation_and_Symbolism.

37. Sethembile Msezane, 'Sethembile Msezane Performs at the Fall of the Cecil Rhodes Statue 9 April 2015,' *The Guardian*, 15 May 2015, accessed 1 April 2017, https://www.theguardian.com/artanddesign/2015/may/15/sethembile-msezane-cecil-rhodes-statue-cape-town-south-africa.

38. Mashabela, 'In Defense of Art Collectives.'

39. Mashabela, 'In Defense of Art Collectives.'

40. Butler and Athanasiou, *Dispossession*, 178.

41. Butler and Athanasiou, *Dispossession*, 141.

CONTRIBUTORS

Catherine Boulle is a writer and researcher based at the Institute for Creative Arts (ICA), University of Cape Town. Since completing her Master's in English Literature at the University of Oxford, focusing on feminism in African-American theatre, her work at the ICA has included curating the Institute's lecture series and symposiums, and initiating new research on contemporary live art in South Africa.

Jay Pather is a choreographer, curator and academic. He is associate professor at the University of Cape Town and director of the Institute for Creative Arts. He was a Fulbright Scholar in Dance Theatre at New York University and since then his work has travelled widely, both locally and internationally, extending across disciplines, sites and cultures.

Katlego Disemelo is a media studies scholar currently engaged in a joint PhD programme at the University of the Witwatersrand and the University of Amsterdam. His research focus lies in contemporary mediations of Black queer performance, subcultures and popular consumer landscapes across the African continent. He is devoted to decolonial approaches to pedagogy, archival praxis and the interrelationships between applied research and LGBTQIA+ human rights activism.

Gabrielle Goliath is a multidisciplinary artist known for her distilled and sensitive negotiations of complex social concerns, particularly relating to situations of gendered and sexualised violence. She holds an MAFA from the University of the Witwatersrand and is currently a PhD candidate at the Institute for Creative Arts, University of Cape Town, where her research explores the possibilities and ethical demands of performing and making shareable traumatic recall.

Khwezi Gule is a curator and writer based in Johannesburg. He is the curator-in-chief of the Johannesburg Art Gallery (JAG). Before this he was chief curator at the Soweto Museums and curator of contemporary collections at JAG. Gule has curated projects locally and internationally, he has contributed essays to various

publications, and delivered conference and seminar papers straddling his areas of interest – art and heritage studies.

Andrew J. Hennlich is associate professor of Art History in the Gwen Frostic School of Art at Western Michigan University, and research associate in the Visual Identities in Art and Design Research Centre, University of Johannesburg. Hennlich's work focuses on contemporary South African visual culture, and recent projects include an exhibition and catalogue titled *After the Thrill is Gone: Fashion, Politics and Culture in Contemporary South African Art*, and essays including 'Space Invaders: Border Crossing in Dan Halter's *Heartland*' in *Safundi*, and 'The Collector's Asylum: The Politics of Disposability in the Work of Julia Rosa Clark' for *Image & Text*.

Mwenya B. Kabwe is a Johannesburg-based, Zambian-born maker of collaborative and interdisciplinary theatre and performance work, facilitator of creative processes, performer, writer and educator with migrant tendencies. Kabwe has a Master's in Theatre and Performance from the University of Cape Town (UCT) where she was a lecturer in the Drama Department. She is currently a PhD candidate at the Centre for Theatre, Dance and Performance Studies at UCT with a research focus on the dramaturgy of African futures. Kabwe is also a lecturer in the Theatre and Performance Division at the Wits School of Arts.

Massa Lemu is a writer who focuses on contemporary African art and a visual artist whose multidisciplinary practice features text, performance and installations. Lemu is currently assistant professor of Sculpture in the Department of Sculpture and Extended Media at Virginia Commonwealth University in Richmond, Virginia.

Nomusa Makhubu is an art historian and artist. She is the recipient of the ABSA L'Atelier Gerard Sekoto Award (2006) and the Prix du Studio National des Arts Contemporain, Le Fresnoy (2014). She received the UCT-Harvard Mandela Fellowship in 2017. Her current research focuses on African popular culture, photography, interventionism, live art and socially engaged art. She lectures Art History at the University of Cape Town.

Bettina Malcomess is a writer and artist whose work exists in a diverse set of media and forms. Under the name Anne Historical, she has produced a series of live and recorded sonic works with analogue devices that inhabit the entanglement of memory, technology and language with history. These are unfinished articulations, in counterpoint voices, of what gets lost in transmission. She co-authored *Not no Place. Johannesburg, Fragments of Spaces and Times* and is the visual editor of *Routes and Rites to the City: Mobility, Diversity and Religious Space in Johannesburg*. She recently formed an interdisciplinary platform for live work called the joining room. Historical/Malcomess's work has been shown at various national and international spaces. She lectures Visual Arts at the Wits School of Arts and is completing a PhD on colonial film history at Kings College, London.

Same Mdluli is an artist, art historian and writer living in Johannesburg, and the manager of the Standard Bank Gallery. Mdluli completed her PhD in History of Art in 2015, and before this completed a Master's in Arts and Culture Management at the University of the Witwatersrand in 2010. She serves as a panel member for visual arts for the National Arts Council and is a member of the Black Mark: Critical Creative Thought collective.

Lieketso Dee Mohoto-wa Thaluki is a performer, academic and live sound/voice artist who studied at the University of Cape Town's Drama Department before going on to freelance as a voice coach and performer with a primary interest in voice in performance practice. She is a wordsmith, a sangoma, an artist, a Lessac Kinesensic practitioner and general performance junkie.

Nondumiso Lwazi Msimanga is an internationally presenting academic and performing artist with a Master's degree from the University of the Witwatersrand. She is an independent arts writer and researcher, and formerly a lecturer in the Theatre and Performance Division at Wits. Msimanga is currently a PhD scholar at the University of Cape Town with a focus on protest and performance in trauma and gender studies. She is artistic director of the Olive Tree Theatre in Alexandra.

Sarah Nuttall is a professor of literature and director of the Wits Institute for Social and Economic Research (WISER). For many years she taught the Fall semester in

the English Department at Yale University and in the African and African American Studies Department at Duke University. She is the author of *Entanglement: Literary and Cultural Reflections on Post-Apartheid*, editor of *Beautiful/Ugly: African and Diaspora Aesthetics*, and co-editor of many books including *Negotiating the Past: The Making of Memory in South Africa, Senses of Culture, Johannesburg: The Elusive Metropolis* and *Loadshedding: Writing On and Over the Edge of South Africa*. Her work is widely cited across disciplines. For five years she has directed WISER, the largest and most established Humanities Institute across the Global South. In 2016 she was an Oppenheimer Fellow at the DuBois Institute at Harvard University.

Alan Parker is a choreographer, performer and lecturer at Rhodes University, currently engaged in doctoral research at the University of Cape Town. Parker's PhD research considers the relationship between live art and the archive, with a specific focus on choreographic strategies aimed at performing the archive.

LIST OF ILLUSTRATIONS

Opening page figure: Nelisiwe Xaba, *Sakhozi says 'Non' to the Venus*, 2012. Courtesy Institute for Creative Arts. Photograph by Ashley Walters.

Figure 1.1. Buhlebezwe Siwani and Chuma Sopotela, *Those Ghels*, 2017. Courtesy Institute for Creative Arts. Photograph by Ashley Walters.

Figure 1.2. Buhlebezwe Siwani and Chuma Sopotela, *Those Ghels*, 2017. Courtesy Institute for Creative Arts. Photograph by Ashley Walters.

Figure 1.3. Khanyisile Mbongwa, *kuDanger!*, 2017. Courtesy Institute for Creative Arts. Photograph by Ashley Walters.

Figure 1.4. Sethembile Msezane, *Excerpts from the Past*, 2017. Courtesy Institute for Creative Arts. Photograph by Ashley Walters.

Figure 2.1. Mohau Modisakeng, *Inzilo*, 2013. Courtesy the artist, Ron Mandos and WHATIFTHEWORLD.

Figure 2.2. Mohau Modisakeng, *Ukukhumula*, 2014. Courtesy Institute for Creative Arts. Photograph by Ashley Walters.

Figure 2.3. Mohau Modisakeng, *Ukukhumula*, 2014. Courtesy Institute for Creative Arts. Photograph by Ashley Walters.

Figure 2.4. Dean Hutton, *Plan B, A Gathering of Strangers (or) This Is Not Working*, 2018. Courtesy Institute for Creative Arts. Photograph by Xolani Tulumani.

Figure 3.1. Steven Cohen, *Dog*, 1998. Copyright: Steven Cohen. Courtesy Stevenson, Cape Town and Johannesburg.

Figure 3.2. Steven Cohen, *Ugly Girl at the Rugby*, 1998. Copyright: Steven Cohen. Courtesy Stevenson, Cape Town and Johannesburg.

Figure 3.3. Steven Cohen, *Ugly Girl at the Rugby*, 1998. Copyright: Steven Cohen. Courtesy Stevenson, Cape Town and Johannesburg. Photograph by John Hodgkiss.

Figure 3.4. Steven Cohen, *put your heart under your feet ... and walk! (blood)*, 2017. Copyright: Steven Cohen. Courtesy Stevenson, Cape Town and Johannesburg.

Figure 7.4. Gabrielle Goliath, *Elegy – Noluvo Swelindawo*, 2017. Courtesy Institute for Creative Arts. Photograph by Ashley Walters.

Figure 7.5. Gabrielle Goliath, *Elegy – Noluvo Swelindawo*, 2017. Courtesy Institute for Creative Arts. Photograph by Ashley Walters.

Figure 8.1. Remember Khwezi protest at the Independent Electoral Commission results ceremony, 2016. Courtesy *The Citizen*. Photograph by Jacques Nelles.

Figure 8.2. Students Qondiswa James and Nsovo Shandlale enact a nude protest in demonstration against institutional racism at UCT and state-sanctioned violence on the University's campuses, 2017. Courtesy GroundUp. Photograph by Ashraf Hendricks.

Figure 8.3. Demonstration at the UCT University Assembly on Jameson Plaza, 2017. Courtesy VARSITY News. Photograph by Thapelo Masebe.

Figure 8.4. Demonstration at the UCT University Assembly on Jameson Plaza, 2017. Courtesy VARSITY News. Photograph by Thapelo Masebe.

Figure 8.5. Demonstration at the UCT University Assembly on Jameson Plaza, 2017. Courtesy VARSITY News. Photograph by Thapelo Masebe.

Figure 9.1. Athi-Patra Ruga, *Prelude to Ilulwane*, 2010. Courtesy Institute for Creative Arts. Photograph by Moeneeb Dalwai.

Figure 9.2. Dean Hutton and Alberta Whittle, *The Cradle*, 2015. Courtesy the artists.

Figure 9.3. Dean Hutton and Alberta Whittle, *The Cradle*, 2015. Courtesy the artists.

Figure 9.4. FAKA, *From a Distance,* 2015. Courtesy the artists.

Figure 9.5. FAKA, *From a Distance*, 2015. Courtesy the artists.

Figure 9.6. FAKA, *From a Distance*, 2015. Courtesy the artists.

Figure 10.1. Umlilo, 'Umzabalazo,' 2017. Photograph by Katlego Disemelo.

Figure 10.2. FAKA, 2017. Courtesy Superbalist.com. Fashion Director: Gabrielle Kannemeyer. Photograph by Bevan Davis.

Figure 10.3. Albert 'Ibokwe' Khoza, *Take in Take out (to live is to be sick to die is to live)*, 2017. Courtesy Institute for Creative Arts. Photograph by Ashley Walters.

Figure 10.4. Albert 'Ibokwe' Khoza, *Take in Take out (to live is to be sick to die is to live)*, 2017. Courtesy Institute for Creative Arts. Photograph by Ashley Walters.

Figure 11.1. Gavin Krastin, *Rough Musick*, 2014. Courtesy Institute for Creative Arts. Photograph by Ashley Walters.

Figure 11.2. Gavin Krastin, *Rough Musick*, 2014. Courtesy Institute for Creative Arts. Photograph by Ashley Walters.

Figure 11.3. Sello Pesa and Ntsoana Contemporary Dance Theatre, *Limelight on Rites*, 2014. Courtesy Institute for Creative Arts. Photograph by Ashley Walters.

Figure 11.4. Igshaan Adams, *Bismillah*, 2014. Performed at the National Arts Festival as part of the BLIND SPOT Performance Art Programme curated by Ruth Simbao. Photograph by Ruth Simbao.

Figure 12.1. Sikhumbuzo Makandula, *Ingqumbo*, 2016. Courtesy the artist. Photograph by Gcobani Sakhile Ndabeni.

Figure 12.2. Sikhumbuzo Makandula, *Hlanga Waphum' eluhlangeni*, 2015. Courtesy the artist and Euridice Kala. Photograph by Euridice Kala.

Figure 12.3. Buhlebezwe Siwani, *iSana libuyele kunina*, 2015. Courtesy the artist.

Figure 12.4. Buhlebezwe Siwani, *Inzilo; Ngoba ngihlala kwabafileyo*, 2014. Courtesy Institute for Creative Arts. Photograph by Ashley Walters.

Figure 13.1. Map of the Rhodes Main Theatre complex provided in the *Astronautus Afrikanus* programme, 2015.

Figure 13.2. Clipping from *The Ottawa Journal*, 28 October 1964.

Figure 13.3. Pamela Phatsimo Sunstrum and Thenjiwe Niki Nkosi, *DISRUPTERS, THIS IS DISRUPTER X*, 2014. Courtesy the artists. Photograph by Simon Rittmeier.

Figure 13.4. Pamela Phatsimo Sunstrum and Thenjiwe Niki Nkosi, *DISRUPTERS, THIS IS DISRUPTER X*, 2014. Courtesy the artists. Photograph by Thenjiwe Niki Nkosi.

Figure 13.5. Mwenya B. Kabwe, *Astronautus Afrikanus*, 2015. Photograph by Jonathan Georgiades.

Figure 14.1. Athi-Patra Ruga, *Performance Obscura*, 2012. Courtesy the artist and WHATIFTHEWORLD.

Figure 14.2. Athi-Patra Ruga, *Ilulwane*, 2012. Courtesy Institute for Creative Arts. Photograph by Ashley Walters.

INDEX

Page numbers in *italics* refer to photographs.

immigration 98, 282, 322
impepho (incense) 112, 114, 219
imperialism 83, 110, 203
incantation 134–41, 143
In case of fire, run for the elevator (Boyzie
 Cekwana) *96*, 97
incoherence 157–8
Indaba ludabi (Gugulective) 332, 333, 337, *338*,
 339–40, 342
indigenous practices 3–4, 85, 253–4, 304
individualism 336
indlamu (Zulu war dance) 5
Industry (nightclub) 223
'Influencers' 222
informal settlements *see* townships
Ingqumbo (Sikhumbuzo Makandula) 267,
 268–70, *270–1*
initiation ritual 6, 271–3
Inkukhu Ibeke Iqanda (Chuma Sopotela) 1, 90,
 108–22, *111, 115, 118*
inner-city public spaces 27–9
'insistent subjectivity' 134–5
Instagram 212, 220–3, 225–9, 231, 234, 237–9
 see also social media
Institute for Creative Arts (ICA) 3, 7–8 *see
 also* ICA Live Art Festival
institutions, as fortresses 93
intersectionality 178, 180, 187, 226, 342
Intervention of the Sabine Women
 (Jacques-Louis David) 174, 318
intimacy 194, 196–9, 215
invisibility 112, 184
Invitation... Presentation... Induction...
 (Athi-Patra Ruga) 320
invocation 125–7, 131, 134–8, 142–3
Inzilo (Mohau Modisakeng) 46–9, *48–9*
Inzilo; Ngoba ngihlala kwabafileyo (Buhlebezwe
 Siwani) 279–80, *280*
Inzwi (Sikhumbuzo Makandula) 277–8
iQhiya 97, 102, 332–6, 340–2, 344–5, *346*,
 347–8
irresolution 131, 143
iSana libuyele kunina (Buhlebezwe
 Siwani) *279*
ISANG *see* Iziko South African National
 Gallery
isicathimiya dance form 5
Islamic culture 257–60
Iziko South African National Gallery
 (ISANG) 35, 51, 54, 87, 138, 140,
 332, 345

J
Jacobs, Sean 125
James, Qondiswa *176–7*
Jansen, Jonathan 63
Jewish communities 66, 319, 321
Joja, Athi Mongezeleli 333
Jomba! Festival 86
Jones, Amelia 77–8
Jones, Kellie 134–5
judgment 313, 323
justice 277

K
Kabwe, Mwenya B.
 Astronautus Afrikanus 286–7, 290–5, *292*,
 300–1, *302*, 303–5
 U nyamo alunampumlo 86
Kanda-Matulu, Tshibumba 125
Kaphagawani, Didier 336
Kasibe, Wandile 94
Katz, Bronwyn 333
!KAURU: Towards Intersections (exhibition) 280
Kavula, Bonolo 333
Kaye, Nick 295
Keidan, Lois 21
Kelapile, Charity Matlhogonolo 333
Keleketla! Library 281–2
Keller, Bonnie B. 326
Khoi-San peoples 4
Khoza, Albert Silindokuhle 'Ibokwe' 7, 98,
 219–22, *232–3*, 234–7, *235*
'Khwezi' (Fezekile Kuzwayo) 172–3
Kilani, Lonwabo 333
Kilimane, Ayanda 333
'kinesthetic imagination' 246–53
Kiwanga, Kapwani 290, 296–7
knowledge 44, 244, 267, 300, 304–5
Krastin, Gavin
 Pig Headed 93
 Rough Musick 98, 246–53, *248, 249*, 262
Kruger, Barbara 35
kuDanger! (Khanyisile Mbongwa) 20–1, 27–9,
 28
Kukama, Donna 125, 127, 136–43, *138, 141*
Kumalo, Nokuphila 140–1, 142
Kuzwayo, Fezekile ('Khwezi') 172–3

L
labour 23, 27–9, 70, 222, 226, 339
Laclau, Ernesto 45
Ladysmith Black Mambazo 5

Watt Smith, Tiffany 149
Wenzel, Jennifer 326
Western, Rat 260
western culture 3–4, 7, 85, 267, 274, 283
White, Gareth 295
white complicity 70–1
whiteness 36, 51–5, 67, 171, 173–5, 180, 182–6, 201–4, 208–9
white paint, application of 173, 184–6
white privilege 35–6, 67, 73, 76, 173–4, 203–4, 208–9
white supremacy 48, 134, 142, 337–40
Whittle, Alberta 194, 202–5, *202, 206–7*, 208–9, 215
'wild antagonism' 45
Wilderson, Frank B., III 276
'wildness' 195–6, 199, 201, 208–9, 214
Williams, Raymond 85
Williams, Weaam 91
Wilson, Mick 85
Wit Man, Die (Tracey Rose) 124–5, *126*, 131, *132–3*, 134–6, 143
Wits University *see* University of the Witwatersrand
women *see* black women

Women's March, Washington (2017) 148–9
Women's March of 1956 187
Wretched of the Earth, The (book) 4, 203

X
Xaba, Nelisiwe *ii*, 6, 7, 8
xenophobic violence 273, 282, 309, 311–12, 322, 323
Xhosa people 6, 271–3, 311–13, 320, 325–7

Y
YouTube 173, 181–2, 183–4, 187, 211–12
see also social media
Yuval-Davis, Nira 114

Z
Zambia 291–2, 304
Zimbabwe *see* Great Zimbabwe
'zone of nonbeing' 137, 142, 269, 283
Zulu people 5, 6, 269–70, 320
Zuma, Jacob 1, 33, 55–6, 148–9, 172–3, *172*, 181, 273, 347
Zuma Must Fall marches 148–9, 181